Modernist Studies
Rima Drell Reck, Editor

Brassaï

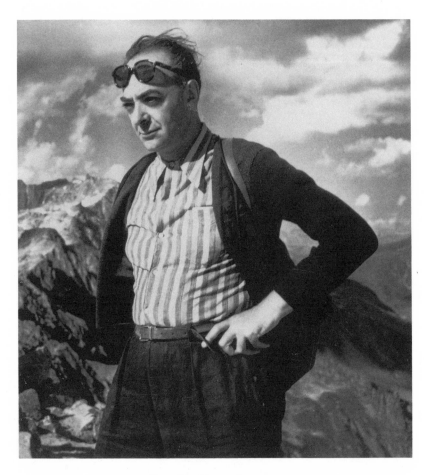

Brassaï at Chamonix. 1945.

Brassaï

IMAGES OF

CULTURE

AND THE

SURREALIST

OBSERVER

Marja Warehime

Louisiana State University Press

Baton Rouge and London

Copyright © 1996 by Louisiana State University Press

All rights reserved

Manufactured in the United States of America

First printing

05 04 03 02 01 00 99 98 97 96 5 4 3 2 1

Designer: Amanda McDonald Key
Typeface: Text Bembo, display ITC Benguiat
Typesetter: Impressions, a division of Edward Bros., Inc.
Printer and binder: Thomson-Shore, Inc.

All writings and photographs by Brassaï copyright © Gilberte Brassaï.

Portions of chapter III were originally published, in different form, as "Writing the Limits of Representation: Balzac, Zola, and Tournier on Art and Photography," *SubStance 58,* XVIII, No. 1 (1989), 51–57, and are reprinted by permission.

Library of Congress Cataloging-in-Publication Data

Warehime, Marja, 1946—
 Brassaï : images of culture and the surrealist observer / Marja Warehime.
 p. cm. — (Modernist studies)
 Includes bibliographical references (p.) and index.
 ISBN 0-8071-1943-1 (cloth : alk. paper)
 1. Brassaï, 1899—. 2. Surrealism—France. I. Title.
 II. Series.
 TR140.B75W37 1995
 770'.92—dc20

 95-343
 CIP

Contents

Preface xiii

Abbreviations xvii

Introduction: A Vision of Culture 1

I
The Eye of Paris and the Surrealist Observer 22

II
Remembrance of Things Past: Cultural Preservation as Renovation 45

III
Between Realism and Surrealism 68

IV
Ethnographic Surrealism and Surrealist Baroque 89

V
The Photographer and the Artists in His Life: Questions of Art
and Style 119

VI
The Photographer as Writer 142

Conclusion: From Modernist to Media Culture 159

Bibliography 177

Index 185

Illustrations

frontispiece
Brassaï at Chamonix. 1945. By Gilberte Brassaï.

following page 84
1. Eugène Atget. "Boulevard de Strasbourg, Corsets." 1912.

2a, 2b. Florence Henri. Self-portrait with mirror, 1928,
and self-portrait, 1937.

3. Walter Peterhans. "Still Life."

4. Medical photograph of a diathermy treatment.

5. Model of an airplane switch lever.

6. Florence Henri. "Columbia Records" (advertisement). 1931.

7. Brassaï. Self-portrait in his darkroom. 1931 or 1932.

8. Charles Meryon. *Ancienne Porte du Palais de Justice.* 1854. From
Eaux-Fortes sur Paris.

9. Charles Meryon. *Le Stryge.* Ca. 1853. From *Eaux-Fortes sur Paris.*

10. Charles Nègre. "Le Stryge/The Vampire" (Henri Le Secq on the
north tower of Notre-Dame). Ca. 1853.

11. Eugène Atget. "Saint-Denis, canal." 1925–27.

12. Germaine Krull. Untitled (Eiffel Tower). Ca. 1929.

13. Eugène Atget. "La Villette, rue Asselin, fille publique faisant le quart devant sa porte" (prostitute on watch in front of her door). March 7, 1921.

14. Germaine Krull. Shadow of the Eiffel Tower, Paris. 1925–30.

15. André Kertész. Shadows of the Eiffel Tower (view looking down from tower to people underneath). 1929.

16. André Kertész. Bistro, Paris (café window at night). 1927.

17. Eugène Atget. "Bitumiers/Spreading Tar." 1899–1900.

18. André Kertész. Siesta, Paris. 1927.

19. Brassaï. The Montmartre cemetery. Ca. 1932. From *Paris by Night*.

20. László Moholy-Nagy. Oskar Schlemmer, Ascona (man reclining by fence with shadows). 1926.

21. Brassaï. Bijou in the bar de la lune, Montmartre. 1933. From *The Secret Paris of the 30's*.

22. Brassaï. Graffiti heart. Collection Gilberte Brassaï.

23. Brassaï. Dancers on display in front of their booth, boulevard Saint-Jacques. Ca. 1931. From *The Secret Paris of the 30's*.

24. Brassaï. Couple at the Bal Nègre, rue Blomet. Ca. 1932. From *The Secret Paris of the 30's*.

25. Man Ray. "Noire et Blanche" (Kiki with an African mask). 1926.

26. Brassaï. Mirrored wardrobe in a brothel, rue Quincampoix. Ca. 1932. From *The Secret Paris of the 30's*.

27. Brassaï. Washing up in a brothel, rue Quincampoix. Ca. 1932. From *The Secret Paris of the 30's*.

28. Brassaï. Nocturnal view from Notre-Dame overlooking Paris and the tour Saint-Jacques. 1933. From *The Secret Paris of the 30's*.

29. László Moholy-Nagy. Berlin radio tower. Ca. 1928.

30. Brassaï. Portrait of Ambroise Vollard. 1932 or 1933? From *The Artists of My Life*.

31. Brassaï. Portrait of D.-H. Kahnweiler. 1962. From *The Artists of My Life*.

32. Brassaï. Picasso's studio by night. 1932. From *The Artists of My Life*.

33. Brassaï. Matisse modeling the second version of his *Vénus à la coquille*. Ca. 1934. From *The Artists of My Life*.

34. Brassaï. Maillol at work on *L'Ile de France*. Ca. 1932. From *The Artists of My Life*.

35. Brassaï. Giacometti beside busts of his brother Diego. 1965. From *The Artists of My Life*.

36. Brassaï. Dali and Gala in their studio. 1932. From *The Artists of My Life*.

37. Brassaï. Germaine Richier at work on a sculpture. Ca. 1955. Collection F. Guiter.

Preface

Many people who might not recognize the name Brassaï would certainly recognize many of his best-known images (some have appeared on posters and postcards): couples in cafés, ladies of the night, perhaps a portrait of Picasso or an image of Paris graffiti. For other potential readers interested in photography, Surrealism, or the Paris of the thirties, Brassaï's name will be as familiar as his images. This book attempts to bridge the gap between these two groups by providing an introduction to one of the most important European photographers of the interwar years and a careful reading of his work, both photographic and literary, that places it in the broader context of cultural history.

In the now almost ten years that I have been working on this book, interest in the photography of the interwar years has grown steadily. A number of groundbreaking exhibitions (and their accompanying catalogs) have drawn attention to major photographers who began working in the twenties and thirties, in some cases shedding a direct or indirect light on Brassaï's photography or his connections to Surrealism. Although the list that follows is not intended to do more than acknowledge sources that have been invaluable to me (there is no attempt to be exhaustive), it also suggests a growing awareness of the importance of photography to an understanding of the period: *Florence Henri: Photographies 1927–1938* (Musée d'Art Moderne de la Ville de Paris, 1978); *André Kertész: Of Paris and New York* (Art Institute of Chicago, 1985); *L'Amour fou* (Corcoran Gallery, 1985); *Henry Cartier-Bresson: The Early Work* (Museum of Modern Art, 1987); *The New Vision: Photography Between the World Wars* (Metropolitan Museum of Art, 1990); *Lisette Model* (National Gallery of Canada, 1990); *Florence Henri: Artist Photographer of the*

Avant-Garde (San Francisco Museum of Modern Art, December, 1990–February, 1991).

None of these exhibitions focused on Brassaï, although *L'Amour fou* devoted considerable attention to his work and the catalog essays represent an important attempt, if not the first, to theorize the role of photography in Surrealism (I should include here an important earlier exhibition: *Photographic Surrealism*—Akron Arts Institute, 1979). I also owe an important debt to the work of André Jammes and Eugenia Parry Janis (*The Art of French Calotype*, Princeton University Press, 1983); that of Bonnie Grad and Timothy Riggs (*Visions of City and Country: Prints and Photographs of Nineteenth-Century France*, Worcester, Mass.: Worcester Art Museum, 1982) published in conjunction with the exhibition of the same name, as well as John Szarkowski and Maria Morris Hambourg's four-volume study of *The Work of Atget* (New York: Museum of Modern Art, 1981–85). Their research allowed me to see Brassaï's images of Paris in a larger historical context. I regret that the pressure of time has kept me from including insights from Molly Nesbit's study of *Atget's Seven Albums* (New Haven: Yale University Press, 1992) or allowed me to study the new edition of Brassaï's *Graffiti* (Paris: Flammarion, 1993). Much work remains to be done (a study of the work of Germaine Krull, for example), and new material can only enhance the reputation of photographers whose work coincides with the increasing importance of visual images in French culture during the late twenties and thirties.

Of the people whose help and support made it possible to complete this book, I am particularly grateful to Madame Gilberte Brassaï for the considerable time she spent reading my manuscript during this past year, for her suggestions, and for her permission to reproduce all but one of the photographs by Brassaï that appear here. I would also like to thank Mme. Françoise Guiter, who very graciously contributed the only available print by Brassaï of her aunt, the sculptress Germaine Richier. While it is not the same photograph that appears in Brassaï's *The Artists of My Life,* it clearly belongs to the same series, and I am very pleased to include it here. My sincere thanks also go to David Travis of the Art Institute of Chicago, who graciously shared his personal collection of *Vu* and *Détective* magazines as well as catalogs from early photography exhibits and materials that I would have had difficulty obtaining otherwise. I want to thank Judit Sipos for helping me read Brassaï's letters to his parents, which, still untranslated from the Hungarian, proved to be an invaluable source of information about Brassaï's early years in Paris. I also profited greatly from the support and encouragement of a number of colleagues who read drafts of various chapters, among them Franz Schultze,

formerly of Lake Forest College, Steven Ungar of the University of Iowa, my colleague Buford Norman, and the late Edouard Morot-Sir. It particularly saddens me that Professor Morot-Sir will not see the finished work; his belief in the value of the research meant a good deal to me.

I would like to thank the staffs of the Art Institute of Chicago, the Cabinet des Estampes of the Bibliothèque Nationale, the Museum of Modern Art, the Metropolitan Museum, and the New York Public Library for their help in locating materials and answering my many questions.

At the Louisiana State University Press, my series editor Rima Drell Reck's enthusiastic reading of the manuscript and Editor-in-Chief Margaret Dalrymple's strong support for the project are very much appreciated.

I would also like to remember here the generosity of the late Janet Mercer, whose friendship made a long, difficult year of writing bearable. Finally, I want to thank my parents—for everything—and my husband Michael Mooney for his unflagging support, endless patience, and for being my better half.

Abbreviations

WORKS BY BRASSAÏ

AML *Les Artistes de ma vie*. Paris: Denoël, 1982. Translated as *The Artists of My Life* by Richard Miller. London: Thames and Hudson, 1982.

Brassaï *Brassaï*. Paris: Editions Neuf, 1952. Includes "Souvenirs de mon enfance."

Camera *Camera in Paris*. London: The Focal Press, 1949.

EL *Elôhivas Levelek, 1920–1940* (Brassaï's *Letters to My Parents*). Bukarest: Kriterion Könyvkiadó, 1980. Letter numbers are followed by page numbers in these citations.

G *Graffiti*. Paris: Les Editions du Temps, 1961; rpr. Paris: Flammarion, 1993.

GN *Henry Miller, grandeur nature*. Paris: Gallimard, 1975.

PA *Paroles en l'air*. Paris: Firmin-Didot, Editions Jean-Claude Simoën, 1977.

Picasso *Conversations avec Picasso*. Paris: Gallimard, 1964. Translated as *Picasso and Company* by Francis Price. Garden City, N.Y.: Doubleday and Company, 1966. Page numbers refer to the translation.

PN *Paris de nuit*. Paris: Arts et Métiers Graphiques, 1933; rpr. Paris: Flammarion, 1987. English edition *Paris by Night*. Translated by Gilbert Stuart. New York: Pantheon Books, 1987. I use both English and French titles in the text. The numbering of the photographs is identical in the two editions.

RH *Henry Miller, rocher heureux*. Paris: Gallimard, 1978.

SPT *Le Paris secret des années 30*. Paris: Gallimard, 1976. The English edition is translated as *The Secret Paris of the 30's* by Richard Miller. New York: Random House/ Pantheon, 1976. I refer to this work by both English and

French titles, occasionally abbreviating the English title to
The Secret Paris.

Voluptés *Voluptés de Paris.* Paris: Paris Publications, n.d.

WORKS ON PHOTOGRAPHY AND SURREALISM

BN Jean Adhémar, *et al. Brassaï.* Paris: Bibliothèque
 Nationale, 1963.

Kertész Sandra S. Phillips, David Travis, and Weston J. Naef.
 André Kertész: Of Paris and New York. Chicago: Art
 Institute of Chicago, 1985.

MOMA John Szarkowski, *Brassaï.* With an Introduction by
 Lawrence Durrell. New York: Museum of Modern Art,
 1968.

SP André Breton. *Le Surréalisme et la peinture.* Paris:
 Gallimard, 1965. Translated as *Surrealism and Painting* by
 Simon Watson Taylor. London: Macdonald and
 Company, 1972. The page numbers in the English and
 French editions correspond exactly.

Brassaï

Introduction
A Vision of Culture

Brassaï's place in the history of photography has long been secure. He first attracted attention in 1933 with the publication of sixty-two black-and-white photographs in a small soft-cover, spiral-bound book entitled *Paris de nuit/Paris by Night*. His studies of the shadowy underworld of the thirties—images that were strikingly, even scandalously, original for the time—opened a new range of subject matter for later photographers; his example inspired a whole generation of photographer-reporters including Robert Doisneau, Willy Ronis, and even Diane Arbus, who felt a special kinship with his work.[1] The publication of *The Secret Paris of the 30's* in 1976 allowed some of his most powerful images from this period to reach a wide audience for the first time. Since his death in 1984, the reprinting of *Paris by Night* in a large-format edition, more elegant than the original, the publication of an important collection of his photographs of Picasso, and the very recent re-edition of his *Graffiti* by Flammarion have drawn new attention to his work.

Yet if Brassaï's work has received considerable critical attention, in another sense it has not received equal critical scrutiny. This is the logical result of the fact, daunting for any critic, that Brassaï was a perceptive and articulate spokesman for his art. So much so that in writing the introduction for the catalog of a major retrospective of Brassaï's photography at the Museum of Modern Art in 1968, Lawrence Durrell claimed to be somewhat at a loss, pointing out that despite the proliferation of commentaries on his work, Brassaï remained "the best guide" to it (*MOMA*, 10). Brassaï's facility as a writer made him an extremely valuable interpreter of his images and his aesthetics. Beginning with publication of *Camera in Paris* in 1949, he wrote

1. See Patricia Bosworth, *Diane Arbus: A Biography* (New York: Avon Books, 1984), 143.

ever-longer, frequently quasi-autobiographical introductions to accompany his collections of photographs. It was only natural to consider Brassaï the best authority on his work, and consequently many essays on his photography took the form of an interview with the photographer or quoted him extensively. With equal frequency, critics focused attention on some aspect of his work related to a particular exhibit of photographs without attempting to do more than give some general background on the photographer.

The earliest attempt to present a comprehensive overview of Brassaï's work was the retrospective of his photography—or rather, as the catalog emphasized, his "photographic art"—organized at the Bibliothèque Nationale in 1963. Like the Museum of Modern Art exhibit that followed it, the exhibition emphasized the museum's mission to select from the immense volume of photographic production "the best work of those we consider 'masters'—masters by the perfection of their technique as well as their original vision of the world" (*BN,* 1). Essentially, the catalog limited its critical approach to a thematic presentation of Brassaï's work, identifying the documents and photographs on view at the exhibit and, with Brassaï's collaboration, providing anecdotal background on them. In the introduction to *The Secret Paris of the 30's,* published over ten years later, Brassaï attempted something rather more difficult: to convey some sense of the cultural and historical importance of his photographs, but typically, he avoided the question of their value as self-contained aesthetic objects. He was undoubtedly gratified by the recognition accorded his work by the Bibliothèque Nationale, although the retrospective must have conveyed a certain finality, because he later joked that he should have given up photography forever after that: "They even presented me with an award, as though I were already dead." [2] There is certainly some irony in this, for it was precisely Brassaï's involvement with life and his intense curiosity about human experience that furnished the substance of his art.

Brassaï's explorations of the shadow side of Paris, his efforts to reveal something of its culture and mysterious qualities, its atmosphere, texture, and form, represent an original and significant contribution to the art of the thirties, as well as to the history of photography. His involvement in the work of other major artists during this time also provides an index of his importance to the culture of the period. A friend of the photographer Kertész, a contributor to the Surrealist-dominated review *Minotaure,* a friend (and ultimately biographer) of Picasso and of Henry Miller, who called him

2. Paul Hill and Thomas Cooper, eds., *Dialogue with Photography* (New York: Farrar, Straus & Giroux, 1979), 41.

"the eye of Paris," Brassaï had contacts among writers and artists, many of whom figured in his photographs. As an expression of the wide range of his interests and sympathies, Brassaï's work as a reporter, a photographer, and later as a writer provides an important perspective on life and the arts in the thirties. Consequently, one of my purposes in undertaking this study of Brassaï is to consider Brassaï's work—focusing primarily on his photographs, but drawing on his literary, critical, and biographical writing—as a particular reflection of the culture of the thirties, the unstable period of the interwar years, dominated by Surrealism at a time when the Surrealists were torn between art and politics.

Yet Brassaï's work resists what would seem to be the most obvious and appropriate form of analysis for this purpose: a straightforward chronological study of his photographic work relating it to the cultural context in which it was produced. This is actually impossible, for although much of Brassaï's most famous work dates from the early thirties, much of what was published then—with the exception of *Paris by Night* (1933) and *Voluptés de Paris* (1935), which Brassaï subsequently disowned—would not have been perceived as a coherent body of work. Dispersed as individual illustrations or clusters of images in numerous periodicals and papers, not all of Brassaï's photographs reached a wide audience or were credited to him. Other images from this period—some considered too revealing—were not published until the people and places he had photographed no longer existed as he saw them. In fact, Brassaï's photographs from the thirties were later published in a number of different collections at different times, and each collection has a somewhat different character. Consequently, I have chosen to focus on the two major subjects that dominate Brassaï's work in the thirties and beyond: images of Paris (including his images of graffiti), and portraits of artists and their studios.[3] In attempting to evoke something of the cultural climate of the thirties through these images, I have also tried to take into account changing perceptions of their value and significance over the course of Brassaï's life. For not the least of the interest of Brassaï's photographs is precisely that their history is implicated in the larger history of culture. Brassaï's images suggest a larger pattern of cultural change and the processes of appropriation and transformation implied in it. In certain respects Brassaï's career as an artist-photographer represents an important cultural bridge between nineteenth-

3. This has led me to neglect the many photographs Brassaï took during his travels as a photographer for *Harper's Bazaar* in the 1940s and '50s, including the very fine *Fiesta in Seville*, even though they offer some interesting formal parallels with his earlier Paris work and treat a familiar subject, "the spectacle" (see Chapter IV), transposed onto a different cultural background.

century realism, Surrealist modernism, and media culture, because the fault
lines of cultural change run through his work.

This book was conceived as a series of independent yet related chapters
that would provide different contexts or frames for viewing Brassaï's work.
These frames are intended to shift the viewer's perspective on Brassaï's art,
to emphasize different features of it in the way that changing the color of
the frame brings out different details in multicolored prints. Some chapters
create frames that emphasize a kind of cultural and historical depth of field,
attempting to show the ways in which Brassaï's images relate to earlier artistic
and cultural traditions even as they appropriate and transform them. Others
focus more narrowly on the thirties or on a particular series of images. I have
also devoted a chapter to Brassaï as a writer, because it is through Brassaï's
efforts to define himself as an artist and to find a literary equivalent for
photography that the contradictions of his position as an artist come into
clearest focus. In the concluding chapter, I suggest that although Brassaï
remains faithful to a traditional view of the artist that has its roots in nine-
teenth-century romantic realism (his model being Baudelaire's *The Painter of
Modern Life*), his career as a photographer and his work as a writer anticipate
the values of media culture in their emphasis on the immediacy and emo-
tional power of the visual image and the spoken word.

Brassaï's passionate interest in the nature of artistic creativity, his ambiv-
alence about being an artist, and his desire to remain an "amateur" are links
between his work and that of the Surrealists. Brassaï knew many Surrealists
and Surrealist dissidents and moved in Surrealist circles in his early years as
a photographer, although he never chose to be formally affiliated with the
Surrealist movement. This might have been enough to justify placing my
study of Brassaï's work in the context of Surrealism. However—and more
important—Brassaï published photographs in the Surrealist-dominated *Min-
otaure* on a regular basis and contributed photographs to illustrate works by
individual Surrealist writers, notably André Breton's *L'Amour fou*. As Ros-
alind Krauss and Dawn Ades point out, some of these photographs—such
as the series of *Sculptures involontaires* or the montage entitled *Ciel postiche*,
both of which were published in *Minotaure*—might be considered among
the finest Surrealist images.[4] Moreover, the thirties, when Brassaï was fully
engaged in the cultural and artistic life of Paris as a journalist and photog-
rapher, were the period of his greatest involvement in Surrealism. Signifi-

4. See Dawn Ades, *Photomontage* (London: Thames and Hudson, 1986), 129, 135. Also Rosalind
Krauss, "Photography in the Service of Surrealism," in Rosalind Krauss and Jane Livingston, *L'Amour
fou: Photography and Surrealism* (New York: Abbeville Press, 1985), 19.

cantly, this period was very rich and productive for Brassaï. Not only was he in contact with some of the most important modern artists of the time, but his sense of himself as an artist was changing as he experimented in a variety of different media. Ideas and themes that emerged during this period provided the inspiration for much of his subsequent work, particularly in later years when intermittently he gave up photography for drawing or sculpture and ultimately for writing. I have gradually come to believe that the direct influence of Surrealism on Brassaï's work was more limited and superficial, its indirect influence more pervasive than I originally thought. Certainly Brassaï produced a small body of work that could be labeled without hesitation "Surrealist": startling composite images achieved through technical manipulations, studies of female nudes that deliberately play on ambiguities of form, and disorienting close-ups that force the viewer to reconsider the nature of common objects. Yet by and large these photographs—particularly those where the visual effect depends on technical manipulations—are not representative of the bulk of his work, which belongs to the documentary tradition identified with Atget.

Surrealism exerted a more pervasive influence on Brassaï's work as a concept and a cultural orientation. The Surrealists' assertion that reality and surreality were "communicating vessels"—that beneath or beyond ordinary events existed another reality that could be grasped if the observer abandoned the comfortable *daylight* sense of the familiar to adopt a new defamiliarizing perspective—suggests another dimension to Brassaï's investigation of the city. By generalizing this principle of defamiliarization, the Surrealist observer becomes something of an ethnographer-explorer whose own culture becomes the field of study. Brassaï's exploration of nocturnal Paris as an exotic world entirely foreign to the city that existed in broad daylight has overtones of "Surrealist ethnography," just as his fascination with Paris graffiti parallels the Surrealist's attraction to primitive cultures.[5]

In some important respects, then, Brassaï's vision of culture was colored by Surrealism. Yet it was shaped by his experience as a journalist, and it was as a journalist that he initially took up photography. Inevitably, the practice of photojournalism and the increasing importance of the image in the press exerted considerable influence on the direction his work took. While the photojournalist's need to document unusual, dramatic, and newsworthy or culturally significant events might seem antithetical to the Surrealist's desire

5. The term "Surrealist ethnography" derives from James Clifford's essay "On Ethnographic Surrealism," in *The Predicament of Culture* (Cambridge: Harvard University Press, 1988). The nature of "ethnographic surrealism" and its relationship to Brassaï's work are considered in Chapter IV.

to discover the marvelous in the most banal of everyday realities, André Breton had already discovered the newspaper's hold on the imagination as a collection of miscellaneous facts or even an anagram of life, suggesting enigmatic revelations. He concluded *Nadja* by transcribing an excerpt from a short newspaper article, noting with ambiguous simplicity: "A morning paper will always be adequate to give me my news."[6]

Viewed from the broader perspective of French culture in the thirties, the gulf between journalism and Surrealism does not yawn quite so wide. The interwar years, *l'entre deux guerres,* are marked by the breakdown of traditional cultural values and hierarchies discredited in the debacle of the First World War (the cultural subversions of Dada and Surrealism have their role to play in this), the development of new orders of knowledge (notably the increasing interest in Freudian psychology, the growing importance of sociology, and the establishment of ethnography as an official discipline), and a certain cultural fluidity or instability rooted both in the political uncertainties and the economic crisis of the period. In a 1934 lecture on "The Author as Producer," given in Paris, Walter Benjamin enjoined his audience to reflect on the fact that "we are in the midst of a vast process in which literary forms are being melted down, a process in which many of the contrasts in terms of which we have been accustomed to think may lose their relevance." The newspaper, which juxtaposed "science and *belles lettres,* criticism and original production, culture and politics," was both the model and "the arena" of this confusion.[7]

Furthermore, certain developments in the world of the press mirrored the cultural shifts of the period. During the thirties the four major daily French newspapers of the pre–World War I era lost their hold on the reading public.[8] A more disaffected readership in search of novelty contributed to the rise—and frequently, rapid demise—of a host of new daily and weekly papers. *Paris-Soir,* established in 1931 as "the journal of illustrated news," became the most successful paper of the period. It eclipsed its competitors by transforming the format of the newspaper and with it the reading habits of the public. The editors declared that "the image has become the queen of our time. We are no longer satisfied to know, we want to see. All great

6. André Breton, *Nadja,* trans. Richard Howard (New York: Grove Press, 1960), 160.

7. Walter Benjamin, "The Author as Producer," in *Thinking Photography,* ed. Victor Burgin (London: Macmillan Press, 1982), 19.

8. These were: *Le Petit Journal, Le Petit Parisien, Le Matin,* and *Le Journal.* Collectively, they accounted for 75 percent of the Paris circulation and 40 percent of that of the provinces. See Claude Bellanger, ed., *Histoire Générale de la Presse française* (3 vols.; Paris: Presses Universitaires de France, 1972), III, 297.

newspapers place next to the article the photographic document that not only authenticates it, but gives us an accurate representation of it." Filling its first and last pages with photographs, occasionally attempting unusual layouts, the editors of *Paris-Soir* sought "the sensational, the picturesque, the unusual, the romanesque," incorporating magazine pages that contrasted with the seriousness of articles on politics and literature, and offering the desultory reader surprising juxtapositions in subject and tone.[9]

No less an index of cultural fragmentation was the phenomenal growth of the periodical press; in fact, this is one of the most important characteristics of journalism in France during the period. Women's magazines and publications devoted exclusively to sports, illustrated news, radio, cinema, and the dissemination of scientific or technical information proliferated.[10] Significantly, it is precisely in their emphasis on photography that Surrealist publications parallel the development of the popular press of the period. Brassaï contributed photographs not only to *Minotaure,* but to *Coiffure, Votre Beauté, Adam, Détective, Dans la Salle de Culture Physique, Secrets de Paris, Le Jardin des Modes, Voilà, Vénus, Paris Magazine,* and *Paris-Soir,* in addition to the more innovative *Vu (EL:* letters 79–81, pp. 155–56). While *Minotaure* was usually printed in a run of three thousand, *Détective* sold every copy of the initial issue: 350,000 copies.[11]

The rapid growth in the use of photographic illustration in the French press merely allowed it to catch up to the more innovative weeklies of the Weimar Republic (1918–1933). The *Berliner Illustrirte Zeitung* and the *Münchner Illustrierte Presse,* to name only two, had abandoned the drawings that had been the novelty of older illustrated papers dating from the nineteenth century, such as France's *L'Illustration.*[12] As editor of the *Münchner Illustrierte* in 1928, Stefan Lorant went further, refusing posed photographs and encouraging photographers to take a series of images on a single subject. Such photo-essays frequently took the form of a central image summing up the event, surrounded by other photographs that provided detail or elaborated on its various aspects. Gisèle Freund indicates that the essays were designed to "have a beginning and an end defined by the place, the time

9. *Ibid.,* 476, 526.

10. *Ibid.,* 460.

11. The circulation for *Minotaure* is given in Maria Morris Hambourg and Christopher Phillips, *The New Vision: Photography Between the World Wars* (New York: Museum of Modern Art/Harry N. Abrams, 1989), 280, n. 117. The information on the initial run of *Détective* appears in Pierre Assouline, *Gaston Gallimard* (Paris: Editions Balland/Points, 1984), 228.

12. The first candid shots were made by one of *L'Illustration*'s reporters to replace artist's drawings. See Bellanger, ed., *Histoire de la Presse française,* III, 96.

and the action, just as in the theater." As she points out, these German weeklies drew the best photographic talents of the period, and in browsing through their pages the reader might find the work of László Moholy-Nagy, Alfred Eisenstaedt (then chief photographer of the Associated Press in Berlin), André Kertész, Martin Munkacsi, Germaine Krull, Umbo (a former Bauhaus student), and the Gidal brothers.[13]

Paris-Soir clearly responded to the innovations of these very successful mass circulation papers, but it had another model closer to home in the form of an illustrated weekly called *Vu*. Founded in 1928 by Lucien Vogel, who had begun to work as a journalist in 1906 and then created and managed *La Gazette du bon ton* and *Le Jardin des Modes, Vu*'s declaration of intent set the tone for *Paris-Soir* some three years later:

> Conceived in a new spirit and with new technical means, *Vu* brings France a new format, the illustrated reporting of world news. From anywhere important events take place, photographs, dispatches, articles will reach *Vu* that will link the public to the entire world . . . and will bring life everywhere to eyelevel.[14]

Better and more tastefully printed than its German counterparts, *Vu* also published essays of general interest by important writers of the period such as Colette, Blaise Cendrars, Georges Duhamel, Pierre Mac Orlan, André Malraux, Paul Morand, Surrealist Philippe Soupault, and Georges Simenon.[15] It attempted novel, sometimes asymmetrical layouts, frequently juxtaposing rectangular, round, and oval photographs of varying sizes. One such arrangement spilled photographs across the page in the form of a cornucopia, while another, proposed by the photographer Kertész, created a vaguely Cubist portrait of the newly crowned Miss France out of a mosaic of partial views: her lips, her ear, her eye, a small full-face view, a larger print of her profile. Photographs of the port of Marseilles by Herbert Bayer and Germaine Krull suggested the new vision of the Bauhaus: angled or plunging views of cranes and the filigree of ironwork emphasizing the beauties of industry through the medium of a new technology.[16] As Sandra Phillips and

13. Gisèle Freund, *Photographie et Société* (Paris: Editions du Seuil, 1974), 115, 117.

14. "Conçu dans un esprit nouveau et réalisé par des moyens nouveaux, *Vu* apporte en France une formule neuve: le reportage illustré d'informations mondiales. . . . De tous les points où se produira un événement marquant, des photos, des dépêches, des articles parviendront à *Vu* qui reliera ainsi le public au monde entier . . . et mettra à la portée de l'oeil la vie universelle." Freund, *Photographie et Société*, 124. My translation.

15. This list of authors was selected from essays found in a series of numbers of *Vu* over the period 1929–31. See also Sandra Phillips' essay in *Kertész*, 42.

16. The cornucopia layout is in *Vu*, LXVIII (July 3, 1929). The Kertész photographs of "Miss

David Travis indicate, *Vu* was probably the most important outlet for contemporary photographers during the twenties. Gallery shows and individual exhibitions could not match the extraordinary range and volume of photographic images it published every week (*Kertész,* 42, 77).

While there was an official salon associated with the Société Française de Photographie, it proved resistant to new approaches. Germaine Krull's photographs of ironwork in the Amsterdam harbor were rejected by the jury for the 1926 Salon and only reached the public eye when her friend Robert Delaunay showed them with his paintings at the Salon d'Automne (*Kertész,* 77). However, two important exhibitions, the first in 1928, the second a year later, drew attention to the work of contemporary photographers. The first was the result of Louis Jouvet's offer to open the foyer of his theater on the Champs-Elysées to a show that became "The First Independent Salon of Photography"—also known as the Salon de l'Escalier because of the double staircase in the foyer. An organizing committee including Lucien Vogel, René Clair, Florent Fels, Jean Prévost, and Georges Charensol presented work by (among others) Berenice Abbott, Laure-Albin Guillot (perhaps a nod to the old guard, as she was a member of the Société Française de Photographie),[17] Georges Hoyningen-Huene (who worked for *Vogue*), Kertész, Germaine Krull, Man Ray, Paul Outerbridge (then in Paris), and as if to balance a list that included mostly non-French photographers, photographs from the Nadar studio and an Adget [*sic*] retrospective. The catalog announced the beginning of an independent salon to be held in May of each year. Its declared purpose was "to demonstrate that photography, far from being a mechanical process, has tended increasingly to become an art with its own laws, independent of reality and pictorial art." [18]

The impact of the Salon de l'Escalier was multiplied by the Paris opening of "The International Exhibition on Film and Photography" (the *Film und*

France vue à la loupe./Seen through a magnifying glass" is in *Vu,* CIV (March 12, 1930). See also Sandra Phillips' discussion of this particular image in *Kertész,* 42. The Bayer/Krull photographs accompanied an article by Henri Danjou entitled "La Porte du Monde—Marseille" in *Vu,* LVI (April 10, 1929).

17. It is some indication of the official recognition of her work that the special issue of *Photographies* published by Arts et Métiers Graphiques for 1932–33 reported she was the first woman to be named "chef de service des archives photographiques des Beaux-Arts, rue de Valois. . . . Ce poste d'archiviste consiste à diriger le service photographique qui est chargé de procurer aux musées les oeuvres d'art qui se trouvent en France. Ces photographies sont vendues au public et rapportent des sommes importantes" (136).

18. Quoted from the catalog of the "1er Salon Indépendent de la Photographie du 24 mai au 7 juin inclus." My translation.

Foto exhibition), organized by the venerable and prestigious Deutscher Werkbund. Established at the beginning of the century as part of the arts and crafts movement, the Werkbund sought to reconcile art and technology, a goal it shared with the Bauhaus, whose masters, former masters, and students contributed important work to the show. Moholy-Nagy, who had left the Bauhaus to work as a designer in Berlin (where Brassaï had crossed paths with him in 1921), collaborated with the executive committee from the Werkbund. He not only served as a member of the panel that selected the photographs, but also designed and installed the main gallery through which visitors entered the exhibit, which spread over fourteen galleries. The catalog listed over nine hundred photographs chosen to demonstrate the expressive potential of photography in the hands of "pioneers in the field of photography and phototypography." [19]

A record of the exhibition published in a trilingual edition under the title *foto-auge,* "photo-eye" (the lowercase letters called attention to the typography), with an introduction by Franz Roh, reproduced seventy-six photographs from the exhibition. Representative of the show as a whole, the collection included an Atget photograph of a corset shop (Figure 1); a montage by El Lissitzky; negative images by Moholy-Nagy and Andreas Feininger; a Florence Henri self-portrait in a mirror (Figure 2a); Dada photomontages by George Grosz, John Heartfield and Hannah Höch; aerial views of a cornfield and a train station; X-ray photographs of flowers and a handbag; two photograms by Man Ray; two Max Ernst photo-paintings; a disorienting press service photograph of the Brooklyn Bridge, which showed it perfectly duplicated by its reflection; an Edward Weston portrait, and a still life by Walter Peterhans (who taught the master class on photography at the Bauhaus beginning in 1929) that juxtaposed the forms and textures of two eggs, a length of lace, a sardine, several irregular slices of onion, a dark glove, and a pair of glasses with mismatched lenses (Figure 3). There was a medical photograph of a woman undergoing a diathermy treatment (Figure 4), an archival photograph consisting of an aerial view of the cone and crater of a volcano, a photograph from the Mount Wilson observatory, and a number of extreme close-ups and fragmentary views of people and objects that focused attention on formal structure. In this category fell a photograph of a flower by Renger-Patzsch, a microphotograph, a close-up of the model of

19. "Werkbund Ausstellung Film und Foto, Stuttgart 1929." *Die Forme IV* (February 15, 1929), 95. Quoted by Beaumont Newhall in "Photo-Eye of the 1920's: The Deutscher Werkbund Exhibition of 1929 in Germany," in *Germany: The New Photography 1922–33,* ed. David Mellor (London: Arts Council of Great Britain, 1978), 78.

an airplane switch lever (Figure 5), and Moholy-Nagy's image, practically an abstraction, of a Paris drain.

The range of the exhibition, its international character, even the "look" of the photographs all support Simon Watney's assertion that "there is a substantial unity of photo-aesthetic values" in much photography of the twenties and thirties—"a coherent, though locally flexible, model of photographic practice from the Soviet Union to France and the USA . . . derived from a wide range of suppositions concerning . . . relationships between seeing, representing and knowing which in turn denied the validity of a crude distinction between aesthetics and politics." [20] However, this apparent aesthetic unity masks diverse intentions and practices; to point out one example: Moholy-Nagy's focus on experimental work involving the manipulation of light or the exploitation of optical surprises latent in photographic technology clashed with both Renger-Patzsch's insistence on photography's ability to render "the magic of material things" and Walter Peterhans' concern with the concrete problems of photographic technique. In addition, as Herbert Molderings observed, from the point of view of social and cultural history, the unity of the exhibition, the resemblance we might find between photographs by Aleksandr Rodchenko or El Lissitzky and those of Renger-Patzsch, Moholy-Nagy, Man Ray, or Peterhans is deceptive, for it is the result of "a temporary historical overlap." The German cult of technology would find its full expression in the Nazi war industry, and the hopes of Rodchenko and Lissitzky that technology would transform every aspect of society and raise the standard of living for the worker were dashed by Stalin and the campaign for socialist realism.[21]

If we also find analogies between Brassaï's disorienting close-ups of art deco ironwork, crystals, a potato with long antler-like sprouts (or the blobs of toothpaste and rolled subway tickets that became "involuntary sculptures"), all of which were later published in *Minotaure,* and certain photographs by Karl Blossfeldt or Renger-Patzsch, the formal resemblances leap out only when the photographs are removed from the cultural contexts in which they were produced. Blossfeldt's magnified views of plant forms in *Urformen der Kunst* and Renger-Patzsch's close-ups from *Die Welt ist Schön* (1928) emphasized formal structure and symmetries that evoked ideas of unity, harmony, and universal order. By contrast, the Surrealists used such

20. Simon Watney, "Making Strange: The Shattered Mirror," in *Thinking Photography,* ed. Burgin, 155.

21. Herbert Molderings, "Urbanism and Technological Utopianism: Thoughts on the Photography of Neue Sachlichkeit and the Bauhaus," in *Germany: The New Photography,* ed. Mellor, 91.

images, including Brassaï's, to disorient the viewer and suggest the mysterious side of everyday objects.[22] While the Surrealists (represented in the *Film und Foto* exhibition by Man Ray, Tabard, and Max Ernst) might have subscribed to avant-garde Russian and German photographers' belief in photography's capacity to transform "the architecture of the book," they took little interest in the beauties of technology per se and would hardly have endorsed Lissitzky's statement in 1926 that "the invention of easel pictures produced great works of art, but their effectiveness has been lost. The camera and the illustrated weekly have triumphed. We rejoice at the new media technology has placed at our disposal."[23]

Far from abandoning painting as an outmoded form of expression, André Breton would endorse it as a valid mode of Surrealist expression two years later in his famous essay *Surrealism and Painting*. He created a pantheon of Surrealist painters in which Picasso assumed the place of honor and Giorgio de Chirico that of fallen idol. Significantly, Breton castigated de Chirico for turning his back on the marvelous city he had created with its succession of porticoes, mannequins, and interiors: "a city as self-contained as a rampart . . . lit within itself in broad daylight," a city that incarnated the Surrealist adventure, and in which Breton found it deliciously impossible to get his bearings (*SP,* 13). In fact, perhaps one of the most telling examples of the differences separating the "new vision" of the Bauhaus from that of the Surrealists is their conception of the city. While the Bauhaus envisioned the city as a beautiful, coherent, finished technical object without ambiguities—its dwellings separated by gardens and green, airy common spaces that would provide easy access to new and efficient modes of transportation[24]—the Surrealist city is characterized by its irrationality: its spatial and psychological ambiguities, its zones of shadow and its labyrinth of streets and passageways through which the Surrealist passes on foot, oriented only by a sense of possible discovery.

Unlike Blossfeldt or Renger-Patzsch, the Surrealists never considered using photography to discover analogies in form and structure between organic

22. The catalog to *L'Amour fou* accentuates this resemblance by juxtaposing close-ups taken from Karl Blossfeldt's *Art Forms in Nature* (published in Georges Bataille's *Documents*) with Brassaï's photograph of art deco filigree and the image of a praying mantis it resembles, both of which appeared in *Minotaure* (see Krauss and Livingston, *L'Amour fou,* 178). However, where Blossfeldt's photographs deliberately evoked architectural forms, Bataille used the same images to buttress a critical attack on architecture in the name of formlessness. The photographs for *Minotaure* were intended to be equally disorienting.

23. Hambourg and Phillips, *The New Vision,* 80.

24. M. N. Delorme-Louise, "La Ville Bauhaus," in *La Ville n'est pas un lieu: Revue d'esthétique 1977, nos. 3–4* (Paris: Union Générale des editions, 1977), 111–12.

and industrially produced objects. What attracted them to photography was the medium's potential for the "perturbation" of objects—natural and man-made. The very nature of the medium guaranteed it, automatically fragmenting the visual field by framing and isolating the image's subject. The effect could be further enhanced by recontextualizing the image: removing it from the context of its function—or more radically still by technically manipulating the image through montage, brûlage, solarization, superimposition, or any combination of such techniques. It is not hard to imagine the photograph of the diathermy treatment that figured in the *Film und Foto* exhibition as an easy target for the simplest form of Surrealist recontextualization: it presented the naked body of a woman covered with metal plates resembling the armor on an armadillo that were attached with wires to a complicated-looking machine. Such an image might have appeared in *La Révolution Surréaliste*, with or without a caption by Man Ray. In any case, the Surrealists frequently borrowed photographs from other disciplines: medical, scientific, and police photographs, anthropological photographs, and movie stills all appeared in *La Révolution Surréaliste*, the dissident review *Documents*, and *Minotaure*, where they had something of the status of found objects, serving as nonillustrative illustrations or allusive counterparts to Surrealist texts.[25]

Despite the fundamental differences in the intentions of many exhibitors, the *Film und Foto* exhibition provides a snapshot of an important moment in the cultural history of photography, rather like a large family portrait taken at a rare moment of solidarity. It marked both the end and the beginning of a new era. Certainly the show's popularity in Paris was one sign of the growing audience for photography in the France of the thirties. The success of the Salon de l'Escalier encouraged *Arts et Métiers Graphiques* to publish an annual special issue on photography beginning in 1930. The Galerie de la Pléaide (where Brassaï eventually became a regular exhibitor), the Galerie d'Art Contemporain, and the Plume d'or opened their doors to photography shows.[26] There would be more independent salons, and an *Exposition Internationale de la photographie contemporaine* was organized in 1936 at the Musée des Arts Décoratifs. Brassaï, by then a well-known photographer, would participate in shows with Man Ray, Kertész, Tabard, and Florence Henri. It was indicative of the changing times that both the organizing committee of

25. See Krauss and Livingston, *L'Amour fou*, 155–56; Hambourg and Phillips, *The New Vision*, 98–99; and for a more comprehensive overview of Surrealist uses of illustration, Renée Riese Hubert, *Surrealism and the Book* (Berkeley: University of California Press, 1988).

26. *Kertész*, 82; Hambourg and Phillips, *The New Vision*, 102.

the Salon de l'Escalier and the 1936 exhibit had ties to commercial publishing. As David Travis points out, in the mid-twenties photographers such as Man Ray, Kertész, and Germaine Krull had no established audience, but by the thirties the growing importance of photography in journalism and advertising created a market that made it difficult for the photographer to operate as a free agent. In addition, photographers had very limited control over the way their photographs were used; increasingly the magazine editor made these decisions, subordinating individual photographs to a layout that created the look and style of a particular publication (*Kertész,* 84).

When Brassaï began to take photographs late in 1929, the changes had already begun. His survival as a photographer depended on the ability to find or anticipate markets for his work and the willingness to accommodate his aesthetic interests to those of his publishers. Certainly in the beginning this was not really an issue as Brassaï intended to take photographs as a sideline, a useful adjunct to his work as a journalist and a welcome source of extra money. However, comparing the trajectory of his career with that of a talented contemporary, Florence Henri, whose photographic work ceased with the end of the decade, suggests some of the factors that led Brassaï to abandon painting for photography and contributed to his success.

Florence Henri had impressive connections to major figures in the art of the period. She began, as did many of the photographers of the period—including Man Ray, Brassaï, and Cartier-Bresson—as a painter. Her teachers were André Lhote (Cartier-Bresson also worked in his studio), then Fernand Léger and Amédée Ozenfant at the Académie Moderne, followed by Josef Albers and Moholy-Nagy at the Bauhaus during the summer of 1927. She began photographing in 1927, and after her return to Paris her work received important recognition, figuring in all the major exhibitions of new photography, including the *Film und Foto* exhibition and innumerable group and individual shows. Her innovative still lifes with mirrors provided a link between the formal investigations of German photography and the psychological interest of Surrealist compositions—including early de Chirico still lifes—that conveyed the enigmatic qualities of common objects. The only one of the "new" photographers to join the established Société Française de Photographie, she opened a highly reputed photography studio that attracted students (including Gisèle Freund) and produced serious work in portraiture and advertising photography (see Figure 6).[27] Her work was interrupted by

27. The *Bulletin de la Société Française de Photographie*'s "Présentation de nouveaux membres" in no. 5 (May, 1929) lists her as a new member. Her sponsors ("parrains") were Messieurs Cabet and Brouard. Interestingly, as it suggests the official old-guard nature of the Société, it also lists M. le Baron de Rothschild (Henri), whose sponsors were Messieurs L. Gaumont and D. Quintin.

the war and faded from public attention. Regrettably, the fact that she never published a book-length collection of photographs contributed to the impression that she had produced very little, even though her photographs appeared in almost every important publication of the thirties.[28]

The eclipse of her work resulted from the increasing professionalism of photography in the thirties coupled with the growing tendency to dismiss the work of avant-garde photographers in the twenties as sterile formalist experiments. While Henri's still lifes and her studio work had commercial value, her own artistic experimentation may have seemed dated in the changing climate of the thirties. Philippe Soupault's 1931 introduction to the *Arts et Métiers Graphiques'* special issue on photography stressed that "a photograph is above all a document." He issued the ominous prophecy that "coming years will see the most solidly established reputations sink into oblivion, and only those who are willing to give serious thought to their métier and rid themselves of all artistic pretensions will be able to carry their effort forward to any useful purpose." Even Man Ray felt obliged to defend his work in 1934, admitting that "in this age . . . it seems irrelevant and wasteful to still create works whose only inspirations are individual emotions and desires."[29] In 1935 Louis Aragon—no longer a Surrealist, but speaking in the name of socialist realism—unwittingly echoed Moholy-Nagy's belief that the camera should supplement the eye when he claimed that "the photograph teaches us to see—it sees what the eye fails to discern," but the remark was intended to justify his assertion that photography should serve as the basis for a return to realism in literature and the arts.[30] "The realists of the Second Empire were vulgar realists," he declared, because "nature was their master." The new realism should use photography as a documentary aid in the same way that a contemporary novelist would dip into newspaper files. The new realism, Aragon asserted, "will cease to be a realism dominated by nature" to become "a realism which is a conscious expression of social re-

28. Herbert Molderings in Suzanne Pagé and Catherine Thieck, *Florence Henri: Photographies, 1927–1938* (Paris: ARC Musée d'Art Moderne de la Ville de Paris, 1978), 4.

29. Philippe Soupault, "Etat de la Photographie," in *Photographie* (Paris: Arts et Métiers Graphiques, 1931). Translated as "The Present State of Photography" in *Photography in the Modern Era: European Documents and Critical Writings, 1913–1940*, ed. Christopher Phillips (New York: Museum of Modern Art/Aperture, 1991), 51; Man Ray, "The Age of Light," *ibid.*, 52.

30. In *Painting, Photography, Film* Moholy-Nagy asserted: "The camera can perfect the eye and supplement it, e.g. by scientific close-ups and mobile shots, etc. . . . The photographic camera reproduces the purely optical image and therefore shows the optically true distortions, foreshortenings, etc." Quoted in Andreas Haus, *Moholy-Nagy: Photographs and Photograms* (New York: Thames and Hudson, 1980), 26.

alities."[31] In this new climate Brassaï made his exploration of the culture of
the city serve both the expressive aims of art and the needs of documentary
journalism. Ultimately the tension between the photograph as social and
historical fact (whose meaning derives from its anecdotal subject or the de-
tails of clothing, gesture, and décor it registers and preserves) and the pho-
tograph as artistic dramatization (whose meaning derives from the internal
structure of the image) is resolved differently in each of his photographs.

A second crucial factor in Brassaï's success was the publication of *Paris by
Night*. In one sense the twenties had invented the book of photographs: Karl
Blossfeldt's *Urformen der Kunst*, Renger-Patzsch's *Die Welt ist Schön*, Werner
Gräff's *Es Kommt der Neue Fotograf* appeared in 1928 and 1929. Germaine
Krull's *Métal* had appeared even earlier (1927), just after she showed her work
at the Salon d'Automne. The ferment in the publishing world created new
possibilities for such publications; Arts et Métiers Graphiques planned a
whole series of them, beginning with *Paris by Night*. André Warnaud, whose
Visages de Paris came out in 1930 (with a number of innovative photographs
by Krull), remarked caustically that it was a period when many of the nou-
veaux riches who fancied themselves bibliophiles tried their hand at pub-
lishing deluxe editions.[32] Even an established publisher such as Gaston Gal-
limard was bitten by the fever, launching one new project after another in
quick succession (the reviews *Détective, Du Cinéma, Voilà*, and finally the
moderate leftist weekly *Marianne*) in the early thirties.[33] If these daily and
weekly illustrated papers and specialized magazines (as well as advertising
photography) increased demand for Brassaï's work, *Paris by Night* established
his reputation. Ultimately, Brassaï's work as a reporter, his contacts in pub-
lishing and art circles—not to mention talent, luck, and timing—assured his
survival later during the difficult war years, but as the case of Florence Henri
illustrates, it is important not to underestimate either the cultural climate or
Brassaï's "will to publish."

Brassaï may have taken his cue from the success of Krull's *Métal*, knowing
that such publications promoted greater recognition and would lead to ex-
hibitions of his work and other professional opportunities. His instincts were
sound, for a series of books published over the next thirty years confirmed
his initial success, substantiated his growing reputation, and complemented
the increasing number of exhibitions devoted to his work. Beginning with
Camera in Paris, Brassaï published at least one collection of photographs every

31. Phillips, ed., *Photography in the Modern Era*, 75–76.
32. André Warnaud, *Visages de Paris* (Paris: Firmin-Didot, 1930), 316.
33. Assouline, *Gaston Gallimard*, 227–38.

ten years. His photo-reportage *Fiesta in Seville* and a selection of photographs
and writings entitled simply *Brassaï* came out in the fifties; the sixties brought
the belated publication of his most "Surrealist" sequence of photographs,
the *Transmutations* of 1934 and 1935, as well as the important series of pho-
tographs entitled *Graffiti,* begun in the thirties and continued over a period
of twenty-five years. Brassaï also published two retrospective collections of
photographs: *The Secret Paris of the 30's* in 1976 and *The Artists of My Life* in
1982. These consolidated work on the two major themes of his career and
kept his images before the public eye. However, his ambitions were not
limited to publishing his photographs, and the successive waves of books that
followed *Paris de nuit* after the war included his long prose poem *Histoire de
Marie* (published with an introduction by Henry Miller), the short autobi-
ographical texts and prose poems that accompanied his photographs in *Bras-
saï,* his *Conversations avec Picasso,*[34] a two-volume biographical work on Henry
Miller, and the collection of essays and short texts that appeared in *Paroles
en l'air.*

Brassaï's writings do not command the attention accorded the originality
of his photographs. Yet above and beyond their value as literary works or
the insights they provide on the creative genius of a Picasso or a Henry Miller,
they inform us indirectly about Brassaï's concerns as an artist and the cultural
milieu in which he worked. They convey something of his sense of humor,
his appreciation for irony, and the wide-ranging interests that make Leonardo
da Vinci and Goethe some of his cultural heroes. His more ambitious literary
works, *Histoire de Marie* and *Paroles en l'air,* channel his sensitivity to verbal
and visual expression into the project of creating a literary form that would
be the linguistic equivalent of photography. These writings make it clear that
Brassaï's formal sophistication and his artistic literariness counterbalanced his
more pragmatic concerns as photographer and played a role, if not always a
determinant one, in both his choice of subjects and the way he represented
them. Brassaï's familiarity with Baroque, Neoclassical, and Romantic artists
and writers—some of whom, notably Rembrandt and Goethe, he evoked
frequently in his work—and his considerable attachment to earlier artistic
and literary traditions seem at variance with the modernist milieu in which
he worked. However, Brassaï's eclecticism reflects not only his permeability
as an artist—his openness to a variety of artistic influences—but also the
fragmentation and reinvention of the cultural tradition that characterized

34. The actual title of the English translation is *Picasso and Company.* The French title is retained
here as it more accurately reflects Brassaï's intention in composing the work. This is discussed more
fully in Chapter VI, "The Photographer as Writer."

both Surrealist activity and the interwar period as a whole. Yet despite this fragmentation, it is clear from these later books—although it was already implicit in the essay that he wrote to introduce *Camera in Paris* in 1949— that Brassaï saw his work as a coherent oeuvre developed in more than one medium. His later retrospective collections of photographs attempt to consolidate the work of many years and place it in the larger frame of cultural history. What gives this oeuvre its underlying unity is the conception of the artist that emerges from it. Brassaï saw himself as an artist whose role was that of perceptive witness, admittedly partial but also privileged, for his life and times. It is in this sense that his work takes on its full importance as a vision of culture, a vision that reflects not only his personal ambitions but the larger cultural forces that shaped them.

As most of Brassaï's work was produced for publication rather than for exhibition, and since many of his photographs have been reproduced frequently in different contexts, there are certain variations in their reincarnations. Reproductions vary in size; some have been cropped; others show more or less contrast or reveal more or less detail in the darker areas of the print; not all have the glossy finish Brassaï preferred. However, it is infrequent that the variations are striking enough to lead to fundamentally different perceptions of an image. Where these variations do appear significant or have been noted by other researchers, I have taken this into account. In the interest of accessibility if not standardization, I have tried to refer to prints reproduced in book-length collections of photographs published during Brassaï's lifetime. Only one of these remains inaccessible to the general reader: *Voluptés de Paris*. Although many of the photographs in *Voluptés* were reprinted in *The Secret Paris of the 30's,* to which the reader can refer, *Voluptés* conveys the erotic dimension of the photographer's role as voyeur and remains an important indicator of the cultural climate of the thirties—as well as a crucial link between *Paris by Night* and *The Secret Paris of the 30's.* I can only hope that *Voluptés* will be reprinted at some later date; comparing it with *The Secret Paris of the 30's* is analogous to comparing an artist's early work with his reinterpretation of the same subject in later, more mature compositions.

I have paid particular attention to *Paris by Night* and *Voluptés de Paris* as books that actually appeared during the thirties, as well as to *The Secret Paris of the 30's* because it is a retrospective work that deliberately echoes the formal preoccupations of *Paris by Night,* both summing up the earlier work and extending its range. *Paris by Night* is discussed in considerable detail in re-

lation to André Kertész's *Paris vu par André Kertész* in Chapter II. Chapter IV studies the formal relationships between *Paris by Night, Voluptés de Paris,* and *The Secret Paris of the 30's* and provides the most detailed discussion of Brassaï's Paris images (in the section entitled "Exploring the Shadows"). While I have by no means neglected other book-length collections of Brassaï's work (notably *Camera in Paris* and *Brassaï* or the *Graffiti*), I have not attempted to analyze each as a collection with its own aesthetic unity. The chapters that follow necessarily alternate broader readings of particular works with close analyses of certain photographs, and it is in the latter case that I particularly regret the inability to reproduce a large number of Brassaï's photographs. I have frequently had to resort to the proverbial thousand words, and can only refer the reader to Brassaï's own books, but then that is probably as it should be.

The various chapters shift back and forth between close consideration of Brassaï's development as a photographer and his place in the larger culture of the thirties and beyond. Chapter I, "The Eye of Paris and the Surrealist Observer," functions as an extended introduction, concluding the overview of Brassaï's work begun here and giving general background on his arrival in Paris, his work as a journalist, his beginnings and *modus operandi* as a photographer, and his connections to Surrealism. In the concluding section I have examined the problematic relationship between Surrealism and photography, discussing the critical issues that emerge when Brassaï's work is considered in the context of "Surrealist photography."

In Chapter II, "Remembrance of Things Past: Cultural Preservation as Renovation," I have placed Brassaï's images of Paris within a large frame, tracing representations of the city, and the city of Paris, from the nineteenth-century lithographs of *Voyages pittoresques dans l'ancienne France* through Charles Meryon and the calotypists, to Atget and the Surrealists, and finally to Brassaï's friend and fellow photographer André Kertész, whose book of photographs, *Paris vu par André Kertész* (1934), provides a vision of Paris contemporary with Brassaï's *Paris by Night* (1933).

The next chapter, "Between Realism and Surrealism," examines Brassaï's "literariness" as a photographer and his relationship to the two antithetical literary and artistic movements that limn his work. I discuss the value attributed to the photograph by French Realism and Naturalism, as well as the relationship between Brassaï's subjects and those of Realist and Naturalist writers. I also draw parallels between *Paris by Night, The Secret Paris,* and two major Surrealist works of the late twenties: André Breton's *Nadja* and Louis Aragon's *Le Paysan de Paris.*

In Chapter IV, "Ethnographic Surrealism and Surrealist Baroque," I examine successive versions of Brassaï's Paris images (*Graffiti, Voluptés de Paris, The Secret Paris of the 30's*), exploring the way in which Brassaï's images are both reflections and agents of cultural change—transforming culture into spectacle, appropriating culture as fashion and style—and examining the tension between subjective vision and documentary image in Brassaï's presentation of his secret Paris.

The following chapter, "The Photographer and the Artists in his Life: Questions of Style," focuses on the series of images of artists and their studios inaugurated by Brassaï's photographs of Picasso for *Minotaure* in 1933 and continued through the forties and fifties, primarily in his work for *Harper's Bazaar.* I analyze characteristics of Brassaï's style as they emerge in his portrayals of the painters and sculptors represented in these images, viewing them as a testing of one medium against another, a juxtaposition crucial to Brassaï's sense of his own art.

In Chapter VI, "The Photographer as Writer," I consider Brassaï's literary work as an integrating force in his career; his effort to "author" his work as a photographer and to define his position as an artist. The chapter provides readings of "Bistrot Tabac" and *Histoire de Marie,* as well as the two-volume biography of Henry Miller. It compares "Bistrot Tabac" to the work of Apollinaire and the Surrealists, and analyzes *Histoire de Marie* and the Miller biography as narratives of success and artistic legitimization. In an effort to practice writing as a form of photography, Brassaï adopts "conversation" as the primary mode of literary expression in all of these works. This particular conception of writing, elaborated in the essay *Paroles en l'air,* leads Brassaï to express most clearly the fundamental contradiction of his career as an artist: the desire to create an art form that would be a direct expression of reality, unmediated and untransposed. This basic contradiction brings his role as a transitional figure clearly into focus.

In the conclusion, "From Modernism to Media Culture," I attempt to suggest Brassaï's importance as a transitional figure—an artist wedded to a traditional conception of art as the expression of the artist's unique vision made accessible through his mastery of form and the formal perfection of his work who adopted a technology that undercut not only this traditional view of art, but that of the art work's uniqueness and what Walter Benjamin referred to as its aura. Significantly, a form of this same contradiction marks Brassaï's work as a writer. For although Brassaï's literary work continually

refers to a tradition of great writers whose art embodies the values of a culture based on the written word, in attempting to elaborate a literary art based on conversation he anticipates the transformation of cultural values effected by the ever-increasing importance of television and video.

I

The Eye of Paris and the Surrealist Observer

The name Brassaï inevitably conjures up the Paris of the thirties. His first book of photographs revealed the then-unfamiliar beauties of a dark city spangled with streetlamps and luminous signs. Critics hailed his work as a technical and artistic *tour de force,* establishing his reputation as a major photographer and a chronicler of city life. Brassaï's images captured the gauzy look of streetlights in the mist, a mosaic of uneven paving stones glistening with rain, and the rough, textured walls of the city, tattooed with signs, posters, and the primitive scrawls, pockmarks, and gouges of graffiti. His city takes form in a dialectic of light and shadow, public and private places, the dazzling lights of the street fair played off against the dark depths of deserted parks. The ambiguous mirrored spaces of cafés, dance halls, and brothels open into shadowy streets, where workers on the night shift mingle with tourists, nightclubbers, tramps, vagabonds, street toughs, and prostitutes. Brassaï's city was the Paris of Henry Miller, Picasso, and the Surrealists, a city where seedy back streets might lead almost anywhere.

Brassaï's nocturnal rambles led him in an unexpected direction. The twenty-four-year-old Gyula Halász who got off the train at the Gare de l'Est in February, 1924, and grabbed a taxi bound for the rue Delambre hardly expected to become *Brassaï,* one of the most important figures in European photography (*EL:* 17, p. 54). Brassaï was later fond of saying that he never even held a camera in his hands until he was thirty. Like his friend Lajos Tihanyi, whom he routed out of bed at ten o'clock on the morning of his arrival (*EL:* 17, p. 54)—and like many of the photographers of this period, including Man Ray—Halász was trained as a painter. Like Tihanyi, he left

Hungary because it seemed too small for his ambitions. However, unlike Tihanyi, whose deafness made him focus intensely on painting, Halász planned to turn both his Hungarian connections and his facility as a writer to advantage. On his second day in Paris he became a card-carrying member of the fourth estate—a correspondent for the *Brassoi Lapok,* a daily political paper from Brasso, his native city on the Hungarian border (*EL:* 17, p. 54). In retrospect, his career as a photographer seems almost overdetermined; he chose the one medium that would allow him to reconcile his artistic ambitions with an insatiable yet philosophical curiosity about life and art. Nonetheless, his becoming a photographer was not so much a conscious decision as an evolving practice; it was made possible and even necessary by the changes that marked the interwar years.

The Transylvanian from Paris

Brassaï's description of Brasso, with its tall pine forest and Gothic church, the Black Cathedral, situates it as a city at the intersection of two civilizations: the last Occidental city on the edge of the former Byzantine Empire. Like his father, a professor of French literature at the University of Brasso who loved the French moralists and *encyclopédistes,* Brassaï chose the Occident, making Paris his cultural home. And like his father, Brassaï was a *citadin endurci,* a confirmed urbanite, drawing creative energy from the life of the city.[1] However, Brassaï belonged to what John Lukacs has called "the lost generation of 1900," which he describes as "the incredibly talented generation of men and women born between 1875 and 1905 who left Hungary in three successive waves of emigration to have highly successful careers abroad as playwrights, filmmakers, musicians, philosophers and scientists."[2]

Born in 1899, Brassaï was in the first wave of emigrants that broke over Europe and America, those whose ambitions (rather than the political situation) dictated wider horizons. Lukacs credits the success of these men and women to a particular moment in Hungarian history when the schools reached a level of teaching comparable to the best schools in Europe and the city of Budapest set a high cultural standard for artistic expression and intellectual exchange. He also associates it with a particular cast of mind: "observant and sensitive," with a comprehension of human nature that was "al-

1. See "Souvenirs de mon enfance," in *Brassaï,* unpaginated.
2. John Lukacs, *Budapest 1900: A Historical Portrait of the City and Its Culture* (New York: Weidenfeld & Nicholson, 1988), 25–26, 138–39.

most always individual, never collective," and—in keeping with the declarative character of the Hungarian language and Hungarian habits of speech—"reluctant to formulate experience in abstract terms."[3] The description suggests a Hungarian dimension to Brassaï's creative sensibility not at all out of place in a photographer, but then Brassaï never denied his origins; despite his naturalization as a French citizen, the name he adopted means "from Brasso."

A photograph of him in the arms of his nurse around 1900 shows that Brassaï was by no means intimidated by the camera; in fact, he appears to be looking beyond it, distracted by something else that has caught his attention, watching it intently with dark eyes. Not surprisingly, perhaps, this was already a characteristic attitude, typical of a kind of distracted concentration that his friends would find both amusing and irritating. Anaïs Nin complained (perhaps with a trace of annoyance that reflects a healthy narcissism) that "he appears not to be observing but when his eye has caught a person or an object it is as if he [becomes] hypnotized"; he keeps on talking to you without even looking at you.[4] In the same vein, Henry Miller claimed that on their first meeting he found Brassaï's eyes hypnotic, just like Picasso's (*RH*, 7). For Miller, Brassaï's protuberant eyes, framed by dark bushy eyebrows, came to symbolize his gift as an artist. In calling Brassaï "the eye of Paris," Miller credited him with the rare gift of "normal vision," the ability to see things for what they are.[5] It is no coincidence that the character of "the photographer" in Miller's *Tropic of Cancer* strongly resembled his friend Brassaï. Interestingly, despite Miller's penchant for exaggeration and his tendency to transmogrify his experience for fictional purposes, he manages to convey a sense of Brassaï's energy, his considerable and eclectic culture, and his fascination with the city as a source of ideas and images:

He knew the city inside and out, the walls particularly; he talked to me about Goethe often, and the days of the Hohenstaufen, and the massacre of the Jews during the reign of the Black Death. Interesting subjects and always related in some obscure way to the things he was doing. He had ideas for scenarios too, astounding ideas, but nobody had the courage to execute them. The sight of a horse split open like a saloon door would inspire him to talk of Dante or Leonardo da Vinci or Rembrandt; from the slaughterhouse at La Villette he would jump into a cab and rush me to the

3. *Ibid.*, 138–39.

4. Anaïs Nin, *The Diary of Anaïs Nin, 1934–39*, ed. Gunther Stuhlmann (New York: Harcourt, Brace & World, 1967), 55.

5. Miller's essay appears in *Brassaï* in French; it was also published in Henry Miller's *Max and the White Phagocytes* (Paris: Obelisk Press, 1938).

Trocadero Museum, in order to point out a skull or a mummy that had fascinated him. We explored the fifth, the thirteenth, the nineteenth and the twentieth arrondissements thoroughly. . . . Many of these places were already familiar to me, but all of them I now saw in a different light owing to the flavor of his conversation.[6]

Given his gift for conversation, it is not surprising that the "eye of Paris" gravitated immediately to Paris cafés. They must have seemed familiar in many ways, an extension of the culture of Berlin and Budapest. Budapest's "era of the coffeehouse" lasted until 1940, its influence so pervasive that a conservative like Jenó Rákosi insisted that "every intelligent person . . . spent a part of his youth in the coffeehouse . . . without that, the education of a young man would be imperfect and incomplete." In Budapest the coffeehouse nourished the press at the turn of the century during the "golden age of newspapers." As in Paris, many writers and journalists found coffeehouses the perfect place to work and headwaiters distributed reams of the "long white sheets of paper (called 'dog's tongues')" to writers who were inspired by the food, drink, or atmosphere to take pen in hand.[7] Brassaï's father moved in literary and journalistic circles, and Brassaï would naturally have associated cafés with writing and the exchange of ideas. He spent his first evening in Paris at La Rotonde. It was a meeting place for artists, he told his parents, where his long hair would be appreciated (EL: 17, p. 54). Later he would also frequent the establishment across the street, Le Dôme, which was a stomping ground for young foreigners. As he would discover, it also attracted a circle of photographers. Once he began work as a journalist he drafted as many articles sitting in cafés as he did in the small rooms he rented, particularly after he discovered that cafés provided free pens and paper (EL: 22, p. 70).

At the buzzing, cosmopolitan Dôme he met German, Russian, and Hungarian writers and artists; it would be several months before he spoke more French than German or Hungarian (EL: 19, p. 60). French was the weakest of his languages, and he admitted to having trouble skimming French newspapers to find sources or ideas for articles that might be of interest to Hungarian readers and justify his somewhat less than princely salary of 390 francs a month (EL: 18, p. 56). With typical enthusiasm, he embarked on a vocabulary enrichment program that involved trying to memorize five or ten

6. Henry Miller, *Tropic of Cancer* (New York: Grove Press, 1961), 194. The description seems surprisingly accurate, although Brassaï took issue with other elements of the portrayal, claiming that the photographer was only very loosely based on his own life. See *Henry Miller, grandeur nature*, as well as Chapter VI, "The Photographer as Writer."

7. Lukacs, *Budapest 1900*, 148, 150–52.

new French words a day (*EL:* 18, p. 57). He also had to look for other assignments to supplement the falling value of his salary, for he was paid in foreign currency, and the value of the franc was rising against the wave of currency devaluations elsewhere in Europe.

He applied—to no avail—to do free-lance work, including drawings and illustrations, for Czech and Yugoslavian papers and magazines; he worked briefly as a sports reporter, and tried to peddle his drawings to a variety of sports and automobile magazines (*EL:* 18, p. 57; 21, p. 65; 22, pp. 66–67). Finally, he established the relationship with two Paris editors for German newspapers that, with his connection to the *Brassoi Lapok,* would be his mainstay until the financial crisis of the late twenties (*EL:* 18, p. 56). There was no guaranteed income, but he could eat well on a mere ten to twelve francs a day. At sixteen centimes, steaming café au lait and croissants were his favorite breakfast, preferably consumed as he pored over a newspaper and inhaled the smell of fresh ink (*EL:* 18, p. 56). Nonetheless, he was so frequently in financial straits that he fell into a routine where if he had money in his pockets he would eat in the brasseries on the boulevard Raspail, but if not he would eat at a small restaurant called the Chartier (photographed by Kertész, who probably had similar habits), and when he came up short he subsisted on bread or fruit and milk, cadging dinner invitations when possible and pawning his clothes when necessary (*EL:* 27, pp. 77, 79). He assured his mother that it saved on storage space in his small apartment and kept the moths away from his best suits (*EL:* 28, p. 80).

It is clear from his letters that Brassaï rather enjoyed the fashionable and social side of reporting: dressing up in bright-colored gloves and an English hat borrowed from Tihanyi to sit in the gallery and await the arrival of the queen of Rumania at a rugby match (*EL:* 21, p. 66), or going to an exclusive fashion show to sketch (and ogle) models wearing Madame Vionnet's latest creations (*EL:* 32, p. 90), or meeting Raoul Dufy on board the three barges Paul Poiret had fitted out for the *Exposition des Arts Décoratifs* of 1925 (*AML,* 48). Named *Amours, Délices,* and *Orgues,* the barges featured gastronomical delights (not to mention witty inventions such as champagne glasses with rounded bottoms designed to force the drinker to empty the entire glass before putting it down), as well as toboggan rides and Moorish dances that Florent Fels (then the director of *L'Art vivant*) saw as a clear signal that Eros had returned to Parisian society.[8]

Despite the excitement, Brassaï still had to cajole, badger, and sometimes threaten the papers that accepted his articles and drawings in order to get

8. Florent Fels, "Le Truc et les machins," in *Voilà* (Paris: Libraire Arthème Fayard, 1957), 105. See also Brassaï's article on Dufy in *AML,* 48.

paid for them (*EL:* 22, p. 67; 23). At one point he attempted to take a German periodical to court (luckily Tihanyi's younger brother was a lawyer); another magazine folded before he could get paid (*EL:* 23, p. 71; 25, p. 75). Scrambling for commissions, then chasing down editors who were slow to pay, took so much energy and time that Brassaï discovered, to his astonishment, that he had seen very few art exhibitions. Those he did see either disappointed or enraged him. No one reading his early letters would have guessed that he would take up photography. On the contrary, he denounced new technical wonders, fearing they would create a world in which there would be no place for art, and deplored the commercialism of the Paris art market (*EL:* 17, p. 58; 20, p. 61). Preoccupied with the idea of arranging an exhibition of his painting, he worried that it was considerably beyond his means (*EL:* 24, p. 73). His own financial situation was, he claimed, something like that of France—a little in debt: more people needed money, fewer people lent money, but creditors were patient (*EL:* 30, p. 86).

The next year, 1925, represented a year of changing directions. Tihanyi's long-awaited gallery exhibition finally materialized, yet despite the pleasure he took in his friend's success, Brassaï came away from it with mixed feelings (*EL:* 33, p. 95). He was dismayed by the Paris critics' indifference to the show, feeling that the exhibition did more for Tihanyi's reputation in Hungary—given the extensive coverage of Paris events in Hungarian papers— than it did in Paris. He concluded, somewhat cynically, that real success in Paris required either powerful friends and an important network of contacts, or the huge sum of money required to rent space in a well-known gallery for several weeks (*EL:* 33, p. 95). At this point he seems to have lost enthusiasm for doing an exhibition of his own work, although this may also be a reflection of the fact that he was increasingly successful in placing drawings and articles in a variety of (mostly German) magazines and papers. He usually published his work under various pseudonyms; they proliferated so wildly that his parents, who actually tried to follow what he was doing, got them confused. Finally, that same year, he published both a drawing and an article on Thomas Mann in *Literarische Welt* under his own name; this was the year when he began to sign his work *Brassaï* (*EL:* 39, p. 104).

While he had not yet taken up photography, he could hardly claim to be a stranger to the medium, as he was frequently accompanied by a photographer who sold her work to British and American papers and allowed him to sell the extra prints (*EL:* 30, p. 85). He did the same with the work of other photographers who supplied him with prints for almost no cost, pleased to see their photos appear in important German papers. Gradually,

and on a small scale, he began to take over the function of a photographic agency at a time when photography was becoming a profitable business (*EL:* 30, p. 85; 31, p. 87). In December, 1925, he announced to his parents that beginning in January he would probably start working for a German press agency that would pay him a regular salary of one hundred marks. He would be responsible for obtaining photographs of interest to German newspapers and commissioning photographs as illustrations for other articles assigned by the agency. Although he mentioned it last, almost as an afterthought, it is no doubt significant that De Gaudenz, the director, wanted him to learn how to take pictures so he could do his own work (*EL:* 41, p. 106).

The suggestion may have taken root, but the job apparently never materialized. However, greater financial security and independence would certainly have been very welcome. Brassaï hated relying on "middlemen," the Paris-based correspondents or editorial assistants for foreign papers. He knew full well that they rewrote his work, but he also suspected that they pirated his material, then rejected his articles as one way of skimming off the cream (*EL:* 30, p. 85; 33, p. 93). In a sense, this was more a blow to his finances than to his creative self-esteem, because he continued to think of himself as a painter, although, as he readily admitted, he did everything but paint (*EL:* 22, p. 67). Nonetheless, journalism offered a real if somewhat unpredictable financial return and provided an outlet for his restless energy, while renting a room for an exhibition at a well-known gallery for two weeks would cost him the unimaginable sum of between five and ten thousand francs. If he had any sense at all he would never pick up a paintbrush again, he wrote his parents (*EL:* 33, pp. 93, 95; 40, p. 105). Gradually, he began to take photography more into account. Although his initial interest in it was strictly illustrative—he needed a photograph of the Pope's Palace in Avignon, or one of the writer Henri Barbusse, or the European shorthand champion (*EL:* 41, p. 106), to accompany particular articles—ultimately photography would fill his need for an art that remained close to life.

By all accounts Brassaï began to take photographs late in 1929. Legend has it that Kertész lent him a camera, but Brassaï always maintained that Kertész merely offered him advice, and that in fact it was a woman friend (perhaps the reporter he occasionally worked with) who lent him a camera and gave him some pointers. Yet it would be impossible to separate his beginnings in photography from his connection to fellow Hungarian André Kertész, and equally impossible to say how much Kertész influenced his work. While it is natural that Brassaï would want to avoid the impression that he was either Kertész's student or his acolyte, it was perhaps inevitable

that Kertész served as a model. By 1929 Kertész had already achieved a considerable reputation both as an artist-photographer and a photojournalist. Not only had he been invited to exhibit his work in a small Paris gallery, but he was asked to participate in numerous group shows including the Salon de l'Escalier and the *Film und Foto* exhibition. His groundbreaking photo-essay on the Trappist monks living in seclusion at their motherhouse in Soligny provided a discreet and sympathetic glimpse into a world not open to the public. Commissioned by *Vu*, but first published in the *Berliner Illustrirte*, it appeared in 1929. Kertész provided the model for a successful professional photographer whose work was the expression of a personal vision. In this sense, his influence may well have been decisive.

An anecdote related in Brassaï's 1949 *Camera in Paris* suggests that it was also Kertész who opened new possibilities for Brassaï by introducing him to night photography. The canonical version of this event places Brassaï deep in conversation with Kertész, who had set up his camera and tripod on the Pont Neuf, hoping to get one last shot of the Seine from the famous bridge. Pausing to adjust the angle of the camera, Kertész resumed talking. Somewhat later, thinking they had dawdled there long enough, Brassaï urged Kertész to take the picture so they could go. "It's being taken," Kertész is reported to have said, "Wait another fifteen minutes and we'll have it." Intrigued by the process ("Open a little box in the middle of the night and half an hour later you have a photo?"), Brassaï went to see Kertész develop the image and bought his first camera the next day—a Voigtlander, 6½ by 9 cm with a Heliar 4.5 lens that would take film or glass plates. The next night he went out to take his first night photograph in the Luxembourg Gardens.[9]

Not that Brassaï would have had any intention of giving up journalism for photography—financially that would have been impossible. In fact, his first article for the *Berliner Illustrirte* was done in collaboration with Kertész, who furnished the photographs (*Kertész,* 143). But by the end of 1929 Brassaï was considering buying both a new typewriter and a Leica.[10] He claimed he had so many commissions for articles that he could barely breathe and hoped that he was on the verge of a real breakthrough (*EL:* 60, pp. 134–35). *L'Il-*

9. This same anecdote is related in Nancy Newhall, "Brassaï: 'I Invent Nothing. I Imagine Everything,'" in *Photography: Essays and Images,* ed. Beaumont Newhall (New York: Museum of Modern Art/New York Graphic Society, 1980), 277–81.

10. See *EL:* 60. The Leica was the quintessential reporter's camera. Kertész used one, but Brassaï either could not afford a Leica or decided against buying one. The intended purchase shows his seriousness, for the Leica would have cost him some twenty-five hundred francs at a time when he was just beginning to eat regularly.

lustration had just bought an article on Clemenceau, and he had sold two articles—the first to appear in his own French—to *Vu* (*EL:* 60, p. 135). Kertész, who had begun photographing for *Vu* in 1928, may have provided the connection, but in any case Brassaï's situation had improved to the point where he expected to escape constant financial worries. With the Leica he could be a mobile reporter (*EL:* 60, p. 136).

By March, 1930, he had bought a camera and sold his first photograph, but there was no more talk of a Leica (*EL:* 61, p. 137). Times were changing, and the future seemed once again uncertain. In *Henry Miller, grandeur nature* Brassaï described some of the visible changes in Paris during the last years of the twenties:

Mens' hats—especially *chapeaux melons*—all but disappeared, like spats, false collars, tramways and their rails, like gas lights, horses, except for the icemen's white Percherons, and Jaffa oranges. Women, freed from their corsets thanks to Paul Poiret and Coco Chanel, took on a masculine air, wore cloche hats, did their hair "windblown" and dressed in comfortable skirts "à la garçonne."[11]

The changes were not simply the whims of fashion, for Wall Street's Black Thursday had a delayed effect on the French economy and the effects of the crash could be felt. It was the beginning of a period Brassaï called "vaches maigres," the lean years when established artists sold their private apartments, the less successful headed for soup kitchens, and American artists, who had colonized the rue Vavin, left Paris in droves. "Montparnasse emptied of its foreign artists, as the crisis worsened," Brassaï recalled, "four million out of work in Germany, thirty million worldwide; ten million votes for Hitler in the German elections, fourteen million two years later" (*GN,* 13). As the economic situation in Germany worsened, Brassaï began to feel its effects; with shrinking budgets came fewer commissions and lower fees (*EL:* 37, p. 110). In 1931 he contracted with a German agency, Mauritius Verlag, in order to place some of his articles (*EL:* 61, p. 137). As he sought other sources of income, his contacts in the French press became more important, and he began to count more on photography, setting up a darkroom in his apartment (*EL:* 62, p. 138). In keeping with his finances it was a minimalist installation

11. "Les chapeaux d'homme—les 'melons' surtout—avaient presque disparu, comme les guêtres, les faux cols durs, les tramways et leurs rails, comme l'éclairage au gaz, les chevaux, excepté les percherons blancs des glacières et des oranges de Jaffa. Quant aux femmes, libérées de leur corset grâce à Paul Poiret et à Coco Chanel, elles avaient pris des allures masculines, portaient des chapeaux cloches, se coiffaient en 'coup de vent' et s'habillaient en jupes confortables, 'à la garçonne.' " *Henry Miller, grandeur nature,* 12. The English translation is my own, as are all others from Brassaï's untranslated works.

(see Figure 7). He didn't own a print dryer and resorted to using his dressing table mirror as a ferrotype in order to produce glossy prints. Meanwhile, the room began to overflow with photographs, and the developing chemicals slowly ate away at the walls and floor, terrifying the hotel manager, who feared they would collapse.[12] However, the next fall Brassaï could report that the very best art publishing house had decided to publish a book of his photographs. The publisher was Arts et Métiers Graphiques, the book would be *Paris de nuit* (*EL:* 65, p. 140).

The Photographer at Work

The intervening period involved endless experimentation with lighting, developing chemicals, all the elements of the process. There is no lack of information about Brassaï's *modus operandi* as a photographer. However, reconstructing the way he worked requires putting together bits and pieces of information from various sources that date from different periods of his life. As a result, this account of his activity both anticipates Brassaï's later work and throws light on his earliest efforts in photography. Fortunately, Brassaï discussed his work freely in interviews—no doubt enjoying the role of interviewee after asking his share of questions as a journalist—and his own books provide considerable information on the subject. The appendix to *Camera in Paris* included a chart indicating what camera, exposure, f-stop, and lens he used for each of the photographs in the book, as well as whether he used a filter (rarely), what the weather conditions were, and the date the photograph was taken. Although published in 1949, many of the photographs in *Camera in Paris* were taken in the thirties and are representative of his work during the period. Most were taken with the Voigtlander Bergheil that was his choice as a first camera. He later acquired a Rolleiflex, remaining faithful to this early equipment despite the immense popularity of the Leica. Unlike Kertész and Cartier-Bresson, he never seems to have *discovered* the Leica (although he eventually bought one) as the instrument most perfectly adapted to his way of taking in the world. Equally foreign to his work is the concept, derived from Cartier-Bresson's photographic practice, of the "decisive moment," a single moment subtracted from the temporal flow of events that provides a pictorial and narrative climax and reveals a truth about its subject.[13] On the contrary, Brassaï's work is essentially static, eliciting admiration for its "easy permanence" (*MOMA,* 7).

12. Roger Klein, "Photography," quoted in *Camera,* 65. See also *EL:* 62, p. 138; 80, p. 155.
13. Although Peter Galassi, who sums up this approach in the terms I use here, argues precisely

Photographs from the thirties that capture Brassaï at work, as well as mirror reflections of him in his own photographs, show him slightly hunched over the camera (the tripod raised it just about to eye-level), squinting into the viewfinder, a cigarette in his hand or dangling from the corner of his mouth. He claimed to use the cigarette in timing exposures on night shots, smoking a Gauloise on clearer nights, a Boyard in deeper darkness, but he also resorted to a magnesium powder flash. Indoors, the flash explosion was strong enough to rattle Picasso's sculptures. It both frightened and amused Picasso, who expressed astonishment that Brassaï rarely bothered to look in the viewfinder to consider the effect of his arrangements. "I figure it out in my head," Brassaï demurred, measuring distances with a string, to the amusement or consternation of bystanders (*Picasso,* 53). His method changed little over the years, although he abandoned the noisy, not to mention dangerous, magnesium powder and substituted film for the cumbersome glass plates that forced him to load the camera from inside a black fabric sack with two sleeves.

Brassaï worked somewhat distractedly, even clumsily, yet his preoccupation apparently functioned as a kind of generalized concentration, an unfocused scanning that would suddenly focus, zeroing in on a particular arrangement or expression that he was quick to capture with the camera.[14] He had a clear sense of what he wanted, or didn't want, surprising Picasso by his desire to retake an entire series of photographs of the artist's sculptures, despite the scarcity and expense of materials during wartime, because he might be able to get a better quality of light. Many of these same characteristics come through in Lawrence Durrell's account of a photographic session with Brassaï some thirty years later (*MOMA,* 10–11). Brassaï had written Durrell requesting permission to take his photograph for an American magazine, but there was some confusion about dates, and he arrived on the same day as a duo of American press photographers. Durrell was dumbfounded that Brassaï had "hardly any equipment at all, one very old camera with a cracked lens hood" and "a tripod that kept kneeling down like a camel." The contrast with the two American journalists, weighted down with par-

that this view tends to "foreshorten Cartier-Bresson's long career into an undifferentiated whole." *Henri Cartier-Bresson: The Early Work* (New York: Museum of Modern Art, 1987), 9.

14. Picasso teased Brassaï frequently about his so-called clumsiness in tripping over things, dropping or breaking them (see *Picasso*), and Françoise Gilot remarks on this in *Ma Vie avec Picasso* (Paris: Calmann-Lévy, 1965), 32. Roger Grenier notes, "One of the most characteristic incidents of his life, it seems to me, happened in Louisiana. He dropped his Rolleiflex into a bayou." Roger Grenier, *Brassaï* (New York: Random House/Pantheon, 1988), unpaginated.

aphernalia, could not have been greater; Durrell recalled that one had a telephoto lens "the length of a submarine periscope." "After several attempts worthy of Laurel and Hardy," Durrell and Brassaï managed to get Brassaï's tripod to stand up, then turned off all the lights because Brassaï's camera was "fond of shadow." "Quietly, absently," Brassaï began to talk about photography, all the while keeping an eye on Durrell, cutting short the conversation to signal him that he had moved into just the right position. He then focused and took his photograph (*MOMA*, 10–11).

Brassaï frequently claimed that he preferred to take only one or two shots of a subject (*BN*, 11). One of his favorite stories was that on assignment for *Harper's Bazaar* he had risked taking only a single portrait of Thomas Mann on the author's eightieth birthday. If the procedure had its tactical value (Mann, exhausted by the onslaught of journalists, might not have agreed to pose otherwise), it also suggests Brassaï's willingness to gamble and his need to assert a form of aesthetic control. Taking the risk that he might fail and lose an important shot gave him the sense, as he put it, that he had earned the photograph rather than winning it in a lottery (*MOMA*, 11). However, despite his insistence on limiting the number of shots he took, this form of aesthetic control really became an issue only in the later phase of his career (the photograph of Mann dates from the mid-fifties, the photograph of Durrell even later), when he had an established reputation and a measure of professional security.

It is clear from his photographs of Paris in the thirties that Brassaï took many shots of the same or similar subjects, varying the lighting, angle, or framing in each one. No doubt this more pragmatic approach represented both an apprenticeship to his medium and a form of insurance. For in those early years he could ill afford to waste either valuable materials or the precious time required for long exposures. Assembling a portfolio of his best work in order to interest a publisher did not prevent him from selling variations on a subject or using these photographs as illustrations for articles. By his own estimation he took enough photographs for four or five books while he was working on *Paris de nuit*, returning to the same subjects, taking just one more variation on a particular shot (*EL*: 67, p. 143).

Trial and error may have wasted precious plates in the beginning as he experimented with the medium and tested its limitations, but an essay on the "Technique of Night Photography" published in *Arts et Métiers Graphiques* in 1933 shows that he was quick to devise practical solutions to his technical difficulties. As the essay reveals, the major problem confronting him in working on *Paris de nuit* was photographing by the light of street-

lamps. These lights were essential to his vision of the city, allowing him to contrast luminous zones with the subtle gradations of grays and blacks produced by crisscrossing shadows blurring into darkness. However, he found that the lights frequently photographed as chalky white circles in a sea of flat, opaque black. Although there were photographic emulsions and developing solutions designed to minimize effects of halation, Brassaï found them unsatisfactory, and worse, unreliable. He complained that they produced iridescent spots, or obliterated halftones. Characteristically, his solution to the problem was tactical rather than chemical. He avoided halos by using elements of the "set"—walls, trees, bridges—to mask streetlights, converting direct into indirect lighting whenever possible. He also took photographs in hazy, rainy, or foggy weather so that the atmosphere would absorb or reflect light and attenuate excessive contrasts.

One of the merits of Brassaï's essay—quite apart from its value as a document—is that it so clearly reveals the pressure of technique on the formation of his style as a photographer. Inevitably, Brassaï's efforts to obscure sources of direct light influenced his sense of composition and his way of framing a scene, while the enveloping atmospheres he favored because they diffused light (mirrors served the same function in interior shots) became an identifying characteristic of his work. Perhaps equally significant, if initially puzzling, are the essay's constant references to cinematic art and its borrowing from film terminology. Puzzling, because notwithstanding the short film, *Tant qu'il y aura des bêtes,* that Brassaï made late in his career, little in his work suggests the cinematic. If he did produce short sequences of photo-essays, such as one entitled "A Man Dies in the Street," which was published both in *Vu* and in *Labyrinthe,* nothing in these photographs suggests a dynamic conception of his subjects.

Brassaï's references to film might be dismissed as circumstantial, and in some sense they were, as the essay was surely written just around the time he spent four months working with fellow Hungarian Alexander Korda on *La Dame de chez Maxims* (*EL:* 74, p. 150). Korda, always interested in attracting new people to film, made Brassaï a very flattering offer just as *Paris de nuit* went to press (*EL:* 69, p. 145). If Brassaï had mixed emotions about accepting—he was impatient to work on a second book tentatively entitled "Paris intime" and was turning over several other projects in his mind—he succumbed to the temptation of a generous salary and the chance to acquire another marketable skill (*EL:* 69–70, pp. 145–47). However, it is not entirely clear what Brassaï actually did on the set of *The Lady from Maxims.* His letters suggest that he took some still photographs (similar to the now famous shot

of the interior of Maxims, which figured in *Camera in Paris*), designed an ad for Korda's film company, played with the film equipment, flirted with the British actresses, and gave Korda advice (*EL:* 75, p. 151; 72, p. 148). He found the hours exhausting, claiming that working in Korda's studio was like living in a submarine, except that the studio was hotter and the air was worse (*EL:* 76, p. 151).

Arguably, the experience left more of a mark on his work than the exotic terminology he used to advantage in his essay. His short apprenticeship in film may in fact have influenced his shift from *Paris de nuit,* where exterior shots and street views predominated, to a "Paris intime," where his photographs focused on the interaction of people in cafés and bars, music halls and *bals.* His essay equates the city at night with a darkened studio set, and it is ultimately the theatricality of this conception, its transformation of reality into "spectacle" (the French sense of the word implying a performance for a spectator) that emerges in some of his best photographs of this period. If it seems incongruous to suggest that Brassaï's experience in a film studio gave him a stronger sense of the theatrical, it is worth remembering the important connections between theater and film. Of the three films Korda made in Paris between 1931 and 1933, perhaps the most successful was the first: his adaptation of Marcel Pagnol's play *Marius.* He merely borrowed Pagnol's cast; two of Pagnol's actors, Raimu and Pierre Fresnay, then relative unknowns, went on to have important film careers.

In the final analysis it is difficult to assess how important Brassaï's few months with Korda were to his development as a photographer, nor is it possible to say with certainty whether any of the photographs taken around this time were directly influenced by his experience in Korda's studio. Nonetheless, several series of photographs (some of which were eventually published in *The Secret Paris of the 30's*) devoted to bistros and Bals-Musette— many of them taken in the rue de Lappe—suggest that Brassaï worked with groups of people as he might have worked with a cast of actors in a studio set. This is not meant to imply that he "directed" them in any real sense of the word.

Brassaï always insisted that none of his photographs was posed, and there is no reason to believe that he behaved differently with the toughs in the rue de Lappe than he did with Lawrence Durrell. No doubt he attempted to put his subjects at ease, to get them to ignore the camera. He probably made an effort not to pay too much attention to them, appearing distracted by the music, conversation, or dancing while he remained watchful, waiting for some revealing expression or gesture, some particular configuration of events.

Certainly this method required both considerable time and patience, but Brassaï maintained that he went to great lengths to win his subjects' confidence. Whenever possible he arranged to be introduced into a particular milieu by someone who was already accepted (the photographer's equivalent of the anthropologist's "local informant"), then tried to establish himself as a regular before revealing that he was a photographer. It is clear from his introduction to *The Secret Paris* that he sometimes succeeded in developing a rapport with his potential subjects and in having them suggest that he take their pictures; in other cases he admits that he paid them, some of them gang leaders and pimps, in order to gain their cooperation.

On some occasions Brassaï would set up his camera in a café, a bistro, a brothel, or a bar and work throughout the evening. Several series of photographs are clearly discernible in *The Secret Paris,* even though they are distributed among different chapters. A case in point is the section entitled "Bals-Musette." We recognize the subjects of these photographs as we leaf through the *The Secret Paris;* they are *habitués* of a local café, then they reappear, sometimes with new partners, as lovers, or among couples dancing. Most of the photographs from "Bals-Musette" were taken in two different night spots on the rue de Lappe, probably on successive evenings. The first photograph of the section shows a group of patrons clustered in front of a bistro. The equivalent of a cinematic *plan d'ensemble,* this photograph introduces the locale and some of the faces that will appear in other photographs in the same section. The next two photographs provide a glimpse of the interiors of two bistros, although only one is from the rue de Lappe; the other functions generically as a typical interior shot. Later photographs show people from the initial shot mingling with other customers, now at the bar, or at a table, now in the foreground, now in the background. The last two photographs in this section were taken in Montmartre and theoretically do not belong to the same series, although there are no visual features that set them apart from the others. These shots, like the others, create the same effect of a continual shifting of emphasis as now one, now another character takes center stage, alternating between supporting and starring roles. The three prostitutes in these last photographs are actually two women: the prostitute we see playing billiards in the first photograph simply changed "costume," putting a dark V-neck sweater over her plaid blouse to pose at the bar for the second "take."

As these series indicate, Brassaï seems to have worked in a very coherent way. He took shots to establish the background, including group shots that give the viewer some sense of proportion and a way to relate individuals to

the larger social context, as well as shots focusing on one or two of the "players" in the scene. If there is something of reportage in this approach, the resulting effect differs considerably from a series on the cesspool cleaners (which also figures in *The Secret Paris*) taken a year earlier in 1931, before Brassaï's experience with Korda. For whatever reason or combination of reasons, in the interval that separated Brassaï's earlier series from his more complex later work in 1932 and 1933, he developed a heightened sense of the possibilities for dramatic interaction between the principals of his photographs. Significantly, it is Brassaï's increasing mastery of his medium and his growing sensitivity to its potential for providing a heightened or dramatic sense of reality (its configuration of the real as image) that links his work to the Surrealists.

Unlike Man Ray, whose work is identified with the Surrealist movement (although he remained something of an unconverted Dadaist at heart), Brassaï seems to have deliberately kept his distance from the group. Yet he met a number of Surrealists soon after his arrival in Paris for the simple reason that they were in and out of the Hôtel des Terrasses, where he had rented a room in order to be in the same building with Tihanyi. Located at the corner of the rue de la Glacière and the boulevard Auguste Blanqui, the hotel mostly accommodated artists. Rattled by the aboveground line of the métro, it also hummed with the noise from the brasserie next door and the vibration from the heavy truck traffic on the boulevard. Yet its location allowed it to serve as an annex to the café life of Montparnasse. Robert Desnos, Raymond Queneau, Henri Michaux, and Henry Miller paid frequent visits to the building to look up their friends.[15] Brassaï met former Dadaist Tristan Tzara through Tihanyi, and probably bumped into Georges Ribemont-Dessaignes, who then asked him to do a portrait he could give his publisher Grasset to use in publicizing his new novel (*EL:* 65, p. 141). Grasset also requested photographs of Paul Morand, François Mauriac, and André Maurois, although it is not entirely clear whether Brassaï actually took them.[16] Assignments like these would have enlarged Brassaï's circle of contacts, introducing him to French writers and artists who might have otherwise remained un-

15. See Brassaï, Henry Miller, and Lawrence Durrell, *Hans Reichel, 1892–1958* (Paris: Editions Jeanne Bucher, 1962), 39.

16. Morand, whose collections of short stories *Fermé la nuit* (*Closed All Night*) and *Ouvert la nuit* (*Open All Night*) met with considerable success in the twenties, would later be asked to write the text that accompanied Brassaï's photographs for *Paris by Night*. Brassaï may never actually have met Morand, but his letter sixty-five of November 5, 1931, in *EL* discusses the photographs and indicates that Tériade suggested he do other photographs of famous painters and writers because it was good business.

approachable, but surprisingly perhaps, he never actually became involved in Surrealism until Tériade, journalist and art critic, whom Brassaï knew from his evenings at the Dôme, engaged him to take photographs for *Minotaure.*

In Search of Surrealist Photography

Surrealism as a movement, with its politics and polemics, seems to have remained foreign to Brassaï, whose temperament led him more to the detachment of observation and irony than to protests and manifestoes. Although it would be misleading to dismiss his connection to Surrealism as unimportant in his work or his development, it would be equally misleading and reductive to represent Brassaï as a photographer-practitioner of Surrealism in any narrow sense.

This is particularly true given the fact that there is no way to define the term "Surrealist photographer" with any precision, though Man Ray seems an obvious example.[17] However, a list of the photographers associated with the movement would be quite long. It would include Jacques-André Boiffard, who provided a number of photographs for André Breton's *Nadja,* Max Ernst, whose photocollages and photo-paintings figured in the *Film und Foto* exhibition, as well as Dora Maar, Lee Miller, Roger Parry, Maurice Tabard, and Raoul Ubac, to name only some of the photographers who did more extensive work in the medium. Nonetheless, in her introduction to the 1979 exhibition *Photographic Surrealism,* Nancy Hall-Duncan acknowledged that "of the many questions unique to photographic surrealism, perhaps the most relevant is the question of is existence."[18] André Breton's inclusion of Man Ray in the catalog of Surrealist artists he extolled in *Surrealism and Painting* apparently sanctioned photography as a Surrealist form of expression. Nonetheless, by including Man Ray in an essay focused on painting, Breton implicitly associated the problematics of photographic representation with those of representational painting. He never directly addressed such issues as the nature of Surrealism's interest in photography, the possibility of a specifically Surrealist practice of photography, or even what made a photograph "Surrealist."

Edouard Jaguer's *Les Mystères de la chambre noire* (1982), on photography and Surrealism, sidesteps such issues by presenting a catalog of the photog-

17. Jane Livingston, "Man Ray and Surrealist Photography," in *L'Amour fou,* Krauss and Livingston, 115–47.

18. Nancy Hall-Duncan, *Photographic Surrealism* (Akron, Oh.: Akron Arts Institute, 1979), 5.

the larger social context, as well as shots focusing on one or two of the "players" in the scene. If there is something of reportage in this approach, the resulting effect differs considerably from a series on the cesspool cleaners (which also figures in *The Secret Paris*) taken a year earlier in 1931, before Brassaï's experience with Korda. For whatever reason or combination of reasons, in the interval that separated Brassaï's earlier series from his more complex later work in 1932 and 1933, he developed a heightened sense of the possibilities for dramatic interaction between the principals of his photographs. Significantly, it is Brassaï's increasing mastery of his medium and his growing sensitivity to its potential for providing a heightened or dramatic sense of reality (its configuration of the real as image) that links his work to the Surrealists.

Unlike Man Ray, whose work is identified with the Surrealist movement (although he remained something of an unconverted Dadaist at heart), Brassaï seems to have deliberately kept his distance from the group. Yet he met a number of Surrealists soon after his arrival in Paris for the simple reason that they were in and out of the Hôtel des Terrasses, where he had rented a room in order to be in the same building with Tihanyi. Located at the corner of the rue de la Glacière and the boulevard Auguste Blanqui, the hotel mostly accommodated artists. Rattled by the aboveground line of the métro, it also hummed with the noise from the brasserie next door and the vibration from the heavy truck traffic on the boulevard. Yet its location allowed it to serve as an annex to the café life of Montparnasse. Robert Desnos, Raymond Queneau, Henri Michaux, and Henry Miller paid frequent visits to the building to look up their friends.[15] Brassaï met former Dadaist Tristan Tzara through Tihanyi, and probably bumped into Georges Ribemont-Dessaignes, who then asked him to do a portrait he could give his publisher Grasset to use in publicizing his new novel (*EL:* 65, p. 141). Grasset also requested photographs of Paul Morand, François Mauriac, and André Maurois, although it is not entirely clear whether Brassaï actually took them.[16] Assignments like these would have enlarged Brassaï's circle of contacts, introducing him to French writers and artists who might have otherwise remained un-

15. See Brassaï, Henry Miller, and Lawrence Durrell, *Hans Reichel, 1892–1958* (Paris: Editions Jeanne Bucher, 1962), 39.

16. Morand, whose collections of short stories *Fermé la nuit* (*Closed All Night*) and *Ouvert la nuit* (*Open All Night*) met with considerable success in the twenties, would later be asked to write the text that accompanied Brassaï's photographs for *Paris by Night*. Brassaï may never actually have met Morand, but his letter sixty-five of November 5, 1931, in *EL* discusses the photographs and indicates that Tériade suggested he do other photographs of famous painters and writers because it was good business.

approachable, but surprisingly perhaps, he never actually became involved
in Surrealism until Tériade, journalist and art critic, whom Brassaï knew
from his evenings at the Dôme, engaged him to take photographs for *Min-
otaure.*

In Search of Surrealist Photography

Surrealism as a movement, with its politics and polemics, seems to have
remained foreign to Brassaï, whose temperament led him more to the de-
tachment of observation and irony than to protests and manifestoes. Al-
though it would be misleading to dismiss his connection to Surrealism as
unimportant in his work or his development, it would be equally misleading
and reductive to represent Brassaï as a photographer-practitioner of Surre-
alism in any narrow sense.

 This is particularly true given the fact that there is no way to define the
term "Surrealist photographer" with any precision, though Man Ray seems
an obvious example.[17] However, a list of the photographers associated with
the movement would be quite long. It would include Jacques-André Boif-
fard, who provided a number of photographs for André Breton's *Nadja,* Max
Ernst, whose photocollages and photo-paintings figured in the *Film und Foto*
exhibition, as well as Dora Maar, Lee Miller, Roger Parry, Maurice Tabard,
and Raoul Ubac, to name only some of the photographers who did more
extensive work in the medium. Nonetheless, in her introduction to the 1979
exhibition *Photographic Surrealism,* Nancy Hall-Duncan acknowledged that
"of the many questions unique to photographic surrealism, perhaps the most
relevant is the question of is existence."[18] André Breton's inclusion of Man
Ray in the catalog of Surrealist artists he extolled in *Surrealism and Painting*
apparently sanctioned photography as a Surrealist form of expression. None-
theless, by including Man Ray in an essay focused on painting, Breton im-
plicitly associated the problematics of photographic representation with those
of representational painting. He never directly addressed such issues as the
nature of Surrealism's interest in photography, the possibility of a specifically
Surrealist practice of photography, or even what made a photograph "Sur-
realist."

 Edouard Jaguer's *Les Mystères de la chambre noire* (1982), on photography
and Surrealism, sidesteps such issues by presenting a catalog of the photog-

 17. Jane Livingston, "Man Ray and Surrealist Photography," in *L'Amour fou,* Krauss and Liv-
ingston, 115–47.
 18. Nancy Hall-Duncan, *Photographic Surrealism* (Akron, Oh.: Akron Arts Institute, 1979), 5.

raphers who were associated with the movement. The sheer volume of work he presents has its own value as evidence. On the other hand, Susan Sontag's *On Photography* (1977), Nancy Hall-Duncan's essay *Photographic Surrealism* (1979), Rosalind Krauss's "On the Photographic Conditions of Surrealism" (1981), its sequel, "Photography in the Service of Surrealism," and Dawn Ades's essay "Photography and the Literary Text" (the last two written for the 1986 exhibition on Surrealist photography, which adopted the title of Breton's *L'Amour fou*),[19] all present important critical perspectives on the relationship between photography and Surrealism. They raise some of the fundamental theoretical questions that emerge when Brassaï's photography is placed in the context of Surrealism.

A, if not *the,* fundamental difficulty in isolating a particularly "Surrealist" practice of photography resides in the apparent contradiction between the representational nature of photographic means and Surrealist ends. The Surrealists' goal, "changer la vie," indicted a culture that repressed desire and shackled the imagination because they disrupted and challenged the established order of things. In the second *Manifesto of Surrealism* André Breton violently rejected "the notion of the sole possibility of the things which *are.*"[20] Surrealism dismissed the limitations of "what is vulgarly understood by *the real*" (*SP,* 2) to turn inward, focusing on the revelations of subjective states—the evocations of inner, subconscious, or dream realities—that could compensate for what Breton called the paucity of reality. Surrealist practices such as automatic writing, the transcription of dreams, plastic experiments with collage or frottage and "games" such as the "cadavre exquis" were meant to liberate creative impulses and restore a sense of the infinite possibilities of human experience.

In *Surrealism and Painting* Breton denounced representational painting for its attachment to vulgar reality, yet photography was wedded to it, and the growing importance of photography was based on the conviction that it could serve to authenticate the events it portrayed. Not only did documentary photography represent, authenticate, and preserve vulgar reality, but as Nancy Hall-Duncan points out, the concept of "truth to the medium" derived from documentary photography; "the idea that to be 'true' to photography one must maintain the objective and descriptive capabilities of the

19. For a critical evaluation of the exhibition and Krauss's essays in particular see Hal Foster, "L'Amour faux," in *Art in America,* LXXIV (January, 1986), 117–28. Foster's concluding "intuition" "that much contemporary criticism and art, much theory and practice of our postmodernist present is partly, genealogically, a theory and practice of 'Surrealism' " (128) makes his position seem rather closer to that of Sontag.

20. André Breton, *Les Manifestes du Surréalisme* (Paris: Gallimard, 1969), 82.

camera" weighed heavily against the Surrealist's use of it to create evocative images of subjective realities.[21]

However, a series of fortunate accidents provided the Surrealists with the means of intervening in the photographic process. The mysterious patterns and silhouettes of Man Ray's photograms, the curious inversions of solarization (the rediscovery of the Sabbatier effect when Lee Miller mistakenly turned on a light during the developing process), and the distortions of *brûlage* (the burning of the negative), when added to the possibilities of multiple exposures, *cliché verre,* shadow effects, negative or sandwich printing, and techniques practiced by the Dadaists such as photocollage and photomontage, provided an impressive repertoire of technical manipulations that could be used to create distortions in the image.[22] These distortions were all the more powerful and suggestive because the image still retained something of its original "documentary" character, both conveying a sense of the surreal lurking in banal appearances and providing a visual equivalent for another reality perceived in dreams. Such images, resulting from technical manipulations of the photographic process, represent Surrealism's only deliberate engagement with the capabilities of the medium in order to portray the subjective reality of the surreal, and it is these manipulated photographs that Susan Sontag identifies as "Surrealist photography" in an official or historical sense. Nonetheless, she considered such photographs to be of only limited interest, "marginal exploits" in the history of photography: mannered images that "only narrowly conveyed photography's surreal properties."[23]

Another dimension of the Surrealist practice of photography can be gauged from the movement's efforts to turn the "truth" of the medium to advantage. Surrealist magazines and reviews (from *La Révolution Surréaliste, Le Surréalisme au Service de la Révolution,* and the anti-Surrealist review *Documents* to *Minotaure*) as well as books such as Breton's *Nadja, Les Vases communicants,* and *L'Amour fou* made extensive use of "straight" photographs, using them in a way that both exploited and undercut their documentary character.

Dawn Ades inventoried issues of these various publications, providing a list of the different types of photographs she saw in *La Révolution Surréaliste:* images of Surrealist objects, some of which were constructed for the sole purpose of being photographed; straight photographs, such as portraits and street scenes; manipulated photographs (double exposures, photomontages,

21. Hall-Duncan, *Photographic Surrealism,* 5.

22. See Ades, *Photomontage,* 106–45.

23. Susan Sontag, *On Photography* (New York: Delta Books, 1978), 52.

etc.); ethnographic and scientific photographs; movie stills; and a variety of popular images such as picture postcards.[24] The range of straight photographs she identified and the varied visual strategies implied in their use do not represent a single type of what Hall-Duncan referred to as "found image" Surrealism—in contrast to manipulated Surrealist images—because it *found* "its objects in everyday reality."[25] Despite the limitations of the "found image" label, it has the merit of suggesting a fundamental Surrealist strategy, the *dépaysement* or defamiliarization that underlies most "found image" practices.

Dépaysement represents the strategic or conceptual counterpart of the Surrealists' delight in discovering bizarre, unidentifiable items, what Susan Sontag called "urban debris" in the cultural no-man's-land of the flea market. While the flea market was the source for many of the odd or popular images that appeared in Surrealist publications, it also provided the operative model for *dépaysement:* the separation or displacement of objects from the referential context that ordinarily defines them in order to allow the viewer to discover their irrational, surreal qualities. Photography, as Sontag suggests, does more than lend itself to this kind of operation, it facilitates it. This ultimately leads her to claim that "Surrealism lies at the heart of the photographic enterprise: in the very creation of a reality in the second degree, narrower but more dramatic than the one perceived by natural vision."[26]

While Nancy Hall-Duncan and Dawn Ades attempt to define the place of photography in the history of the Surrealist movement, both Susan Sontag and Rosalind Krauss redefine Surrealism in relation to photography. In "Photography in the Service of Surrealism," Krauss rescues photography, "the great unknown, undervalued aspect of Surrealist practice," from the margins of the history of Surrealism to place it at the center of the movement.[27] She discovers in it the exemplar for Breton's "convulsive beauty" ("Beauty will be convulsive, or will not be," Breton claimed in the concluding line of *Nadja*) and consequently the key to Surrealist aesthetics and a unified field theory of Surrealist style. Referring to Breton's remarks on the subject in the prologue to *L'Amour fou: Photography and Surrealism*, Krauss conceives the fundamental aesthetic perception underlying "convulsive beauty" as "the experience of reality transformed into representation." In its

24. Dawn Ades, "Photography and the Surrealist Text," in *L'Amour fou*, Krauss and Livingston, 156.

25. Hall-Duncan, *Photographic Surrealism*, 9.

26. Sontag, *On Photography*, 78, 52.

27. Rosalind Krauss, "Photography in the Service of Surrealism," in *L'Amour fou*, Krauss and Livingston, 24.

fragmentation and duplication of the visual field within the frame of the image, the photograph provides the model for this transformation. Surrealist photography, Krauss maintains, puts "enormous pressure" on the frame, which configures the real not as an interpretation of reality but as a sign, "a sign of signification": "what the camera frames, and thereby makes visible, is the automatic writing of the world: the constant, uninterrupted production of signs."[28] While Krauss's examination of Surrealist photography is inclusive, referring to both manipulated and documentary images, the direction of her argument leads her to insist, initially, on particular effects that result in the fragmentation of images and on "doubling," or duplications of form, in manipulated images. However, the argument gradually shifts to encompass straight images, and its conclusion—that photography configures the real as a sign—though important and persuasive, is most convincing when applied exclusively to documentary images. Ultimately, Krauss's concern with the relationship between documentary images and the surreal links her work on photographic Surrealism to that of Susan Sontag.

Although Sontag asserts that photography engineered "a Surrealist takeover of the modern sensibility," in an ironic reversal she accuses the Surrealists of misunderstanding the fundamental relationship between photography and the surreal. Their mistake, she argues, was in assuming, "as loyal Freudians," that the source of the surreal was the timeless, universal unconscious, "whereas it turns out to be what is most local, ethnic, class-bound, dated." Photographs that represent "moments of lost time, of vanished customs," she maintains, "seem far more surreal to us now than any photograph rendered abstract and poetic by superimposition, underprinting, solarization and the like."[29]

Her emphasis on "to us now" signals a shift in perception: the result of the cultural evolution in which Surrealism has supposedly subsumed the modern sensibility and been, in turn, transformed by it. And perhaps the most striking feature of Sontag's argument—other than its equation of photographic and Surrealist sensibilities—is precisely its juxtaposition of a devalued or trivialized historical Surrealism with a curiously ahistorical, generalized, yet time-bound surreal. "What renders a photograph surreal," Sontag insists, "is its irrefutable pathos as a message from time past, and the concreteness of its intimations about social class." The "contemporary" surreal photograph is then necessarily documentary: "concrete, particular, anecdotal (except that the anecdote has been effaced)," while "what is surreal

28. Krauss and Livingston, *L'Amour fou*, 35.
29. Sontag, *On Photography*, 51, 53–54.

in such photographs is the distance imposed, and bridged, by the photograph: the social distance and the distance in time."[30] Significantly, however, this is merely an example of temporal *dépaysement*. The Surrealists themselves exploited this practice, which functions in a manner analogous to Surrealist metaphor, by juxtaposing two distant realities whose contact produced the spark of the surreal.[31]

There is an inevitable—and implicitly acknowledged—circularity to Sontag's argument, for the surreal she describes is ostensibly the product of her own modernist reinterpretation of the Surrealist sensibility. She herself deliberately adopts one of the forms of this Surrealist sensibility: the penchant for quotations and "for the juxtaposition of incongruous quotations" in an appendix that contains passages taken from fiction, critical works, poetry, newspapers, ads, and even Roget's thesaurus, all of which are "on photography."[32] While this penchant apparently dictated the analogy she establishes between collections of quotations and collections of photographs, it also has methodological consequences, for by equating photographic and Surrealist sensibilities, Sontag "quotes" the surreal, relativizing it by framing and appropriating it, thereby removing it from one particular cultural and historical context (rather as though she were removing a photograph from an album) to place it in another.

Yet her rejection of a timeless, "absolute" surreal in favor of a "relativizing" time-bound surreal sheds considerable light on the ahistorical sensibility of Surrealism and its preference for parataxis. The juxtapositions of parataxis provide the foundation for Surrealist metaphor, narrative strategies (see the prologue to *Nadja*), and the ordering of collections that range from the broad field of the flea market to the most inconsequential grouping of personal memorabilia. The Surrealists were avid collectors, and their collections included postcards, tarot cards, African and Oceanic artifacts, flea-market finds, graffiti, and notably, even though it is of another order, the curious collection of artistic and literary precursors that Breton presented as the Surrealist pedigree in the first manifesto. He listed, among others, "Swift, Surrealist in malice; Chateaubriand, Surrealist in exoticism; Hugo, Surrealist when he isn't stupid; Fargue, Surrealist in atmosphere and Reverdy, Surrealist at home."[33]

30. *Ibid.*, 54, 58.
31. Breton, *Manifestes*, 51.
32. Sontag, *On Photography*, 75.
33. Breton, *Manifestes*, 38–39. For a discussion of the narrative of collection see Susan Stewart's very fine book: *On Longing: Narratives of the Miniature, the Gigantic, the Souvenir, the Collection* (Bal-

Such collections relativize history by reordering its discrete elements on the basis of individual—or merely different—priorities and norms; its ultimate referent is the sensibility of the collector. However, drawing on Sontag's view of Surrealism "as a pervasive—perhaps dominant—modern sensibility," James Clifford demonstrated its importance as a "crucial modern orientation toward cultural order" prevailing in the twenties and thirties in which "reality is no longer a given, a natural, familiar environment. The self, cut loose from its attachments, must discover meaning where it may—a predicament . . . that underlies both Surrealism and modern ethnography." [34] Brassaï's exploration of the exotic world of nocturnal Paris and his collection of photographs of graffiti suggest the importance of this more generalized, pervasive Surrealist sensibility in his work. However, Sontag's distinction between Surrealism and the surreal also suggests something of the cultural transformation of historical Surrealism, its absorption and generalization in contemporary culture. Her marginalization of the historical Surrealist movement parallels the disappearance of any reference to it in Brassaï's later presentations of his early work. In fact, the nocturnal city of *The Secret Paris of the 30's* has come to be associated with the vanishing past, and so with history.

timore: Johns Hopkins University Press, 1984) as well as my review of it for *SubStance 49*, XV (1986), 97–99.

34. Clifford, *The Predicament of Culture,* 117–19. Although Clifford makes it clear that he did not intend to restrict the subject "to French culture of the twenties and thirties" (118).

II

Remembrance of Things Past
Cultural Preservation as Renovation

L ike one of those twelfth-century Romanesque churches, topped with Gothic towers and spires in the thirteenth or fourteenth century, then refurbished inside during the Renaissance, I carry three quite distinct, superimposed images of Paris in my head: the Paris of 1903, the Paris of 1924, and the Paris of today." [1] Brassaï's church provides a striking equivalent for the memory images that make up his Paris: his first view of the city, a year in Paris when he was four; the postwar Paris he rediscovered in his twenties; and the Paris of his eighties. His mental city becomes an architectural palimpsest in which the new is layered over the old, altering but not quite effacing it. Certainly the year he spent living the life of "un petit Parisien" on the rue Monge during his father's sabbatical created a foundation of strong impressions. It was a year in which he discovered the Luxembourg Gardens, *crème caramel,* and the movies, although there were some narrow escapes: from the panic of the crowd during an assassination attempt on Alphonse XIII, and from being trampled by carriages as he crossed the Champs-Elysées with his brother. He did lose his hat, crushed under the victoria of a *grande dame* whom he discovered, years later, to have been Oriane, duchesse de Guermantes. [2]

The architectural comparison, like the evocation of the duchess de Guermantes, betrays Brassaï's increasing preoccupation with Proustian themes and motifs in his later writing. His Romanesque church recalls Proust's great novel cycle, the "immense edifice du souvenir" that was to be built like a cathedral and marked with the stamp of time. [3] If in his twenties Brassaï felt

1. Brassaï, "The Three Faces of Paris," *Architectural Digest,* XLI (July, 1984), 30.
2. Brassaï, "Souvenirs de mon enfance," in *Brassaï,* unpaginated.
3. Marcel Proust, *A la recherche du temps perdu* (3 vols.; Paris: Gallimard, 1966), I, 47; III, 1045.

the loss of the Paris of his childhood, finding (like Proust's narrator) that the city was very different after the war, he could not have foreseen the dimension that the passage of time would give his photographs from the thirties. Nonetheless, his lament for a vanished and vanishing Paris in the preface to *The Secret Paris of the 30's,* published some forty years after those photographs were taken, makes an implicit parallel between Proust's art and his own, equally marked by the stamp of time.

More significant than any connection between his work and Proust's, however, is the fact that Brassaï's nostalgia for an earlier Paris can be related to a broader regressive current of nostalgia, stemming from a perception of cultural erosion and loss that marked the work of earlier artists and photographers. Brassaï's work should be seen in the larger context of representations of the city and the country, some of which were deliberate efforts to preserve a vanishing culture.

Preserving a Vanishing Culture

Baron Isidore Taylor and Charles Nodier collaborated on one of the earliest of such works, the *Voyages pittoresques et romantiques dans l'ancienne France,* begun in 1819. Each of the volumes in the series was to document a particular region, describing and illustrating "the ruins and monuments of France from the Middle Ages and earlier periods which were fast disappearing as they were allowed to fall into decay or were quarried for building stone."[4] Of more than topographical or archaeological interest, the series published some three thousand lithographs by some of the greatest lithographers of the period. While the series ceased publication in 1878, before it devoted a volume to Paris, it did not reject cities in favor of lush pastoral or dramatic scenery and picturesque ruins. However, as Bonnie Grad and Timothy Riggs indicate, the lithographs usually conveyed no real sense of urban experience. They either used the city as a backdrop for picturesque architecture or viewed it from a distance that allowed the viewer to see it as a coherent whole, framed by the surrounding countryside.[5]

Even in the case of Paris, which in the early nineteenth century was larger than all of the other major French cities put together, the country came right

4. Bonnie L. Grad and Timothy A. Riggs, *Visions of City and Country: Prints and Photographs of Nineteenth-Century France* (Worcester, Mass.: Worcester Art Museum, 1982), 17, hereinafter referred to as *Visions.*

5. *Ibid.,* 65–68.

up to the edge of the city. André Morizet points out that the urban *flâneur* would see hardly anything but trees and gardens once he got beyond the old sections that made up the city center. When then Prime Minister Guizot invited Victor Hugo to visit him in the country, the trip involved going no farther than Auteuil. Yet Paris had already begun to expand beyond its traditional perimeters during the Restoration. By 1829, when gaslights were put in the Place Vendôme, the city began to light up the night sky.[6] In a collection of poems entitled *Les Campagnes hallucinées* (1893), the poet Emile Verhaeren takes the panoramic view typical of the *Voyages pittoresques,* but portrays this nocturnal city as both magnificent and menacing:

> La ville au loin s'étale et domine la plaine
> Comme un nocturne et colossal espoir;
> Elle surgit: désir, splendeur, hantise
> Sa clarté projette en lueurs jusqu'aux cieux
> Son gaz myriadaire en buissons d'or attise
> Ses rails sont des chemins audacieux
> Vers le bonheur fallacieux
> Que la fortune et la force accompagnent;
> Ses murs se dessinent pareils à une armée
> Et ce qui vient d'elle encore de brume et de fumée
> Arrive en appels clairs vers les campagnes
>
> C'est la ville tentaculaire. . . .

> (The city stretches out far away and dominates the plain
> Like a colossal nocturnal hope;
> It looms up: desire, splendor, obsession
> Its myriad gold gaslit thickets stir up sparks
> Its rails are bold roads
> Towards false happiness
> That force and fortune travel
> Its walls line up like an army
> And what issues from it still of haze and smoke
> carries as clear calls to the countryside
>
> It is the tentacular city. . . .)

6. André Morizet, *Du Vieux Paris au Paris Moderne, Haussmann et ses prédécesseurs* (Paris: Librairie Hachette, 1932), 92–93, 97, 223, 226.

Verhaeren's tentacular city spreads over the countryside, multiplied by the myriad gaslights that extend its reach into the night sky; its smoky haze drifts out toward the clear countryside beyond its walls like a challenge. Yet if the city represents both a source of hope and an illusion of false happiness, it is nonetheless the central source of energy in the poet's vision: all roads (and all rails) lead to the city. The ambivalence that characterizes Verhaeren's vision of the city underscores the importance of Raymond Williams' assertion that "the contrast of the country and the city is one of the major forms in which we become conscious of a central part of our experience and the crises of our society."[7] Verhaeren's city crystallizes certain of these oppositions, but they become clearer because he takes a long view. The borders between Paris and the surrounding countryside had blurred much earlier as entrepreneurs and workers fled the high cost of housing and doing business by moving outside the city walls. Ringed with a haphazard conglomeration of slums and industry, the city was less and less sharply distinguished from the surrounding "suburbs," although there was a marked contrast between urban order and suburban squalor. The distinction between city and country was further confused by the new fortifications built around the capital in the 1840s, unofficially annexing some suburbs and excluding others. Yet the city's tendency to absorb the countryside around it, what Verhaeren later called the "tentacular city," led it to expand to the very edge of its fortified limits.

By 1853, when Napoleon III appointed Baron Haussmann préfet de la Seine, entrusting him with the responsibility of making Paris the most beautiful city in the world, the city was already suffering from a number of serious urban problems: filthy streets, poor sanitation, overcrowded and unhealthy living conditions. Yet Haussmann's plan for opening up the city by widening streets, creating broad boulevards, parks, and open urban spaces required extensive demolitions opposed by such famous citizens as Victor Hugo, whose love of medieval architecture may well have been influenced by the *Voyages pittoresques,* as he was an early subscriber to the series.

Hugo's fulminations against the "démolisseurs" began in *Odes et Ballades* and continued in articles that appeared in *La Revue des Deux mondes* in 1823.[8] However, as James Burke indicates, Hugo's *Notre-Dame de Paris,* "first published in 1831, was the wellspring of a movement that glorified the history

7. Raymond Williams, *The Country and the City* (London: Chatto and Windus, 1973), 289.

8. See André Jammes and Eugenia Parry Janis, *The Art of French Calotype* (Princeton: Princeton University Press, 1983), n. 121, p. 117, hereinafter referred to as *Calotype.* This chapter owes an important debt to Janis' work; for a critical view of her approach see Christopher Phillips, "A Mnemotic Art?: Calotype Aesthetics at Princeton," *October,* XXVI (Fall, 1983), 35–62.

of France, the city of Paris and the cathedral." [9] Brassaï himself confirmed
the power of Hugo's portrayal of the city and the cathedral some one hun-
dred years later when he recounted a nocturnal climb to the top of Notre-
Dame. Stunned by the extraordinary view in which the dark forms of the
gargoyles were silhouetted against the lights of a city wrapped in milky fog,
he felt past and future, history and legend blend, and expected to meet
Quasimodo, the bellringer of Notre-Dame (*SPT,* "The Concierge of Notre-
Dame").

Hugo's involvement in the groundswell of support for the preservation
of old Paris also included an official position on the government-supported
Comité des Lettres, Philosophie, Sciences et Art, which had been charged
with undertaking a survey of the country's architectural heritage. It was
replaced in 1837 by a more active committee, the Historic Monuments
Commission, which proceeded to implement a suggestion made by Baron
Taylor (appointed Inspecteur Général des Beaux-Arts et Musées de France
after the series of *Voyages pittoresques* ceased publication) that the commission's
survey be illustrated with daguerreotypes "as an additional means of ensuring
the desired degree of accuracy in any restoration." [10] Significantly, Taylor
himself had introduced some photographs in one of the later volumes (on
Burgundy) of the *Voyages pittoresques,* suggesting what was to be the gradual
displacement of the tradition of picturesque lithographic views by the need
to record architectural sites with greater precision and accuracy. Later on, in
a kind of aesthetic reversal, the overlap between photography and lithography
became the basis for the artistic claims made for Brassaï's early photographs
of Paris. When Arts et Métiers Graphiques advertised the photographs in
Paris by Night as a "*tour de force* technique," they balanced technology with
art, claiming that the photographs had "une puissance d'eaux-fortes," the
evocative power of etchings.

Art and Cultural Preservation

The work of Charles Meryon represents a significant moment in the tran-
sition between prints and photographs. Meryon's etchings combined the
vision of an artist with the accuracy of photographic rendering in order to
record a Paris that would vanish as Haussmann transformed the city. One of

9. James D. Burke, *Charles Meryon: Prints and Drawings* (*Catalogue raisonné*) (New Haven: Yale
University Art Gallery, 1974), 2.

10. Jammes and Janis, *Calotype,* 53.

the major printmakers of the nineteenth century, his most important subject was the city of Paris—medieval Paris with its Gothic architecture, crowded old neighborhoods and labyrinthine networks of streets and narrow alleys. Meryon's most famous series of prints, the *Eaux-Fortes sur Paris,* was issued in several installments beginning in 1852.[11]

If Victor Hugo was the most important influence on Meryon's work, Baudelaire was perhaps his most important champion. He gave Meryon's work its first official recognition in the Salon of 1859, where he praised "the sharpness, delicacy and certainty of his design. I have rarely seen the solemnity of an immense city depicted with more poetry," he went on,

the majesty of piled up masonry, the bell towers pointing a finger at the sky, the obelisks of industry vomiting their coalitions of smoke against the heavens, the marvelous scaffolding of monuments under repair, lending to the solid body of the architecture the openwork of their own architecture, so paradoxically beautiful; the tumultuous sky overcast with anger and bitterness, the depth of perspectives increased by the knowledge of all the human dramas contained in them, not one of the complex elements that make up the mournful and glorious setting for civilization was forgotten. If Victor Hugo had seen these excellent prints, he would have been pleased.[12]

Meryon's vision of Paris is highly personal, even idiosyncratic. If it conveys his admiration for the threatened beauty of the old neighborhoods where he lived, it also dramatizes his sense of the darker, more sinister forces at work in the city. The frontispiece of his *Eaux-Fortes sur Paris* provides the symbolic entrance into his city; entitled "Old Portal of the Palace of Justice," it represents two dark medieval towers enlarged out of scale in such a way that they loom before the viewer like the gates of hell, while a demon hovers above them holding a banner inscribed "Paris" (Figure 8). Yet Meryon was also a meticulous draftsman, obsessed by the need for exactness in his rendering of architectural detail. Some of his initial drawings were made with the help of a camera obscura, and Meryon also worked from daguerreotypes, although he did not hesitate to enlarge certain elements of a scene, eliminate others, or make subtle shifts in perspective in order to create dramatic effects.

Meryon's sense of the city as a threatening and dangerous place is clearly expressed in one of the best-known prints in the Paris series: *Le Stryge (The*

11. Burke, *Meryon,* 27.

12. Charles Baudelaire, *Oeuvres complètes* (Paris: Gallimard, 1966), 1038. See also Burke, *Meryon,* 8, for a slightly different translation of the French text, which I have adapted in the interests of accuracy.

Vampire), which represents a grimacing gargoyle on the north tower of Notre-Dame (Figure 9). Behind and below him stretches a panorama of the city dominated by the tour Saint-Jacques, all that remained of the medieval church of Saint Jacques de la Boucherie, destroyed in 1802. Meryon's focus on the tower and the gargoyle suggests a theme similar to that of the *Voyages pittoresques:* Gothic architecture in its modern context.[13] Yet the birds that circle the tower (they reappear in other prints in the series) convey a sense of something more sinister, which is borne out by the verses Meryon appended to the image: "Insatiable Vampire, Eternal Luxuria / Coveting the Great City / As its feeding place." The vampire embodies the evil of the modern city, Baudelaire's, Hugo's, and Meryon's city, and appropriately, the gargoyle itself was a recent addition to the cathedral. Parisians had been following the restoration of Notre-Dame since the 1840s, and this particular gargoyle was the work of Viollet-le-Duc, newly installed in 1850.

Meryon's most productive period, the period of the *Eaux-Fortes sur Paris,* coincides with the five *Missions Héliographiques* sponsored by the Commission des Monuments Historiques, which were concluded by 1852. Despite Baron Taylor's suggestion, the commission decided against daguerreotype for the missions "not only because of its 'cold tinge,' shiny surface and unreproducibility, but because given its small scale it could not make clear the scale relationships of large building complexes."[14] The committee's preference for calotype appears to have been based on the relative simplicity of the photographic process, the portability of paper negatives, their reproducibility, and the rich chiaroscuro of the images, which could emphasize structural organization without obscuring important architectural detail. In the play of light and shadow that defines its subjects and in its potential for the creation of atmospheric effects, the calotype shares certain visual conventions with lithography.

Not surprisingly, many of the early calotypists were drawn to the picturesque urban Gothic of Paris. Henri Le Secq, whose early work on the cathedral of Amiens resulted in his being assigned photographic "missions" to Champagne, Alsace, and Lorraine was, with his neighbor on the Ile Saint Louis, Charles Nègre, a connoisseur of Old Paris who photographed many of the same subjects that attracted Meryon. Nègre's photograph of Le Secq on the tower of Notre-Dame, made a year earlier than *Le Stryge,* takes the same view of city as Meryon, but its witty juxtaposition of Le Secq in top

13. Grad and Riggs, *Visions,* 94.
14. Jammes and Janis, *Calotype,* 53.

hat and formal attire with the grimacing gargoyle has none of the heavy,
threatening atmosphere of Meryon's print (Figure 10).[15] Brassaï's photograph
of Paris from Notre-Dame echoes both Meryon's etching and Nègre's pho-
tograph some eighty years later. Brassaï, like Meryon, captures the gargoyle
close-up with the tour Saint-Jacques behind him, although he transforms
the gargoyle, making him a sympathetic, even humorous figure, while the
tower, almost completely dissolved in fog, has become a shadowy phantom
shape in the background (see Figure 28). Another of Brassaï's photographs
of the tour Saint-Jacques—wrapped in the lacework of scaffolding Baudelaire
found so paradoxically beautiful—would appear in André Breton's *L'Amour
fou* (Brassaï's reinterpretation of this view of the city will be discussed in
Chapter IV).

A number of critics have drawn attention to the parallel between Mer-
yon's work and that of contemporary photographers.[16] As James Burke notes
in his essay on Meryon, "in the representation of urban and Gothic subjects,
Victor Hugo's most prominent followers are Meryon and the photogra-
phers."[17] Yet it is not merely a question of subject matter, as there are also
similarities in visual effects. Grad and Riggs dismiss the sharp detail of Mer-
yon's prints and the strong contrasts of light and shadow that give them a
"superficially 'photographic' look" in order to emphasize parallels of vantage
point and composition.[18] Meryon's work includes few of the panoramic
views we might associate with the *Voyages pittoresques;* his compositions fre-
quently frame one segment of the visual field as though it were seen through
the camera lens. This tight framing is invested with particular emotional
power, for Meryon's city does not open out into the country, or even to the
horizon, but closes in on the viewer, who is confronted by rows of houses
and overwhelmed by massive architectural structures. Even in compositions
such as *Le Pont au Change (The Exchange Bridge)*, where the perspective is
uncharacteristically broad, the viewer's vantage point is at the level of the
water so that the bridge looms dramatically, threateningly, overhead. Yet in
his isolation of specific sites, buildings, and architectural detail, particularly
those structures slated for renovation or demolition, Meryon's work bears
close comparison with that of Le Secq, so much so in the case of their

15. Eugenia Parry Janis, "The Man on the Tower of Notre Dame: New Light on Henri Le
Secq," *Image*, XIX, no. 4, pp. 13–25.

16. In addition, Janis reports that Le Secq collected Meryon's work, noting that it "is partly a
question of vision and sensibility that lead Le Secq to collect the work of contemporary printmakers
including that of Meryon, Millet and Whistler." *Calotype*, 209.

17. Burke, *Meryon*, 36.

18. Grad and Riggs, *Visions*, 125.

representations of the old Tourelle de la Tixeranderie (demolished by Hauss-mann to extend the rue de Rivoli) that Janis finds "Meryon's etching looks like a cropped version of Le Secq's photograph." [19]

Yet the importance of visual effects—the beauties of atmosphere created by tone and shading that characterize both etching and calotype—is not entirely negligible. In the case of the calotype, the soft, matte quality of the image, which Janis compares to an old print, is a result of the process. Al-though paper negatives were waxed to create a smoother surface and increase the clarity of the photograph, a subtle blurring of the outlines and fine gradations of shadow remained essential qualities of the resulting image.[20] For photographers who preferred this process, the image's tonal range and atmosphere more than compensated for its lack of clarity. Le Secq's origi-nality in using this chiaroscuro as an element of composition reinforces his connection to Meryon. A similar preoccupation with the qualities of chiar-oscuro and atmosphere also characterizes Brassaï's art, suggesting a parallel between his aesthetic and that of the calotypists. Yet Brassaï's work was rooted in a different photographic practice, and in a profoundly different conception of his subject: a perception of the city and its culture that must be placed under the sign of Atget, despite the more direct influence of nascent pho-tojournalism and Surrealism. Atget's work plays a pivotal role in the transition between older cultural values, including the traditional view of the photo-graph as a document, and the reinterpretation or translation of these values into a new cultural context dominated by a modern, Surrealist sensibility.

Redefining Culture: From Atget to the Surrealists

The work of Eugène Atget (1857–1927) provides an essential link between the documentary photography of the Missions Héliographiques, the work of the calotypists, and the visual concerns of the Surrealist avant-garde.[21] An

19. Janis, "The Man on the Tower," 21.

20. Jammes and Janis, *Calotype,* 33.

21. The chain of influence I am attempting to establish here precludes discussing the work of Charles Marville. If Marville was Atget's immediate predecessor, important differences—both tech-nical and procedural—separate their work. See Marie de Thézy, "Marville et la naissance du Paris d'Haussmann," in *Colloque Atget: Actes du Colloque au Collège de France 14–15 juin 1985* (Paris: Fernand Hazan, 1986). Marville's photographs of architectural views were no doubt commissioned by Le Service des travaux historiques created under Haussmann to undertake a general history of the city of Paris. Consequently, he was not free to choose his subjects. Atget preferred to work as a free agent and subsequently find a buyer for his views of the city. In comparing their photographs, de Thézy concludes that Marville's style had little influence on Atget.

enigmatic figure in the history of photography, Atget came late—he was perhaps forty—to the medium. His early work in the theater and his attempts at painting may have influenced his decision to supply "documents pour artistes." As a commercial photographer selling photographs for use as models or documents to craftsmen, painters, connoisseurs, and institutions such as Bibliothèque Historique de la Ville de Paris, Atget produced an extraordinary body of work—thousands of photographs of Paris, its inhabitants, and surroundings: landscapes, architecture, sculpture and monuments, shops, flowers—ranging from straightforward, literal views concerned exclusively with conveying information about their subjects to highly subjective impressions, oblique or fragmentary views, and atmospheric images of great visual complexity and formal elegance.[22]

Guided by the needs and requirements of his clients, Atget's work at first followed traditional lines. He photographed street scenes, picturesque views of the city, old architecture, and famous monuments. His work, like that of the Missions Héliographiques and Le Service des travaux historiques set up by Haussmann, served the need to document and preserve a cultural heritage. But as he continued to photograph, Atget became interested in certain facets or visual qualities of his subjects that went beyond and even interfered with a purely documentary approach to them. His collection of images expanded beyond traditional categories to include various modes of city transportation, domestic interiors, shops, shop signs, and shop windows, the gypsies and ragpickers (the "zoniers") living in the fortified zone just outside the city, brothels and prostitutes, and street fairs. These series show his increasing concern for everyday life and popular or folk art as part of the city's culture. According to John Fraser, it is city streets and the movement on them that "are at the centre of Atget's apprehension of the city as a whole," a city "in which one moves around, consumes things, seeks mental refreshment and rests."[23] Atget's modern city refers both to the past and to the beauties of nature, and in his most successful photographs Atget reconciles the opposition between modernity and tradition, nature and culture. Fraser concludes that:

Atget's astonishing poise, his continual voracious interest, curiosity, wholly unsentimental love and respect for so many different forms of existence, his Rembrandtesque ability to treat in exactly the same spirit the conventionally beautiful and the

22. See John Szarkowski and Maria Morris Hambourg, *The Work of Atget* (4 vols.; New York: Museum of Modern Art, 1985).

23. John Fraser, "Atget and the City," *Cambridge Quarterly* (Summer, 1968), 205, 208.

conventionally sordid, issued from the fact that in his approach to the energies of the city he was able wholly to avoid these dichotomies.[24]

If Atget inherited and willingly adopted visual conventions that emphasized straightforward, denotative images of discrete, tangible objects in deep space, his work gradually moved toward more complex, connotative images. Objects became charged with symbolic or metaphoric value, and their interrelationships are conveyed by means of formal associations and atmosphere. "The relatedness of life, art and nature became manifest on all sides," Maria Morris Hambourg maintains, discussing Atget's later work, "in rain glazed pavements, moldering stones, window reflections, the enveloping fog and mist." As she points out, in the last five years of Atget's production, up until his last illness in the spring of 1927, the initial categories he devised to organize his collection—its division into "the land, historic civilization and popular culture"—remained "structurally intact," but "were dissolving from within." [25] If we extrapolate from one of John Szarkowski's hypotheses about Atget's work, namely that it was his "goal to explain in visual terms of great richness and complexity the spirit of his own culture," we might see this "dissolution" as a very particularized expression of an important cultural shift in the postwar period, a shift in which traditional sources of cultural authority are discredited and traditional categories of specialization and knowledge break down, becoming fluid and permeable.[26]

 In many ways Atget's work stands in opposition to the avant-garde's rejection of traditional notions of art and culture. Certainly, he never provides dynamic or close-up views of modern technology or machine culture, and he ignored the best-known of modernist symbols, for as Szarkowski points out, in all his thirty years of work Atget never photographed the Eiffel Tower.[27] Yet in a series of twelve photographs of the Canal Saint-Martin begun in 1925, Atget portrayed an industrial section of Paris in ways that convey his recognition of the sculptural beauties of industrial forms. In one of the photographs of the series—of the Canal Saint-Denis, which joins the

 24. *Ibid.*, 210.
 25. Szarkowski and Hambourg, *The Work of Atget*, III, 26.
 26. *Ibid.*, I, 19. The avant-garde's hostility to the museum and traditional culture is well-known. Thomas Michael Gunther ("Man Ray et Co.: La Fabrication d'un buste," in *Colloque Atget: Actes du Colloque au Collège de France, 14–15 juin 1985*, pp. 66–73) cites the breakdown of separations between the media and traditional areas of specialization such as painting, sculpture, architecture, and typography as one of the most marked characteristics of the modern period.
 27. Szarkowski and Hambourg, *The Work of Atget*, I, 13.

Canal Saint-Martin—the triangular roofs of sheds on the banks of the canal, the strong verticals of the cylindrical smokestacks next to them, and the crisscrossed metal of a crane dominate the upper half of the image, forming a strong, dark central band against a pale sky (Figure 11). Such an image suggests an aesthetic interest in the dynamic, angular, industrial forms that fascinated Germaine Krull, Herbert Bayer, and other "new vision" photographers. Atget's crane, seen from a distance across the canal, represents a delicate, miniaturized version of the kind of form that Krull would celebrate in striking close-ups of the Eiffel Tower only two years later (Figure 12). However, in Atget's photograph the sharp verticals and angularities of the landscape are smoothed and blurred by their reflections in the still water of the canal that fills the lower half of the image. Atget's treatment of the water as soft and luminous recalls his photographs of the reflecting pools of Saint Cloud. It is typical of his later work that Atget portrays the linear and angular forms of the industrial in terms of the quiet serenity and luminous atmosphere of the pastoral.[28]

The end of the war marked the beginning of this second period when the categories by which Atget classified his work were transformed and fused in a larger, more inclusive vision of culture. However, in a real, physical sense the war slowed rather than accelerated the transformation of Atget's city. All public works were suspended, and after the war funds were set aside to finance housing construction only on an emergency basis. Ironically, the last few meters of the boulevard Haussmann were not completed until 1926, the year before Atget's death. By this time Haussmann's Paris had become another layer of the older, prewar city. By 1921 Man Ray had moved to Paris and, thanks to an introduction by Marcel Duchamp, joined the ranks of the Dadaists and proto-Surrealists. He lived only a few doors down from Atget on rue Campagne-Première in Montparnasse, where Brassaï was to settle in 1924. It is not surprising then that Brassaï actually met Atget, or, given the Surrealist's appropriation of Atget's work, that Man Ray would later claim to have discovered him.[29]

In 1925, when an art dealer named Zborowski introduced Brassaï to Atget, Brassaï was still working as a free-lance journalist, selling his articles and drawings as well as photographs he got from various sources to foreign—mostly German—newspapers. While he tried to find time to paint, probably focusing on portraits, earning a living took up most of his time. He fre-

28. *Ibid.*, IV, 165–66.
29. Hill and Cooper, eds., *Dialogue with Photography*, 17–19.

quently complained that with so many things to juggle at once and so many people to keep happy he needed the diplomatic genius of a Talleyrand (*EL:* 30, p. 84). Nonetheless, as an artist and a journalist he valued his contacts and cultivated his connections. He judged Zborowski to be a better poet than a businessman and liked to drop in on him, climbing up the steps to his cramped rooms in the rue Joseph Bara to see his artists' latest work. As he related the story for *Camera* in 1969, he was chatting with Zborowski and looking at some still lifes by Soutine when the bell rang. The visitor was Atget. Zborowski greeted him like an old friend and introduced Brassaï. Almost forty years later Brassaï recalled the photographer's "dark, somewhat threadbare overcoat," his "frank, likable face" and "great simplicity of manner." The photographs Brassaï saw that day were 24″ × 30″ prints, proofs taken directly from the plates, arranged in albums.[30] He was struck by them: "Streets and alleyways of the Paris quartiers, the façades of buildings, dark courtyards with their little boxes for the concierge, costermongers, brothels, street girls, ancient signs, small time street traders—all redolent of Paris and its atmosphere. They were everyday photographs such as were scorned by 'artistic photographers' but they had meaning and an expression of extraordinary beauty."[31] Interestingly, although Brassaï seems to have seen quite a number of Atget's photographs, he makes no mention of either the views of Versailles or the images of parks that make up two important series in the photographer's work. Either Atget made a prior selection of works he hoped would sell based on the potential clients he planned to visit on a particular day, or Brassaï remembered only those subjects that related to his own later work.[32]

Regardless, Brassaï's late-developing image of Atget is certainly colored by his own practice of photography, for although he maintains that he had not been "bitten by the photography bug" at the time he met Atget, his appreciation for Atget's work suggests the denunciation of "artistic photographers" and the soft-focus artfulness of pictorialism that characterized his own profession of faith in photography later. Yet despite his admiration for Atget's "everyday photographs," his emphasis on Atget's "great simplicity of manner" and his "simple, unassuming view of life" suggests that his account

30. Brassaï, "My Memories of E. Atget, P. H. Emerson and Alfred Steiglitz," *Camera,* XLVIII (January, 1969), 4–37. Man Ray, who as a collector of Atget's work probably had a better sense of the size of the prints, indicated that they were smaller than this (18 × 24 cm.). See Hill and Cooper, eds., *Dialogue with Photography,* 17.

31. Brassaï, "My Memories," 4.

32. Brassaï indicates that he had only this one chance meeting with the older photographer.

may have been influenced by the view of Atget current in Surrealist circles during the late twenties and thirties, namely that Atget was just a simple workman, "almost naive," as Man Ray put it, "like a Sunday painter." [33]

Man Ray was friendly with Atget and bought prints from him now and again, eventually amassing a collection of some forty or fifty of them. However, as Man Ray was essentially a studio photographer, he may have had little sympathy for a way of working and an outlook very different from his own. [34] He found Atget's work uneven and technically faulty, if interesting in ways that he felt Atget himself might not have understood. [35] The photographs he collected represent a particular facet of Atget's work: views of streets and street life, nudes and brothels, mannequins and shop windows, photographs of the "zone," and street fairs. When he showed his prints to the Surrealists, they became enthusiastic about the work of this Douanier Rousseau of photographers and asked to publish some of his work in *La Révolution Surréaliste*. No doubt Atget's response: "Don't put my name on it. These are simply documents I make," confirmed their opinion that he was an "unconscious" artist. [36]

Inevitably, the Surrealists saw Atget in the light of their own aesthetic preoccupations, translating the value and significance of his work into different terms. Considered within the framework of Atget's own categories, his images illustrate the intellectual, spiritual, and aesthetic values of an important cultural heritage as it was expressed in the concrete forms of its architecture and monuments, its traditional trades and crafts. The Surrealists saw his work differently, and one of Atget's early photographs, the storefront of a corset shop dating from 1912 that was shown in the *Film und Foto* exhibition (and reproduced in *foto-auge*, see Figure 1) provides an interesting example of the way in which his work was reinterpreted by the avant-garde. In keeping with Atget's documentary aims, this photograph might have been part of a survey of trades, or might have recorded a certain conception of beauty typical of the period. Or it might have been a tribute to the shop-

33. Hill and Cooper, eds., *Dialogue with Photography*, 18.

34. These interests are reflected in the number of procedures such as rayograms, solarization, multiple exposures, and superimpositions that he developed or exploited in his own work.

35. Berenice Abbott, of course, did not share this view of Atget as a "primitive," unaware of the nature and value of his work. She made efforts to get to know him and at some considerable sacrifice bought all of his plates after his death in an effort to preserve them. However, despite her efforts to present his work as that of a reflective and deliberate photographer, it is Man Ray's view that prevailed in Surrealist circles. See Berenice Abbott, *The World of Atget* (New York: Berkeley Windhover Books, 1977), vii–x, xxi.

36. Hill and Cooper, eds., *Dialogue with Photography*, 18.

keeper's industry and aesthetic imagination. Fernand Léger suggests something similar in a description of a haberdasher painstakingly arranging seventeen vests with appropriate cuffs and ties in a shop window:

We [Léger and his friend] were tired and left after the sixth, having been there for one hour watching this man, who, after adjusting his articles by a single millimeter, would go outside to have a look. Each time he went out, he was so absorbed that he didn't see us. Skillfully setting things just right, he arranged the spectacle, as if his whole future depended on it, his forehead tense and his eyes strained.[37]

However, placed in the context of the *Film und Foto* exhibition, Atget's photograph probably surprised the viewer by the absence of any human presence, the void filled by mannequins: "headless and inhumanly corseted dummies," as Simon Watney refers to them.[38] From this point of view, the photograph invites comparison with the disquieting mannequins of de Chirico's still lifes, and its composition alienates the viewer by focusing on the monotony of obsessively repeated forms. No doubt for precisely these reasons, Walter Benjamin claimed Atget as a Surrealist precursor in "A Short History of Photography" published in *Literarische Welt* in 1931. Atget had taken the first step, Benjamin asserted, by emptying the city of its inhabitants, making a "clean sweep" that allowed the Surrealists to establish "a healthy alienation between environment and man, opening the field for politically educated sight."[39]

The Surrealists saw Atget's Paris as the setting for surprising, disturbing, but potentially revealing encounters. His photographs of streets and shops, street fairs, prostitutes, and "zoniers" caught glimpses of the way the obscure workings of need and desire shaped the life of the city (Figure 13). The Surrealists identified with his work because, like that of other photographers in the twenties to mid-thirties (notably that of Kertész, Germaine Krull, and Brassaï), it appeared to represent discrete perceptions they themselves might have had as solitary walkers in the city. For them, Atget becomes the avatar of Fargue's "piéton de Paris" ("pedestrian of Paris"). With the publication of a number of Atget's photographs in *La Révolution Surréaliste*—"L'Eclipse," retitled "Les Dernières Conversions," appeared on the cover of number seven—the Surrealists might well have felt they discovered him.[40] Brassaï may

37. Szarkowski and Hambourg, *The Work of Atget,* III, 174.

38. Burgin, ed., *Thinking Photography,* 167.

39. Walter Benjamin, "A Short History of Photography," in *Classic Essays on Photography,* ed. Alan Trachtenberg (New Haven: Leete's Island Books, 1980), 210.

40. These included "The Eclipse" and views of shop windows that suggested a parallel with de Chirico's mannequins, published in number seven, and a detail of a staircase focusing on an Art

have seen these issues, or the May, 1929, issue of *Le Crapouillot*, devoted to Paris, which included Atget's photographs, or the 1930 *Atget, photographe de Paris* with a forward by Pierre Mac Orlan, just as he may have seen some or all of Man Ray's collection of Atget prints. Yet it remains unclear exactly what kind of influence Atget's work had on him, even though he went on to make many of Atget's subjects his own.[41]

Nonetheless, Atget's work would have appealed to Brassaï's sense of himself as an urban connoisseur. Not that he was alone in that; the process of urban renewal had heightened the public's awareness of the city as a repository of aesthetic and cultural history and intensified the urbanite's pride in knowing the city inside and out. In the mid-twenties the review *L'Art Vivant* capitalized on its readers' desire to discover the city in a series of articles on the different arrondissements of Paris.[42] Number eight of 1925 proposed a "Plan de Paris" that opened with a tour of the first arrondissement (illustrated with drawings). More often than not the articles sounded a nostalgic note. The tour guide for the first article confessed that "he sometimes dreamed that he had grown old and was coming back to walk with his memories through this old quarter where the most ancient past confronted the present and great silent spaces opposed with all their force the intolerable fracas of the streets."[43] A second article two months later (this time illustrated with news agency photographs) presented the results of an informal poll of passersby, who condemned the creation of one-way streets as inimical to city life and regretted the encroachments of unionized grooms, who had displaced the ragged but independent porters who used to chase down taxis in the hope of earning a few francs. The author concluded by promising an article on the views of the city's nocturnal denizens in the future.[44] Such subjects were "in the air," and Brassaï was by no means the only photographer to interpret—or reinterpret—the city after Atget.

Nouveau banister, which appeared in number eight. None of these photographs appeared with Atget's name, at his request.

41. There are some interesting similarities. One of the photographs in Man Ray's collection, a photograph of a stairwell of the Hôtel de Sens, reminds the viewer of Brassaï's photograph of a dove on the stairway leading to Picasso's studio.

42. *L'Art vivant* (directed by Florent Fels) was published twice a month from 1925 to 1930, more irregularly until 1939, when there were only seven issues.

43. "Je rêve, parfois, que je suis devenu vieux et que je reviens me promener avec mes souvenirs dans ce vieux quartier où le passé le plus ancien fait face au présent et où de grands espaces de silence s'opposent de toute leur force à l'intolérable fracas des rues." *L'Art vivant* (April 15, 1925), 1.

44. LeGrand-Chabrier in *L'Art vivant* (July 15, 1925), 18–19.

Reinterpreting the City

During the thirties, the climate in publishing favored new projects and the growing importance of photojournalism whetted the public's appetite for *seeing* the sights. Brassaï's *Paris by Night* was only one of a surprising number of photographic books on Paris that appeared in the late twenties and thirties. Germaine Krull's *Métal* celebrated the dynamic patterns of ironwork in fragmentary close-ups of the Eiffel Tower, cranes, and other elements of the industrial landscape; more of her photographs appeared in *100x Paris,* published in 1929. *Atget, photographe de Paris* came out in 1930, as did André Warnaud's *Visages de Paris,* which also contained photographs by Krull. Moï Ver's visual montages and multiple-exposure shots of the city followed in 1931, as did *Paris: 258 Photographs,* published by Flammarion. *Paris de nuit* would finally come off the press in the last days of 1932. Around this time Brassaï envisioned doing two other follow-up volumes on the city streets and markets for Arts et Métiers Graphiques, although the projects never materialized (*EL:* 65, p. 141). The following year, 1934, marked the publication of *Paris vu par André Kertész* with text by Pierre Mac Orlan. Other books would follow, including *Paris de jour* published by Arts et Métiers Graphiques as the companion to *Paris de nuit,* although the more conventional photographs by Roger Schall stirred little interest despite an introduction by Jean Cocteau. In 1938 *Envoûtement de Paris* presented 112 photographs illustrating quotations from the novels of Francis Carco. However, as both Kim Sichel and David Travis observe, the publication dates of these various volumes are somewhat misleading because they do not necessarily reflect the order in which the photographs were taken. Many of André Kertész's photographs antedated photographs taken by Germaine Krull (the most widely published of the major photographers at the time) and Brassaï, even though Kertész's book of photographs did not appear until later.[45]

Individual photographs from this period present greater similarities than differences—Krull, Kertész, Bill Brandt (who was in Paris working at Man Ray's studio), Brassaï, Marcel Seuphor (a friend of Kertész's who lived for a time in the Hôtel des Terrasses), among others, photographed similar subjects (see Figures 14 and 15), including the Seine, the quays, bridges, the streets, the markets of Les Halles, *clochards,* and the *fêtes foraines,* or street fairs, and many photographers tried their hand at night photography. Ultimately, however, Krull, Brassaï, and Kertész reached a larger audience through their

45. See Kim Deborah Sichel, "Photographs of Paris, 1928–1934: Brassaï, André Kertész, Germaine Krull and Man Ray" (Ph.D. dissertation, Yale University, 1986), 177; as well as *Kertész,* 81.

publications of major books of photographs. Krull's *Métal* showed her link to the Bauhaus vision of Moholy-Nagy, but despite their originality and beauty, her other photographs of the city were reduced to small-format illustrations. The photographs by Brassaï and Kertész are the *raison d'être* of the books in which they appear, and they have a greater visual impact on the reader because both are presented as the more intimate, or personal, view of a walker in the city. Of course, in the case of *Paris de nuit* Paul Morand's essay creates the viewing persona, where in Kertész's work, as the title indicates, Kertész is explicitly identified as the photographer/observer. Yet the two works merit comparison, for despite certain similarities they reveal subtle differences in vision.

As we might expect, Kertész had far more control over his work than Brassaï, who, although he had a say in the selection of photographs, did not do the final layout for *Paris de nuit*. Charles Peignot and Jean Bernier—directors of the series *Réalités* in which *Paris de nuit* was to appear—made final decisions concerning the book's format (*EL: 67*, p. 143). The first printing of *Paris de nuit* was a small, spiral-bound, soft-cover book on the order of 7″ × 9″. Morand's essay preceded the photographs, each of which filled an entire page. There were no margins, and the spiral binding cut right through the photographs, although the book could be opened fully to see the entire image. Notes identifying and commenting briefly on their subjects followed on separate pages.

The layout of Kertész's book was far more sophisticated, blending text with photographs whose asymmetrical placement on the page led the eye through the book. Nonetheless, some of the photographs in the two books might have been exchanged without the reader being much the wiser. Kertész's night photograph of a street where a urinal casts a long, somewhat menacing shadow might have found a place in *Paris de nuit,* along with some of his views of deserted streets and cafés (Figure 16). Both Kertész and Brassaï photographed *clochards,* façades of buildings, gardens, roofs, chimneys, and kiosks. Both captured the atmospheric effects of rain and fog or haze and showed a similar graphic sensibility, although it was perhaps more marked in Brassaï's work.

However, Brassaï's portrayal of the city was both more traditional and more dramatic than Kertész's. More traditional in the sense that guides to Paris by night, the city's amusements, tourist attractions, and dangers were hardly new. Nor was there anything truly novel about Brassaï's attempt to show the different facets of the city that might tempt a tourist or *flâneur*—from famous monuments and *grands boulevards* to back alleys and little-known

spots of historic interest, such as the oldest police station in Paris. His evocation of different modes of transportation—train, market cart, limousine, barges, métro—harks back to Atget's series on the same subject. His shots of the vegetable seller at Les Halles, the magazine vendor at his kiosk, the baker, the newspaperman working on the press, the workmen polishing the tramway rails in a shower of sparks belong to the even older tradition of images of "les petits métiers," a theme of popular art even before Courbet monumentalized "the knife grinders, the tinker and the stone breakers."[46]

Some of Courbet's subjects may have been suggested by an even older tradition, as in the famous series of popular lithographs entitled *Les Cris de Paris,* which was designed to awaken interest in the work of tradesmen. *Les Cris* probably inspired Atget's series on the subject, and Kertész had done a similar series for *Vu* in 1927 and 1928. What distinguishes Kertész's and Brassaï's representations from this earlier tradition is the ambiguity that attaches to them. Courbet's portrayals of the working class made strong political statements, while Atget's work demonstrated his sympathetic awareness of their contributions to the culture of the city (Figure 17).[47] It is less clear whether Kertész and Brassaï ally themselves with the working class, but in general *Paris vu* emphasizes common human experiences while *Paris de nuit* contrasts class differences.

Where Brassaï adopts older thematic traditions in representing the city, he invariably reinterprets them in a dramatic fashion. His preference for strong contrasts goes beyond reversals of tone, as Paul Morand suggests in the opening paragraph of his preface to *Paris de nuit:* "Night is not the negative of day; black surfaces and white are not merely transposed, as on a photographic plate, but another picture altogether emerges at nightfall." The second photograph of the book plays on class as well as tonal contrasts by recording "for the first time," as the notes pointed out, "this nightly rendez-vous of dignity and impudence—the shiny splendor of the Arc de Triomphe and the grimy little locomotive" that circled the Etoile on its nightly route from the suburbs, bringing vegetables to the central market.[48] Brassaï no

46. Meyer Schapiro, "Courbet and Popular Imagery," in *Modern Art, 19th and 20th Centuries: Selected Papers* (New York: George Braziller, 1978), 51.

47. *Ibid.*

48. In "Photographs of Paris" Kim Sichel notes: "His camera records the fashionable night spots of the Etoile and the Opéra, but its informal compositions redefine the sites in Brassaï's terms, and show his derision for them as well. For instance, a shot of a *clochard* rooting through the garbage immediately follows a view of the brilliantly lit Opéra lobby" (183). While the point is well taken, Brassaï was not responsible for the layout of the book, so juxtapositions of this kind cannot be safely imputed to him. Nonetheless, Sichel's interpretation of this particular image in terms of internal

doubt intended this nightly rendezvous to be as humorous as it was dramatic, but it is emblematic of the collection taken as a whole, where the photographs contrast luxury with squalor, the sublime with the grotesque, and the traditional beauties of nature—water, flowers, and trees (recast in urban form as the quays, the flower stalls, and the parks)—are played off against the industrial landscape and the glittering illusions and artifices of the city in the creation of an urban baroque.

In some cases Brassaï deliberately chose dramatic subjects, like the view of a lone firefighter sharply silhouetted against the smoke and flames who directs a thin stream of water on the burning buildings below from halfway up a narrow, fragile-looking ladder. The only comparable photograph in *Paris vu* shows a painter at work on a tiny platform suspended from an industrial chimney. He is busy putting a new coat of paint on it, his pail slung below him. Yet despite the grim industrial landscape, Kertész's image is touched with whimsy, and the repainting seems more playful and optimistic than arduous or dangerous; we envy the painter his apparent weightlessness and bird's-eye view of the city. Almost everything in Kertész's work avoids the dramatic; where he adopts the plunging perspectives typical of Bauhaus photographs, he softens their effect. Many of his fishermen, painters, readers, and *clochards* are seen from above, but Kertész does not permit the viewer to "look down on them" or see them as formal elements in a larger composition (Figure 18). Rather, he uses the space that separates them from the viewer as a buffer. The viewer is allowed a glimpse into their space, but cannot intrude on it.

On the other hand, it is precisely Brassaï's treatment of space, combined with the strong contrasts of night photography, that convey most effectively the drama of his own vision of the city. For if in Kertész's *Paris vu* space means the free and democratic open air—none of the photographs is an interior shot—Brassaï makes the viewer keenly aware of the contrast between open, public spaces and mysterious, half-hidden, enclosed, private, or potentially dangerous ones. He captures this contrast with the utmost simplicity in photographs that show normally open, public places, such as the city parks, when their gates are shut and locked. Shadowy spaces loom ahead of

juxtapositions merits attention: "The black train, contrasted to the white arch, clearly juxtaposes the two sides of Paris. The train moves conspicuously across the foreground, while the arch is partially obscured by trees and by its odd angle, suggesting the eastern, working class Paris of Les Halles is alive and dynamic while the staid western section is immobile" (186). I am not entirely convinced that this demonstrates the depth of Brassaï's political convictions, given his interest in both sections of the city. His delight in telling contrasts seems sufficient to explain it.

the viewer, both off-limits and forbidden. Certainly the drama of open and closed, outside and inside, immediately suggests both the class and sexual connotations that are fundamental to Brassaï's Paris; however, neither is more than suggested in *Paris de nuit,* in which only five of the sixty-two photographs treat lovers, brothels, or prostitutes. Colin Westerbeck has remarked on the respectful distance from which Brassaï made most of these photographs, noting that fully one-third of the photographs in *Paris by Night* "were high angle shots, many of them panoramic while only a tenth of the photographs that make up *The Secret Paris* were made from a similar vantage point." [49]

This distance emphasizes the "starkly graphic" view of the city that Westerbeck identifies as the dominant quality of *Paris by Night.* Brassaï makes the viewer aware of the patterned field of paving stones caught by a streetlight or the network of parallel lines created by the train tracks fanning out from the Saint-Lazare station. The grillwork of fences and grates, the grid formed by structural supports, the ironwork of cranes or the stonework of bridges create the compositions of many of the images. The importance of this graphic element links Brassaï's work to German—and more particularly Bauhaus—photography in the late twenties and thirties. While Brassaï, like Kertész, rejected the Bauhaus approach as too cold and formalist, many of the photographs of *Paris by Night* show he had absorbed certain of its stylistic qualities, using them to symbolic effect. In this regard, his beautiful photograph of the Montmartre cemetery (number thirty-one in *Paris by Night*— see Figure 19) bears comparison with Moholy-Nagy's 1929 portrait of Oskar Schlemmer (Figure 20). In Brassaï's photograph the crosswork shadow projected by an unseen fence creates a dark grid through which the viewer sees the glimmer of the white tombstones that lie beyond it. In Moholy-Nagy's portrait we see the edge of the chain-link fence whose dark shadow falls across Schlemmer's face and body. However, the shadow in Moholy-Nagy's portrait functions as a formal pattern competing with features of the subject. In Brassaï's image the shadow forms an intangible and symbolic barrier between the living and the dead, establishing the outer boundary of a mysterious beyond, which the viewer can only glimpse.

It is true that formal elements—pattern, line, and tonal contrasts—vie with the human element in many of Brassaï's photographs of tradesmen and *petits commerçants.* The baker is photographed through a grate that both frames and fragments the image. The rail polishers' fireworks blanch their features,

49. Colin J. Westerbeck, Jr. "Night Light: Brassaï and Weegee," *Artforum,* XVI (December, 1976), 36.

making them unrecognizable; the sewermen are obscured by the dark, complicated forms of the engines and pump. The worker manning the newspaper press, the milkman loading his cart, and the newspaper vendor in his kiosk are less important as portraits than as functions. Yet two very powerful portraits remain. One is a very disturbing image of a *clocharde* sitting on a bench, her clothing a motley assortment of castoff finery and rags, her features sharpened by fatigue and a hostile wariness that suggests mental instability. The second is one of the famous portraits of Bijou (sometimes referred to as "Miss Diamonds") the "ancient cocotte" whose garishly made-up face and awkwardly mannered, theatrical pose are set off by her many rings and strings of fake pearls, her tulle-wrapped hat, and the ratty fake fur of her coat collar, an image that inspired the postwar interpretation of Giraudoux's *The Madwoman of Chaillot*.[50] (Perhaps the most familiar of the images of Bijou is the close-up that appeared in *The Secret Paris*—see Figure 21. However the shot I refer to here is the full shot of Bijou reproduced in *Paris de nuit*. It is a far less intimate, three-quarter view of her in which both her hands and feet assume awkward yet theatrical poses.)

Surprisingly perhaps, Kertész's *Paris vu* also included only two photographs that got close enough to their subjects to be considered portraits. The first is of a war veteran who, pausing in his stroll along the banks of the Seine, turns his back to the viewer and, framed by his crutches, leans over the parapet to watch the movement of the water. The other represents two vendors at the flea market: one young and thickset, the other older and more careworn, absorbed in conversation. It is precisely because Kertész's subjects appear lost in thought or absorbed—completely unselfconscious—that his photographs seem natural. The camera does not appear to intrude on the action it records and is in fact identified with it. By contrast, Brassaï's portraits reveal his subject's reaction to the photographer's presence: one stares warily beyond the camera, the other poses for it; both appear aware of being seen. Kertész's photographs suggest the commonality of human experience: his *clochards* sleep or wash their feet in the canal; the flea market vendors exchange confidences; the war veteran daydreams. Brassaï's portraits suggest an interest in picturesque or marginal characters whose behavior and habits are unconventional, even troubling or disturbing by bourgeois standards. It is this other "culture," apparently governed by different rules and norms, that Brassaï began to explore in photographs he grouped under the tentative title

50. See "The Madwomen of Paris," *Harper's Bazaar* (April, 1946), 148–49, where Brassaï's photograph of Bijou is juxtaposed with that of Marguerite Moreno, costumed and made-up for her role in the Giraudoux play.

"Paris intime," and in the series of photographs of graffiti begun almost at the same time, in 1931 (*EL:* 78, p. 153).

These photographic series will be discussed in Chapter IV, as neither of them actually reached a wide public—except as illustrations or through exhibitions—until much later. Consequently, the following chapter provides a different kind of cultural frame for Brassaï's work by exploring his relationship to the two antithetical literary and artistic traditions that shaped his work during the thirties: Realism and Surrealism.

III

Between Realism and Surrealism

Perhaps the least typical of Brassaï's photographic series was an experiment in Surrealist automatism that he never repeated. These were the photographs that make up *Transmutations*, prints dating from the mid-thirties composed by engraving over previously exposed glass plate negatives. Brassaï had originally photographed a series of female nudes, but drew over them, reshaping the original images to reflect his own formal obsessions. As he described the process in the introduction to *Transmutations*, he felt almost like "a sleepwalker" as he watched "dislocated parts of the photographs [reorganize] themselves into new combinations," but was compelled "to reveal the hidden figure which lay in each mental picture."

The resulting prints both conceal and reveal their original subjects, for as Brassaï indicates, "some debris . . . survived: a piece of quivering breast, a foreshortened face, a leg, an arm," emerging dizzyingly from a welter of cross-hatchings. The images provide glimpses of the curious metamorphoses of the female body made possible by a Surrealist process of unnatural selection. "Realism was outweighed by oneirism," Brassaï acknowledged, speculating on the origin of his desire to tamper with the photographic image: "What impulse did I obey, what temptation overcame me when I seized several glass plates to engrave them? Respectful of the image printed by the sun, hostile to any intervention, had I, in spite of myself, come under the influence of the Surrealists I was seeing so frequently at that time? Who knows?" [1]

1. See the introduction to *Transmutations* (Lacoste, France: Gallerie des Contards, 1967). Text is in English and French.

If the 1934–1935 series of *Transmutations* marks Brassaï's closest approach to the ideology and practices of orthodox Surrealism, it also reveals a considerable respect for the photographic process that makes this series unusual in the universe of his photography. Clearly, most of Brassaï's work is more readily associated with the objective, documentary conception of photography which, although given professional sanction in photojournalism, goes back to nineteenth-century Realist artists and writers. Viewing Brassaï's photographs against the background of Realism is justified as much by his attitude toward the medium as by the nature of his images. By contrast, Brassaï's connection with Surrealism seems incidental or episodic. Yet Surrealism dominated the arts in Paris during the interwar period, and Brassaï's association with modernist artists and writers who moved in the Surrealist orbit created the climate in which he did much of his most important work.

Placing Brassaï between Realism and Surrealism represents an attempt to suggest certain fundamental oppositions that shaped his work and characterize the viewer's perception of it. In addition, as both Realism and Surrealism appealed to the photographic image and appropriated it in different ways, assessing these two differing conceptions of photography provides both a way to evaluate the medium's changing status in French culture over time and to see Brassaï's place as a transitional figure in the evolution of sensibility that is implicit in cultural change. Situating Brassaï between two antithetical artistic and literary movements also reveals something of his "literariness" as a photographer. For Brassaï's work entertains complex relationships with art and literary history by alluding to a broad range of artists and writers with whom he sensed some elective affinity.

The Literariness of the Photographic Image from Realism to Surrealism

"L'art photographique est un art littéraire" ("Photographic art is a literary art"), Pierre Mac Orlan asserted in his introduction to the 1930 *Atget, photographe de Paris*.[2] Perhaps best-known for the somber novel *Quai des brumes*, which Marcel Carné made into one of the most striking films of the thirties, Mac Orlan was a reporter, novelist, and critic whose writings on photography constituted an important, if idiosyncratic, effort to elaborate an aesthetics of the medium. Two years before the book on Atget, he had prophesied that in twenty-five years every writer and reporter would know how

2. Pierre Mac Orlan, *Atget, photographe de Paris* (Paris: Henri Jonquières éditeur, 1930), 2.

to use a camera.[3] While the prophecy no longer seems radical or surprising, it underscored a growing awareness of the importance of photography as a medium of mass communication and an adjunct to the written word. Yet for Mac Orlan photography served more than the need for illustrations; it inspired and complemented the writer's work by providing crucial insights into the nature of modern culture. "Photography contributes a clearly contemporary element that most perfectly reproduces the intellectual spectacle of a period dominated by movement and speed," he argued in his preface to *Atget*.[4]

Of course, Mac Orlan's use of the term "intellectual spectacle" has its ambiguity; it evokes both the photograph's paradoxical suggestion of speed by arrested movement and the possibility of reducing contemporary culture to a series of images that could be collected, scrutinized, reviewed, and, potentially, interpreted. Regardless of the ambiguity, the intellectual spectacle of photography fascinated a number of French writers whose reflections on the medium constitute the most important source of its aesthetics during the late twenties and thirties. As David Travis points out, "most of the photographers in Paris, from Man Ray on, worked with or had close friends who were writers, journalists or poets" (*Kertész*, 86).

These writers, many of them Surrealists, form a curious counterpoint to the Realist and Naturalist writers and artists who—some fifty years earlier—had discovered in photography the model for the objective representation of reality they sought in their work. The emergence of photojournalism between 1928 and 1931 seemed to confirm what was by then the popular perception of photography as a quintessentially realistic medium, an inherently objective, documentary means of representation.[5] Yet the French writers who reinvented an aesthetics for photography in the late twenties and thirties also saw its possibilities as a means to probe the nature of reality. "Man Ray . . . knows how to work out essential problems," René Crevel asserted in a 1925 article for *L'Art Vivant*, "by that I mean those originating in the spectacle of a so-called exterior world whose realities . . . we suddenly perceive as perhaps less real than we might have liked to believe."[6] What

3. Pierre Mac Orlan, "Les Compagnons de l'aventure," in *Le Mystère de la malle numéro un* (Paris: Union Générale des éditions, 1984), 236.

4. "La photographie apporte un élément nettement contemporain qui reproduit le plus parfaitement le spectacle intellectuel d'une époque dominée par la vitesse." Mac Orlan, *Atget*, 8.

5. Tim N. Gidal, *Modern Photojournalism: Origin and Evolution, 1910–33* (New York: Macmillan, 1973), 5.

6. "Man Ray . . . sait poser des problèmes essentiels—j'entends ceux qui naissent du spectacle d'un monde dit extérieur dont on s'aperçoit tout à coup que les réalités, les formes, les couleurs ne

Crevel discovered in the images of a photographer like May Ray—above and beyond the troubling particularities of a world so familiar that it had almost become invisible—was the revelation of the photographer himself, his rediscovery of reality from a particular perspective as observer. "Painting isn't photography, painters say," Crevel wrote, "but photography isn't photography either, that is to say, isn't a copy." For that very reason, he insisted, "the photographer can no more content himself with meticulous narration than the painter or the poet."[7] Crevel's struggle to redefine photography as something more than "photography" highlights the disparity between Realist and Surrealist appeals to the medium, appeals which alternately find either objective or subjective referents for the photographic image.

Photojournalism gave formal recognition to the perception of photographs as documents, but the public had long taken it for granted that, unlike the photographer, the artist invented his subjects, or if he did not invent them, imaginatively transfigured them. At the very least he was expected to arrange them aesthetically. Already in 1850 the public's hostility to Courbet's painting of two stone breakers provided some measure of the resistance to an art whose aesthetics appeared to derive from photography. Courbet claimed he had met the workers who figured in his painting *The Stone Breakers* outside the village of Maisières and, "struck by the most complete expression of wretchedness," asked them to pose for him.[8] The painting unleashed a storm of protest at the Salon of 1850. Not only was the subject declared unfit for a painting, but the workers themselves were criticized as brutish, worn, and dirty. Writer and critic Jules Champfleury jumped in the fray, declaring Courbet's work a test case: "starting today, critics can get ready to fight for or against realism in art."[9]

Almost ten years later, in the Salon of 1859, Courbet's friend Baudelaire would make the case against "photographic" realism, expressing his horror of photography as a mechanical reproduction of reality potentially destructive of art. Seen in the context of a larger debate which pitted artistic Realists against Idealists in the 1850s, Baudelaire's reaction expresses the fear, shared

sont peut-être pas si simplement réelles qu'on eût aimé à le croire." René Crevel, "Le Miroir aux objets," *L'Art vivant,* XIV (July 15, 1925), 24.

7. "La peinture n'est pas de la photographie disent les peintres. Mais la photographie non plus n'est pas de la photographie, c'est-à-dire n'est pas de la copie. . . . C'est pourquoi, pas plus que le peintre ou le poète, le photographe ne peut se contenter d'une narration méticuleuse." *Ibid.*

8. T. J. Clark, *Image of the People: Gustave Courbet and the Second French Republic* (Greenwich, Ct.: New York Graphic Society, 1973), 79.

9. Jean-François Chevrier, "Editorial," trans. C. L. Clark, *Photographies,* VI (December, 1984), 9.

by many of his contemporaries, that the extraordinary mimetic powers of photography would threaten the very nature of art, which aimed at a truth transcending resemblance.

Courbet, who claimed he could not paint an angel because he had never seen one, exemplifies the desire to be faithful to an experience that animates artistic and literary Realism as well as documentary photography. However, the photograph's referentiality, its indissoluble attachment to an exterior subject or situation, argued powerfully in favor of its status as a document. The objective nature of photography was crucial to the Realist or Naturalist writer's appeal to the medium for justification in writing about vulgar, ugly, or even shocking subjects. Pierre Martino pointed out the tremendous influence exerted by the "document" on the literary imagination of the Goncourts, while their predilection for portraying the rough vulgarities of lower-class subjects typical of Naturalism influenced a younger generation of writers seeking to move away from the Idealist novel: "It was permissible, from then on, for the novelist to choose the most scabrous subjects without having to fear the reproach of pornography; his description could claim photographic exactness." [10]

During the late 1800s, the period of Naturalism's greatest notoriety in France, Emile Zola was frequently lampooned in the press as the spokesman for the movement and the advocate of a scientific approach to literature. "Zola observant l'humanité" ("Zola Observing Humanity") is the title of a caricature that ridiculed the movement, while another in Le Courrier français of March 30, 1890, portrayed Zola ready to fight off Romanticism armed with a magnifying glass, a pen, and a camera. The camera was indispensable, for both Realists and Naturalists valued the photograph as a model for objective observation.

Jules Champfleury counseled the writer to observe carefully, then transcribe his observations, limiting as much as possible any intervention: "the ideal would be a sort of stenography of the character's words and a series of photographs." [11] In "Le Roman expérimental" Zola quoted the biologist Claude Bernard, whose La Médecine expérimentale supplied a framework for his theory, concurring with Bernard's view that "the observer states, purely

10. "Il était permis désormais à un romancier de choisir les sujets les plus scabreux, sans qu'il eût à craindre le reproche de la pornographie; ses descriptions pouvaient prétendre à l'exactitude photographique." Pierre Martino, Le Naturalisme français (1870–1895) (Paris: Armand Colin, 1923), 20.

11. "L'idéal serait une sorte de sténographie des propos des personnages et une série de photographies." Philippe Van Tieghem, Les Grandes Doctrines Littéraires en France (Paris: Presses Universitaires de France, 1968), 220.

and simply, the phenomena he has before his eyes. . . . He must be the pho-
tographer of phenomena." [12] However, Zola required something more, for
once the documents were assembled the artist had to interpret the facts. To
fellow Realist Maupassant, whose Naturalism owed more to Flaubert's *mot
juste* and a sense of well-chosen detail than to photography, the "photo-
graphic" was not art. In the preface to *Pierre et Jean,* he claimed that the
writer "if he is an artist, will seek, not to show the banal photograph of life,
but to give us a vision more complete, more striking and more probing than
reality itself." [13] Even Balzac, Zola argued, appealing to the master of Realism
in defense of his aesthetic, "does not restrict himself to being the photog-
rapher of the facts he collects since he intervenes directly to place his char-
acter in situations he controls." [14]

However, in his 1880 short story "L'Inondation," Zola introduced doc-
umentary photography in a different and more disturbing context. The nar-
rative took as its subject an actual flood of the Garonne River, which dev-
astated Toulouse in June, 1875. The narrator of the story, the grandfather,
watches as the rising floodwaters claim the members of his large family, one
by one, while he remains powerless to save them. Alone at the end of the
story, he wants only to recover and bury his dead. He hears that a large
number of bodies carried upstream by the floodwaters were recovered in
Toulouse, but he arrives in the city after all the flood victims have been
buried. Yet the authorities have taken care to photograph the unidentified,
and it is "among these lamentable portraits" that he recognizes his grand-
daughter Véronique and her fiancé Gaspard. Their bodies were so tightly
clasped together in a final embrace that they had to be photographed to-
gether. "They are all I have left," the grandfather says pitifully, concluding
his story, "this frightful picture, these two beautiful children swollen by the
water, disfigured, still showing the heroism of their tenderness on their livid
faces. I look at them and I cry." [15]

12. "L'observateur constate purement et simplement les phénomènes qu'il a sous les yeux. . . .
Il doit être le photographe des phénomènes." Emile Zola, "Le Roman expérimental," in *An An-
thology of Critical Prefaces to the Nineteenth-Century French Novel,* ed. Herbert S. Gershman and Kernan
B. Whitworth, Jr. (Columbia, Mo.: University of Missouri Press, 1962), 166.

13. "Le réaliste, s'il est artiste, cherchera, non pas à nous montrer la photographie banale de la
vie, mais à nous en donner la vision plus complète, plus saisissante, plus probante que la réalité
même" (Zola, "Le Roman expérimental," in *An Anthology of Critical Prefaces),* 197.

14. "Il ne s'en tient pas seulement en photographe aux faits recueillis par lui puisqu'il intervient
d'une façon directe pour placer son personnage dans des conditions dont il reste le maître." Martino,
Le Naturalisme français, 37.

15. "Ils étaient ensevelis . . . seulement on avait eu le soin de photographier les inconnus. Et

The grandfather's photograph draws its power from the fact that as an exact reproduction of reality it provides incontrovertible evidence that the bodies were recovered. "They are all I have left" the grandfather says, and in possessing the photograph he does in some sense recover his dead. However, more is visible in the photograph than grotesque Naturalist details of physical decay, because the photograph captures a significant configuration of reality and allows the grandfather to "see" the "heroism of their tenderness" in the lovers' faces. Although Zola uses this vision to suggest the grandfather's powerful emotional attachment to the subjects of the photograph, ultimately the image conveys a truth about its subjects that goes beyond mere recording.

As "L'Inondation" indicates, Zola had immediately sensed the practical importance of the new medium. He was eager to try his hand at it, and by 1887 or 1888 photography had become a hobby that he would practice with "extreme passion." Yet Zola took no photographs of Paris that correspond to the city as it figures in *Le Rougon-Macquart;* he was more interested in his family, his neighborhood, and the beauty of the city parks. While he was fascinated by the fact that the camera allowed him to record more than he could see as an attentive observer, he saw the photograph as a personal record or souvenir. Multiplied into a series it became a family album, the photographic essay on his children entitled "Denise et Jacques, Histoire vraie," which he had luxuriously bound for their mother, Jeanne Roserat. Nonetheless, Zola admitted that the visual image had tremendous power over him: "My visual memories have a power, an extraordinary relief, when I evoke the objects that I have seen, I see them as they are in reality, with their lines, their forms, their colors, their smell and their sounds. It's an overwhelming materialization; the sun that was shining on them practically dazzles me." [16]

"Hallucinatory" would not be too strong a word for these visual impressions, yet with all his susceptibility to visual stimuli Zola's most powerful and troubling view of photography emanates from his literary art. "L'In-

c'est parmi ces portraits lamentables que j'ai trouvé ceux de Gaspard et de Véronique. . . . Je n'ai plus qu'eux, cette image affreuse, ces deux beaux enfants gonflés par l'eau, défigurés, gardant encore sur leurs faces livides l'héroisme de leur tendresse. Je les regarde et je pleure." Emile Zola, "L'Inondation," in *A Survey of French Literature,* ed. Morris Bishop (2 vols.; New York: Harcourt, Brace & World, 1965), II, 182.

16. François-Emile Zola and Massin, *Zola photographe, 480 documents* (Paris: Denoël, 1979), 44. "Mes souvenirs visuels ont une puissance, un relief extraordinaire, quand j'évoque les objets que j'ai vus, je les vois tels qu'ils sont réellement, avec leurs lignes, leurs formes, leurs couleurs, leurs odeurs, leurs sons. C'est une matérialisation à outrance; le soleil qui les éclairait m'éblouit presque." *Ibid.,* 9.

ondation" hints at a dark side to photography, linked both to death and transfiguration, and suggests that the photographic image might allow the viewer to glimpse transcendent reality—as through a glass darkly—in the very form of events. Zola would have rejected any such claims for photography as incompatible with its nature as a medium, yet the troubling mythic view of photography that emerges in "L'Inondation" persists in Mac Orlan's conception of the social fantastic, in the Surrealists' efforts to surprise and reveal the surreality latent in the most banal reality—and, more recently, in the critical work of Susan Sontag and Roland Barthes.

Nonetheless, it was the "documentary image" that proliferated in the thirties, illustrating a rapidly increasing number of newspapers and magazines. By the thirties photography was no longer viewed as a threat to art, and Mac Orlan noted with approval that "certain literary reviews . . . have understood all the secret things that photography could reveal, in a face, in an attitude, in a city, a street, a simple geometric form, a shadow on a wall." [17] If Mac Orlan considered photography "the great expressionist art of our time," [18] it was because he believed the photographic image could "develop" the latent forms of social reality, the *fantastique social* of a period. Arrested, distanced, and made accessible as "intellectual spectacle," the rapid movement and fluid forms of events assumed a shape and a finality that could be interpreted by an attentive observer. "Everyone knows how to read between the lines," Mac Orlan claimed, "which is to say that everyone knows how to discover a reflection of his own anxiety behind a curtain of trees, at a crossroads, on a corner, behind a half-closed door. There are minutes when the world stops breathing in order to listen. The social fantastic is merely a more or less ingenious interpretation of this rather complicated image." [19]

If Mac Orlan's conception of the *fantastique social* remains somewhat nebulous, it nonetheless plays a crucial role in his critical writing about art and popular culture. The social fantastic has much in common with a conception of the *Zeitgeist*, the particular form of taste, sensibility, or imagination that characterizes a period. "Every period creates certain rather mysterious outward forms," Mac Orlan insisted, "very arbitrary forms, perhaps, but which

17. "Certaines revues littéraires . . . ont compris toutes les choses secrètes que la photo pouvait révéler, dans un visage, dans une attitude, dans une ville, une rue, une simple forme géométrique, une ombre sur un mur." Pierre Mac Orlan, *Masques sur mesure* (Paris: Gallimard, 1965), 29.

18. *Ibid.*, 28.

19. "Chacun sait lire entre les lignes. C'est à dire que chacun sait découvrir un reflet de sa propre inquiétude derrière un rideau d'arbres, devant un carrefour, au coin d'une rue, derrière une porte mal fermée. Il y a des minutes où le monde s'arrête de respirer afin d'écouter. Le fantastique social n'est qu'une interprétation plus ou moins ingénieuse de cette image assez compliquée." *Ibid.*, 15.

seem in keeping with the creative genius of those who give it a style."[20] The *fantastique social* elevates elements of décor to the level of signs—albeit mysterious ones—and Mac Orlan's predilection for a décor including glittering city lights and electric signs—preferably reflected on wet asphalt—the music hall and the street fair, his fascination with the lives of sailors, prostitutes, and gangsters (the "apache" of the times) who inhabited this décor suggests a sensibility particularly in harmony with Brassaï's nocturnal world.[21]

This conception of the social fantastic remains relevant to Brassaï's work because, like Surrealism, it represents a critical reflection on culture contemporary with Brassaï's images. Both visions of culture were rooted in the uneasiness that accompanied the breakdown of values and the fragmentation of cultural orders in the period following the war. For Mac Orlan this uneasiness explained a turning inward that led the once-familiar, yet now-mysterious city to replace exotic, faraway places as the theater of adventure. "It's because the street, for example, shows itself to be infinitely rich in diverse hypotheses that . . . geographical adventure no longer excites the imagination," he contended. "Each man carries adventure with him like a small lamp that can shed light on the bewildering disorder in which everyone is striving to hide away his few pennies."[22]

The Surrealists pursued this adventure in a defamiliarized city, hoping to discover the "marvelous" André Breton described in the first *Manifesto of Surrealism*. In a formulation that resembles Mac Orlan's definition of the social fantastic to a surprising degree, Breton maintained that "the marvelous is not the same in every period, it participates obscurely in a sort of general revelation of which only some detail comes down to us: these are the romantic *ruins,* the modern *mannequin* or any other symbol apt to stir the human sensibility for a time. In these forms . . . we nonetheless see portrayed an irremediable human anxiety and that is why I take them into consideration."[23]

20. "Toute époque crée des apparences assez mystérieuses, des apparences très arbitraires d'ailleurs, mais qui semblent en rapport avec la puissance d'invention des hommes qui lui donnent un style." *Ibid.,* 28.

21. See the comparison of *Paris by Night* with *Paris vu par André Kertész* in Chapter II.

22. "C'est parce que la rue, par exemple, se montre infiniment prodigue en hypothèses variées que . . . l'aventure géographique n'excite plus l'imagination. L'aventure est dans l'homme qui la porte en soi comme une petite lumière qui peut éclairer le désordre effarant où chacun s'évertue à cacher ses sous." Mac Orlan, *Masques sur mesure,* 13–14.

23. "Le merveilleux n'est pas le même à toutes les époques; il participe obscurément d'une sorte de révélation générale dont le détail seul nous parvient: ce sont les *ruines* romantiques, le

In some sense the negative, or reverse image, of the Surrealist "marvelous" is the social fantastic. With its mysterious and menacing overtones, its evocation of violence and crime, its obscure fatality, the social fantastic suggests a far more somber, pessimistic—even sordid—vision of the times: a reflection of society in a dark mirror. Like Brassaï's photographs, Mac Orlan's conception of the social fantastic emerges from a vision of the nocturnal world of the city, but where the Surrealists glimpsed the "marvelous" in individual revelations of the surreal—Breton's "La Nuit du tournesol" for example— Mac Orlan interpreted certain nocturnal presences as manifestations of the unconscious of an entire society. "We can say that the phantoms that inhabit the shadows of our times are the waste products of human activity," he asserted.

One doesn't meet these manifestations, dangerous ones for the most part, except in the places where man usually disposes of undesirable elements that threaten his existence. Prostitutes, for example, attract these phantoms like a magnet attracts iron. In the predestined places where they practice their profession, the fantastic elements born of human activity go to meet each other. A man who is a murderer during the day goes there searching some semblance of peace. He trails behind him the fantastic décor of the drama of which he is the author.[24]

Mac Orlan's belief that photography transforms the elements of just such a décor into an intellectual spectacle of mysterious appearances requiring literary elaboration could hardly be further from Baudelaire's view of photography as an artless, mechanical medium for the reproduction of reality. If the differences that separate them illustrate the enormous disparity between subjective and objective interpretations of photography, they also signal a changing attitude toward technology. In fact, Mac Orlan considered photography's revelations a function of its nature as a medium: "Photography's

mannequin moderne ou tout autre symbole propre à remuer la sensibilité humaine durant un temps. Dans ces cadres qui nous font sourire, pourtant se peint l'irrémédiable inquiétude humaine, et c'est pourquoi je les prends en considération." Breton, *Manifestes,* 26.

24. "On peut dire que les fantômes qui habitent l'ombre de notre temps sont les déchets de l'activité humaine. On ne rencontre des apparences, pour la plupart dangereuses que dans les endroits où l'homme a pour habitude de se débarrasser des éléments indésirables qui peuvent nuire à son existence. Les filles, par exemple, attirent les fantômes comme l'aiment attire l'acier. Dans les lieux prédestinés où elles exercent leur profession, les éléments fantastiques qui naissent de l'activité humaine se donnent rendez-vous. Celui qui a tué dans la journée vient y chercher un semblant de repos. Il traîne avec soi tout le décor fantastique du drame dont il est l'auteur." Mac Orlan, *Masques sur mesure,* 28.

greatest strength in the literary interpretation of life consists . . . in the power it has to create death for a fraction of a second." [25]

If this little death, the stoppage of lives and events occasioned by the photograph, configures reality, these figures of reality, like certain facts that obsess Breton in *Nadja,* "belong to the order of pure observation, but on each occasion present all the appearances of a signal, without our being able to say precisely which signal." [26] This is why Mac Orlan saw photography as a rich source of material for what he termed the "literary interpretation of life." Yet Mac Orlan, unlike Breton, never reduced photographs to illustrations in any traditional sense, preferring to let the image inspire the words. "A face immobilized by the photographic lens can be considered in depth. It lets itself be seen. It is the most powerful document that could possibly be found as the source of a book," he insisted in his preface to *Atget, photographe de Paris.* [27]

By contrast, as early as the first *Manifesto of Surrealism* (1924) André Breton betrayed his preference for verbal rather than visual images. If he dismissed realistic representation as trite in any medium, denouncing passages of description in modern novels as the literary equivalent of banal postcards, he had a far greater distaste for visual "descriptions" of reality, because they were more closely bound with the poisonous mediocrity of vulgar reality. He prescribed the revelations of automatism as an antidote, particularly the striking images whose juxtapositions and combinations of familiar elements called up a (sur)reality without exterior referents: the "visuel invarifiable" of Surrealist metaphor.

Four years later in *Surrealism and Painting* Breton abandoned the high ground of this early position to acknowledge the possibility of a relationship between Surrealism and painting, but he still categorically rejected realistic art, insisting that plastic art must respond to the need for new values by referring to a purely "interior" model. In an essay on Picasso written for the first issue of *Minotaure* he admired the revolutionary nature of Picasso's art precisely because it broke away from "the childishness of so-called artistic 'realism' " (*SP,* 103).

As Rosalind Krauss points out in *The Photographic Conditions of Surrealism,* "Breton should have despised photography as a quintessentially realist me-

25. "La plus grande force de la photographie pour l'interprétation littéraire de la vie consiste . . . dans le pouvoir qu'elle détient de créer la mort pour une petite seconde." *Ibid.,* 30.

26. Breton, *Nadja,* 19.

27. "Un visage immobilisé par l'objectif photographique peut s'estimer profondément. Il se laisse voir. C'est le document le plus puissant qu'il soit possible de trouver à l'origine d'un livre." Mac Orlan, *Atget,* 7.

dium and yet he had a curious tolerance for it."[28] In fact, Breton's interest in photography triumphs over his ambivalence. Given his mistrust of the visual image and his views on the "childishness" of realism, his remarks on Man Ray in *Surrealism and Painting* show a surprisingly subtle appreciation for photography as a medium with the power to "compromise" reality:

If . . . "the mirror can be considered a diaphanous body disposed to receive all the shapes represented to it," one could hardly say the same of the photographic negative, which begins by demanding that these shapes take a favorable position, when it does not surprise them at their most fleeting. . . . The photographic print, considered in isolation, is certainly permeated with an emotive value that makes it a supremely precious article of exchange (and when will books that are worth anything stop being illustrated with drawings and appear only with photographs?); nevertheless, despite the fact that it is endowed with a special power of suggestion, it is not in the final analysis the faithful image that we aim to retain of something that will soon be gone forever. (*SP,* 32)

In the final analysis, however, despite or perhaps because of its particular power of suggestion, Breton remained uncertain about what status to accord the photographic image—capable of "compromising" exterior reality, it could never represent a purely "interior" model.

The contradictions of Breton's position on photography emerge clearly in the difficulties he encountered in illustrating *Nadja* with photographs. Only in the closing section of *Nadja* does Breton explain that he had hoped to provide images of some of the people, places, and objects in his account "taken at the special angle from which [he himself] had looked at them."[29] The illustrations represent a wide range of subjects: shots of monuments, buildings, storefronts, and objects (paintings, statuettes, and a mask among others), as well as portraits and photographic reproductions of drawings, letters, and texts. Breton did not take the photographs himself, making do with available images and photographs taken by friends and fellow Surrealists. Man Ray furnished portraits of Surrealists Paul Éluard, Benjamin Péret, and Robert Desnos, while Jacques-André Boiffard and Henri Manuel supplied others (including a portrait of the author), as well as shots of Paris streets and monuments. Surprisingly flat and conventional, none of the images has the experimental qualities Susan Sontag associated with the Surrealist legacy to photography. Even Man Ray's portraits are unremarkable, almost boring frontal views of his subjects.

28. Rosalind Krauss, "The Photographic Conditions of Surrealism," *October,* XIX (Fall, 1981), 13.

29. Breton, *Nadja,* 151–52.

Breton himself was dissatisfied with the illustrated part of the book, claim-
ing the photographs did not capture the special qualities, the atmosphere or
aura, of their subjects.[30] While the images do corroborate the existence of
important persons, places, and things that figure in Breton's story, they fail
to represent landmarks or "major strategic points" in the changing "mental
landscape" of his narrative.[31] The temporal unfolding of Breton's text con-
flicts with the nature of the photographs intended to illustrate it, for the
powerful and changing aura of feelings, memories, and associations that sur-
rounded their subjects, determining the special angle from which Breton
hoped to portray them, is a product of his experience, while the photograph
represents only the revelations of a single instant in time.

Breton's inability to resolve the conflict between objective and subjective
realities distorts his sense of photography as a medium, leading him to assim-
ilate the photographic image to the old problem of appearance versus reality.
Significantly, Breton manages to overcome his ambivalence toward photog-
raphy when he "finds" those images that suggest or fit his sense of the
enigmatic nature of (sur)reality. It is no coincidence that he preferred Brassaï's
images of nocturnal Paris with their strong but velvety contrasts, their rainy
or foggy atmospheres, finding in them the mystery absent from his own
efforts to document it in *Nadja*. Nor is it a coincidence that Brassaï was more
successful in evoking the surreal that Breton had failed to capture in the
photographs that illustrated *Nadja*. In one sense this is precisely because
Brassaï did not hesitate to develop experimental techniques: "artifices, sug-
gested by the very subject that you want to photograph," that allowed him
to document his vision of nocturnal Paris.[32]

Yet Breton's more limited understanding of the expressive potential of
photography does not obscure the very real "coincidence" between his vi-
sion of the nocturnal city and that of Brassaï, a coincidence that worked
against Brassaï, who felt obliged to emphasize that he had never found his
inspiration in illustrating Breton's work. When Breton requested three pho-
tographs to accompany the text of "La Nuit du tournesol" (later included
in *L'Amour fou*) for *Minotaure* 7, Brassaï supplied him with three nocturnal

30. Increasing attention has been directed to the correspondence, or lack of it, between the
text and the "illustrated part" of *Nadja*, as well as on the nature of the Surrealist book and Surrealist
approaches to illustration and mimesis. See in particular Renée Riese Hubert, *Surrealism and the
Book* (Berkeley: University of California Press, 1988); Michel Beaujour "Qu'est-ce que *Nadja?*" *La
Nouvelle Revue française*, CLXXII (1967), 780–99; essays by Ades and Krauss in *L'Amour fou*.

31. Breton, *Nadja*, 153–54.

32. "Artifices, suggérés par le motif même qu'on veut photographier." Brassaï, "Technique de
la photographie de nuit," *Arts et Métiers Graphiques*, XXXIII (January 15, 1933), 27.

shots, one of the open-air market Les Halles, another of the flower market near the quays of the Seine, and a third of a Gothic bell tower—la tour Saint-Jacques—all of which corresponded perfectly with the atmosphere of Breton's poem. However, "contrary to what the author of *Nadja* thought at the time," Brassaï insisted later, "these photographs hadn't been specially made for him. I had already had them for some time, even the tour Saint-Jacques, just as he had described it 'beneath its ghostly veil of scaffolding' " (*Picasso,* 38).

Between Realism and Surrealism

Brassaï was born in 1899, exactly fifty years after the scandalous Realism of Courbet's *The Stone Breakers* and about ten years after the period in which Zola's Naturalism created the greatest shock waves. While he came too late to take up the banner of Realism or Naturalism, Brassaï's photography has its clearest affinities with the documentary approach and subject matter of these older traditions. Yet if Brassaï's apparently Naturalist predilection for subjects drawn from lower—even criminal—classes and the margins of bourgeois society recalls some of the figures of Balzac's *Comédie humaine* or Zola's fictional universe, Brassaï identified himself with this tradition more indirectly through Baudelaire's *The Painter of Modern Life.*

In the introduction to *Camera in Paris,* where he attempted to define his vision and aesthetics as a photographer, Brassaï claimed Constantin Guys as an antecedent for his work as an artist-reporter, quoting Baudelaire's description of Guys as "an artist portrayer of manners," a "genius of mixed composition, in other words a genius with a pronounced literary element," whose work would have been a valuable complement to Balzac's *Comédie humaine.* The painter of modern life is a "passionate observer," Baudelaire wrote, whose "passion and [whose] profession is to merge with the crowd," an artist "who loves being incognito and carries his originality to the point of modesty."[33]

The dualities that pervade Baudelaire's description—artistic versus literary talent, passionate observation coupled with professional detachment, artistic originality or Baudelairian dandyism coexisting with unassuming modesty, self-consciousness coupled with the desire to merge with the crowd—also pervade both Brassaï's career and his aesthetics. The dualities extend to Bras-

33. Charles Baudelaire, *Selected Writings on Art and Artists,* trans. P. E. Charvet (Cambridge: Cambridge University Press, 1972), 394–95.

saï's conception of the photograph, whose "double destiny" he made his own as an artist. The photograph, he maintained, is

the daughter of the world of externals, of the living second and as such will always keep something of the historic or scientific document about it; but it is also the child of the rectangle, a child of the beaux-arts which requires one to fill up the space agreeably or harmoniously with black and white spots or colors. (*MOMA*, 13)

Yet in citing Constantin Guys as a model and a precursor for his work, Brassaï conveyed some sense of his literariness—for Guys is a symbolic figure of the modern artist rather than a practical model. Moreover, Brassaï's Constantin Guys is very much Baudelaire's creation, and *The Painter of Modern Life* presented Brassaï with an aesthetics, a particularly rich amalgam of romantic realism, which he could adopt as his own. Such literary mediation is equally important in determining Brassaï's choice of certain subjects. As he reveals in the introduction to *The Secret Paris of the 30's,* his love for what the poet Jacques Prévert termed "la beauté dans le sinistre" was inspired by the classless heroes of Stendhal, Mérimée and, most importantly, Dostoevsky.

Brassaï claimed to identify with Dostoevsky's outlaws, admitting he was fascinated by their power, their pride, their courage and scorn for death:

For me too . . . this infatuation with low places and shady young men was no doubt necessary. Could I otherwise have torn these few images from the astonishing Paris night of the thirties before they sank into nothingness. For me, fascination with a subject was always an indispensable stimulus. (*SPT,* Introduction)

Dostoevsky's "Russianness" also fascinated a whole generation of French writers, including André Gide, Jacques Rivière, Marcel Proust, and Paul Claudel. Moreover, as Henri Peyre pointed out, Dostoevsky's works were translated and readily available in France in the years from 1929 to 1939, and were much read and discussed as classics.[34] Gide particularly savored Dostoevsky's foreignness and liked to contrast "the French tradition of storytelling in which the whole picture receives an equal light," to Dostoevsky's "lurid effects," "glaring light illuminating one feature or one happening, the rest remaining steeped in darkness as in a Rembrandt painting."[35] While it is impossible to point to Dostoevsky's lurid effects as an influence on Brassaï's preference for night photography, the formal effects produced by their love of strong contrasts are strikingly similar.

34. Henri Peyre, *The French Literary Imagination and Dostoevsky* (Tuscaloosa: University of Alabama Press, 1975), 6.
35. *Ibid.*

If Dostoevsky's foreignness heightened the appeal of his work, making it seem exotic to French aesthetic sensibilities, something similar seems to have occurred in photography during the late twenties and thirties. For when Brassaï began to take an interest in photography, the major photographers working in Paris were not French: Man Ray, André Kertész, Germaine Krull, Eli Lotar (*Kertész*, 70–71). While social and economic factors undoubtedly played their part in the curious absence of great French photographers in the period immediately following Atget's death, the gap also confirms a shift in the cultural perception of photography. At the end of the nineteenth century Zola's highest praise for photography was as an aid to observation: "You can not claim to have really seen something until you have photographed it," he claimed in 1901.[36] However, in his "Considerations on the Evolution of Photography" for the special yearly issue on photography put out in 1936 by Arts et Métiers Graphiques, Jean Vétheuil presented an entirely different view of the medium. According to Vétheuil, photography was a form of human expression comparable to writing, and like writing it required the practitioner to acquire a certain discipline: in order to become a photographer you had to learn to see like a photographer, that is, to acquire a photographic eye. "You have to have grown up with the movies," Vétheuil claimed, "swallowed its grey matter for hours, absorbed thousands of newspapers, magazines, posters, driven a car, admired the precision of machines and documents, withstood the extravagances of artists and architects, digested art nouveau, have had your vision daily attracted, educated, deformed in order to learn the ABC of this new human writing which is photography." Significantly, Vétheuil lamented the fact that the French had been slow to acquire this visual education, with the result that "it had become a cliché to say that the French didn't have a photographic eye."[37]

On the other hand, French literature has long had a tradition of cultural criticism, and ever since Montesquieu's *Lettres persanes* the foreigner whose vision of Paris reveals the city's "strangeness" to Parisians blinded by the seeming naturalness of their own cultural habits has become a literary convention, then an ethnographic commonplace. The transposition and transplantation of the convention in photographic terms was equally important

36. Sontag, *On Photography*, 87.

37. "Il faut avoir grandi avec le cinéma, avalé pendant des heures sa pâte grise, absorbé des milliers de journaux, de revues, d'affiches, conduit une voiture, admiré la précision des machines et des documents, subi les extravagances des peintres et des architectes, digeré le style *art décoratif*, avoir l'oeil quotidiennement ainsi éduqué, attiré, déformé pour apprendre l'ABC de cette nouvelle écriture humaine qu'est la photographie." Jean Vétheuil, "Considérations sur l'évolution de la photographie," *Arts et Métiers Graphiques*, special number *Photographies* (1936), 121.

in the twenties. Berenice Abbott, who worked in Man Ray's studio during this period, indicates that her "estrangement" from America was an important factor in her later choosing it as a photographic subject: "If I had never left America, I would never have wanted to photograph New York. But when I saw it with fresh eyes, I knew it was *my* country, something I had to set down in photographs."[38]

The visitor's tour of a region or city had long been a stock subject for lithographers before photographers—precisely because the viewer's lack of familiarity with the site provided the distance appropriate for aesthetic contemplation and/or cultural analysis. In this sense, Brassaï's foreignness may have played an important role in his artistic career, leading him to renew old traditions and see new subjects for photography. This is not to suggest that— unlike Baudelaire's Constantin Guys—Brassaï remained apart from his cultural milieu. On the contrary, Marcel Natkin, in his *L'Art de voir en photographie,* considered Brassaï one of the preeminent representatives of *L'Ecole de Paris* and perfectly able to marry "Hungarian sentimentality" with French classicism.[39] Yet in his photographs in the early thirties, Brassaï chose "to penetrate [an]other world, [a] fringe world, the secret sinister world of mobsters, outcasts, toughs, pimps, whores, addicts, inverts" (*SPT,* Introduction), deliberately re-creating the perspective of the foreigner or stranger by placing himself in the role of outsider.

It is precisely this dimension of Brassaï's work, its exploration of Paris as an unfamiliar culture, that links his representation of the city to that of the Surrealists, and in particular to Breton's *Nadja* and Louis Aragon's *Le Paysan de Paris,* two of the most important Surrealist works of the late twenties. Breton's discovery of the marvelous surreal in a defamiliarized city plays a fundamental role in *Nadja,* while Aragon's novel explores the shadowy, labyrinthine Passage de l'Opéra, an ambiguous passageway, neither public nor private, open nor closed, which was slated to be destroyed in the process of urban renewal. Where Breton rediscovered Paris with Nadja as his guide, Aragon took the traditional opposition between the naive peasant and the sophisticated urbanite and played on the theme of the peasant's astonishment at life in the big city. In both works a certain estrangement or disorientation is the essential condition of the voyage of discovery and of the Surrealist revelation of the city.

38. Sontag, *On Photography,* 67.

39. Marcel Natkin, *L'Art de voir en photographie* (1935; rpr. Paris: Editions Tiranty, 1948), 4, 12. The second edition of Natkin's book, destined to provide photographers with a certain visual education, uses more of Brassaï's photographs as illustrations than any other single photographer's. See the sections "L'Ambiance," "La Perspective," and "Pluie et Brume."

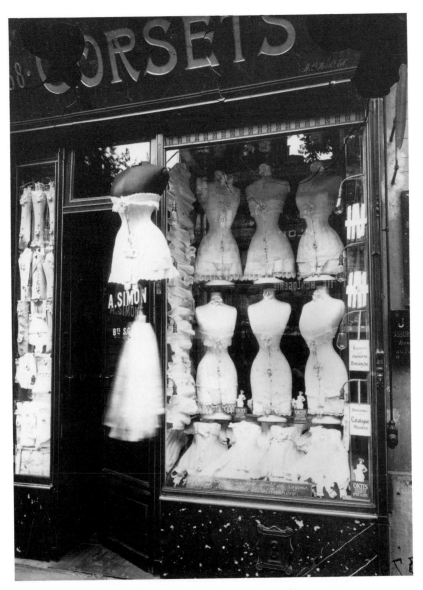

1. Eugène Atget. "Boulevard de Strasbourg, Corsets." 1912. PP:379. Albumen silver print, 9⅜ × 7 in. The Museum of Modern Art, New York.
Print by Chicago Albumen Works (1984).

Photograph copyright © 1994, the Museum of Modern Art, New York.

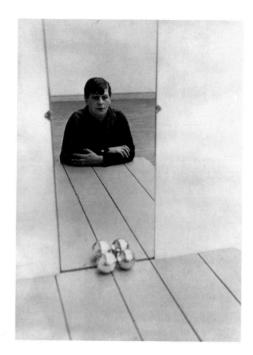

2a. Florence Henri. Self-portrait with mirror. 1928.
Copyright © Galleria Martini & Ronchetti, Genova, Italy.

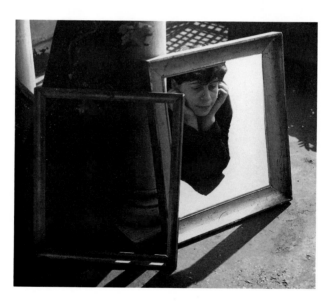

2b. Florence Henri. Self-portrait. 1937. Gelatin silver print, 9⁷⁄₁₆ × 10¹⁵⁄₁₆ in.
(23.9 × 27.8 cm). Collection of the J. Paul Getty Museum, Malibu, California.
Copyright © Galleria Martini & Ronchetti, Genova, Italy.

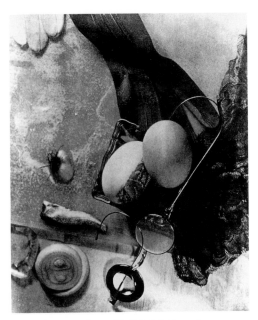

3. Walter Peterhans. "Still Life." From *foto-auge*.
Copyright © Ernst Wasmuth Verlag, Tübingen.

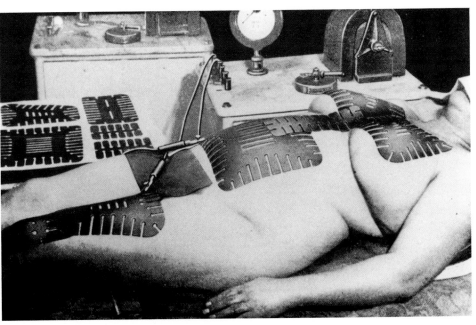

4. Medical photograph of a diathermy treatment. From *foto-auge*.
Copyright © Ernst Wasmuth Verlag, Tübingen.

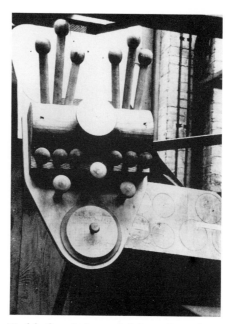

5. Model of an airplane switch lever. From *foto-auge*.
Copyright © Ernst Wasmuth Verlag, Tübingen.

6. Florence Henri. "Columbia Records" (advertisement). 1931. Gelatin silver print,
9¾ × 15⅜ in., 24.7 × 39.0 cm. Collection of the J. Paul Getty Museum,
Malibu, California.

Copyright © Galleria Martini & Ronchetti, Genova, Italy.

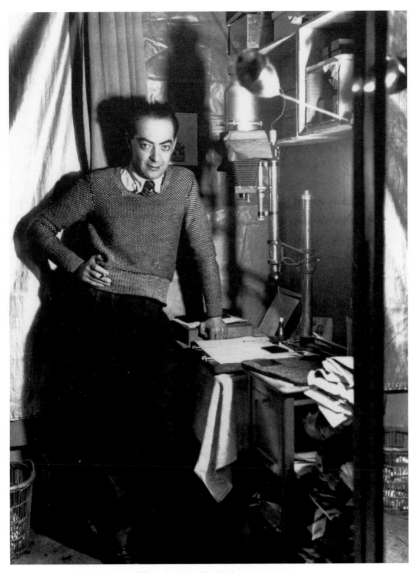

7. Brassaï. Self-portrait in his darkroom. 1931 or 1932.

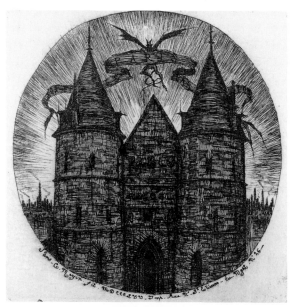

8. Charles Meryon. *Ancienne Porte du Palais de Justice*. 1854. From *Eaux-Fortes sur Paris*. Courtesy the Toledo Museum of Art, Museum Purchase Fund.

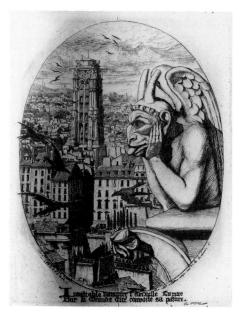

9. Charles Meryon. *Le Stryge*. Ca. 1853. From *Eaux-Fortes sur Paris*. Yale University Art Gallery, the gift of "A Lover of Prints."

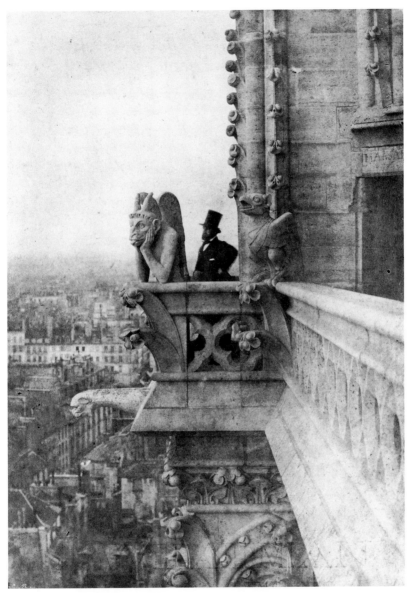

10. Charles Nègre. "Le Stryge/The Vampire" (Henri Le Secq on the north tower of Notre-Dame). Ca. 1853.

Courtesy National Gallery of Canada, Ottawa.

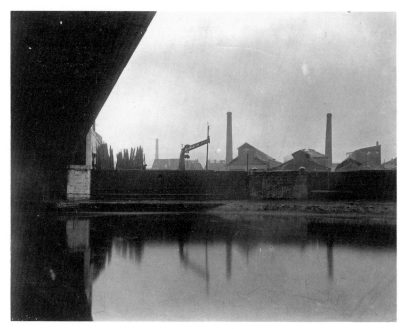

11. Eugène Atget. "Saint-Denis, canal." 1925–27. LD:1264. Albumen silver print,
7″ × 9⅜″. The Museum of Modern Art, New York. Abbott-Levy Collection.
Partial gift of Shirley C. Burden.

Photograph copyright © 1993, the Museum of Modern Art, New York.

12. Germaine Krull, German born Poland, 1897–1985. Untitled (Eiffel Tower). Ca.
1929. Silver gelatin print, 20.8 × 16.1 cm, Mary and Leigh Block Photography Fund,
1987.75. Photograph © 1993, the Art Institute of Chicago, all rights reserved.

Copyright © Germaine Krull Foundation, Wetzlar, Germany.

13. Eugène Atget. "La Villette, rue Asselin, fille publique faisant le quart devant sa porte, 19e" (prostitute on watch in front of her door). March 7, 1921. AP:6218. Albumen silver print, 9⅜″ × 7″. The Museum of Modern Art, New York.

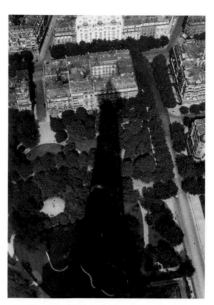

14. Germaine Krull, German born Poland, 1897–1985. Shadow of the Eiffel Tower, Paris. 1925–30. Silver gelatin print, 22.2 × 15.3 cm, Photography Purchase Account, 1984.1202. Photograph © 1993, the Art Institute of Chicago, all rights reserved.
Copyright © Germaine Krull Foundation, Wetzlar, Germany.

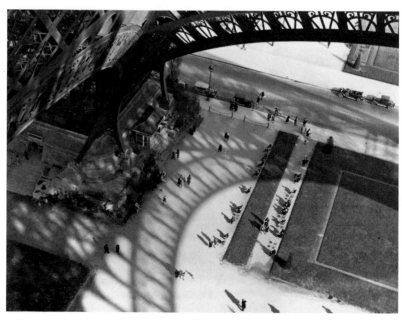

15. André Kertész, American, 1894–1985. Shadows of the Eiffel Tower (view looking down from tower to people underneath). 1929. Silver gelatin print, 16.5 × 21.9 cm, Julien Levy Collection, Special Photography Acquisition Fund, 1979.77. Photograph © 1993, the Art Institute of Chicago, all rights reserved.
Copyright © André Kertész Estate.

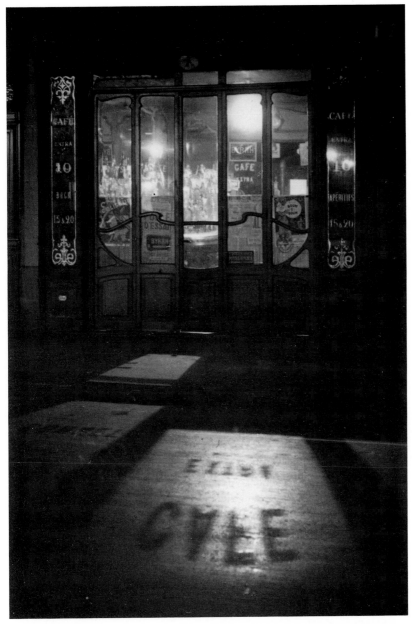

16. André Kertész, American, 1894–1985. Bistro, Paris (café window at night). 1927.
Silver gelatin print, 20 × 12.9 cm, Julien Levy Collection, Special Photography
Acquisition Fund, 1979.72. Photograph © 1993, the Art Institute of Chicago,
all rights reserved.

Copyright © André Kertész Estate.

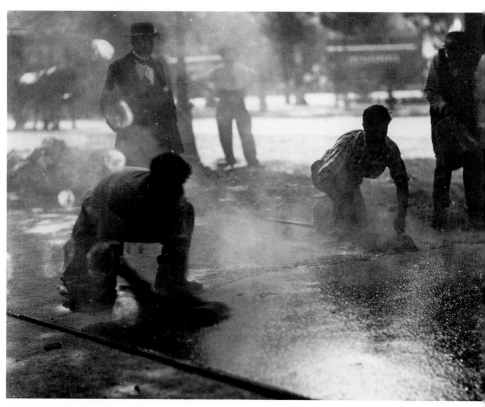

17. Eugène Atget. "Bitumiers/Spreading Tar." 1899–1900. PP-3231. Gelatin silver print from dry plate, 6⅞″ × 8¼″. The Museum of Modern Art, New York.

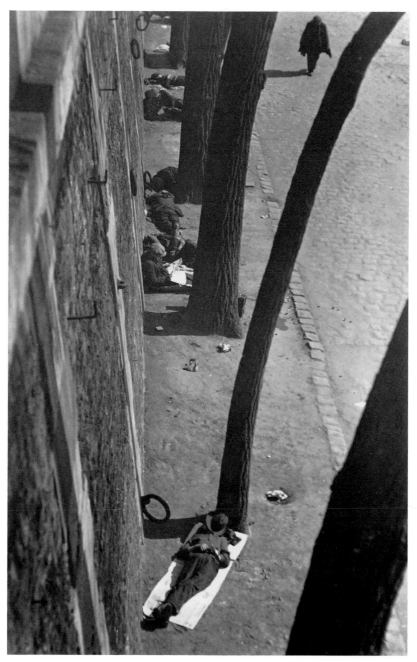

18. André Kertész, American, 1894–1985. *Siesta, Paris*. 1927. Silver gelatin print, 23.9 × 15.5 cm, Julien Levy Collection, Special Photography Acquisition Fund, 1979.80. Photograph © 1993, the Art Institute of Chicago, all rights reserved.

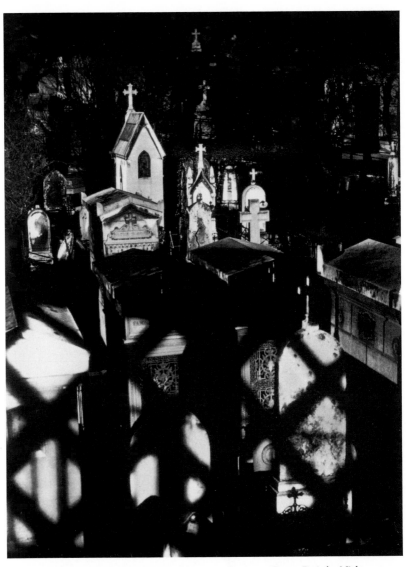

19. Brassaï. The Montmartre cemetery. Ca. 1932. From *Paris by Night*.

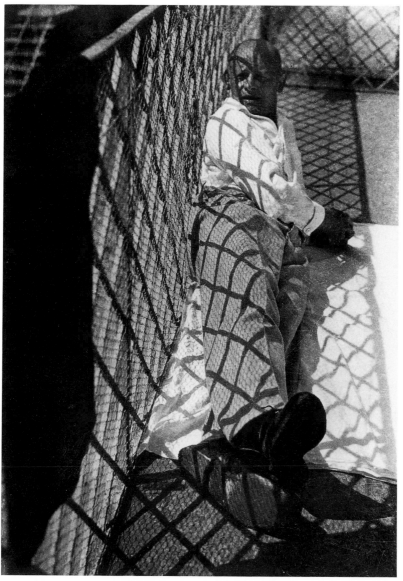

20. László Moholy-Nagy, Hungarian, 1895–1946. Oskar Schlemmer, Ascona (man reclining by fence with shadows). 1926. Silver gelatin print, 29.2 × 21.2 cm, Julien Levy Collection, gift of Jean and Julien Levy, 1978.1090. Photograph © 1993, the Art Institute of Chicago.

Copyright © Hattula Moholy-Nagy.

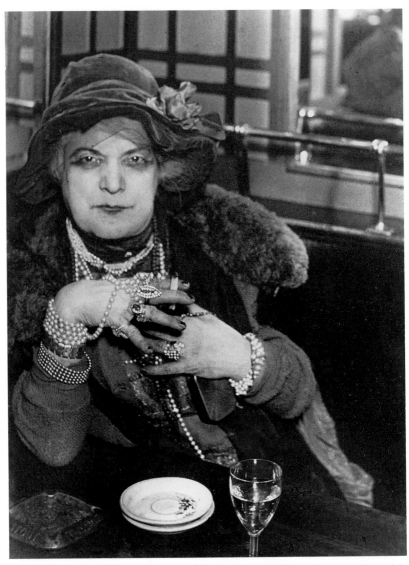

21. Brassaï. Bijou in the bar de la lune, Montmartre. 1933. From *The Secret Paris of the 30's*. Gelatin silver print, 11⅞ × 9⅛ in. (30.2 × 23.2 cm). The Museum of Modern Art, New York, David H. McAlpin Fund. Photograph copyright © 1994, the Museum of Modern Art, New York.

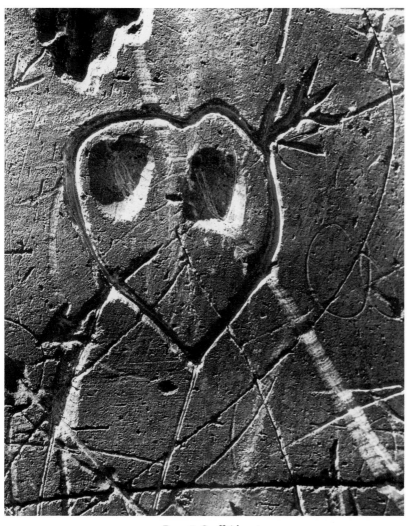

22. Brassaï. Graffiti heart.

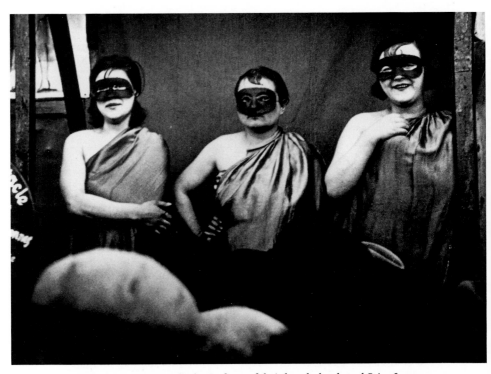

23. Brassaï. Dancers on display in front of their booth, boulevard Saint-Jacques.
Ca. 1931. From *The Secret Paris of the 30's*.

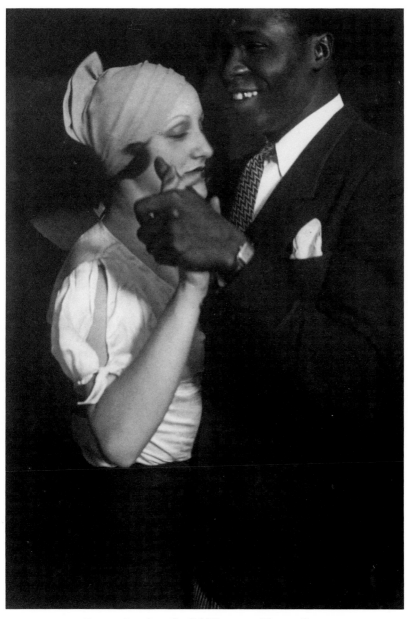

24. Brassaï. Couple at the Bal Nègre, rue Blomet. Ca. 1932.
From *The Secret Paris of the 30's.*

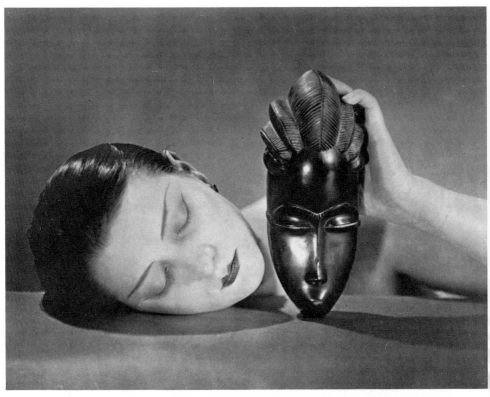

25. Man Ray. "Noire et Blanche" (Kiki with an African mask). 1926. Gelatin silver
print, 6¾″ × 8⅞″. The Museum of Modern Art, New York. Gift of James Thrall
Soby. Copyright © 1994 Artists Rights Society (ARS), New York
ADAGP/Man Ray Trust, Paris.

Photograph copyright © 1994, the Museum of Modern Art, New York.

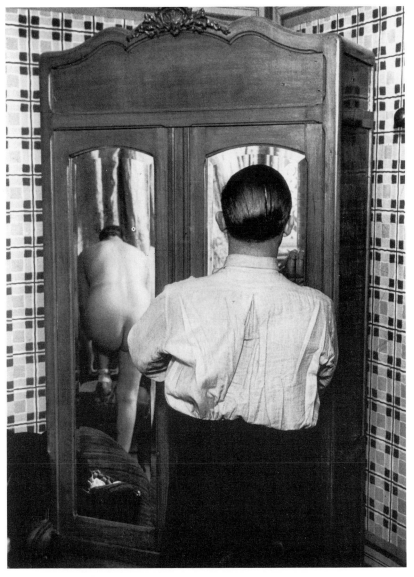

26. Brassaï. Mirrored wardrobe in a brothel, rue Quincampoix. Ca. 1932.
From *The Secret Paris of the 30's.*

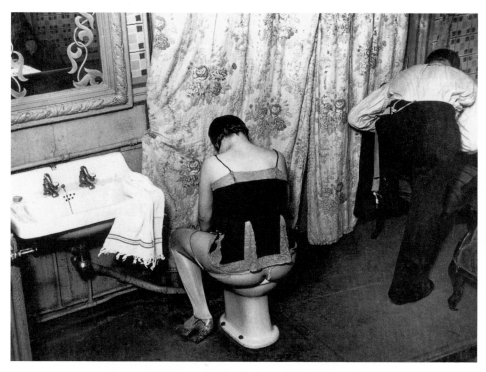

27. Brassaï. Washing up in a brothel, rue Quincampoix. Ca. 1932.
From *The Secret Paris of the 30's*.

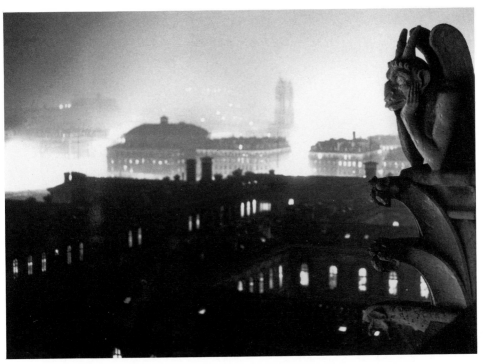

28. Brassaï. Nocturnal view from Notre-Dame overlooking Paris and the tour
Saint-Jacques. 1933. From *The Secret Paris of the 30's*.

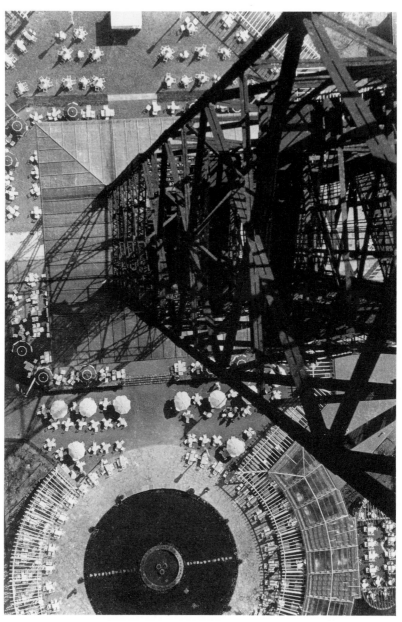

29. László Moholy-Nagy, Hungarian, 1895–1946. Berlin radio tower. Ca. 1928. Silver gelatin print, 36 × 25.5 cm, Julien Levy Collection, Special Photography Acquisition Fund, 1979.84. Photograph © 1993, the Art Institute of Chicago, all rights reserved.

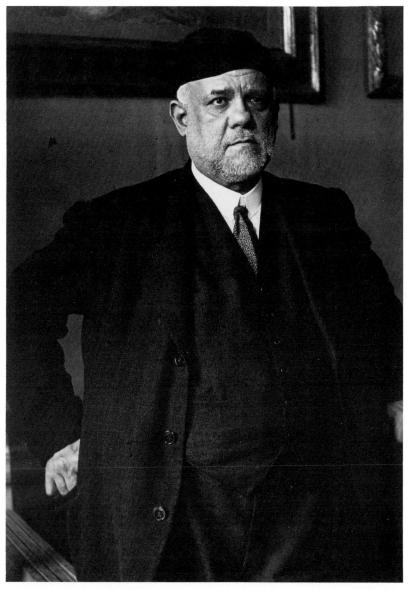

30. Brassaï. Portrait of Ambroise Vollard. 1932 or 1933? From *The Artists of My Life*.
Gelatin silver print, 15¼ × 11¼ in. (38.7 × 29.2 cm). The Museum of Modern Art,
New York. David H. McAlpin Fund. Photograph copyright © 1994, the Museum of
Modern Art, New York.

Copyright © Gilberte Brassaï, all rights reserved.

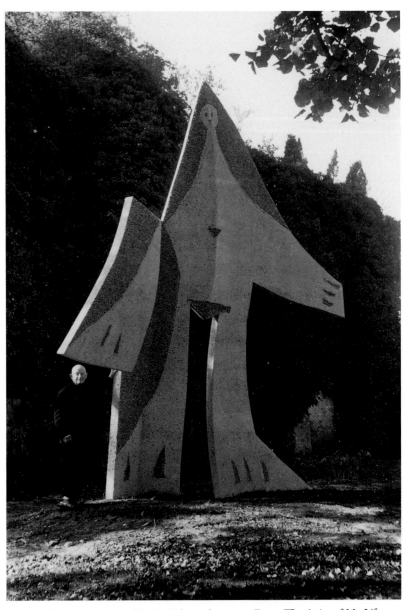

31. Brassaï. Portrait of D.-H. Kahnweiler. 1962. From *The Artists of My Life*.

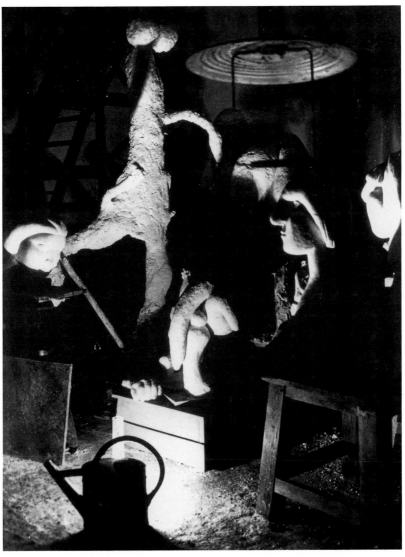

32. Brassaï. Picasso's studio by night. 1932. From *The Artists of My Life*.

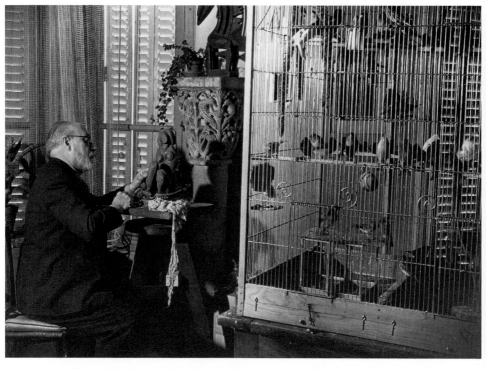

33. Brassaï. Matisse modeling the second version of his *Vénus à la coquille*. Ca. 1934.
From *The Artists of My Life*.

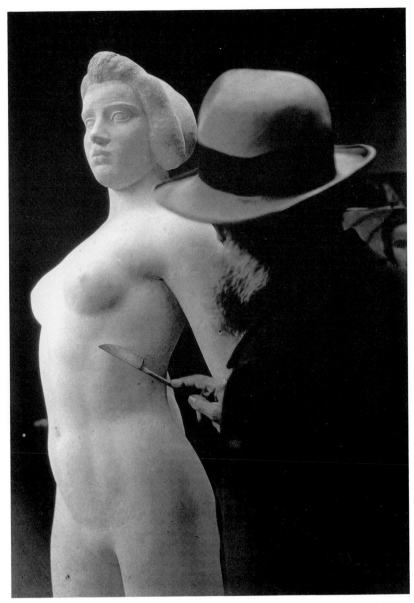

34. Brassaï. Maillol at work on *L'Ile de France*. Ca. 1932. From *The Artists of My Life*.

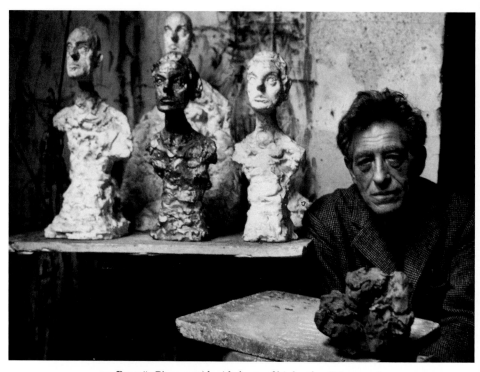

35. Brassaï. Giacometti beside busts of his brother Diego. 1965.
From *The Artists of My Life.*

36. Brassaï. Dali and Gala in their studio. 1932. From *The Artists of My Life.*

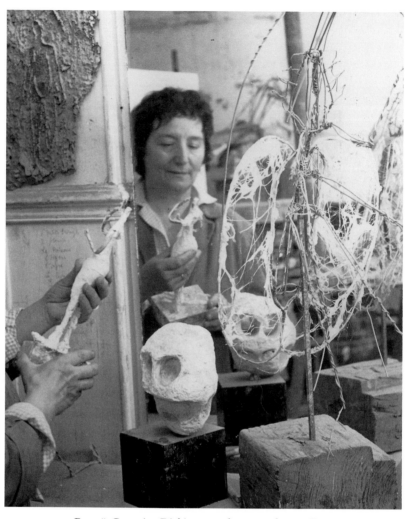

37. Brassaï. Germaine Richier at work on a sculpture. Ca. 1955.
Photo Brassaï, Collection F. Guiter.

Objective Vision and Subjective Perception: Comparing Paris by Night and The Secret Paris of the 30's

Arts et Métiers Graphiques' issue number thirty-one of September, 1932, contained an advertisement that invited its readers to consider choosing an "intelligent gift" from among its most recent special volumes. The suggestions included a special issue on photography, another on caricature, a volume of photographs entitled *Through the Clouds* (*A Travers les nuages*), and the forthcoming *Paris by Night*. An earlier issue (number twenty-nine) had presented *Through the Clouds* as "120 documents, 120 amazing photos": aerial photographs of clouds and atmospheric phenomena taken from planes, balloons, and dirigibles. Issue thirty-one advertised *Paris by Night* as a "captivating promenade" in the company of Paul Morand with sixty unpublished photographs by Brassaï: "The photographs, a veritable technical *tour de force,* capture the stops along the way with all the power of etchings." [40] Paul Morand, a well-known writer whose collections of short stories *Ouvert la nuit* (*Open All Night*) and *Fermé la nuit* (*Closed All Night*) had met with considerable success in the early twenties, provided the name recognition (and associations with the nocturnal theme) that would attract readers to the work of an as yet unknown photographer. As the advertisement suggests, the attraction of the photographs was the novelty and beauty of night photography, which as a technical *tour de force* was on a par with aerial photography.

The sequel to *Paris by Night,* originally titled "Paris intime" was published as *Voluptés de Paris* (*Sensual Delights of Paris*) in 1935, not long after Brassaï had begun to work for *Minotaure.* The second book was intended as a study of the mores of the city's nocturnal inhabitants, but Brassaï rejected the publisher's efforts to sensationalize his photographs and disavowed the book. Only a small number of these photographs were reprinted in *Camera in Paris* after the war, and many others from the same period were not published until Brassaï made them available in *The Secret Paris of the 30's* some forty years later. In some sense, then, even though all of these photographs were the products of a single enormously creative period (which also included the beginning of his series *Graffiti*) that lasted from about 1931 to 1934, the different and deferred presentations of the photographs result in our perceiving *Paris by Night, Voluptés de Paris,* and *The Secret Paris* as distinctly separate works. Not surprisingly, *The Secret Paris of the 30's* interprets the city in a way that would not have been possible at the time the photographs were taken.

40. *Arts et Métiers Graphiques,* XXXI (September 15, 1932).

As *Voluptés de Paris* did not reach the same public as *Paris by Night* or *The Secret Paris,* and as many of the photographs (or versions of them) that originally appeared in it were reprinted in *The Secret Paris,* I have left more serious consideration of this "transitional" work for the following chapter. However, a comparison of *Paris by Night* with *The Secret Paris of the 30's* does suggest changes in perspective, some the result of Brassaï's evolution as an artist, others the effect of historical and cultural change.

As Colin Westerbeck notes, "to go back to *Paris de nuit* after studying *The Secret Paris* affords a real surprise, for the dominant quality of the former seems completely absent from the latter. That quality is a starkly graphic one." Yet this graphic quality alone is not sufficient to characterize the differences between the two works, and as Westerbeck admits, "in general *Paris de nuit* differs from *The Secret Paris* as much in substance as it does in style." Westerbeck suggests, very perceptively, that these changes in substance and style may reflect Brassaï's increasing skill as a photographer, a mastery of the medium that made him bold enough to overcome the "respectful distance" of his early work and achieve a synthesis of "sentiment and aesthetics, form and content" in his café and dance-hall photographs.[41]

Nonetheless, the two works present two different versions of Paris. *Paris by Night* documents the formal beauties of a darkened city at a time when such images were original and striking subjects in themselves. The captions for the images reinforce this sense of novelty by asserting certain images were captured by the lens "for the very first time" (*PN,* caption 2). While the majority of the photographs show the beauty of the city as a setting, those few that focus on a beggar, a prostitute, or a tramp, keep the respectful distance of a solitary walker who recognizes them as familiar nocturnal presences. They are part of the décor like the workers on the night shift, the police on their bicycles, nightclubbers, cancan dancers, or the baker loading the oven with loaves that will be freshly baked by breakfast. Such nocturnal presences—disquieting or reassuring—are generalized as the native flora and fauna of Parisian nights. To come closer, and to document a particular, recognizable individual involved both risk and misunderstanding, as in the case of Bijou, who had been paid to pose in all her finery. She was horrified by the caption (added by the editor) in *Paris by Night* that identified her as a dream image from one of Baudelaire's nightmares, and put in an appearance at the publisher's office to protest angrily: "I'm a nightmare, am I, that will cost you plenty" (*BN,* 10).

41. Westerbeck, "Night Light," 35–36.

In one sense, *The Secret Paris* must have been the book Brassaï dreamed of publishing in the thirties; ironically perhaps, it could only be published once the world he portrayed no longer resembled his images and they had receded into a safely distant historical past. The degree of "closeness," apparent naturalness, and intimacy Brassaï attained in these photographs made them very powerful. They represent an extraordinary achievement, particularly given the nature of his subjects and the risks involved in getting close to them. Yet the character of Paris changes with the times in this later work— not only have the formal beauties of a darkened city become commonplace, but once-scandalous or pornographic photographs have lost some of their power to shock. The photographs in *The Secret Paris* reflect not only the period during which the photographs were taken, but Brassaï's changing perception of them and their changing cultural value and significance.

A comparison of these two different versions of Paris also suggests the tension between objective vision and subjective perception. Brassaï recognized a sacred realist obligation to represent things as they are, referring to photographers as members of a religious order who don a black veil; however, he admitted that his efforts to create a faithful and respectful, "objective" representation of his subjects were constantly threatened by his own self-consciousness.[42] Although he was acutely aware of this tension in his creative work, his realist self-abnegation led him to concentrate on his subjects. Ultimately, he realized that for this very reason his photographs represented him as much as they did his subjects. "Photography is never objective," he admitted in a lecture given in the sixties. "There was a time when I was trying desperately to add nothing to what I saw, to put nothing of myself in my photos, and the more I tried, the more immediate the viewer's reaction was: But that's a photograph by Brassaï." [43]

Not coincidentally, one of the most powerful and elusive conceptions of the marriage between objective reality and subjective perception is the surreal. In Brassaï's portrayal of the city the surreal presides over the conception of the image, for as Brassaï revealed in *The Secret Paris,* he frequently collaborated with chance, leaving the determination of his subjects to the *hasard objectif* that André Breton considered to be the result of the meeting between desire and external necessity:

42. Brassaï, *Ten Photographs by Louis Stettner* (Paris, New York: Two Cities Publications, 1949), unpaginated.

43. "La photo n'est jamais objective. Il fut un temps où j'essayais désespérément de ne rien mettre de moi-même dans mes photos, et plus je m'y efforçais, plus la réaction des spectateurs était immédiate. Mais c'est une photo de Brassaï." Quoted in Pierre Bourdieu, *Un Art Moyen: Essai sur les usages sociaux de la photographie* (Paris: Editions de Minuit, 1965), 221.

Sometimes, impelled by an inexplicable desire, I would even enter some dilapidated house, climb to the top of its dark staircase, knock on a door and startle strangers awake, just to find out what unsuspected face Paris might show me from their window. (*SPT*, Introduction)

In *The Secret Paris* Brassaï emphasizes the historical value of his images as documents, yet he warns the reader against taking an artist's view of history as objective truth. For this very reason Brassaï's *The Secret Paris* is exemplary. It demonstrates the tension between objective vision and subjective perception, a tension that remains an important factor in the history and aesthetics of photography. So powerful a factor that Susan Sontag moved to define photography not as an artistic or technical practice but psychologically, as the paradigm of an "inherently equivocal relationship between self and world—its version of the ideology of realism sometimes dictating an effacement of the self in relation to the world, sometimes authorizing an aggressive relation to the world that celebrates the self. One side or other of the connection is always being rediscovered and championed." [44]

Brassaï's *The Secret Paris* attempts to make subjective and objective vision coincide, with the paradoxical result that his work contradicts the normal history of the photographic image. "With time," wrote Jean-François Chevrier, "images lose the meaning they carried initially. We forget their function. We retain only those photographs whose form is developed enough to be receptive to new meanings. It is in this way that the history of art is constituted, that of photography like all the others." [45]

Perhaps the publication of *The Secret Paris* cannot forestall further aestheticizing of Brassaï's photographs, but their art did not prevent him from making an effort to reclaim them as documents by writing their history. In a 1974 interview he remarked, "I have taken many photographs in my life and published relatively few books, so now I prefer to travel in the universe of my photographs and make them better known." [46] In some sense, then, we owe *The Secret Paris* to Brassaï's literary ambitions. His desire to travel in the universe of his photographs revealed the broader literary, historical, and ethnographic dimensions of his work and pushed back its cultural vanishing point.

44. Sontag, *On Photography,* 123.

45. Jean-François Chevrier, "La Bibiothèque Nationale: Collections du XXe Siècle, entrées octobre–décembre, 1983," in *Photographies,* IV (April, 1984), 84.

46. Hill and Cooper, eds., *Dialogue with Photography,* 41.

IV

Ethnographic Surrealism and Surrealist Baroque

Any collection of photographs is an exercise in Surrealist montage and the Surrealist abbreviation of history.

—Susan Sontag, *On Photography*

Attracted as we are by the strangeness of primitive customs, we know more about the habits of the pygmy or African bushman than we do about a Parisian from the rue des Solitaires," Brassaï wrote in the introduction to his photographs of Paris graffiti. He went on to regret that "apart from a few timid efforts" an ethnology of the more developed societies did not exist. Graffiti, he contended, were "social facts" about modern man, whose secrets were no less profound than those of the caveman and certainly equally worthy of study—particularly, he concluded wryly, as modern man provided the added advantage of being a living subject (*G,* 10).

Despite Brassaï's desire for an "ethnology"—the equivalent of U.S. "cultural anthropology"—of more advanced societies, his own tentative efforts in this vein more closely resemble "a general cultural disposition," which James Clifford termed "ethnographic surrealism." [1] Ethnographic surrealism reverses the procedure by which the ethnologist/anthropologist observes a foreign culture, then attempts to establish parallels between this unknown culture and his own, making the strange familiar and comprehensible. An ethnographic surrealist practice operates on a familiar culture, attempting to break down cultural conventions by short-circuiting the traditional habits of thought or perception that "normalize" a particular order of things. "The mad beast of convention must be hunted down," André Breton insisted in an essay on "The Crisis of the Object," where he advocated the *perturbation* and *dépaysement* of ordinary objects in order to undermine the perceiver's assumptions about their function and utility (*SP,* 279). Significantly, however,

1. Clifford, *The Predicament of Culture,* 119–22, 145–58.

the word *dépaysement* takes on its fullest meaning when applied to the exploration of a familiar cultural landscape as though it were an unknown, foreign reality. In *Le Paysan de Paris* Louis Aragon describes just such a nocturnal "ethnographic" expedition to the Paris park Buttes-Chaumont (not far from Brassaï's rue des Solitaires) in the company of Marcel Noll and André Breton. The voyage of discovery assumes mythic proportions in Aragon's telling of the trio's uncertain wanderings in the mysterious darkness that he, only half-mockingly, called their Mesopotamia.[2]

Brassaï's photographs accomplish similar displacements. His photographs of graffiti defamiliarize an insistent, all too familiar element of urban reality by isolating and framing individual scrawls as works of art (Figure 22), while his photographs of nocturnal Paris record his own discoveries in a dark continent. The desire to capture ephemeral forms of social reality underlies all of his best work of the thirties—both the photographs of graffiti and the images of Parisian nights and their "secrets"—and reflects the particular cultural climate of the late twenties and thirties in which the emergent science of ethnography had much in common with the Surrealist avant-garde.

Exploring Reality: Science and Avant-Garde Art

In the introduction to a 1981 exhibition entitled "Exploring Society Photographically," Howard Becker considered the uneasy relationship between science, particularly social science, and art when one is seen "as the discovery of truth about the world and the other as the aesthetic expression of someone's unique vision. All very well," he concluded, "except that so many artists' visions are of the truth about the world and scientists' discoveries of that truth contain so strong an element of personal vision. The two enterprises are confounded in ways that cannot be unmixed."[3] In his 1936 essay "The Crisis of the Object," André Breton made a larger, more audacious claim: that there was a correlation between shifts in scientific theory and developments in poetry and the arts (*SP,* 275). Regretting the lack of a comparative history that would demonstrate this conclusively, Breton pointed to—as one example—the year 1830, pairing the discovery of non-Euclidian geometry with the triumph of French Romanticism. His discus-

2. Louis Aragon, *Le Paysan de Paris* (Paris: Gallimard, 1926), 167.

3. Howard S. Becker, *Exploring Society Photographically,* catalog to accompany the exhibition at the Mary Leigh Block Gallery, October 16–November 29, 1981, Northwestern University, Evanston, Ill., 9.

sion of the connection between the two is as suggestive as it is inconclusive. However, the connections between modern science and modern art are beginning to be explored by scholars whose work attempts to demonstrate the affinity between French avant-garde art and emerging sciences. Science and art appear interrelated in particularly complex ways when both are considered "social facts," shaped by the specific social and cultural milieu in which they arose. In this sense, both the Durkheimian sociology implied by Brassaï's use of the term "social facts" and the nascent ethnography of the late twenties and thirties have a profound affinity with the avant-garde art of their time.[4]

A real family relationship links the two sciences: Durkheim's nephew and fellow university scholar, Marcel Mauss, became one of the founders of the Institut d'Ethnologie, the first French institution to undertake the professional training of ethnographers.[5] It was Mauss who introduced Durkheim to British scholarship on comparative religions that may have led him to conceive his major work on primitive Australian society, *The Elementary Forms of Religious Life,* while Mauss's work in ethnography broadened and complemented the Durkheim School's interest in primitive societies.

E. A. Tiryakian points out that the formative years of Durkheimian sociology, beginning in the late 1880s, coincided with the period in which a new vision of reality was elaborated in the sciences—particularly physics—finding its initial expression in the work of the Impressionists. Both the Impressionist painters and the *Fauves,* who displaced them as the avant-garde, depicted a world for which Aristotelian logic and Euclidian geometry no longer provided an adequate definition: a reality where absolutes dissolved into relatives, leaving an immaterial world of appearances, shifting and unstable. The high point of the Durkheim School's activity, from 1905 to the First World War, coincided with the period that saw Picasso and Braque elaborate a new approach to form called Cubism. They penetrated the sur-

4. My discussion of the Durkheim School summarizes E. A. Tiryakian's more complex and complete treatment of the subject in "La Sociologie naissante et son milieu culturel," *Cahiers Internationaux de Sociologie,* LXVI (1979), 97–114.

5. Donald Ray Bender calls attention to the curious relationship between the two: "It is an interesting paradox that while the Durkheimian School has contributed greatly to ethnological theory and while Marcel Mauss and Lucien Lévy-Bruhl cooperated in the formation of the Institute of Ethnology of the University of Paris which provided a long needed institution for the training of professional ethnologists, it is the dominance of the School during the early part of the twentieth century which actually inhibited the growth of a discipline of ethnology in France." *Early French Ethnography in Africa and the Development of Ethnology in France* (Minneapolis: University of Minnesota Dept. of Anthropology, 1964), 55.

face of the unstable world of appearances in order to represent reality in terms of basic geometric forms and structures. As Tiryakian indicates, their effort to grasp the fundamental geometry of reality provides a new perspective on one of the more paradoxical features of the Durkheimian School: the fact that the first modern school of sociology concentrated so much of its attention on primitive and archaic societies. Significantly, both the Cubists' and the Durkheimians' research can be seen as efforts to grasp the fundamental structures of reality. Tiryakian concludes that Durkheim's work on primitive societies represents an effort to recover what had been lost under layers of civilization: the fundamental structures of social organization.[6]

However, in the upheaval of the First World War the worth and permanence of civilization and civilized values appeared less certain. Paul Valéry—whose work the Surrealists revered, then abjured—felt the world had been rocked to its foundations and admitted "Nous autres civilisations, nous savons maintenant que nous sommes mortelles" ("We now know that civilization is mortal").[7] For the Dadaists and the Surrealists who followed them, the values of European civilization had been compromised by the barbaric realities of war. They launched their own campaign against a culture they considered wholly discredited, ethically and aesthetically bankrupt. While the Dadaists preferred to engage in cultural sabotage, the Surrealists elaborated a program of action. Claiming with Rimbaud that "la vraie vie est absente," they insisted on the necessity to "change life," beginning with the perception and representation of reality. They found little inspiration in "art," turning instead to ethnography.

André Breton's 1929 essay *Surrealism and Painting* tars modern art with a broad brush. Dismissing even Cubism as another of the ridiculous styles cluttering the cultural landscape, he turned his back on the "business" of art and on museum culture, disdaining "the beaten track and paths that lead nowhere" (*SP*, 3). The Surrealists' efforts to expand the limits of individual human reality by plumbing the Freudian unconscious lead directly to their fascination with primitive art. The two are linked from the movement's very beginnings. The inaugural show at the Galerie Surréaliste in 1926 featured paintings by Man Ray juxtaposed with sculptures from the Pacific Islands; a year later a similar exhibit combined Tanguy's paintings with American Indian "objects," including Northwest Coast and Pueblo Indian carvings.[8]

6. Tiryakian, "La Sociologie naissante," 106–107, 110, 113.

7. Paul Valéry, "La Crise de l'Esprit," in *Oeuvres complètes* (2 vols.; Paris: Gallimard, 1957), I, 988.

8. Elizabeth Cowling, "The Eskimos, the American Indians and the Surrealists," *Art History*, I (December, 1978), 486.

Of course, the Surrealists were not the first to admire the formal qualities of primitive art. Charles Meryon considered many primitive works the equal of archaic Greek masterpieces. In the mid-1800s he had envisioned establishing a primitive art museum in Paris to house the collection of Polynesian art he amassed during a tour of duty as ship's artist on the French naval expedition to Tahiti from 1843 to 1846.[9] Temperamentally and temporally closer to the Surrealists was Apollinaire, who had collected African fetishes even before the war, his interest in primitive art leading to his (false) arrest for the theft of Phoenician statues from the Louvre. The Surrealists, like Apollinaire, were drawn to *objets sauvages,* whose exotic strangeness and striking formal qualities combined to produce their particular power of suggestion. The African, Oceanic, and Eskimo cultures they glimpsed through the artifacts they collected provided concrete embodiments of an "other" world view expressed through a creative logic that implicitly challenged Western conventions (see *SP,* 283).

The Surrealists' perception of their own culture as only one of a number of possible cultural alternatives is an attitude the movement shared with the emerging discipline of ethnography. Charting the "close proximity" in which Surrealism and ethnography develop during the late twenties and thirties, James Clifford argues that "ethnography and Surrealism are not stable unities. . . . The boundaries of art and science (especially the human sciences) are ideological and shifting, and intellectual history is itself enmeshed in these shifts. Its genres do not remain firmly anchored."[10]

Concrete connections between Surrealism and ethnography are provided by those who, having drifted in, then out of the Surrealist orbit, were drawn to the work of Marcel Mauss and to ethnography, notably Georges Bataille and Michel Leiris. While Bataille was a founding member of the Collège de Sociologie in the late thirties, his interests in ethnography remained essentially theoretical. However, during his editorship of the short-lived journal *Documents* (1929–1930), he provided both a forum for dissident Surrealist views and an example of "how ethnographic evidence and an ethnographic attitude could function in the service of a subversive cultural criticism."[11] Michel Leiris, who went on to study with Marcel Mauss, ultimately became the secretary/archivist for the Mission Dakar-Djibouti, the first French ethnographic expedition. On the expedition's return in 1933 *Minotaure* devoted

9. Aaron Sheon, "The Discovery of Graffiti," *Art Journal,* XXXVI (Fall, 1976), 22.

10. Clifford, *The Predicament of Culture,* 118.

11. *Ibid.* See also Warehime, " 'Vision sauvage' and Images of Culture: Georges Bataille, Editor of *Documents,*" *French Review,* LX (October, 1986), 39–45.

a special issue to articles by the members of the mission, timing it to coincide with an exhibition of the mission's collection of artifacts and documents opening in the new "African room" of the Musée d'Ethnographie. By this time, Clifford concludes, modern art and ethnography had separated into "fully distinct positions." [12]

Yet the two positions still overlapped somewhat, despite the institution-alization of ethnography—its effort to distinguish itself as a science. In fact, the continued aesthetic interest in artifacts of primitive societies served as some measure of ethnography's hold on the imagination and its growing recognition as a discipline. The communication between ethnography and art had lost none of its importance some eight years later when Lévi-Strauss, quondam Surrealist and ethnographer in exile in the U.S. during the Oc-cupation, celebrated the collections of Northwest Coast art in the American Museum of History, "predict[ing] that 'the time is not far distant when the collections of the North West Coast will move from anthropological mu-seums to take their place in art museums among the arts of Egypt, Persia and the Middle Ages.' "[13]

Nonetheless, Lévi-Strauss's focus on the aesthetic qualities of primitive art rather than the alternative cultural values it proposes resembles the ori-entation of *Minotaure*. More an art review than a forum for cultural criticism, *Minotaure* redefined the shifting relationship between Surrealism and eth-nography in the light of the Surrealists' changing personal and political al-liances. Moreover, *Minotaure* served as the side door through which Brassaï would officially enter the Surrealist universe.

From Minotaure *to Surrealist Baroque*

Given its origins, *Minotaure* might have followed in the wake of *Documents*. Dawn Ades reports that it was originally intended "as an organ of Surrealist dissidents" and that much of the discussion that preceded its founding in 1933 took place in Roger Vitrac's apartment, with Jacques Baron, André Masson, and Georges Bataille in attendance.[14] The journalist and art critic Tériade, who played an instrumental role in these discussions and ultimately

12. Clifford, *The Predicament of Culture*, 134.

13. Cowling, "The Eskimos . . . and the Surrealists," 494.

14. Dawn Ades, *"Minotaure,"* in *Dada and Surrealism Reviewed*, with an introduction by David Sylvester and a supplementary essay by Elizabeth Cowling (London: Arts Council of Great Britain, 1978), 279.

became *Minotaure*'s artistic director, apparently hoped to reconcile the dissidents with Breton, but as Ades indicates, nothing came of it. *Minotaure* became a more mainstream, even exclusive, publication than its predecessor and never attempted the radical dislocation and free association of cultural orders that characterized *Documents*.

Backed by the publisher Albert Skira, Tériade invited the participation of his friend and associate Maurice Raynal who, like him, had followed Apollinaire in writing art criticism for *L'Intransigeant,* a daily evening paper. Regardless of their openness to new ideas and important movements—their desire for Surrealist participation in *Minotaure* being one indication of that— Skira, Tériade, and Raynal represented more conventional views on art and culture that made their association with the Surrealists something of an unholy alliance. Only three years before, in *Surrealism and Painting,* Breton had gone out of his way to denounce the bankruptcy of traditional art criticism, specifically targeting Raynal, whose articles (along with those of Florent Fels and Vauxcelles) he accused of "exceeding the bounds of imbecility" (*SP,* 8). Consequently, the members of the editorial board had their differences, and although the special issue on the Mission Dakar-Djibouti suggests that the Surrealists frequently had the final say in editorial decisions, they were not the only ones to raise their voices.

Brassaï recalled a particularly bitter argument about Maurice Raynal's article "Dieu, Table, Cuvette" on modern sculpture, destined for *Minotaure* 3–4. "Laurens, Lipschitz and Despiau pleased the Surrealists as little as Maillol or Brancusi," he remarked dryly (*Picasso,* 13). Brassaï would naturally have taken an interest in the outcome of the argument because, although he did not mention it, the article was to be illustrated with his photographs, which were eventually published when Raynal's article was accepted over the Surrealists' objections. In fact, it was Brassaï's friendship with Raynal and his contacts with Tériade, a fellow habitué of the Dôme, that originally led to his invitation to take photographs for *Minotaure*.

While some of Brassaï's reservations about Surrealism were no doubt born out of his friendly connection to the more conservative elements of the editorial board, others stemmed from his own more traditional views on the importance of pictorial qualities in painting—and his real appreciation for the work of sculptors such as Maillol and Brancusi. Yet *Minotaure* provided an intellectual leaven for his own aesthetics and influenced a sensibility that might otherwise have developed along more traditional aesthetic lines. "I liked this fever of discovery away from the beaten paths of art and science," he admitted later, "this curiosity to prospect for new veins of ore, this mental

electricity which constantly charged through the little office at *Minotaure,* where André Breton flicked his whip at the mind" (*Picasso,* 15). Brassaï's own high voltage found an appropriate ground in *Minotaure* precisely because the review moderated more strident expressions of Surrealist iconoclasm. If Brassaï's eclectic tastes blurred distinctions between popular and high culture, good and bad taste, in ways typical of Surrealism, unlike the Surrealists he took a long inclusive view of cultural tradition. This may explain the fact that he understood Surrealism in terms of a fascination with the irrational, the inexplicable, and the bizarre, linking it to the other movement whose influence shows in his work: the Baroque.

"Never has the relativity of the notions of good and bad taste appeared more clearly than in the Italian Baroque," Brassaï asserted in an article for *La Gazette des Beaux-Arts;* we owe its works not to "a sense of balance and plastic beauty, but to humor, sensuality, mystification, excess, to a passion for the strange and fantastic." He ascribed the novel and creative elements of the Baroque to its "bad taste," the "lack of restraint and discernment" that makes it disconcerting, "like a dream that excludes neither the deformed, the horrible, the monstrous or even the macabre." [15] This dream universe also bears a distinct resemblance to the productions of Surrealist automatism, and Brassaï's description of the Baroque as a movement leading art in new directions, crossing "the threshold of the irrational to give rise to primitive, exotic, even barbaric works of art," reinforces the resemblance.[16] He will find exactly the same phenomenon of seminal "bad taste" in the Paris graffiti he photographed and published in *Minotaure* in the early thirties, claiming that "this bastard art of seedy backstreets" upset all the established laws of aesthetics (*G,* 12).

Brassaï's Baroque appears eminently Surrealist in its break with classical norms, its affinity with primitive and exotic works, and its love of the strange and fantastic. In addition, Brassaï's use of analogy to bridge the gap between profoundly different phenomena—and different historical realities—is itself some evidence of a Surrealist sensibility. His introduction to *Graffiti* operates in a similar way, relating his astonishment at finding "Mexican art in Ménilmontant, the art of the Steppes at the Porte des Lilas, Prehellenic art in

15. "Jamais la relativité des notions de 'bon goût' et 'mauvais goût' n'apparaît mieux que devant les oeuvres du baroque italien, qui ne sont pas dues au sens de la mesure et de la beauté plastique, mais à l'humour, à la sensualité, à la mystification, à la démesure, à la passion de l'étrange et du fantastique. . . . Il déroute comme un songe qui n'exclut ni le difforme, ni l'horrible, ni le monstrueux, ni même le macabre." Brassaï, "La Villa Palagonia, une curiosité du baroque sicilien," *Gazette des Beaux-Arts* (September, 1962), 351.

16. *Ibid.*

Belleville and the art of the Iroquois in the Latin Quarter," not to mention one or two graffiti that might have been signed by Picasso, or Miró, or Klee (*G*, 12). It is not surprising, then, that the public caught its first glimpse of Brassaï's photographs of graffiti in the pages of *Minotaure*.

The Art of Graffiti

Brassaï's 1961 introduction to *Graffiti* clarifies the Surrealist dimension of his project without mentioning Surrealism. In a formulation that owes as much to the Bataille of *Documents* as to Breton, Brassaï claims that art was forever changed when "the irruption of instinct, dream, chance and automatism" created an opening for the "elementary forces" that art had been charged with containing and redirecting.[17] As a result the operation of projection replaced the artist's elaboration of his subject, preexisting forms or "found" elements replacing elements of the artist's invention so that it was precisely the awkwardness—rather than the formal perfection—of the finished work that served as a guarantee of authentic creation (*G*, 11). While this theory explains the basis for Brassaï's promotion of graffiti to the level of art, the description also suggests a parallel between graffiti and automatic writing— both spontaneous manifestations of the creative impulse—and links them to the formal awkwardness of primitive art when measured against Western standards. Significantly, it also fits the projective work of the photographer, who finds his subjects as the Surrealists do their "found objects," choosing them because in some obscure way they correspond to unconscious desires.

Brassaï may have discovered what was to become the first of his series of graffiti on a wall outside his apartment building, but it is probable that his interest in graffiti grew as he made views of city streets while working on *Paris By Night*.[18] Although there is only one such photograph in *Paris By Night*, number thirteen, where the camera lingers on a cracked and peeling façade, there is other evidence of Brassaï's interest in such views. Commissioned by the review *Marianne* to do a study of Paris slums in the thirties, Brassaï concentrated his attention on the façades of the buildings, claiming that they were "more revealing than their inhabitants" (*BN*, 12).

Peeling paint, cracks, weathered posters and advertisements create rich tactile surfaces in a number of street views dating from the early thirties that

17. See Georges Bataille, "L'Esprit moderne et le jeu des transpositions," *Documents* (1930); rpr. *Oeuvres complètes I* (Paris: Gallimard, 1970), 271–74.

18. Louis Stettner, "A Visit to Brassaï," *Photo Notes* (Fall, 1948; rpr. Rochester, NY: Visual Studies Workshop, 1977), 13.

were ultimately published in *The Secret Paris*. A photograph from the chapter entitled "Ladies of the Evening" (the image originally appeared in *Voluptés de Paris*) provides the clearest link between the graffiti and Paris-street series. Its subject is ostensibly a smartly dressed prostitute, a fringed foulard knotted at her throat, the cigarette in her mouth held at a deliberately jaunty or defiant angle, who leans with studied casualness against a lamppost. Yet on the wall beside her is a scribbled graffiti face that distracts the viewer's attention. The photograph pulls in two directions, each demanding separate treatment.

Brassaï narrows his scope in concentrating on the graffiti, but his subject could be seen as a product of Freudian overdetermination, condensing a number of divergent interests in a single series of images elaborated over a period of twenty-five years. Not the least of these interests was the artist's temptation to look at the wall as a painterly surface. The richly textured surfaces of city walls might have suggested collages and, as the preface to *Graffiti* indicates, they also reminded Brassaï of Leonardo da Vinci's advice in his *Treatise on Painting*. The master counseled painters to study cloud formations or the spotted, irregular surfaces of old walls, letting their shapes suggest ideas for new compositions. The Surrealists were equally interested in this advice, no doubt seeing it as a pre-Surrealist form of automatic activity. Brassaï himself tended to diminish the importance of psychology and psychological interpretations—even in his portraits—always maintaining that his principal interest was in the nature of form.[19] Understandably then, the walls and façades of the city, even the patterns made by broken windows, provided curious forms and textures that inevitably caught his eye.

The graffiti also served as a focus for his reflections on the nature of creativity and the origins of art. Brassaï might have known Freud's studies of Leonardo, or Michelangelo—certainly the Surrealists were fascinated by Freud's reading of Jensen's *Gradiva*—but Brassaï never refers to Freud's work on art, even though his *Conversations avec Picasso* show he is aware of Freud's interest in the "cas Dali." It is more likely that his conception of the project was influenced by his reading of Baudelaire's *The Painter of Modern Life* and his personal association with Picasso and the Surrealists. (In fact, Robert Desnos also had a collection of images of graffiti, some of which were reproduced as illustrations for an article on the subject published in *Arts et Métiers Graphiques* in 1937.) Certainly Brassaï, Picasso, and the Surrealists were all fascinated by the artwork of children, primitive societies, and naive

19. "Je ne m'occupe pas de psychologie. Je photographie un portrait comme un objet. . . . Je pense que la forme exprime tout. On n'a pas besoin de psychologie." *BN*, 15.

painters because their work seemed to hold clues to the nature and meaning of the artistic impulse. For the Surrealists such productions—whether Nadja's enigmatic drawings, the art of naive and primitive painters, or the work of mediums, the striking metaphors of automatic writing, or Ernst's frottages and Dali's dreamscapes—all suggested the treasures of the human unconscious, a rich vein of ore that might be mined by Surrealist means in the hope of establishing a new modern mythology.[20]

Neither Picasso's nor Brassaï's fascination with the nature of artistic creativity had the same "theological" dimension. Their interest, as Brassaï portrays it in the *Conversations avec Picasso,* is grounded in a quasi-scientific curiosity about the nature of creativity and its role in human development. In one of his conversations with Picasso, Brassaï delightedly explains to the artist that it took the eye of a poet—Goethe—to recognize the formal analogy between the vertebrae and the structure of the cranium, composed of highly evolved vertebrae "fitted together like the pieces of a construction toy" (*Picasso,* 74). Although Brassaï's interest in skeletons and bones reflects his preference for linear and sculptural forms, it is also related to his passion for primitive art, particularly cave painting. Brassaï considered cave painting, like graffiti, to originate in a process similar to that suggested by Leonardo in which primitive man discovered and traced the shape of a bison in the irregularities of a cave wall. Unlike Georges Bataille, whose study of the art of Lascaux led him to theorize that art originated in man's desire to transgress prohibitions, to destroy, deform, or mutilate (a desire supposedly satisfied in the activity of scoring and marking the wall's surface), Brassaï deliberately avoided dwelling on the destructive elements of the artistic process, claiming art as a formal expression of man's survival instinct and a means to self-knowledge.[21] It is this same interest in the origins of art that explains Brassaï's (and Picasso's) fascination with children's art as the product of what Picasso called "the genius of childhood," a mysterious artistic gift that inevitably disappeared without a trace, although something of the same freshness of vision characterizes the work of naive painters—and graffiti artists (*Picasso,* 86).

In his introduction to *Graffiti,* Brassaï recalled Restif de la Bretonne's "inscriptions," the generally scatological graffiti with which the author delightedly defaced Paris. However, Brassaï's real precursors are to be found in

20. See Aragon's *Paysan de Paris* and Breton's essay from the forties on "Autodidactes dits 'naïfs.'" *SP,* 291–94.

21. See Georges Bataille's essay on Lascaux: "Lascaux ou la naissance de l'art," in *Oeuvres complètes IX* (Paris: Gallimard), 1979.

the Romantic movement of the next century, which sparked an interest in popular art forms as valuable social and historical documents and led to a reassessment of the artistic value of graffiti, children's art, primitive and folk art. Victor Hugo admired the doodles his son made in the margins of his Latin book, Balzac's novel *Ferragus* included descriptions of graffiti observed in the rue Pagevin, and Champfleury praised the directness and honesty of childlike art because it came from the heart, not the mind.[22] While the Romantic movement led to efforts to preserve the architectural heritage of France through projects such as the *Voyages pittoresques*, it also inspired Champfleury to study popular art. Fearing that folk arts would eventually disappear even more completely than primitive societies once they were exposed to a more sophisticated culture, he began to collect popular prints from different regions of France. In the introduction to his study *L'imagerie populaire*, he issued a cry of alarm:

Before popular imagery completely disappears it must be studied from its origins, its flowering in the past and its present development. Already the prints of the last century form a category of new archaeology which requires thorough research. We can still find Assyrian monuments, but we can hardly find any more popular imagery. . . .

The savage and the genius make audacious ruptures with traditional rules [of art]. We must look deeply into their art and leave aside the notions of technical skill and imitative ability.[23]

While Champfleury defended these breaks with tradition, Baudelaire is among the first to insist on their artistic merit. In his *The Painter of Modern Life*, he attempts to convince his contemporaries of the aesthetic value of the "inevitable synthetic, childlike barbarousness, which often can still be seen in a perfect type of art (Mexican, Egyptian, Ninevite barbarousness)" where artists have simplified and exaggerated in order to capture an overall effect. Baudelaire admired the art of Constantin Guys precisely because his mature work revealed traces of his first awkward, childlike efforts as a draftsman, traces that only heightened the effects of his mastery of the medium because they conveyed the intensity of his impressions. It was Guys who inspired Baudelaire's famous definition of genius as "l'enfance retrouvée à volonté," childhood recaptured at will.[24] Brassaï quotes this definition in his introduction to *Graffiti*, adopting it as his own. Yet he viewed graffiti not only as art, but as traces and signs of the process of creation—formal man-

22. Sheon, "The Discovery of Graffiti," 16–22.

23. *Ibid.*, 21.

24. Baudelaire, *Selected Writings*, ed. Charvet, 406, 396, 398.

ifestations of the perception and creation of meaning. Brassaï considered "the wall" an ambiguous space, a "shadowy zone with uncertain boundaries where the 'propositions' of nature and man's 'dispositions' meet halfway" (*G,* 24). At night, however, this shadowy zone with its uncertain boundaries blurs still further, becoming indistinguishable from the city itself.

Exploring the Shadows: Voluptés de Paris *and* The Secret Paris of the 30's

Paris by Night was no sooner off the press than Brassaï sold the remaining photographs to the popular magazine *Voilà* (directed by Florent Fels) and began another phase of his exploration of the city (*EL:* 77, p. 152). In December, 1933, he wrote his parents that he was taking the final photographs for his "Paris intime." Pierre Mac Orlan had agreed to write the preface, and publication was scheduled for March (*EL:* 78, p. 153).

By October, 1935, it was clear that the book had stalled at the publishers. Although Brassaï had received an advance, the publisher claimed he was financially unable to bring the book out (*EL:* 80, p. 155). When the book finally did emerge from the printer it was entitled *Voluptés de Paris,* and there was no introduction by Mac Orlan. The unsigned preface mimicked a carnival barker's spiel, touting the city to the potential reader like a lewd sideshow attraction: "Paris the paradise of desire, the capital of Adventure. . . . Paris where you can find your every fantasy in reality. . . . Puisez Messieurs-Dames! Il y en a pour tout le monde au grand bazar des voluptés de Paris" ("Dip right in Ladies and Gentlemen, there is something for everyone at the great Parisian bazaar of sensual delights"). Available by mail order, the book would be sent in a plain wrapper. No doubt on some level Brassaï was horrified at the transformation of his "Paris intime," for although he (like Germaine Krull, Sougez, and numerous other struggling photographers) sold photographs to popular and sensationalist thirties magazines like *Détective* and *Scandale,* he risked undermining the serious reputation he had acquired with *Paris de nuit.* He disowned the work, which does not figure in most of his official bibliographies.

However, *Voluptés de Paris* did not entirely escape critical notice. Peter Pollack in his 1958 *Picture History of Photography* judged it among Brassaï's best work, "an invaluable collection of Brassaï's essential pictures."[25] Pollack's judgment does not seem unreasonable, particularly given the fact that neither

25. Peter Pollack, *The Picture History of Photography* (New York: Harry N. Abrams, 1958), 519.

Graffiti nor *The Secret Paris* had been published. In fact, *Voluptés de Paris* contains some of Brassaï's best and worst photographs. Among the latter figures a photograph of the "lovers," a couple, their faces hidden in shadow, embracing on the stony ground of the zone "not far from the fortifications," as the caption indicates. Their embrace, awkward and stagy with an underlying current of violence, recalls Brassaï's work for *Scandale*, "la revue des affaires criminelles." Apparently posed, and hastily taken, the photograph lacks both formal organization and the atmosphere typical of Brassaï's work. It was not reprinted later, although that makes it something of an exception, for most of the photographs from *Voluptés de Paris* reappear in *The Secret Paris of the 30's* (some were reprinted even earlier in *Camera in Paris*), where their formal elegance or ethnographic value, coupled with the temporal "distance" that separates them from the viewer, eliminates any possibility of labeling them obscene or pornographic.

Inevitably, many of the photographs that figured in *Voluptés de Paris* or *The Secret Paris* flirted with the curiosity and prurient interests aroused by prohibited, off-limits, or simply offbeat subjects. The Baroque quality of Brassaï's sensibility, his "delight," as John Szarkowski put it, in "the primal, the fantastic, the ambiguous, even the bizarre," which he photographed with "profound poise and naturalness," led Szarkowski to call him "an angel of darkness" as late as the 1960s (*MOMA*, 7). Yet in a 1976 interview with Colin Westerbeck, Brassaï suggested that a major reason for his interest in these photographs after so many years was precisely that they would now seem innocent.[26] If the sexual revolution of the sixties changed the cultural climate to the degree that Brassaï was able to publish more of his photographs, in so doing he also allowed the viewer to grasp the larger subject of his work, what Roland Barthes would call the "erotic" dimension of the city.[27]

26. Westerbeck, "Night Light," 34–35.

27. Brassaï's work also participates in and reflects on this erotic dimension in a more narrow sense. His work builds on the impulse that pushed Dignimont, artist and connoisseur of the erotic, to commission Atget's photographs of prostitutes and brothels for his own private collection a decade earlier. Yet Brassaï's work also reflects a cultural shift, a greater availability of such subjects to artists and writers. In the wake of Freud's research the Surrealists attempted their own inquiry into the nature of sexuality, bravely publishing the results in the 1928 *La Révolution Surréaliste*, despite the fact that they revealed a somewhat surprising timidity and conventionality. Henry Miller's highly enthusiastic exploration of sexuality in his fiction has been more closely associated with Brassaï, whose photographs illustrated Miller's *Quiet Days in Clichy*. But in many ways Brassaï's work is much closer in spirit to Colette, who fictionalized her own experiences in the equivocal world of the music hall. Like Colette, Brassaï is sensitive to varying shadings of sensuality and sexuality, as well as to the theatrical projection of sexuality.

Barthes' speculative essay on "Semiology and Urbanism," originally published in the early seventies, suggests an approach to the city that clarifies the relationship between the erotic and ethnographic dimensions of Brassaï's work and its theatrical conception of space and action.[28] Barthes examines the possibilities of an urban semiology whose premise he derives from the chapter of Victor Hugo's *Notre-Dame de Paris* in which Hugo depicts the book as the rival of the city monument because both are inscriptions in space. The analogy between city and text has gradually become a familiar one, as has its complement: the urbanite who "reads" the city or, as Barthes put it, who "according to his obligations and his movement about the city takes fragmentary samples of the city's discourse in order to actualize them in secret."[29]

Barthes argued that no definitive meanings can be assigned to the city's discourse as it continually generates new signs and transforms old meanings into metaphors. It is, in fact, the "infinitely metaphoric nature of urban discourse" that leads to the perception of the "erotic" dimension of the city. Taken in the broadest possible sense, this erotic dimension defines the city as the place where we meet the "other," or experience ourselves as other.

The "otherness" of Brassaï's city is in part a product of a transposition of values, literal (daylight becomes darkness) and figurative (the social codes of nocturnal life contrast with those of ordinary bourgeois society). The shift from day to night alters the perception of familiar things and of space itself. In this sense Brassaï's images only superficially resemble the more lightheartedly romantic and decorative view of the city that characterized René Clair's studio set for the 1930 film *Sous les toits de Paris*. If the same mosaic of wet paving stones, the same irregular pattern of rooftops and chimneys silhouetted against the sky, the same narrow streets and theatrically defiant toughs make appearances in both, nonetheless Clair portrayed a picturesque and familiar Paris—too familiar to make a strong impression on the French public at first—while Brassaï dramatized the ambiguous otherness of the city.

From his first images in *Paris by Night,* Brassaï focused the viewer's attention on the contrast between open, public spaces and hidden, private, and possibly dangerous ones. In both *Voluptés de Paris* and *The Secret Paris* the drama of darkness and light, open and closed, inside and outside serves as

28. Roland Barthes, "La Sémiologie et l'urbanisme," in *L'Aventure sémiotique* (Paris: Editions du Seuil, 1985).

29. "L'usager de la ville (ce que nous sommes tous), est une sorte de lecteur qui, selon ses obligations et ses déplacements, prélève des fragments de l'énoncé pour les actualiser en secret." *Ibid., 268.*

the formal counterpoint to the drama of class and sexual difference that is played out in the mirrored spaces of cafés, brothels, and hotels, or the dark alleys where apaches and prostitutes, tourists, nightclubbers—and the photographer himself—move in and out of the shadows.

The moment of greatest dynamic tension in the dialectic of public and private spaces defines one of Brassaï's most important subjects: the spectacle in all its forms. Cabarets, *bals,* street fairs and their sideshow attractions, the Folies-Bergère, cafés, and "houses of illusion," occupy a privileged place in the iconography of Brassaï's Paris. Ambiguous spaces, both open and closed, they serve as the theater where public performances and private fantasies or dramas are played out (sometimes simultaneously) before others (friends, tourists, clients, voyeurs, the photographer himself) who remain outside the action or are alienated from it as spectators. A high degree of self-consciousness attaches to these images, which foreground either the spectator or the theatrical dimension of the "performance," sometimes operating a reversal that collapses the difference between them: the spectator becomes an actor—sometimes unwittingly—or the viewer gets a glimpse of the actor behind the scenes. This is one way Brassaï adapts the theatrical qualities of the Baroque to his own style.

The spectacle also has an important commercial dimension: open to the paying public, it must attract a public to survive. This commercial dimension is sometimes explicit, sometimes implicit in the content of Brassaï's images, but it also figures in the production and marketing of the image. While Brassaï certainly did take photographs for his own private collection of images, he was also constantly on the lookout for potential commercial outlets for his work. One such outlet was the market we might call cultural tourism—the connoisseur or tourist's curiosity about exotic, erotic, dangerous, or otherwise unusual aspects of the life of the city safely distanced as amusement or entertainment, or transformed by the writer or photographer's style into local color. As a journalist Brassaï had written for such a market, doing articles on subjects such as opium and cocaine dens, the dog cemetery at Asnières and "The Prostitutes' Priest" (*EL:* 60, p. 135). The first subject in particular so pleased his German editor that he was rewarded with commissions for several more articles. Given his success in placing this kind of work, Brassaï may have taken the photographs of opium smokers as well as those of student Saturnalia or the exotic Bal Nègre in the rue Blomet, all of which figure in both *Voluptés* and *The Secret Paris,* as potential illustrations for other articles. He probably began his series of photographs of lesbians and homosexuals in the hope of illustrating a book Colette was writing on the subject (*BN,* 18).

Although these examples emphasize the commercial aspect of cultural tourism and its influence on Brassaï's choice of subjects, cultural tourism also has its aesthetic side. A more personalized, aesthetic form of cultural tourism is suggested by Henry Miller's discovery of Paris and his fictional appropriation of it, or the Surrealists' exploration of the city in search of the revelations provided by chance conjunctions of people and places, both of which find echoes in Brassaï's work. Still other strains of cultural tourism are discernible in the work of artists and writers for whom the city provided both a subject and a sense of place. This is true of the poetic realism of Francis Carco as well as Pierre Mac Orlan's more expressionistic treatment of the city. If cultural tourism edges into cultural criticism in both the Surrealists' and Mac Orlan's work, it takes on a more sociological coloration in the work of writer-journalist Henri Danjou, whose book *Place Maubert: Dans les bas-fonds de Paris* came out the same year (1928) that his article on tramps and vagabonds appeared in *Vu* with Germaine Krull's photographs.

The commercial and aesthetic dimensions of cultural tourism play a role in determining what is fashionable. Perhaps the best example of cultural tourism as fashion is provided by another literary amateur of the city: Léon-Paul Fargue, author of *Le Piéton de Paris (The Pedestrian of Paris)*. Not only did Fargue occasionally accompany Brassaï on photographic forays into his favorite *quartiers,* but he served as a guide to rich literary friends whom he introduced to the low-life of the area around the Canal Saint-Martin. Brassaï himself made a point of the fact that Fargue started the vogue for little bistros (*BN,* 17).

Yet in *Le Piéton de Paris* Fargue grumbled that what there was of authentic culture in Montparnasse (he preferred Montmartre, considering it to have a real history) was fast disappearing in a wave of vulgarity. The café waiters were all unionized and you were as likely to find tramps and hoodlums sitting in cafés doing crossword puzzles as you were to see *rentiers* [those with independent income] at the races.[30] Fargue singles out the rue de Lappe, which figures importantly in Brassaï's Paris, to bemoan the fact that the area had lost its hard edge and was being exploited for its picturesqueness by local businesses. "This shadowy jewel of the eleventh arrondissement has changed a good deal in recent years," he lamented:

It's no longer anything more than an artery, a sticky varicose vein of the latest electric shop signs, that seems open to let the bitter blood of the music hall escape. Riffraff wearing derby hats hang around under the arcades like rumpled tin soldiers. Cats

30. Léon-Paul Fargue, *Le Piéton de Paris* (Paris: Gallimard, 1939), 103.

cross the damp oozing pavement to purr and rub up against the ankles of cops on their bicycles. To look "sporty" men without false collars relieve themselves at length under the arches of the carriage entrances while samples of high-toned snobbism who have pulled up there in Deluges or Bugattis unreservedly admire the free-wheeling human types.[31]

In fact, he complains, the rue de Lappe is hardly better than a stage set, even "the puddles look like they were put there by stagehands from the Opéra-comique." His half-ironic solution to the irremediable changes was to save the fast-disappearing culture of the eleventh arrondissement by turning it into the equivalent of a museum exhibit of an "ancient" civilization: "Why doesn't someone re-create a fragment of the real rue de Lappe as an exhibit for some corner of the Exposition—if only to appreciate how far we have come."[32]

Fargue's description of a real street become stage set, where real people play themselves, acting out their lives as they go about their business, provides a striking example of the way in which the real becomes spectacle. Of course, Fargue's sense of loss would hardly be shared by the tourist arriving in a Bugatti, who saw the "real" rue de Lappe for the first time. Nonetheless, it is precisely the psychological distance created by the spectator's presence, the self-consciousness it instills in both observer and observed, that transforms their perception of the real. Much like the physicist's or ethnographer's intrusion on the physical or cultural phenomena he observes, the presence of an observer or spectator perturbs the system and ultimately, although perhaps only very slightly or gradually, alters it.[33] For Fargue the very nature of places

31. "Ce n'est plus qu'une artère, une varice gluante d'enseignes électriques de la dernière heure, qui semble ouverte et de laquelle s'échappe un aigre sang de music-hall. Des voyous en melon traînent le long des voûtes comme des soldats de plomb froissés. Des chats traversent le pavé suintant et ronronnent le long de la cheville des agents cyclistes. Des hommes privés de faux col, pour faire 'sport,' se soulagent longuement sous les portes cochères, pendant que les échantillons du haut snobbisme venus là par Delage ou Bugatti, admirent sans réserve des types humains si libres d'allure." *Ibid.*, 99.

32. *Ibid.*, 102–103.

33. While this is the perception that lies behind Heisenberg's uncertainty principle, it is also a source of concern for the anthropologist. In pointing out that the term "participant observation" can be misleading, Margaret Mead noted that when the anthropologist lives in a native community he changes the form of it, providing new employment and new sources of material objects. Margaret Mead and Rhoda Métraux, *The Study of Culture at a Distance* (Chicago: University of Chicago Press, 1953), 47. More subtle psychological changes are considered by Jean Jamin, who notes the tendency of current research in enthology to "réintroduire le sujet observant et le sujet observé dans ses analyses; aussi tente-t-elle d'apprécier les effets sociaux et culturels de l'observation dite participante." Jean Jamin, "Une Initiation au réel: A propos de Segalen," *Cahiers internationaux de Sociologie*, LXVI (1979), 127.

and events was transformed because of the presence of the spectator. Ultimately the spectator might be absorbed into the system as a paying customer or an "extra" who plays a cameo role, but, in any case, the shift in perception introduced by the spectator is at the heart of an increasing awareness of the erotic dimension of the city.

Brassaï's photographs both reproduce and formalize this awareness. In doing so they naturalize the artificial by recording a moment in an ongoing process, hence what Szarkowski calls "their poise" and the seeming naturalness of the images. Inevitably however, like Fargue's museum exhibit, they derealize the culture they attempt to preserve. Brassaï's photographs become synonymous with a certain image of Paris, a certain look or style, at once avant-garde and fashionable. By 1939, when an article in the August *Harper's Bazaar* chided the chic modern woman for "the apache habit of talking with a cigarette drooling" out of the corner of her mouth, imitating apache manners and dress had already gone out as a fashionable pose.[34] Significantly, *Harper's Bazaar*—a fashion magazine with overtones of high culture—would be Brassaï's most important professional outlet during the forties and fifties.[35] This was also the period when Brassaï would translate his vision of the city into other media.

When the September, 1945, issue of *Harper's Bazaar* announced a striking innovation in theatrical décor, the subject was Brassaï's photographs of a Paris street, enlarged to life size, which formed the backdrop for *Le Rendez-vous*: "the most talked about ballet in the new [liberated] Paris . . . based on a theme by Jacques Prévert." A short paragraph summed up the theme, its dark fatality typical of the late thirties: "It is Paris. It is night. At a street corner a young couple kiss, a clock strikes, a young man meets a woman, his destiny, his death." Seven months later the April, 1946, issue announced another new Paris production: Giraudoux's *The Madwoman of Chaillot*. Its star, Marguerite Moreno, based her interpretation of the madwoman on Brassaï's haunting portrait of Bijou, the "old cocotte" reduced to telling fortunes in Paris cafés, whose photograph had appeared in *Paris de nuit*. The short article was illustrated with Brassaï's photograph juxtaposed with images of Moreno in costume.[36]

Marcel Carné also sought to re-create the look of Brassaï's Paris for his 1946 film *Les Portes de la nuit*.[37] Ironically, André Bazin paid greater homage

34. *Harper's Bazaar* (August, 1939), 89.

35. In the forties and fifties *Harper's Bazaar* published articles or excerpts of work from important French writers including Colette, Jean Giono, Saint-Exupéry, and Simone de Beauvoir on Sartre.

36. *Harper's Bazaar* (September, 1945), 146–47; (April, 1946), 148–49.

37. Brassaï's *Conversations avec Picasso* reports that in August, 1945: "Marcel Carné, Jacques

to Brassaï's style than to Carné's film when he observed that the ambiance of the décor "invaded the screen." While "this observation is not necessarily or *a priori* a reproach," Bazin hastened to add, "nevertheless, the proliferation of décor in *Les Portes de la nuit* implies that this film is based on a *baroque* style in contrast to the *classical* simplicity of *Le Jour se lève* where the décor is almost completely subordinated to its dramatic function" (my emphasis).[38] During this period, what might have been seen as the disturbing or ambiguous content of Brassaï's images was displaced by a perception of style, the nocturnal imagery becoming a metaphor for the dark days of the thirties, a symbolic way of conveying the sense of fatality and impending doom that surrounded the apprehension of war.

While both *Voluptés de Paris* and *The Secret Paris* are also products of a Baroque vision of the city, by and large they escape (if for different reasons) being consumed as spectacle or absorbed as style with much of Brassaï's production of the forties and fifties. Neither work can be completely reduced to elements of an urban décor; neither is saturated with the heavy, ominous quality that attaches to the conception of the social fantastic and pervades the urban drama in Mac Orlan's work.[39] Ironically, in the case of *Voluptés* the aesthetic qualities of Brassaï's images are attenuated by the dubious taste that guided their presentation. The book seems to reflect the more sensationalist leanings of the publisher Vidal, who was also the force behind *Scandale*.

Although Brassaï had published his work in *Scandale* on more than one occasion, he had every reason to be dismayed by the title and the tone of the preface, which sensationalized even the most innocent of the photographs. If few of the photographs were completely innocent, they were rarely explicitly erotic. In a number of cases the eroticism of the image depended on the substitution of a sign of the forbidden for the evocation of "volupté." A case in point is the image of three masked women who stand on the platform at the entrance to an attraction at the Foire du Trône. While they

Prévert, the decorator Trauner, Joseph Kosma, and myself met at Les Vieilles on the rue Dauphine to discuss *Les Portes de la nuit*. Carné wanted to re-create in the sets the atmosphere of my early book *Paris by Night*." Picasso, n. 190.

38. "Dans *Les Portes de la nuit* le réalisme du décor en dépit des apparences n'est guère plus dramatique. L'ambiance envahit tout l'écran. Cette constatation n'est pas nécessairement et *a priori* un reproche." André Bazin, "Le Style et l'univers de Marcel Carné," in *Marcel Carné*, by Robert Chazal (Paris: Editions Seghers, 1965), 146.

39. We might also add Eugène Dabit's *Hôtel du Nord*. Both Mac Orlan and Dabit interpret the city in ways that suggest comparisons with Brassaï's work. Both were (with *Le Jour se lève*) interpreted by Carné in the dark hours of the late thirties.

function as (rather depressing) signs of coming attractions, they are not the real focal point of the image; rather it is the round sign to the left of the stage reminding the crowd of spectators that no one under sixteen will be admitted. This shift away from the center of the image occurs almost by default, for Brassaï seems to have caught his performers off guard or between acts. The women look offstage, two in the direction of the sign; the third stares blankly past the crowd of spectators whose hats fill the right-hand corner of the image. None of the women onstage connects visually with the faceless male audience, and the photograph conveys no erotic tension. The viewer's eye wanders from the woman in the center of the image out to its edge in the direction of her gaze, or follows the lighter areas in the print: a hat in the foreground, a light bulb hanging over the women's heads, the shiny material that the women have draped over their scanty costumes, or their nudity, and moves back out to the sign at the edge of the image. (A more successful version of this shot from *The Secret Paris*—see Figure 23— brings events into focus, clarifying them for the viewer. The hats of the spectators define the foreground, and beyond them the three women—the center one stolid, mannish, and somewhat wary, the other two smiling— face the crowd. The wooden supports of the curtain that frames the platform parallel the edges of the image, drawing the viewer in toward the stage. The sign, now no more than a detail of the décor, is only partly visible—only "tacle" is legible.)

Another shot of street fair "voluptés" actually takes signs as its subject. Two signs indicating "Spectacle inédit pour adultes seulement" ("Extraordinary Show for Adults Only") and "Séance pour les adultes à partir de seize ans" ("Show for Adults Sixteen and over") are at the center of the image; below them is suspended a photograph of a woman wearing a tutu. Standing next to the signs but half turned away from the viewer is a woman in a similar short grass skirt, whose role may be that of the woman in the photograph. She stands nonchalantly, ankles crossed, as though waiting for her cue. This photograph (number three in *Voluptés*) does not have an equivalent in *The Secret Paris*, nor does photograph thirty-four, a variation on the same theme where the erotic nature of the subject—a *cliché galant*—is diffused by the presence of photographers who fiddle with their cameras and lighting while the half-naked subject turns her back to them to face what appears to be the mirror of an armoire just glimpsed at the edge of the photograph. While aesthetically none of the three photographs is very successful—they all seem formally "out of focus," like the shot of the women at the Foire du Trône—these photographs emphasize the theatrical nature of the events they

portray and suggest one of the most persistent presences in the photographs of *Voluptés de Paris,* the spectator/voyeur.

In most if not all (some ninety-four out of a hundred) of the photographs that appear in both *Voluptés* and *The Secret Paris,* the spectator is assimilated to the invisible photographer/viewer. However, in the photographs of *Voluptés* the masculine spectator is a far more insistent presence (figuring in a quarter of the photographs), and he serves to define the provocative nature of the image. The most innocent of such photographs reinterprets one of Atget's "Surrealist" subjects: the mannequin. Brassaï's photograph takes as its subject the corset shop window that figures in both Atget's early and late work. More direct and literal than atmospheric, Brassaï's photograph is closer in feeling to Atget's early work, yet the subject is transformed by the presence of a man—we see only his silhouette and profile—gazing into the lighted shop window. He seems drawn to the mannered gesture of the mannequin, who discreetly exhibits her charms along with her undergarments.

A far less innocent, but more powerful and elegant photograph—very disturbing in its underlying sadomasochism—was taken at the Folies-Bergère. This photograph foregrounds a voyeur/customer in a top hat silhouetted against the bars that rim the stage and enclose it as a "cage." His back turned to the invisible photographer, he watches as seven women inside the cage dressed in sequined but topless leotards languorously act out the part of wild beasts. (In the far more tame *Secret Paris* version, the image is shot from above the "cage," its bars barely visible. There is no spectator, and the women are lying down as though sunbathing. If there is still a sense of the photographer's peeping at them and catching them unaware, the real meaning of the spectacle evaporates.)

The best of the photographs from *Voluptés de Paris* that find their way into *The Secret Paris of the 30's* give formal expression to Surrealist-Baroque perceptions of incongruity or "otherness." This is the case of the photograph showing a uniformed policeman with his arm around a topless performer, both completely absorbed in the show they are watching from backstage, their heads stuck through the stage curtain, or the beautiful photograph of the couple dancing at the Bal Nègre (Figure 24). (This image should be compared with Man Ray's photograph of Kiki with an African mask from 1926—Figure 25—as it provides some insight into the differences in style and temperament of two major photographers of the thirties. While the aesthetic perception underlying the images is similar, Man Ray's image is carefully posed and thoroughly aestheticized.) Other examples of Brassaï's

perceptions of "otherness" include several photographs of homosexual or lesbian couples in which the viewer recognizes with perhaps just a split-second delay that one partner is a transvestite. However, two photographs provide some sense of the shift in perception Brassaï effects in recontextualizing these images in *The Secret Paris.*

The first, entitled "Hôtel meublé" in *Voluptés de Paris,* was taken in a *maison d'assignation* on the rue Quincampoix (Figure 26). Arguably one of the most beautiful of the photographs in *Voluptés,* it figures in the section "Houses of Illusion" in *The Secret Paris.* The image shows a man, seemingly fully dressed, standing in front of the mirrored panel of an armoire to button his shirt or knot and straighten his tie. The other mirrored panel frames the reflection of the back of a naked woman who is bending over to put on a stocking. The curves of her shoulders and buttocks assume the violin shape that Man Ray spoofs in a photograph of his then mistress, the famous Kiki, entitled "Le Violon d'Ingres."[40] The shape recurs in Brassaï's photographic studies of nudes, as well as his drawings and sculpture, revealing his fascination with formal analogies between the female form and musical instruments or fruit.[41]

Nothing else in the image attracts the viewer's attention except the wallpaper, which assumes particular importance because its strong repeat pattern of light and dark squares fills the rest of the space around the armoire. Very modern and very busy, the wallpaper clashes with the more delicate curved forms and decorative molding of the armoire. The clash of styles and the juxtapositions of light/dark, dressed/undressed, man's image/woman's reflection play off the spatial ambiguity of the composition. Brassaï uses the woman's reflection to create the illusion that the figures are together in the space of the frame—even though they have their backs to one another. The carefully composed photograph casts the man in the role of voyeur.

Not surprisingly, all of the photographs in *Voluptés* constitute the man as the spectator, the woman as the passive object of his gaze. However, a second glance at this particular image suggests the man is not looking at the woman's

40. The title puns by linking the idiom meaning "a hobby" with Ingres' nudes, not to mention the idea that Kiki might be an absorbing avocation.

41. Obviously such analogies exist in Picasso's work, and as Breton points out in *Surrealism and Painting,* they also anticipate qualities of the Surrealist image. Brassaï's interest in this analogy is expressed in a conversation with Picasso (Wednesday, October 20, 1943) about a series of twenty nudes he photographed, all in curving lines and contours—his Paris "arrondissements." He admits that "the thing that has always fascinated me in the female body is the aspect of it that seems to be some sort of vase, or musical instrument, or fruit." *Picasso,* 69.

reflection, but considering his own as he finishes dressing. If there is a voyeur, it is the photographer, whose gaze links the two figures in the complicated, illusory space of his composition.

The companion piece to this image does not appear in *Voluptés de Paris*. It centers on a prostitute, half-dressed in a black lace-trimmed camisole, stockings, and high heels, who is washing herself at a bidet, while to her right a man—fully clothed—finishes dressing, bending over to pull on a shoe or sock (Figure 27). Although it was taken in the same room of the hôtel meublé, this second photograph was shot from an entirely different vantage point and appears so different (the distinctive wallpaper almost completely hidden by a flowered, floor-length curtain) that if it were not for glimpses of the wallpaper and the fact that the massive, ornate mirror over the washbasin to the left of the bidet is reflected in a panel of the armoire in the other photograph, the viewer would have no reason to think the images were related.[42]

Brassaï shifts not only the physical vantage point from which the second photograph was taken, but its psychological or figurative vantage point as well, for the second image has a very different quality. Nothing in its apparently casual, seemingly haphazard composition suggests the photographer's presence, although part of the image's impact derives from the viewer's astonishment that this is a photograph, that the subjects allowed the photographer's intrusion. Almost too explicit—although the subjects' faces are averted—but certainly not erotic, this photograph would not have fit in *Voluptés*. Its fascination lies elsewhere: in its very intimate, yet very cool, detached—hygienic—portrayal of prostitution.

In comparison to "Hôtel meublé," the seeming artlessness of this photograph is striking. It confers almost as much importance on the large white washbasin that dominates the left half of the image as it does on the prostitute who occupies the center of the frame. In fact, the photograph has three distinct, isolated focal points: the washbasin, the prostitute on the bidet, and the man dressing to her right. In this photograph, as in all of the photographs reprinted in *The Secret Paris*, Brassaï directs the viewer's attention away from the image as spectacle—constituted by the implied or actual presence of a spectator—to emphasize the image's value as a document. Yet the photograph is not stylistically neutral, even if this were possible or desirable, as in the case of the professional ethnographer. In this photograph the casual, disjunctive composition might be read as the formal representation of the

42. The photographs appear in the same chapter of *The Secret Paris,* but they are not placed together.

arbitrary association between the man and woman, whose relationship has become a matter of hygiene.

Despite Brassaï's disclaimers, the photographs of *Voluptés de Paris* pay homage to Eros, framing the erotic as spectacle and aestheticizing the role of the voyeur. However, Brassaï is careful to present *The Secret Paris of the 30's* as a collection of personal documents, glimpses into the nocturnal life of the city in the thirties, records of a vanished and vanishing Paris. As befits the broader scope of the second work, there are images of bums, ex-cons, policemen, a series on cesspool cleaners, the now famous images of couples in cafés, fireworks from Bastille Day celebrations, and more intimate glimpses into the lives of street-fair and circus performers such as "Conchita" or "The Human Gorilla" and his infant son. Many of the same photographs—or variations on them—link *Voluptés* to *The Secret Paris*. Fully half of the photographs in *The Secret Paris* are images of lovers, street fairs, the Folies-Bergère, prostitutes and brothels, lesbian and homosexual bars and nightclubs; many are merely reprinted from *Voluptés,* although some are reduced in scale and presented as a cluster of images. Brassaï's recontextualization of these once "obscene" images diffuses and generalizes their erotic charge, converting it into another form of the exoticism attaching to representations of an earlier period.

Paradoxically, this temporal distancing parallels the seemingly greater naturalness of the images, which increases the effect of directness or intimacy. There are two major reasons for this, the first being that the spectator, either implied or actually present, does not play as important a role as a mediating figure, while the second is that Brassaï deliberately deemphasized elements of formal composition. As Colin Westerbeck points out, in at least two cases Brassaï cropped earlier versions of his photographs, sacrificing certain formal elements of the compositions in order to focus more attention on the people in the image. Westerbeck objected to the cropping, claiming it weakened the images by eliminating reflections and empty spaces that had symbolic value in the compositions. He theorized that Brassaï's sense of his work became "more human" as time passed, and that he was moved by "simple human nostalgia, which usually prefers sentiment unmitigated by art," to eliminate whatever formal elements would distract from the viewer's interest in his subjects as people.[43]

43. Westerbeck, "Night Light," 39. When Westerbeck questioned Brassaï about this in the course of the interview, Brassaï's response was that the cropping was done for formal reasons: "The eye should fall here, and it is necessary not to chase after things which distract it." A number of the photographs from *Paris de nuit* were cropped for similar reasons. In most cases the cropping strength-

Westerbeck's objections concern only a few of Brassaï's images, and the changes he observes affect those images in subtle ways. More important, Westerbeck focuses attention on a fundamental issue: the status of *The Secret Paris* as a revised work, a hybrid or heterogeneous structure that has much in common with the image of the Romanesque church that Brassaï used to symbolize his changing vision of Paris. Like the church, altered by the addition of Gothic towers and the refurbishing that gives it a Renaissance interior, *The Secret Paris of the 30's* is a complex, multilayered construction mixing aesthetic perceptions from different periods of Brassaï's life as an artist and reflecting a new perception of the meaning of his photographs.

Clearly, one of the most powerful elements in Brassaï's recontextualization of these photographs from the thirties is the narrative that frames them, focusing attention on their content rather than their formal qualities. Like all of Brassaï's writing, even the ethnographic commentary accompanying his photographs of graffiti, it is an autobiographical narrative. Yet it does not unfold chronologically, forming instead a series of independent chapters like beads on a string. Each chapter elaborates on a subject associated with a cluster of photographs: "The Concierge of Notre-Dame," "The Urinals of Paris," "A Night with the Cesspool Cleaners," "The Bals-Musette." Written in a light, conversational style, some of these chapters could almost have been written as short features for *Vu*. In fact, Brassaï's images of fortune-tellers suggest Kertész's photographs for an article on the same subject that appeared in *Vu* during the thirties, while the series of images of cesspool cleaners might have been a follow-up to Kertész's series of photographs of *petits métiers* for the same review. Germaine Krull's photographs for Henri Danjou's article on tramps and vagabonds for *Vu* might well have been replaced by the photographs Brassaï chose for the section entitled "The Last Bum of the Cour des Miracles." Yet these images were fresh and unfamiliar to the reader in the seventies when *The Secret Paris of the 30's* was published.

ens the composition by tightening and focusing it. Westerbeck's point is well taken, nonetheless, as these instances of cropping were done well after the initial publications of the images. His argument seems particularly valid in the case of the famous photograph of two lovers (photographed in the Bal des Quatre Saisons, rue de Lappe) turned sullenly away from each other as if after a quarrel. The original print includes the out-of-focus reflection of a woman's face in the mirror above the couple's heads; the star-shaped nail that holds up the mirror takes the place of the woman's eye in the reflection. As Westerbeck suggests: "this disfigurement turns the mirror image into a kind of fantasy that might be going on right at this moment in the man's mind." However he goes on to assert that "an eye that is masked or blinded from the camera is a constant motif in Brassaï's photographs." There is no evidence for this, although the comment might apply to Surrealist Victor Brauner, one of whose paintings was later taken to have prefigured his loss of an eye.

Brassaï avoided discussing the artistic and literary life of cafés like the Dôme (despite its importance in his own artistic development) in order to concentrate on lesser-known aspects of the period. Yet he does expand on images from his early work (notably the photographs of Bijou from *Paris By Night*— see Figure 21), which made a strong impression on an earlier public.

Consequently, Brassaï's narrative is neither a memoir nor an attempt to write social history. Practical considerations such as the desire to avoid clichés about the period and to introduce new material to the public while capitalizing on earlier successes dictated the selection of particular images, these in turn suggesting the development of Brassaï's narrative. Nonetheless, there is an effort to provide a unifying visual metaphor for the collection of photographs.

Two paired shots frame the text: the first is an image of a gas company employee lighting a lamp on the Place de la Concorde, figuratively illuminating the people and places that figure in the subsequent images. The last photograph in the book shows a similar lamp being extinguished in the rue Emile Richard (in Brassaï's neighborhood—the fourteenth arrondissement), putting out the lights, so to speak, and closing the book. This framing echoes the layout of *Paris By Night,* which opened and closed with close-ups of the rain-wet streets of the city, showing a concentric pattern of paving stones that recalled the then familiar René Clair film *Sous les toits de Paris.* The framing also recalls Paul Morand's "captivating promenade," by suggesting that the photographs placed between these two shots are records of what was seen on a nocturnal ramble that lasted from dusk to dawn. These formal echoes are clearly intended to recapture the spirit and style of the thirties that characterized *Paris by Night,* but they also suggest the work's relationship to the current of nostalgia that animated the *mode rétro* of the seventies.

The nocturnal promenade that structures the work begins with Brassaï's climb to the top of Notre-Dame. The first photograph in this chapter serves as the equivalent of a cinematic establishing shot (Figure 28) by providing a gargoyle's view of the city from the tower of Notre-Dame. From here the reader descends the two hundred–some steps from the tower, following Brassaï into the streets and then into the closed and secret places evoked by the title. The photographs in the early chapters recall a nineteenth-century Paris. In fact, Brassaï's panorama of the city, like Meryon's famous etching *Le Stryge* (see Figure 9), is inspired by Victor Hugo's famous description of the city in *Notre-Dame de Paris.* Both Meryon's etching and Brassaï's photograph adopt exactly the same perspective on the city: Viollet-le-Duc's gargoyle, the product of nineteenth-century restoration efforts, is silhouetted against a sea of

roofs out of which rises the tour Saint-Jacques. Sentinel, figurehead, and lookout, Meryon's gargoyle is a menacing, almost diabolical figure, an embodiment of the forces of evil suggested by the birds ominously circling the tower. In a figurative sense *Le Stryge* stands just inside the gates of the city (represented in the frontispiece to Meryon's *Eaux-Fortes sur Paris*) like a guardian at the gates of hell.

Brassaï's photograph adopts the same approach, but gives this figure an ironic twist. For even though the lights below make the milky haze rising above the city seem like smoke from hell's fires, Brassaï's gargoyle is not a guardian or a sentinel but a casual observer who looks out over the city, his elbows propped up on the ledge (see Figure 28). As Colin Westerbeck observed, "the casual, almost languid way his head is cupped in his hands as he contemplates the city is really comical." [44] The gargoyle stands in for the photographer, a curious yet detached observer of the human comedy, unshockable, more bemused than frightened or threatened by the curious twists and turns of fate he can trace in the winding streets below.

While the gaslights that symbolically illuminate the images in the book are vestiges of an earlier time, the Hugolian Paris of these early chapters gives way to the Proustian Paris of the second half of the book, where the chapter on "Sodom and Gomorrah" is only one of the many references to *A la Recherche du temps perdu*. Certainly the emergence of lesbianism and homosexuality as important themes of literary work has roots in earlier literature—Baudelaire and Balzac's treatments of perverse or criminal love are obvious examples, just as Balzac's Vautrin provides a French equivalent for the criminal hero Brassaï admired in Dostoevsky's fiction. Yet Brassaï seems most strongly influenced by Proust in his conception of his work from this period—no doubt because Proust's reflection on the role of time and memory played a role in Brassaï's meditation on his earlier work. Perhaps it is also for this reason that Surrealism, one of the most important artistic influences on Brassaï's work in the thirties, fades into the background as an explicit reference.

Nonetheless, its influence can be felt in the ethnographic surrealism of Brassaï's larger photographic project: his desire to discover the nature of the hidden reality lurking "behind the façades, in the wings," and on the margins of society where the half-lit streets, the cafés, music halls, dingy bars, and hotels revealed glimpses of another "secret, suspicious world closed to the uninitiated" (*SPT*, Introduction). The desire to escape the limits of his own subjectivity by entering into another culture led Michel Leiris to ethnog-

44. Westerbeck, "Night Light," 36.

raphy. By contrast the Surrealists' desultory·exploration of Buttes-Chaumont as Mesopotamia seems like a parodic quest, yet both cast some light on Brassaï's exploration of the seemingly ordinary in search of another reality.

Certainly Brassaï's efforts to represent an exotic, defamiliarized culture are distinctly different from more recent empirical research using photographs as records. John Collier clarified the limits of this research in "Photography and Visual Anthropology" in which he asserted that there are only three ways to use photographs scientifically: "to measure, to count and to compare." Photographs provide a reliable means to map and inventory particular locales and record "patterns of human distribution and mingling." "There really are no other ways to use photographic records scientifically," he maintained, "except to use photographs as stimuli in interviewing. Certainly the projective use of photographs offers a rich recovery of data, but so do old maps and ink blots." [45]

Collier would be, at the very least, uneasy about any ethnographic claims made for Brassaï's work, which could easily be dismissed as a very selective personal vision, implicitly "projective," predicated on the romantic identification—even infatuation—with his subjects that Brassaï considered an almost indispensable stimulus for his best work. Yet as Howard Becker indicated, "many artists' visions are of the truth of the world," and Brassaï's *The Secret Paris* also represents a particular mapping of space that focuses on the shadowy intersections between public and private domains. Collier himself notes that the line separating them varies enormously from culture to culture, and as Brassaï's recontextualization demonstrates, it also shifts within cultures over time.

Like ethnographic surrealism, Brassaï's work represents "a way of taking culture seriously, as a contested reality," [46] but it also draws attention to the role of the observer and the repercussions of participant observation on this culture. In this regard—if only in this regard—we might draw a parallel between Brassaï's representation of another culture and that of the writer Victor Segalen, who, as Jean Jamin points out, was considered too much of a poet to be an ethnographer, too much a lover of the exotic to be an ethnologist. [47] Widely traveled in Polynesia and China, Segalen both dramatized and fictionalized his encounters with these cultures. While he attempted initially to re-create the exotic culture as he imagined it seen

45. John Collier, "Photography and Visual Anthropology," in *Principles of Visual Anthropology,* ed. Paul Hocking (The Hague: Mouton Publishers, 1975) 213, 218.
46. Clifford, *The Predicament of Culture,* 121.
47. Jamin, "Une Initiation au réel," 126.

through the eyes of the other, he turned increasingly to examining the culture through his own responses to it, his efforts to grasp its hidden truths and essential mysteries. If professional ethnologists and anthropologists dismiss Segalen's work, for Jamin at least Segalen's importance to ethnology resides in his preoccupation with the difficulties inherent in ethnographic description. Michel Leiris's journal-account of the Mission Dakar-Djibouti in *L'Afrique fantôme* takes up these same problems in the context of the first French ethnographic expedition. However, according to Jamin, Segalen sensed even earlier that "no society, no culture possesses an ideal vantage point—geometric center, ethnologist's dream—from which it can be seen all at once." [48] Segalen realized that the observer was implicated in what he saw, that his way of seeing, his desires, his perspective on the other inevitably had an impact on the way this other culture could be seen and understood. The observer—like the narrator in Segalen's 1922 novel *René Leys*—can never be certain how much the other is a reflection of himself.

The "play of mirrors" Jamin describes assumes considerable importance in Brassaï's definition of his subjects, yet this does not overshadow the formal complexities of his representation of them. The fascination of his work is precisely the tension it sustains between the image as social fact and artistic dramatization, objective and subjective reality. "All documents of all periods are false," Picasso argued vehemently in Brassaï's *Conversations avec Picasso,* "they all represent life 'as seen by artists.' . . . That alone would be enough to make [them] suspect. You speak of 'objective reality,' but what is objective reality?" (*Picasso,* 141). Brassaï's *The Secret Paris* remains suspect as a re-creation of the past because it is a personal collection, and in that sense is an exercise in the Surrealist abbreviation of history. Yet it also provides ethnographic evidence, fragments salvaged from a past we cannot recover, but can only partially reconstruct.

In the last chapter of *The Secret Paris,* "An Opium Den," the emphasis falls more on subjective vision than on cultural history. Haunting images of ghostly faces, these photographs portray their subjects' withdrawal into an opium dream. Yet the last image we see, just before the gas lamps are extinguished, is of Brassaï himself—although he is identified only as "M. B."—dressed in a brocade kimono and reclining on a low, cushioned couch, a pipe in his hands. His photograph reaffirms the double nature of these images as art and as evidence: it is both the artist's signature and a reminder that the photographer was present as a witness.

48. "En décrivant la réalité des autres dans une perspective de soi, Segalen pressentait que nulle société, nulle culture ne possède ce lieu idéal—centre géométrique, rêve de l'ethnologue—d'où elle peut être vue toute à la fois." *Ibid.,* 130.

V

The Photographer and the Artists in His Life
Questions of Art and Style

Brassaï's *The Artists of My Life* bears some family resemblance—if only that of a distant relative—to Vasari's *The Lives of the Artists.* Both works appeal to the public's curiosity about the people whose creations shaped the cultural landscape. The first biographical work of its kind, Vasari's *Lives* appeared in 1550, just eight years before a book entitled *Natural Magic* detailed the first use of the camera as an aid to artists and draftsmen.[1] Vasari, a highly successful painter under the Medici, undertook the writing of a "treatise on the illustrious artists from the time of Cimabue to the present" at the urging of the Bishop of Nocera, who felt that "someone of the profession" would be best suited to deal with the technical details involved in the project.[2] Vasari had to steal time from numerous commissions during the seven years it took to write the treatise, but he was industrious and obsessed by art. One critic compares him to Uccello, still "murmuring about the beauties of perspective as his wife nagged him to bed."[3] This same fascination with art and artists underlies Brassaï's representations of some of the most famous artists of the modern period. His work, like Vasari's, could have been dedicated "to those who follow and delight in the arts."

1. Beaumont Newhall, *The History of Photography* (New York: Museum of Modern Art, 1978), 11.
2. T. S. R. Boase, *Georgio Vasari: The Man and the Book* (Princeton: Princeton University Press, 1979), 43.
3. George Bull, trans., Introduction to *The Lives of the Artists,* by Giorgio Vasari (New York: Viking Penguin, 1965), 9.

Like Vasari, Brassaï "had a thoroughly professional knowledge of the arts," and "a great interest in human nature and gossip about it."[4] Both men apparently had a gift for friendship, in addition to the talent and insight that made them valuable friends. More than one historian insists that Vasari's friendship with Michelangelo was "not to be explained simply by Michelangelo's appreciation of the useful publicity his compatriot could provide."[5] By the same token, in a review of Brassaï's *Conversations with Picasso*, Alan Bowness points out that Brassaï's "great advantage as an interlocutor arises from his being an artistic personality in his own right and someone whose talents as a photographer interested Picasso."[6] Matisse's daughter suggested something similar when she told Brassaï, "You were one of the people he really liked, one of the ones he felt gave him something" (*Picasso*, 254).

In any case, for both photographer and painter the association with a great contemporary artist was a determining factor in their perception of the arts of their time. Michelangelo's career furnished the climax for the scheme and structure of Vasari's *Lives* by serving as a confirmation of his thesis that a decline in the arts could be reversed by an artist of great genius.[7] Brassaï never ascribed the same teleological importance to Picasso, yet their friendship colored his relationship to other artists, and Picasso occupies the central place in Brassaï's pantheon of artists as the epitome of creative intelligence. On a more personal level, Picasso continually challenged Brassaï to define himself as an artist, and the *Conversations with Picasso* provide revealing glimpses of Brassaï's own views on art and aesthetics. With the introduction to *Camera in Paris*, Brassaï's most direct statement about his aesthetics, the *Conversations* help to define Brassaï's particular vantage point on the artists of his life.

The title of the book, *The Artists of My Life*, might suggest that Brassaï wanted to document important influences on his own development as an artist, but he quickly dispels that impression. "Art and artists were part of my own day to day life," he explains in the introduction, presenting his images and the short essays that accompany them as a "species of family album, a photographic record of . . . friends and acquaintances" (*AML*, 9). Diplomatically, he introduces the artists in alphabetical order, for unlike Vasari, Brassaï had no need to establish the canon; the artists of his life were already famous. In fact, in most cases their stature as artists was precisely the

4. Boase, *Georgio Vasari*, 43.
5. Bull, Introduction, 10.
6. Alan Bowness, "Two Books on Picasso," *Studio*, CLXXIV (July, 1967), 71.
7. Bull, Introduction, 15.

reason for his association with them. Published in art and popular magazines, his photographs not only provided "useful publicity" for them but established his own reputation as a photographer and an artist.

If we consider these photographs the product of a compromise between professional necessities and personal interests, that in no way lessens their importance as a major subject in Brassaï's work. As a continual reprise of the subject of the artist over a period of some forty years, the photographs raise important questions about Brassaï's conception of the artist and the way in which he envisioned the relationship between photography and more traditional art forms. His photographs frame the artists and reframe their work in his own compositions, emphasizing the tension between the subjective representations of art and the so-called "objective" representations of photography. Highly reflexive in that they represent a meditation on the nature and conditions of artistic creation, his photographs also represent a testing of one artist's medium against another.

Defining a Point of View

Brassaï was aware that the artists he photographed might view his work patronizingly, considering him a failed artist, someone who lacked either the talent or the conviction to do serious work in a traditional medium. Something of this attitude emerges in his *Conversations with Picasso,* in which he reports Picasso's astonished reaction on seeing his drawings. "You're a born draftsman," Picasso exclaimed, "Why don't you go on with it? You own a gold mine and you're exploiting a salt mine." "A lively discussion ensued," Brassaï continued dryly. "I tried to explain to him why I had decided in favor of photography. He interrupted me often and I listened to his objections and his reproaches" (*Picasso,* 47).

Brassaï does not make the reader a party to his defense of photography in the *Conversations with Picasso,* but the introduction to *Camera in Paris,* published just after the war, does attempt to justify his preference for photography and to explain the nature of his vision as a photographer. It is a curious self-justification, for Brassaï hides behind the third person just as he might have hidden behind his camera, referring to himself indirectly as "a man who has given the best part of his life to an occupation of absorbing interest."[8] Equally striking are his efforts to define his "occupation" by ex-

8. *Camera,* 9. He sustains the third person throughout the introduction, despite several remarks where the apparently inadvertent use of "I" confirms that he is expounding his own views.

clusion. Unwilling or unable to classify the nature of his work, he tells the reader that he is *not* a professional photographer, *not* a reporter, *not* a poet. Is he then "by default" an artist? He raises the question, but his answer— that he is not an artistic photographer—suggests a reluctance to make such claims for his work.

In fact, he went much further, adamantly refusing to consider his work artistic photography—"Artistic photographer! Horrible!"—basing his refusal on a deliberate confusion of photographic "art" with special effects (*Camera*, 10). *Camera in Paris* condemns such effects in no uncertain terms, whether achieved through the organization of the shot: "Puzzle pictures, . . . 'against-the-light effects,' luminous halos, viewpoints from awkward angles, dizzy bird's eye views, the world seen through the eye of the microscope"; or through darkroom manipulations of the print: "such childish amusements" as superimpression or solarization. Brassaï also derides efforts to imitate the "latest fads" in painting, deliberately rejecting both the soft-focus pictorialism that dominated the work of the preceding generation of photographers and the kind of photographic experimentation—photograms, distortions, photomontage—advocated by Moholy-Nagy (*Camera*, 10). In the now famous essay "Photography is Manipulation of Light" that appeared in a Bauhaus publication in 1928, Moholy-Nagy called attention to the way photographs can extend the human field of vision because they provide "an unprejudiced optical view which our eyes, bound as they are by the laws of association, cannot give us." Unlike Brassaï, Moholy-Nagy advocated a careful examination of photographs "in a so far unaccustomed style—rare views, oblique, upward, downward, distortions, shadow effects, tonal contrasts, enlargements, microphotographs" (see Figure 29).[9]

Brassaï's rejection of any form of special effects clearly identifies him with the documentary approach typical of his work after the war. For despite his Surrealist experiments in *Transmutations* and isolated, if brilliant, examples of Surrealist montage, such as the *Ciel postiche* that appeared in *Minotaure* in the mid-thirties, Brassaï never seriously pursued the kind of technical experimentation that fascinated Man Ray and characterized Moholy-Nagy's approach to the medium. However, he was not the simple reporter he suggests in the introduction to *Camera in Paris*. Several of the photographs in that collection demonstrate the influence of the Bauhaus's investigations into optical effects that could be obtained by using the camera as an extension of the eye. Although Brassaï never sacrificed a coherent representation of his

9. Andreas Haus, *Moholy-Nagy: Photographs and Photograms* (London: Thames and Hudson, 1980), 48, 127.

subjects to the striking visual effects that could be obtained by extreme close-ups, bird's-eye, or worm's-eye views of them, his rooftop view of a "Sub-urban Street" (photograph number 39 in *Camera in Paris*), the smoky pan-orama of Paris seen in the fog from the top of Notre-Dame (number 32), and a plunging view of the stage at the Folies-Bergère (number 44) show him willing to exploit such vantage points to convey the complexities of visual perception. If his repudiation of formal experimentation is not as clear-cut as it first appears, neither is his rejection of drawing in favor of photog-raphy. In the second part of the preface to *Camera in Paris* Brassaï deliberately blurs the distinction between them by identifying himself with Constantin Guys, then with Rembrandt, whom he boldly baptizes the father of pho-tography.

Brassaï's choice of Guys as a model or precursor for his work is both apt and revealing. He claims Guys as the first eyewitness reporter—Guys's draw-ings appeared in *Punch* and *The Illustrated London News*—the antithesis of the artist, who (he quotes Baudelaire) is a "specialist," an isolated figure "chained to his palette like a serf to the soil" (*Camera,* 11). Guys, on the other hand, is "a man of the world," a "connoisseur of life," a "collector of impressions," whose career allowed him to satisfy his boundless curiosity. Yet a certain Baudelairian dandyism attaches to this position, for although Baudelaire's Guys delights in mingling with the crowd, he remains apart from it, the intensity of his perceptions a function of his alienation. There is, in fact, as Jeremy Wood has pointed out, "something of the dandyism and detachment of Baudelaire's *flâneur* to be found in Brassaï's approach to the habitués of Parisian night life." [10] However, if Baudelaire's "observer is a prince, who, wherever he is, keeps his incognito," Brassaï counterbalances notions of ar-istocratic superiority and reserve by appealing to the "humanity" of Rem-brandt, "the ancestor of all reporters of life." Brassaï invokes Rembrandt as one of a "family of minds" (including Goya, Daumier, and Hokusai, with nods to Degas and Toulouse-Lautrec) concerned with investigating reality. Artists such as these, he argued, whose work embraces the full range of human experience, not excluding the poor, the old, or the outcast, "awaken painting from the torpor of convention by administering to it a whiff of fresh air from the street" (*Camera,* 12).

Equally significant, however, is the fact that these artists produced an important body of graphic work. Brassaï consistently (and strategically) val-ued sketches and drawings more highly than carefully elaborated composi-

10. Jeremy Wood, "Brassaï: A Major Exhibition," *Pantheon: Internationale Zeitschrift fur Kunst,* XXXVIII (1980), 119.

tions, even claiming that if he were asked to choose he would take one of Picasso's drawings over all of the artist's other work because drawings were the freest expression of an artist's personality and the clearest expression of his genius (*Picasso*, 56). Not surprisingly, in his praise for Rembrandt as a reporter of life, Brassaï neglected the artist's great paintings in favor of his drawings, contending that even the smallest "are vibrant with life," often "surpassing his finished pictures in perfection of style and beauty" (*Camera*, 18).

Brassaï's emphatic preference for drawing is one indication of his affinity with what John Rupert Martin referred to as the "style-consciousness" of the Baroque: "the direct expression of the original idea, untrammeled by tedious detail and finish."[11] However, this predilection for drawing also assumes significant heuristic and ideological importance in Brassaï's aesthetics. By dissociating the photographic process from its original role as a mechanical aid to painters in solving problems of perspective, Brassaï elaborates his own myth of the origins of photography. He assimilates the photographer's image to the artist's drawing because both satisfy the impulse to record certain visual impressions. Rembrandt's graphic style, the "shorthand" of his drawings then becomes "the first instrument designed for the purpose of seizing the fleeting moment. . . . the birth of the snapshot two hundred years before the invention of photography" (*Camera*, 17).

Brassaï sees its direct, vital link with reality as the source of photography's strength and its "power and prestige" as a modern medium. "Since they [photographers and cinematographers] possess the real power, it matters little whether they are considered to be 'artists' or as mere operators of picture machines," he concedes. He adopts photography as the new modern mode of expression, claiming that the great respect paid painting is "due to its former glory and not to the part it plays in modern life" (*Camera*, 16–17). If this implies a manifest destiny for photography implicit in its nature as a medium, the same view was held by Picasso (as Brassaï reports it in the *Conversations*):

Why should the artist persist in treating subjects that can be established so clearly with the lens of a camera? It would be absurd, wouldn't it? Photography has arrived at a point where it is capable of liberating painting from all literature, from the

11. "The consciousness of style—especially the cultivation of a distinctive personal manner—is characteristic of the Renaissance as well as the Baroque," Martin adds. "The difference is one of degree. For there is in the seventeenth century an intensified 'style-consciousness' that gives rise to such aesthetic phenomena as the 'bizarre and extravagant' architecture of Borromini and the 'unfinished' works of Rembrandt." John Rupert Martin, *Baroque* (New York: Harper & Row, 1977), 35.

anecdote, and even from the subject. In any case, a certain aspect of the subject now belongs in the domain of photography. So shouldn't painters profit from their acquired liberty, and make use of it to do other things? (*Picasso*, 46–47)

Where Baudelaire saw photography as a serious threat to the continuing vitality of painting and of art itself, Picasso embraced it. Yet he remained jealous enough of the prerogatives of his art to reproach Brassaï for playfully rearranging some objects in his studio before he photographed them. "It's your arrangement, not mine," he chided Brassaï, "the manner in which an artist uses the objects around him is as revealing as his works" (*Picasso*, 100). Of course, his insistence that Brassaï's photographs be "truthful," that they merely document a preexisting arrangement, might also have had its roots in a new science of creativity he envisioned. This new science, as he described it to Brassaï, would study the creative artist for clues about the nature of man, requiring precise information about when and under what circumstances artists did their work. "I often think about such a science," Picasso admitted, "and I want to leave to posterity a documentation that will be as complete as possible. That's why I put a date on everything I do" (*Picasso*, 100).

Brassaï may have taken the notes on which he based his *Conversations with Picasso* with a similar idea in mind, as they provide precisely the sort of documentation Picasso's science demanded. Brassaï's fascination with the circumstances of creation extended to all the artists of his acquaintance. Despite his conviction that the artist's life never explains his work, Brassaï had an intense interest, verging on outright curiosity, about the details of an artist's life.[12] His writings are full of facts taken from what André Breton referred to in *Nadja* as "the realm where the . . . personality, victimized by the petty events of daily life, expresses itself quite freely and often in so distinctive a manner."[13] He copied the list of paint colors Picasso ordered, recorded Henry Miller's changing preferences in literature and in liqueurs, even photographed the tiny nude with her legs spread that Maillol had modeled and hidden in a closet. This same fascination with the concrete details of an artist's life emerges in his photographs.

Nonetheless, Brassaï's apparent disappearance behind the things he photographed raises all the more urgently the question of what constitutes his style as a photographer. Brassaï insisted that the form of a photograph was as important as its subject, the formal perfection of the image ensuring that

12. Brassaï, "Reverdy dans son labyrinthe," *Mercure de France*, CCCXLIV (January–April, 1962), 164.

13. Breton, *Nadja*, 13.

it would "penetrate the viewer's memory" in order to become—literally—
"an unforgettable image." [14] In *Camera in Paris* he resolved the problem of
form versus content by adopting a paradoxical aesthetic of self-effacement,
maintaining that the more scrupulously the photographer respected "the
independence and autonomy of his subject" the more completely his own
personality would merge with it. The resulting photograph would "betray
his presence by a tone, a light, a familiar twist, which it would be difficult
to define" (*Camera*, 19). He refined the same paradox some forty years later
in an interview in which he affirmed that "photography reflects the infinite
variety of subject matter offered by the natural universe. But the range of
vision of the 'great photographers' is extremely narrow. They must confine
themselves to their own peculiar obsessions and types of images, which can
express character and feelings." [15]

The photographs in *The Artists of My Life* provide a series of images that
allow us to characterize elements of Brassaï's style, a certain tone, light, a
familiar twist. If they are only a sampling of Brassaï's many photographs of
important literary and artistic personalities, they represent something of a
professional specialty, for despite Brassaï's protests that he never took on
"assignments," his success in photographing Picasso's sculpture for the first
issue of *Minotaure* led to other commissions of the same type. *Minotaure*
requested photographs of five contemporary sculptors for issues three and
four. *Verve, Life, L'Oeil, Liliput,* and *Coronet* published photographs of Bon-
nard, Maillol, Matisse, and Picasso in the thirties and forties, and Brassaï
went on to do a series of photographs on famous artists and writers that
appeared in *Harper's Bazaar* off and on over a period of thirty years. Other
such photographs were published as illustrations in Brassaï's books on Picasso
and Henry Miller. A good selection of them is reproduced in *The Artists of
My Life* (most originally appeared in *Minotaure, Verve, Life,* or *Harper's Ba-
zaar*), and it provides a focus for examining a series of photographs on a
single theme.

The Artists and the Photographer

There are some drawbacks to limiting our attention to this particular work:
The Artists of My Life was not published until 1982, and the selection of
photographs necessarily reflects Brassaï's mature approach to his work, not

14. Hill and Cooper, eds., *Dialogue with Photography,* 39.
15. *Ibid.,* 41.

to mention practical difficulties in locating early negatives or reproducing certain photographs. In addition, different prints of particular photographs produce slight variations or shifts of emphasis: a photograph of D.-H. Kahnweiler, published in the English version of *Conversations avec Picasso,* appears in *The Artists of My Life* as a darker print that obscures details of Kahnweiler's clothing more clearly visible in the earlier reproduction. However, such variations have only a minimal effect on the viewer's general perception of the photographs. Moreover, the photographs in *The Artists of My Life* closely approximate the size of Brassaï's own museum prints, reproducing well both their strong contrasts and their glossy surface.

Of course, the photographs that make up *The Artists of My Life* vary greatly: some images focus on particular objects or works of art, others are shots of an artist's home or studio, some portray the artist at work, or out and about in the city. Taken at different times and under different conditions, some photographs seem more anecdotal, others deliberately artful. All are the product of particular circumstances, but also the result of a delicate, rarely explicit transaction between the photographer and the artist in which the photographer must be, as Brassaï suggests in *Camera in Paris,* patient, sly, and diplomatic (*Camera,* 19). He confessed that he had to cheat a little in order to photograph Bonnard, who, reserved and retiring, fragile after his wife's death, refused to pose for the portrait Brassaï had come to take. The sculptor Jacques Lipchitz had made another appointment for the time of the photographic session and, in a hurry to leave, was unwilling to give Brassaï more than several views of his studio. By contrast, other subjects were particularly eager to have their picture taken.

Both Matisse and Picasso were intensely curious about their image. "It's entirely different—the way other people see you and the way you see yourself at certain moments in the mirror—" Picasso remarked to Brassaï. "Several times in my life I have surprised an expression on my face that I have never been able to find in any of the portraits of me. And they may have been the most truthful of my expressions. We should arrange to put a hole in a mirror, with a lens behind it, so it could capture your most intimate expressions when you weren't even thinking of it" (*Picasso,* 119). If Picasso was interested in such photographs as a means of self-scrutiny, an effort to master his own image by studying its variations, other subjects hoped to have their portraits confirm the existence of a particular side of their personality: "People think I'm a withdrawn, sad man," Matisse complained, "but by nature I'm cheerful, even though my appearance leads people to think differently" (*AML,* 214). Brassaï must have felt some trepidation in showing his photographs to dif-

ficult subjects like the choleric Vollard, because although he could hardly be reproached for failing to get a likeness, his subjects remained the final arbiters of a "good" likeness.

In *Act of Portrayal* David Lubin suggests that the portraitist is "constantly engaging in forms of exploitation, . . . real-life artists capitalizing on real-life people." Yet the exploitation may involve an exchange: the artist can repay his subjects with "relatively appealing depictions of themselves." However, Lubin emphasizes that this is only the most "crude and literal" form of exploitation involved in portraiture; "far more subtle and more important," he argues, is "the way in which the real-life portraitist exploited or manipulated his medium to develop his fictive construction and, simultaneously, manipulated the fictive construction as a means of challenging the medium." Although Brassaï's photographs, even the most carefully composed among them, could never be considered the same kind of a fictive construction as a painted portrait, they share the inherent contradiction of the portrait: the necessity to produce an acceptable likeness of an individual and the potentially antithetical requirements of aesthetic form, internal consistency, and closure.[16]

Given the interaction (or interference) of subjects and circumstance with the photographer's vision, as well as the rapidity with which he must work, no one photograph can justify broad generalizations about a photographer's style. In fact, Brassaï's photographs of two famous art dealers—Vollard, who "cornered the market on Cézanne" (*AML*, 210), and D.-H. Kahnweiler, who gambled his future on the revolutionary importance of Picasso's *Demoiselles d'Avignon*—represent striking differences in tone and approach, suggesting the tension between Classical and Baroque tendencies in Brassaï's work. The photograph of Vollard is a simple, balanced composition that suggests the dealer's formidable physical presence (Figure 30). It is based on a double triangle, the large, primary triangle formed by the subject's pose. Vollard's hands form the base of this triangle; his head is at its apex. The smaller reverse triangle created by the stark white of Vollard's shirt against his dark suit anchors the composition. By contrast, Brassaï's photograph of Kahnweiler (Figure 31) suggests the qualities Brassaï associated with the Baroque (humor, mystification, excess, a passion for the strange and the fantastic).[17] Photographed standing next to Picasso's huge, irreverent sculpture of an angel, Kahnweiler is not only dwarfed by it, but blissfully unaware that

16. David Lubin, *Act of Portrayal: Eakins, Sargent, James* (New Haven: Yale University Press, 1985), 4, 12.

17. Brassaï, "La Villa Palagonia," 351–52.

its outstretched wing appears to threaten him with decapitation. The contrast between the two portraits suggests the range of work Brassaï produced on art and artists, adapting a variety of styles (Classical, Baroque, Rococo, Cubist, Surrealist, Bauhaus) to photographic effect.[18] However, it is precisely Brassaï's versatility and eclecticism that dictate an approach to his style through the particular act of imagination that configures his subjects as images.[19]

Joel Snyder suggests that a photographer's images give "expression to his rules of attending" and "in so doing [teach] his audience to attend in the same manner."[20] If we consider Brassaï's style to reflect his particular "manner of attending," the formal diversity yields some unity. His compositions reflect a patient watchfulness that leads him to wait for moments in the ongoing flow of events that seem complete in themselves. Consequently, his images have a static, "posed" quality, even when they record movement, such as the blur of Dufy's hands as he works. Only rarely—one in a hundred—do the photographs in *The Artists of My Life* freeze a gesture or a moment in time in such a way as to suggest something abruptly interrupted. Rather Brassaï's photographs prolong moments by suspending time. There is no contradiction in the fact that Brassaï delighted in photographing the ephemeral—the face Matisse doodled on a chalkboard in his studio with his eyes closed, Picasso's fragile paper sculptures or the towers Picasso built on his mantel out of empty cigarette packs—because his images guarantee the ephemeral a kind of permanence.

In writing *Conversations avec Picasso*, Brassaï complained that he was so "accustomed to a global and instantaneous vision of things" that "the necessarily arbitrary order imposed by an attempt to describe them" was baffling and disconcerting (*Picasso*, 240). This vision leads him to create a complex visual field by opening up the rectangle of the photograph—complicating its referential space with mirror reflections and fragments of deep space glimpsed through open doors or windows—and including numerous compelling objects, all of which compete for the viewer's attention. By tempting

18. Admittedly, these labels remain the subject of controversy.

19. Brassaï's photographs of Maillol's studio range from the monumentality of a Baroque vision of Maillol to the charm of the Rococo. Brassaï photographed a series of small figures placed on a window ledge in the studio: female nudes modeled in slightly different attitudes surrounding a kneeling couple. Viewed from left to right the different positions assumed by the various figures suggest a single figure executing a graceful turn. The figures trace a sinuous line reminiscent of the composition of Watteau's *Pilgrimage to Cythera*, stabilized by the strong horizontal and verticals of the window frame.

20. Joel Snyder, "Picturing Vision," *Critical Inquiry*, VI (Spring, 1980), 510.

the viewer to try to take in everything at once, Brassaï introduces, if not movement, a certain tension in his images. He often places his artist/subject off-center, in the middle rather than the foreground of the image, and while this allows him to use the artist's surroundings as attributes or emphasize the mysterious difference of creation that isolates him (there are few women in *The Artists of My Life*), it also very frequently has the effect of reducing the artist to one object among others of his own making. There are important exceptions to this: some photographs of Braque, a wonderful double portrait of Dali and Gala, certain images of Vollard, Maillol, and Germaine Richier are tightly focused on the artists. Nonetheless, such close-up portraits are in the minority in *The Artists of My Life*.[21]

The majority of Brassaï's photographs show him to be particularly attentive to the artist's surroundings and perhaps even more interested in the way they evoke the artist than in the actual presence of the artist. In some cases he—as Kertész did before him—uses objects metonymically. The fascinating series of photographs he took of artists' palettes provides indirect portraits of the artists: Bonnard's casual, unassuming arrangement of paint tubes on a low table, Dali's classic palette daubed with paints and theatrically held out at arm's length, Miró's carefully organized and neatly arranged worktable, Picasso's jumble of twisted paint tubes, abandoned on the floor like stubbed-out cigarettes.

When he does photograph the artists themselves, Brassaï's preference for relating the artist to his surroundings has an almost Balzacian quality. The famous description of Madame Vauquer's boardinghouse at the beginning of Balzac's *Père Goriot* is the classic example of the reciprocal interaction between subject and environment: Madame Vauquer's person supposedly explained her boardinghouse just as the boardinghouse implied her person, and the desolate interior of the house was repeated in the equally down-at-heel look of her boarders.[22] Yet Brassaï's tendency to read the objects that surround the artist as signs, the exteriorization of a particular creative sensibility, suggests a genuine fascination with the objects themselves. He shared

21. Nonetheless, the seated portrait of Maillol, a study in tones and textures, and the portrait of Dali and Gala are among the most beautiful in the book.

22. "Toute sa personne explique la pension, comme la pension implique sa personne. . . . Son jupon de laine tricotée, qui dépasse sa première jupe faite avec une vieille robe, et dont la ouate échappe par les fentes de l'étoffe lézardée, résume le salon, la salle à manger, le jardinet, annonce la cuisine et fait pressentir les pensionnaires. . . . Aussi le spectacle désolant que présentait l'intérieur de la maison se répétait-il dans le costume de ses habitués, également délabrés." Honoré de Balzac, *Père Goriot*, in *Oeuvres Complètes II: Etudes de moeurs, scènes de la vie privée* (Paris: Gallimard, 1963), 852.

the Surrealists' passion for collecting as well as their sense of the significance of certain chance arrangements of objects. The Surrealist and the collector in him are particularly drawn to the artist's involuntary compositions: Bonnard's personal gallery of postcard prints tacked up on a wall with a genuine Renoir; the incongruous clutter of Le Corbusier's cramped, old-fashioned office where form had little to do with function; the "surrealistic atmosphere" (*AML*, 119) created by works both finished and half-finished, abandoned and jumbled together in the corner of a studio. The surrealistic effect is even stronger when he surprises an entire "community" of life-sized nudes holding court in the garden adjacent to Maillol's studio.

Brassaï's reframing of the artist's works in such involuntary compositions allows him to shift the viewer's perception from their status as works of art to their existence as independent objects having a history and mysterious life of their own. This reframing also blurs the distinction between actual works of art and other objects in the artist's studio which, if only by association, bear the impress of his personality. The unusual stove that competes with the artist for the viewer's attention in one of Brassaï's most famous portraits of Picasso might well have been one of the artist's sculptures. The photograph reflects both artists' considerable interest in *objets trouvés*. Brassaï never failed to remark on unusual objects that ended up in Picasso's studio—from the wineglasses found fused together in the ruins of Martinique after a volcanic eruption to the grotesquely beautiful "carcass of a skinned rabbit, dry and dark as a mummy," that Picasso found discarded in the courtyard of the Louvre and displayed on a wall (*Picasso*, 126). Brassaï himself was a passionate collector of small stones, bits of wood, skeletons and bones, as well as unusual objects that, along with paintings, books, negatives, photographs, and boxes of letters, accumulated in his apartment until he exiled them to his studio (*RH*, 239).

Brassaï's global vision holds together these compelling objects, integrating them in compositions based on oppositions—formal oppositions: darkness and light, juxtapositions of different forms and styles, the illusion of movement in an essentially static composition—or conceptual oppositions, notably the perception of incongruity, or the creation of analogies between disparate forms. The pictorial or perceptual tension created by such oppositions and their resolution in a particular image suggests a relationship to the revelation of Surrealist metaphor, its "spark" produced by the juxtaposition of distant or incongruous realities. Several of the photographs of studios in *The Artists of My Life* strike a spark by juxtaposing works of different styles and scale, although the most strikingly Surrealist is perhaps a photo-

graph of the enormous thighs of Maillol's *Vénus au collier* towering over a lilliputian community of nudes crouched at her feet. However, the dynamic equilibrium achieved by balancing opposing elements also has its analogies with the Baroque.

Brassaï's attraction to the Baroque is implicit in his admiration for Rembrandt, but there is also much in his work to suggest the theatricality and illusionism, the spatial ambiguities and psychological complexities associated with Baroque style. However, nothing in Brassaï's appropriation of certain elements of the Baroque style suggests he shared the world view that linked Baroque naturalism to a sacralized view of the world in which the "familiar objects of visible reality can be looked on as emblems of a higher, *invisible* reality."[23] On the contrary, "Brassaï doesn't want to hear about occult things," Brassaï quoted his wife as saying in *Henry Miller, rocher heureux*. "For him, the visible world contains everything, explains everything. He doesn't think that the 'beyond' exists" (*RH*, 159). The remark bears comparison to André Breton's assertion in *Surrealism and Painting* that "surreality is contained in reality itself and is neither superior or exterior to it" (*SP*, 64).

Certainly it is a peculiar form of the Baroque, a resolutely secular Surrealist Baroque that we find in certain of Brassaï's Paris photographs where backstage shots of the ballet, the opera, and the Folies-Bergère set the tone for the equally theatrical spectacle provided by the extremes of Paris society he photographed: the high society of Maxim's and the Ritz, and the marginal societies—brothels, cafés, gangs, dance halls, and opium dens—that dominate the "secret Paris." In *The Artists of My Life* Brassaï's affinity with the Baroque is most obvious in compositions where his handling of light and space tends to efface the difference between reality and representation, or to dramatize the act of creation and the relationship between artist and spectator. The chiaroscuro characteristic of *Paris by Night* has an equally powerful effect in the nocturnal photograph of Picasso's sculpture Brassaï took for the first issue of *Minotaure*.

Anxious to take one last photograph of a group of Picasso's sculptures, Brassaï discovered that it had become too dark to photograph with available light. As there was no electricity in the stable Picasso used as a studio, he resorted to placing the artist's kerosene lamp behind a watering can in order to diffuse its harsh glare, just as he had used buildings and trees as screens to mask streetlamps in his earlier photographs of Paris. In the resulting photograph, the irregular surfaces of the sculptures absorb and reflect the light, their forms dramatically redefined by the interplay of light and shadow. De-

23. Martin, *Baroque,* 119.

spite the lamp's steady gleam, the irregular patches of light and shadow seem to flicker and give the illusion of movement, as though Picasso's "people" were stirring uneasily in the darkness (Figure 32). A subtle but no less significant use of light creates and fuses the patterns that make up an image of Matisse "modelling the second version of his *Vénus à la coquille* next to one of his birdcages" (*AML,* 126–27; Figure 33). The light illuminates and dramatizes the act of creation (only Matisse's face, hands, and a white rag on the worktable catch the light), while it flattens and reduces the other elements of image to a decorative design similar to those that fill the background in many of Matisse's paintings.

Brassaï also uses shadow in ways more typical of the Bauhaus than the Baroque, making shadow function as a positive shape in his compositions. The famous portrait of Picasso neatly framed in the shadow cast by his stove owes most to German Formalism of the thirties. Yet it is impossible to neatly classify Brassaï's stylistic effects. His beautiful photograph of the Montmartre cemetery uses shadows as positive forms (the fence that marks the boundary of the cemetery is visible only as a grid of shadows cast on the tombstones) in a composition where their atmospheric and symbolic qualities suggest Baroque effects (Figure 19). The coexistence of references to a number of diverse styles in a single photograph is equally typical of Brassaï's work and a good example of what William Rubin calls "Modernist syncretism." [24] If Picasso aggressively appropriated the work of his masters and rivals, Brassaï's work frequently engaged him in the elaboration of a syncretic style in which we can find traces not only of styles that strongly influenced him, but the styles of his subjects, which he masters in his own compositions.

In this regard we can compare the photograph of Matisse (Figure 33) with the image of Maillol putting the finishing touches on the larger-than-life-size sculpture of a woman he called *L'Ile de France* (Figure 34). Unlike most of the images in *The Artists of My Life,* this photograph was taken close up and slightly below the artist's eye-level. The resulting image collapses the distance between the sculptor and his work, fusing them into a single two-headed form in which, incongruously, the sculptor's hat competes for our attention with the sculpture's head. Maillol's back is almost completely turned to the camera; his hand replaces his face as the focus of our attention because it is almost in the center of the image, framed in the shadowy space between the arm of the sculpture and his own body. We read the soft felt of his hat, the woolly salt-and-pepper of his beard, and the dark curve of the

24. William Rubin, ed., *"Primitivism" in Twentieth-Century Art: The Affinity of the Tribal and the Modern* (2 vols; New York: Museum of Modern Art, 1984), I, 10.

collar and sleeve of his overcoat against the smooth, hard, white body of the sculpture. The juxtaposition of two massive forms (one white, one dark; one hard and smooth, the other softer, textured; one nude, one fully clad) that completely fill the frame suggests the simple monumentality of the sculptor's art as well as the formal oppositions of Brassaï's Surrealist Baroque. The static equilibrium of Maillol's work is broken by the tension Brassaï introduces into the image, a tension that results from the diagonal thrust of the two figures when seen from an angle and the distortion resulting from their spatial compression.

The incongruous juxtaposition of the sculptor's hat with the sculpture's head created by this distortion is one very discreet indication of Brassaï's sly sense of humor. Closely allied to a sharp sense of the ridiculous or the ironic, an attraction to the fantastic or the grotesque, the humorous element of his photographs frequently intensifies effects of contrast or incongruity. Not only does Brassaï capture the Surrealist atmosphere of Maillol's studio, but he shows us Matisse, dressed in a smock that looks like hospital whites, drawing his nude model with a studied detachment that makes his physical resemblance to Sigmund Freud all the more noteworthy. The comic element emerges full force in the photograph of the art dealer Kahnweiler standing next to his prized acquisition, the larger-than-life angel created by Picasso. The angel is a huge, flat Cubist cutout, a giant paper doll in stone, almost triangular in shape, its tiny round head a mere dot atop its huge body. The triangular shape is repeated in the angel's wings, its navel, and in the triangle of "angel genitalia" between its legs. The angel's left wing hangs like the blade of the guillotine over the tiny Kahnweiler, who leans casually against the sculpture, one hand on the angel's left leg. Although Kahnweiler's body blends with the shadows at the lower left of the photograph, his round, bald head catches the light, providing a formal parallel with the pinhead of the angel. Brassaï plays with scale in a similar fashion in other photographs, but this one captures the tone of Picasso's humor and raises it to a different formal level even as it suggests Diane Arbus' more somber reflections on the resemblances that can link people to the objects they value.

However, it is perhaps exactly such reflections that lead Brassaï to equate art and reality in portraits where he measures the artist against the work of art. The substitution of one for another occurs in the opening pages of the collection where—forbidden to photograph Bonnard—Brassaï photographs one of the artist's self-portraits on a couch in the corner of his studio (*AML*, 15). There are other examples of such implicit comparisons: the sculptor Charles Despiau posed in front of the collection of his busts, his face vaguely

resembling the bust to his right (47); a photograph of Picasso holding the "neck" of a bronze bust, its round head next to his own (178); Dufy's face repeated by the small portrait on the mantel behind him (49). However, the most complex of Brassaï's investigations into the curious relationship between art and reality is a photograph of Giacometti, whose composition is a variation on the Despiau photograph (66–67). Spread over two pages, the photograph of Giacometti is one of the few close-up photographs in the collection, showing the artist from the shoulders up at the far right of the frame (Figure 35). His head is on the same level as a row of three busts of his brother Diego (so he becomes the fourth bust in the row). The uneven lighting shades Giacometti and the second bust in the row, making them appear to be of darker material than the other two forms. In front of Giacometti and in the extreme foreground of the image is a dark, rough lump of unworked clay of the same tone and shadings as his face. The "family" resemblance between Giacometti and the busts is clear, the difference in features balanced by the similarity between the rough way the clay of the busts is worked and the craggy features of Giacometti's own face. The richness of the portrait emerges in the way it mediates the oppositions between self and other, life and art, animate and inanimate forms, mortality and immortality: the workings of the sculptor and the workings of time as a sculptor of faces.

If the portrait's artfulness resides in the seemingly natural way it creates an analogy between the artist and the forms of his art, the analogy results from the careful composition and lighting that lead us to compare them as representations. In other photographs the analogy between art and reality becomes a motif—a picture within a picture—where a window in the artist's studio frames a view of the world outside. The best-known of these photographs (reproduced in *Labyrinthe, Picasso and Company,* as well as in *The Artists of My Life*) is a shot of Picasso's studio showing his Afghan hound Kazbeck sprawled beneath a window that opens out on the vaguely Cubist tableau composed by receding waves of roofs and chimneys (189). Other "exterior" landscapes and cityscapes are framed in Dali's and Miró's studios (43, 146).

In *The Artists of My Life* Brassaï often positions his subjects in ways that allow him to create a frame within the frame of the photograph. He fits the artist into the contrasting square of the fireplace (Dufy, 49; Maillol, 120), or the architecture of a room or street (Miró, 145, 150); the space of a shadow (Picasso, 129; Laurens, 83), or the space of a mirror (Kokoschka, 70, 71; Matisse, 134; Richier, 196). Open or closed doors frame Dali and Gala (30,

31), Giacometti (55), Laurens (78–79), Le Corbusier (91), Matisse (129, 130), Miró (153), Dora Maar (181), and Hans Reichel (191). This framing functions reflexively, suggesting the photographer's effort to capture reality within the frame of his photographs, but it also repeats the invisible frame that constitutes the rectangle, defining the image by enclosing it and implying a space outside it. Rosalind Krauss's efforts to discover a Surrealist aesthetic "within the photographic rather than the pictorial code" focus on this frame. She calls attention to the "enormous pressure" Surrealist photography placed on the frame of the photograph as a "spacer" that isolates some part of reality from the rest, framing it as "an example of nature-as-representation, nature-as-sign." [25]

Brassaï does play on the double nature of the image—its referential relationship to reality, its transformation of reality into a representation; however, the nature of his subjects and the biographical, documentary context in which he presents them here limit our reading of them as signs. Perhaps for this reason relatively few of Brassaï's photographs in *The Artists of My Life* (the photograph of Germaine Richier discussed later is a notable exception) configure reality as the "empty sign"—seemingly meaningful, although obscure and mysterious—the "signifier of signification" that Krauss finds in Surrealist photography.[26]

However, a complex double portrait of Gala and Dali in their studio in the Villa Seurat (where Brassaï sometimes visited Henry Miller) combines both the internal framing and mirror reflections that define the space of Brassaï's images, suggesting an allegory of (photographic) creation. The photograph shows Dali standing next to an open doorway, one arm around Gala, the other encircling a female bust with a necklace of ears of corn sitting on a cabinet against the wall (Figure 36). Some of Dali's paintings and some other objects—an art deco vase or statuette, as well as the bust—are visible, while through the doorway we glimpse a chair and other small objects on a desk or table. On the same wall as Dali, balancing the rectangle of the open door, is a full-length mirror in which we see Brassaï's reflection. The mirror reflects yet another space, apparently an adjacent room, in which Brassaï has set up his camera and tripod. The image suggests the equivalence of "real" and reflected space and creates a parallel between the photographer and the artist. In fact, Brassaï's self-portrait competes with that of Dali, but discreetly, for Brassaï is present in the photograph only as the image of a reflection. However, this reflection does serve as a kind of signature, evoking his creation of the image within the frame of the image.

25. Krauss, "The Photographic Conditions of Surrealism," 17, 31.
26. *Ibid.*, 31.

Brassaï rarely intrudes in his photographs (although he also figures as a mirror reflection in a photograph of Kokoschka), but he is indirectly present in them though numerous references to his own themes (graffiti, the city), talents, and tastes. These references also function as a kind of invisible signature, reminders of the creative intelligence at work in the so-called objective representations of the photographer's work. However, Brassaï's aesthetic of self-effacement also leads to a form of self-portraiture most evident in his fascination with the eyes of the artists he photographed. Whenever Henry Miller recalled his first impressions of Brassaï, he never failed to mention the impact that Brassaï's "enormous globes" had made on him. Large, dark, prominent under heavy, dark brows, they were "unusual," Miller claimed, "not only in a physical sense, but for the impression they conveyed of an uncanny ability to take in everything at once" (*Picasso*, ix). Brassaï is hypnotized by this same feature in Picasso. His eyes, he reported, "seem enormous . . . because they have the faculty of opening very wide." They are the eyes "of a visionary, prepared for perpetual astonishment" (*Picasso*, 23). His favorite portrait of Picasso is one in which he claims to "capture the fiery fixity of [Picasso's] gaze that could pierce, subjugate, devour whomever or whatever he looked at" (*AML*, 170). He focuses on the same feature in Braque, noting, "in my opinion, it was Braque's dark brown eyes, very like those of Proust in their dark-ringed sockets, that formed the major attraction of his face" (*AML*, 16). He photographed Dali from slightly above eye-level, increasing the impact of the artist's large "moonstruck" eyes (*AML*, 32). Brassaï's fascination with the eyes of the artists he photographs assumes a larger, symbolic significance when it is compared with emphasis his compositions place on their hands.

Hands figure importantly in the iconography of *The Artists of My Life* where Brassaï calls attention to their role in translating creative vision into form. Inevitably, however, given the nature of Brassaï's own creative work, "vision" supplants the direct contact between materials and form. The primacy of eye over hand, vision over technique, suggests his affinity with Proust, who defined art as vision in a famous description of style:

Style for the writer, just like color for the painter, is a question not of technique but of vision. It is the revelation, which would be impossible by direct and conscious means, of the qualitative difference that exists in the way the world appears to us, a difference which, if art did not exist, would remain the eternal secret of each of us.[27]

27. "Le style pour l'écrivain aussi bien que la couleur pour le peintre, est une question non de technique mais de vision. Il est la révélation, qui serait impossible par les moyens directs et conscients, de la différence qualitative qu'il y a dans la façon dont nous apparaît le monde, différence qui, s'il n'y avait pas l'art, resterait le secret éternel de chacun." Proust, *A la recherche du temps perdu*, III, 895.

Proust's definition of style provides not only a valuable justification for dismissing nagging questions about the photographer's dependence on a mechanical process, but more significantly, it places vision at the heart of artistic creation. Brassaï's portrait of Germaine Richier (like his favorite portrait of Picasso) places the artist's gaze at the center of the photograph. It is both a significant and a powerful image, one that merits serious attention within the context of the collection because it draws together a number of themes and compositional elements that characterize *The Artists of My Life*. Unfortunately, this particular image (originally published in *L'Oeil* in 1955) is no longer available for publication. Consequently, in an effort to give a general idea of its composition, I have reproduced another photograph from what must have been a series of similar portraits of Richier. However, the image reproduced here (Figure 37) differs in a number of ways from the photograph that appears in *The Artists of My Life*. Significantly, Brassaï's preference for a more intense, somber portrayal of Richier in his book leads us back to his preoccupation with the nature of creation rather than the personality of the artist.

If the portrait of Richier in *The Artists of My Life* provides another illustration of Brassaï's fascination with the artist's gaze, the composition of the image has much in common with the double portrait of Dali and Gala in its use of mirror reflections, yet it is highly unusual in the context of the other photographs because its carefully calculated, deliberately artful composition uses the mirror reflection to fragment the image of the artist. The composition is strongly reminiscent of Velasquez' *Venus and Cupid,* the "Rokeby Venus," in which the reclining Venus studies her image in a mirror held up by Cupid. The viewer sees Venus from the back, but also sees her face reflected in the mirror. Eminently Baroque, the composition also suggests the ambiguous relationship between the viewer and the work of art in *Las Meniñas*. The composition is not the only one of this type in Brassaï's work; it closely resembles two earlier photographs, one a "Ballerina" in *Camera in Paris* and the second a student couple (un)dressed for the Bal des Quat'z Arts that appeared in *The Secret Paris of the 30's*.

In each of the three compositions the subjects turn away from the viewer, but their faces are fully visible as reflections in a mirror. In each case it is unclear whether they are looking at themselves in the mirror or at the photographer (or a spectator) behind them. The photograph of Richier is the most striking and the most ambiguous of the three because it is not immediately obvious that her image is a mirror reflection. The sculptress appears to be watching, intensely and anxiously, from a doorway. It is only when we

see her disembodied hands modeling a small sculpture in the lower left corner of the image that it becomes clear that the image of her face is a reflection.

The photograph of Richier also suggests a comparison with the portraits of Florence Henri. Henri's portraits, most frequently self-portraits or portraits of women, use mirrors to repeat, isolate, capture, and frame their subjects. (See Figures 2a and 2b for examples of Henri's use of frames, both mirror and picture frames.) As Suzanne Pagé points out, the particular quality of her portraits "consists less in 'taking' the person's likeness than in restoring the very image of the subject's mystery. So the mirror, in a very subtle *mise-en-abyme,* removes them from real space and time, projecting them into that illusory space, which is precisely the secret space of reflection created by the camera." [28]

Pagé considers Henri's fascination with mirror images and her use of the *mise-en-abyme* as signs of her modernity. As Rosalind Krauss and Craig Owens suggest, Brassaï's compositions with mirrors can be similarly interpreted.[29] Certainly the reflected image in Brassaï's photograph of Richier can be seen as a reference to the nature of the photographic medium; however, the dramatic effect of the photograph, its mysterious evocativeness, derives from the clash between the illusory and mimetic spaces that coexist in the image.

Brassaï creates a formal opposition between the gaze of the artist's reflection, which appears directed outside the image back into the "real" space of the photographer/viewer, and the reach of her hands, which pulls the viewer's attention back into mimetic space toward the center of the image. Here, as in other mirror compositions, Brassaï creates ambiguous spatial relation-

28. "La qualité très particulière de ses portraits (surtout féminins et autoportraits) consiste moins à ⟨⟨saisir⟩⟩ la personne qu'à lui restituer l'image même de son mystère propre. Le miroir alors, dans une mise en abîme très savante, les soustrait au temps et à l'espace réels les projetant dans cet espace de l'illusion qui est précisément l'espace de réflexion secret de la boîte photographique elle-même: ce travail sur l'écriture photographique est un des traits de la modernité de Florence Henri aujourd'hui." Pagé and Thieck, *Florence Henri,* unpaginated.

29. For a discussion of *mise-en-abyme* and mirrors in the work of Brassaï and other photographers (not including Florence Henri) see Craig Owens, "Photography *en abyme," October,* V (Summer, 1978), 73–88. On Brassaï, Surrealism, and *mise-en-abyme* see Rosalind Krauss, "Nightwalkers," *Art Journal,* XLI (Spring, 1981), 33–38. Krauss suggests that "Brassaï was more than just congenial to the Surrealist sensibility, but participated in their work at a deeper level." To the hypothetical objection that there is "nothing very surreal-looking about his photographs," she asserts that it is "the space of the abyss itself—of man captured in a hall of mirrors, in a constantly bifurcating field of representation—that Brassaï holds in common with men like Aragon [clearly the Aragon of *Paysan de Paris* is intended] and Breton" (38).

ships, confusing the distinction between representation and reflection. Yet
he does this by splitting the artist in two, showing her hands as though they
were unrelated to her image in the mirror. The split separates the image of
self-conscious observation from that of creative activity, suggesting both a
fundamental duality at the heart of artistic creation and the artist's alienation.
Of course, the artist's alienation is deliberately staged, and inevitably, Brassaï's
composition leads us back to a consideration of the photographer, whose
work requires a kind of professional alienation, a critical balance between
detachment and involvement. Ultimately, the image conflates the space of
the artist and the photographer by forcing the viewer to place them both,
conceptually, just outside the mimetic space defined by the photographer's
image in the "real" space implied by the artist's gaze.

Although the Richier photograph adapts elements of Baroque style, it is
nonetheless a strong, important statement of Brassaï's modernism. However,
if we look very closely at Brassaï's modernist engagement with photography
we can also find underlying it something of the old romantic conception of
the artist as a "visionary" who sees a larger significance, if not necessarily a
grand design, in the forms of events. Brassaï did not have leanings toward
mysticism, preferring the material world of everyday realities to that of
dreams and visions. Yet he, like the Surrealists, was fascinated by the patterns
of repetition that underlie both premonition and coincidence, what the Sur-
realists referred to as "le hasard objectif," "strange interferences" between
the subjective and the objective.[30]

Brassaï's own experience provided him with events that had a certain
formal consistency: "I was born in Transylvania on the ninth of September
1899 at 9:00 in the evening," he wrote in "Memories of my Childhood."
"This number has followed me all of my life. I even live at number 81."[31]
He considered at least two of Picasso's paintings premonitory works: one
heralding the birth of his second son, another that prefigured the artist's first
visit to Juan-les-Pins (Picasso, 60). He qualifies some of his conversations with
Hans Reichel and Henry Miller as premonitory (RH, 87, 263) and wonders
in The Artists of My Life if Vollard might not have had a premonition of the
role a small bronze statuette would play in his death (AML, 215).

Knowing this, we might try to read the signs of Germaine Richier's fate
in his photograph of her, taken five years before her early death. Her anxious

30. Michel Carrouges, André Breton et les données fondamentales du Surréalisme (Paris: Gallimard,
1950), 246.

31. "Je suis né en Transylvanie, le 9 septembre 1899, à 9 heures du soir. Rien que des neuf ou
des multiples de neuf dans ma date de naissance. Ce chiffre me poursuit toute ma vie. J'habite
toujours le numéro 81." Brassaï, "Souvenirs de mon enfance," in Brassaï, unpaginated.

reflection, the small mask or skull-like sculpture on her worktable, the wire sculpture whose skeletal armature cuts through the reflection of her face, are all enigmatic and ominous. However, such a reading has to be weighed against the nature of Richier's art, her creation of the disquieting figures that, Brassaï confessed, gave him the impression "of entering some strange universe left behind in the ravaged aftermath of some atomic deluge" (*AML,* 194). Nor should we disregard the fact that some of Richier's work might have initially attracted Brassaï because the forms resembled those in his photographs of graffiti.

Brassaï's images are those of a "seer" alert to significant form, the products of a visual intelligence quick to be surprised and moved by moments in which phenomena seem to take on significance. Brassaï both recognizes and creates such moments. In this sense, his style might be considered the product of objective chance: the sum total of the evidence he provides on the "strange interferences" between subjective perceptions and objective realities. Brassaï may have been surprised that Braque considered even his most austere, disciplined Cubist paintings to be "emanations" of himself. "Something compels me to do this thing rather than that," he told Brassaï, who probably agreed with his belief that, ultimately, "there's a kind of mystery underneath it all, just as there is a mystery underlying life" (*AML,* 19).

VI

The Photographer as Writer

Writing always represented an important form of compensation for Brassaï, although strictly monetary at first. If he was only able to eke out a living in journalism during his early years in Paris, that says more about the nature of the times than his facility as a writer. It may seem surprising that he never seriously considered a more literary calling. Yet there were certain practical considerations. Earning a living as a writer would have forced him to choose a language (Hungarian, German, French?) and limited his audience, while painting—and ultimately photography—allowed him to envision an international career. And he had every reason to congratulate himself on his choice; the thirties proved to be a remarkably successful, productive period in which photography provided him with a livelihood and a means of self-expression. However, the German Occupation threatened both. Far from offering opportunities to continue with night photography, darkness brought danger. The simplest gestures—stooping to pick up a package of cigarettes—might provoke a "hände hoch" and menacing questions (*Picasso*, 10). Brassaï's decision to ignore the Germans' request that he apply for a work permit left him unable to do free-lance photography or publish his photographs.

En chômage, out of work, as he explained his situation to Picasso (*Picasso*, 53), he turned to writing as some compensation for the loss of photography. Although Brassaï's initial impulse in taking up a pen was to record rather than invent, leading him to imagine a linguistic equivalent for photography, writing served as an integrating force in a career whose creative principle more resembled distraction than the intense concentration he admired in Picasso. In the late twenties Brassaï allowed himself to stray from painting

into photography, and in the years following the Second World War he tried his hand at drawing, painting, sculpture, tapestry, set design, and filmmaking, insisting he had a "horror" of specialization. However, he increasingly defined himself as an artist through his writing.

Writing began to dominate his creative activity in the 1960s. Not only did he produce introductions for several important collections of his photographs (*Graffiti* in 1961, *The Secret Paris of the 30's* in 1976, *The Artists of My Life* in 1982), but he completed biographical works on Picasso and Henry Miller (*Conversations avec Picasso* in 1964; *Henry Miller, grandeur nature/ Henry Miller, Lifesize* in 1975; a second volume, *Henry Miller, rocher heureux/ Henry Miller, Happy Rock*, appeared in 1978). In 1977 he published *Paroles en l'air/Words in the Air* or *Idle Talk*, as the introduction to a collection of the prose poetry he had written during the forties, including both the previously unpublished "Bistrot Tabac" and the longer, more ambitious *Histoire de Marie*, which had come out in 1949 with an introduction by Henry Miller. By and large, like the poetry of *Paroles en l'air*, the substance of all these later works dates from the thirties and the forties. Retrospective works, they allowed Brassaï to recapture something of the most fertile period of his career and to take the measure of two artists whose work had long been associated with his own: Picasso and Henry Miller.

Writing also provided him, directly or indirectly, with a pretext for meditating on the nature of his art; only the wealth of detail typical of his biographies obscures the fact that photography became his most important subject as a writer. Yet where he reflected on photography in these later works, he was no longer preoccupied with its expressive potential as a technology; rather he abstracted an aesthetic philosophy from it, making photography the central metaphor for his activity as an artist. In *Paroles en l'air* he represented photography as the operation of an artistic sensibility that had existed long before the actual invention of photographic technology. Conceding that the invention of photography made this particular kind of artistic sensibility intelligible, he insisted nonetheless that "the photographic spirit didn't wait for Niepce."[1]

Taking photography as the paradigm for a particular relationship between subject and object allowed Brassaï to reconcile the old contradiction between photography and art, yet his effort to write in the spirit of photography reveals the larger contradictions of his position as an artist with particular

1. "L'Esprit photographique n'a pas attendu Niepce pour se manifester, mais seuls l'invention de la photographie, son processus, le rapport du photographe avec la réalité pouvaient le rendre *visible* et *intelligible*." *PA*, 27.

clarity. Brassaï's photographs provide subtle, complicated answers to questions about the complex relationships between artist and world, subject and style; his writing deals with such questions more directly. What follows, then, is an attempt to discover a key to Brassaï's place in a culture in transition by examining the literary expression of a photographic sensibility.

Brassaï's witty dismissal of his art, his famous quip "je n'invente rien, j'imagine tout" ("I don't invent anything, I imagine everything"), evaded the question of style by placing all the emphasis on the "real things" to be represented. The artist need not create his subjects, merely represent what he sees. This alone would place Brassaï squarely in the Realist tradition—Balzac himself professed to be no more than the secretary of French society, merely recording what he observed. Brassaï's photographic work does carry on a tradition of urban sociology originating with Balzac and Zola, although its scope is restricted to individual observations, fragmentary glimpses of people and events. In later collections of his photographs, Brassaï attempted to establish the continuity of his observations by inserting them in a larger socio-historical narrative, but neither his poetry nor his biographical works pretend to the broad scope of their Realist and Naturalist predecessors. On the contrary, Brassaï's work accumulates accounts of particular moments, incidents, encounters, or atmospheres, prolonging them and giving them some permanence by putting them on record. His writing is fragmented and digressive, at best anecdotal, quite literally circumstantial in that it remains bound to the circumstances of its production without being imaginatively transposed or transmuted. As in his photographs, Brassaï contented himself with selecting, focusing, or "cropping" his material.

In another sense, however, the dominant qualities of Brassaï's realism derive less from nineteenth-century Realism than from journalism: the focus on the who, what, when, where of events, the importance placed on concrete detail and anecdote, the simple, direct style, the concern with "human interest"—and a certain underlying flair: the intuitive sense of what makes a good subject, and a good story. Brassaï's writing frequently takes the form of an eyewitness account or suggests the behind-the-scenes presence of a curious but sympathetic observer. This is not to say that Brassaï would have seen journalism as a distant or poor relation of literary art. Journalism played an important cultural role in Hungary, attracting important writers and intellectuals—including Brassaï's father (*EL: 77*, p. 152)—who were able to communicate their views on political and aesthetic issues directly to the public through the press. The existence of a wide audience for their work was reflected in the proliferation of newspapers and magazines, some of

which drew on the Hungarian folk tradition, or sought to promote it, as a source of national pride and artistic inspiration (*Kertész*, 22–23).

This journalistic tradition probably influenced Brassaï's choice of subjects as a photographer and as a writer, although he also shared the Surrealists' fascination with popular culture and their interest in primitive art. Popular, even crude forms of expression like graffiti attracted him precisely because he saw in them the intensity and vitality essential to great art. He was convinced, for example, that the Paris he photographed in the thirties represented the city at its "least cosmopolitan," its "most alive, most authentic," and that this nocturnal world "preserved almost unchanged the folklore of its remote past." [2] This desire to capture language at its most alive led Brassaï to focus on spoken language, particularly the rapidly changing forms of slang and popular speech. The voice of Céline's narrator may have echoed in his mind; certainly *Voyage au bout de la nuit* was the most startlingly original novel to emerge in the early thirties, shocking the public by its rejection of polished literary language in favor of the vulgarities of popular speech. Yet Céline's fascism no doubt led Brassaï to eliminate him from the list of great writers—he cites Diderot, Joyce, and Proust—who were able to create the illusion of spoken language or capture the interplay of different voices.

Brassaï's "Bistrot Tabac" gives some indication of his fascination with conversation; it is, in fact, the foundation of all his poetry and biographical works. The form of the conversation varies: we hear only one side of the conversation in *Histoire de Marie,* follow the conversation through reconstituted journal notes in the *Conversations with Picasso,* and participate in a conversation stretched over time and distance in an exchange of letters with Henry Miller. On some level Brassaï's formal preoccupation with conversation reflects his considerable gifts as a conversationalist. Miller marveled at Brassaï's wit and stamina, paying tribute to them in the introduction to *Histoire de Marie,* in which he recounted his encounter with Brassaï around midnight after the funeral of their close friend Tihanyi. Brassaï's intense feelings poured out in a flood of words; "he had a lot to say to me that night," Miller reported, "three full hours he kept me riveted to the same spot . . . talking to me about Saint Thomas Aquinas and Goethe's *Faust* that he had just rediscovered." [3] Miller admitted to Brassaï later that "If I could

2. *SPT,* Introduction. Sandra Phillips notes this passage and suggests its similarity to Kertész's attitudes: "Kertész's early views of Paris present the workingman's city as well as the bum's. With an intuitive sense of their culture, he went to their bars, photographed their dancing customs and their folk art—such as a decorated laundry sign—and documented their street fairs and flea markets." *Kertész,* 29.

3. "Il avait beaucoup à me dire cette nuit-là. Trois heures durant, il me tint rivé au même

reconstitute your conversation on that occasion I would consider myself a real genius" (*GN*, 44). In *Paroles en l'air* Brassaï called Proust a "causeur impénitent," an unrepentant talker, knowing that he shared a similar bent; clearly pleased to be characterized this way himself, he quoted Miller's remarks about him in his biography of Miller.

Brassaï no doubt found further justification for considering conversation an art in reading Goethe, who held it to be an important mode of thinking. In the third book of his autobiography, Goethe described his "peculiar habit" of converting even his soliloquies into dialogues. "As it was my custom and pleasure to spend most of my time with other people, I would even transform my solitary thinking into social intercourse," Goethe confessed, adding that he would imagine various interlocutors of different temperaments depending on his need for a quiet, appreciative listener or "natures more given to contradiction."[4] Brassaï's *Conversations avec Picasso* pay homage to Eckermann's *Gespräche mit Goethe*, as well as to Picasso's verve as a conversationalist (and his own), but the title of the English translation, *Picasso and Company*, obscures the tribute.[5]

Brassaï's "Bistrot Tabac" interweaves several conversations overheard in a Parisian café on August 20, 1943—the day the Red Army retook the city of Kharkov. The date's larger historical importance is overshadowed by anecdotal histories, which crisscross in poignant or ironic counterpoint. In one sense Brassaï's effort to capture these conversations resembles a Realist's alternative to automatic writing. In both cases the writers attempt to become what André Breton called "modest recording apparatuses." However, where the Surrealists insisted the writer attend to the still, small voice welling up from the depths of the unconscious, Brassaï focuses on local color and culture. Where "le Surréalisme poétique" sought to reestablish "the absolute truth of dialogue by dispensing the interlocutors from the obligations of politeness, allowing them to pursue their own soliloquies," Brassaï considered conversation as a social or cultural medium reflecting both an individual and a milieu, both of which put their stamp on language.[6]

endroit . . . m'entretenant sur Saint Thomas d'Aquin et sur le *Faust* de Goethe qu'il venait de redécouvrir." Brassaï, *Histoire de Marie*, with an introduction by Henry Miller (Paris: Editions du Point du Jour, 1949), 19. Also quoted in *GN*, 44.

4. David Luke and Robert Pick, eds. and trans., *Goethe: Conversations and Encounters* (Chicago: Henry Regnery Co., 1966), 7.

5. "La conversation de Picasso était à la hauteur de son génie créateur, pleine d'humour, de cocasserie, de coq-à-l'âne, d'images imprévues, de raccourcis vertigineux." *PA*, 23.

6. Breton, *Manifestes*, 40, 49.

Obvious and important differences separate the practice of automatic writing from Brassaï's poetic experiment with conversation, yet both raise questions about the role of the writer as the producer of a text and the status of the text as literature. Breton asserted that automatic writing was not a method of literary creation but "une véritable photographie de la pensée" ("a true photography of thought").[7] The analogy had the merit of allowing him to argue that the writer was merely the agent of textual production, not the *author* of the text.

Brassaï's appeal to photography represents a compromise; he maintained that his poetic texts, including "Bistrot Tabac" and *Histoire de Marie,* were verbal snapshots—"l'oeil ayant cédé la place à l'oreille" ("the ear taking the place of the eye") (*PA*, 23)—taken in the subjects' "natural light." As "author" he merely captured his subjects in their own words and avoided intruding to provide psychological commentary, physical description, or background information. He preserved the notion of authorship, if in a limited or diminished form. Paradoxically, he insisted that he deliberately rejected the possibility of using a tape recorder because it distracted the listening writer from the real import of the conversation. If the implicit parallel between camera and tape recorder works to the detriment of photography (ironically, the intrusion of technology seems more flagrant in the case of photography, where the photographer must set up a camera and tripod to record events), Brassaï equates the photographer's selective vision with the selective work of memory, arguing that it is in the interval between hearing the words and the conscious effort to reconstruct the conversation that a secret and mysterious operation takes place, allowing the writer to engage in the creative work of recollection, which the tape recorder would eliminate.[8]

In emphasizing the creative reconstructions of memory, Brassaï once again evokes Proust, whose work became an increasingly valuable reference point for his meditations on his art. Roger Grenier noted that "At the end of his life, [Brassaï] found a way to reconcile his two big passions, photography and literature. He set about writing an essay on Proust and photography . . . when it is published we will see that Proust in real life as well as in his writings, was completely obsessed by photography."[9] Yet it seems more appropriate to evoke Apollinaire than Proust in assessing Brassaï's work as an

7. André Breton, *Les Pas perdus* (Paris: Gallimard, 1969), 86.

8. "C'est dans l'intervalle, entre les propos entendus et leur reconstitution, que s'effectue en nous-même un travail secret et obscur, le travail de la *remémoration*." *PA*, 22.

9. Grenier, *Brassaï*, unpaginated.

artist/poet. Apollinaire, the naturalized Wilhelm Kostrowitsky, flâneur and urban poet, art critic and journalist, was friends with most of the important writers and artists of prewar Paris. His association with Cubism and nascent Surrealism, his close ties to Picasso, whose legend as the *monstre sacré* of modern art he helped establish, all suggest circumstantial similarities with Brassaï's situation as an artist. Their paths would inevitably have crossed had Apollinaire lived. Yet other similarities emerge from their work, the most obvious being their efforts to find verbal equivalents for visual forms.

Apollinaire's attempt to cast his poetry in visual form resulted in hybrid poem-images, the famous *Calligrammes.* However, it is his *poèmes-conversations,* dating from about the same period, that present the closest analogy to Brassaï's work. Perhaps the best-known of these poems, "Lundi Rue Christine," is also constructed on the fiction of "linguistic photography." [10] Like "Bistrot Tabac," it supposedly represented the record of conversation overheard in a café. In fact, when the critic Michel Décaudin ventures the suggestion that as an "audio-montage" "Lundi Rue Christine" might prefigure the photomontages of the twenties, he makes the same associative jump that allowed Brassaï to claim that the "spirit of photography" predated the actual existence of the camera. [11]

But if "Lundi Rue Christine," like "Bistrot Tabac," was produced in "the spirit of photography," the resulting texts could not be more different. Apollinaire uses "quotations" from the real world of his experience as raw materials, much as Picasso and Braque introduced scraps of newspaper, playing cards, or wallpaper samples in collages and paintings. The poem's abrupt shifts from one source and level of perception to another convey a rush of sensory impressions, a richness and complexity of experience that can only be partly grasped at any moment. Anonymous voices displace the poet as narrator or author, leaving only a sense of the poet as receptor or mirror.

Brassaï practices a similar kind of authorial anonymity, letting other voices speak in his stead and making his presence felt only in the rendering of a concert of voices. Yet where Apollinaire sacrificed the coherence of individual stories, deliberately fragmenting and dispersing the speaking subject, Brassaï attempted to re-create the subject's unity and coherence out of the murmur of conversations in which some voices and some words are lost or indistinguishable. Consequently, his contention that "writing can only ren-

10. Timothy Mathews, *Reading Apollinaire: Theories of Poetic Language* (Manchester: Manchester University Press, 1987), 154.

11. Michel Décaudin, "Collage et montage dans l'oeuvre d'Apollinaire," in *Apollinaire, Eine Vortragsreihe aus der Universität Bonn* (Wiesbaden: Franz Steiner Verlag, 1980), 34.

der spoken language by paring down, condensing and stylizing" (*PA*, 20), results in a series of more conventional, almost theatrical exchanges, a suite of dialogues that focuses attention on one speaker at a time, but gradually introduces a recognizable cast of characters headed by *la patronne*, the owner of the café.

The photographic analogy that links Apollinaire's poem-conversations to those of Brassaï suggests their openness or receptivity to experience, a receptivity that replaces poetic or artistic inspiration.[12] To extend the analogy, Brassaï's linguistic photograph is more carefully posed (and more conventional) than Apollinaire's striking poem. Brassaï attempted to capture disparate, random elements of human experience in a coherent form that would convey their larger significance. Fascinated by anecdotal histories, he was convinced that "however futile or inept they may appear, these conversations ["bavardages"] give us the color of the times, plunge us into a moment in History" (*PA*, 11).

Brassaï's micro- or infra-histories effect curious shifts in scale and perspective because the importance of historical events is determined by the degree that they impinge on individual lives. If the fact that Kharkov has been recaptured by the Russians signals that the Germans are now losing the war, the fact pales in the discomfort of the summer heat. "Nous vivons un été mémorable" ("We are living through a memorable summer"), says one voice, but it is clear from the context that he is not talking about the war, but referring to the dry weather that has been good for the grapes, practically guaranteeing that 1943 will be a good vintage year. "Bistrot Tabac" equates narrative and history, art and experience in ways that inevitably incline Brassaï's work toward biography.

Histoire de Marie is the most fully realized of the brief lives that precede Brassaï's full-scale efforts at biographical writing. Published in 1949 with an introduction by Henry Miller, who claimed it was "more fascinating and far more honest than the sociological portraits of Zola's monumental novels," *Histoire de Marie* is the story of the cleaning lady who worked in Brassaï's apartment building, told "in her own voice." The story is composed of forty-four short sections, each with a separate title, that take up subjects as disparate as Marie's views on unwed mothers, banks, and Marie Antoinette, her plans for her funeral, and her occasionally violent run-ins with other tenants (notably two irate neighbors who break a bottle over her head). Several sections,

12. *Ibid.*, 36. Décaudin's remark concerns only Apollinaire, but his discussion of Apollinaire's practice of collage leads him to formulate the role of the poet as "receptor" and to define Apollinaire's status as a writer in ways that are singularly applicable to Brassaï.

Naturalist in inspiration, treat the operation she underwent at a charity hospital to remove an abdominal tumor and the dangers of the resulting phlebitis, while the last section in part one shows her suffering from the eczema caused by laundry soap and bleach. The second part, "Marie's Trial," deals with the efforts of the *Société* that owns her apartment building to have her evicted—on trumped-up charges that horrible smells emanate from her small room on the eighth floor and that her midnight trysts with a lover keep the other tenants awake.

Literary antecedents other than Zola come to mind, but *Histoire de Marie* rings odd changes on them: the life of a saint told as a burlesque; a new version of Villon's *Ballade,* portraying an Heaulmière who never knew love or great beauty; a revision of Flaubert's Félicité, showing a Félicité too isolated to reveal her capacity for devotion, or perhaps even an almost destitute double of Proust's Françoise. Ultimately, however, Marie's portrait belongs among the homeless and marginal figures that people *The Secret Paris of the 30's.*[13] Brassaï had some experience of the poverty of these solitary figures, and he might have imagined their isolation, but he represents them in ways that suggest their fierce independence, their resilience and pluck, their ability to hold their own. Clearly he prefers to see them as primitives, philosophers, exiles, or outlaws, rather than as those forced to live on the margins of society, victims of their poverty or lack of education. If his portrayal of them is an attempt to have them "recognized," it is not exactly as victims.

It is left to Henry Miller to raise such issues in his introduction. Miller sees Marie as a type, a sad pariah, one of the poor "who will always be with us" because nothing is ever done to improve their lot: "The Maries of this world know they are condemned, that under no form of government will anyone ever do anything to relieve them."[14] Miller praises Brassaï for having attempted *une sorte de documentaire,* urging him to undertake other portraits: a bus driver, a prostitute, a pawnbroker, a politician, a criminal, even a dictator—portraits of all levels of society. Miller does not seem aware that such a project had already been undertaken, and by a photographer.

August Sander's photographic series on the German people, called *The Face of Our Time,* was begun in 1911, although as Susan Sontag points out, it was banned by the Nazis in 1934 as "antisocial."[15] Each of Sander's portraits

13. Another of the *solitaires*—the taxi driver who narrates "Nuit de Noël" and other short pieces that figure in *Paroles en l'air*—struck Brassaï as a character out of Molière: "I had the impression that it was Alceste, the angry Misanthrope of Molière's play, turned taxidriver in order to escape the world in the noise of the crowd, who was sitting behind the wheel." *PA,* 14.

14. Brassaï, Miller's introduction to *Histoire de Marie,* 13–14.

15. Sontag, *On Photography,* 59.

was to be an "archetype picture" representing a particular class, trade, or profession. However, Brassaï represents Marie not as a type but as "une originale," who like Proust's Françoise had a "strange genius." "Beings like Marie, illiterate—specimens fortunately more and more rare—" he wrote in *Paroles en l'air,* "don't go by what they have learned in newspapers and books but by the original ideas that arise from their own thinking. They see and judge everything with the freshness and intensity of the primitive or the child." [16] Where Miller waxes sentimental over Marie, identifying with her as a symbol of the human condition, moved by her limitations and her suffering, Brassaï portrays her with the detachment of the photographer, allowing for humor, irony, and a certain grotesque. Significantly, Brassaï's portrait of Marie allows us to gauge most clearly the quality in his work that attracted Diane Arbus, linking his work to hers and to that of her teacher Lisette Model, whose own studies of grotesques, particularly the grotesques of poverty and old age, were done with "almost clinical detachment." [17]

Something of the sensibility now most closely associated with Arbus' work is visible in individual photographs published in *The Secret Paris of the 30's,* notably in the pictures of the masked women photographed at a street fair, the "Human Gorilla," the two smiling prostitutes or lesbians photographed at the Bal-Musette, and even the famous Bijou. It lurks in superficially banal photographs such as "Family Outing" from *Camera in Paris* and surfaces in another photograph from the same collection, "Shop Window," that shows the dark silhouette of a huge woman, her back to the camera, staring at a brightly lit shop window in which shapely mannequins model girdles. These highly charged photographs where the line between normalcy and freakishness, reality and illusion seems thinnest are diffused in larger collections where, balanced by other more neutral subjects, they lose their disquieting edge.

Brassaï denied the impact of such photographs when he claimed, "I'm not interested in psychology. I make portraits the way I make pictures of objects. . . . I think that form expresses everything. You don't need psychology." [18] However, as Colin Westerbeck points out, "[Brassaï's] subjects were as a rule aware of the camera and had to accommodate it in some way, performing for the lens even if Brassaï himself did not prompt that perfor-

16. "Les êtres comme Marie, analphabêtes—spécimens heureusement de plus en plus rares—ne pensent pas d'après ce qu'ils ont appris dans les livres et les journaux . . . mais d'après les idées originales qui naissent dans leur tête. Ils voient et jugent toutes choses avec la fraîcheur et l'intensité du primitif ou de l'enfant." *PA,* 12–13.

17. Bosworth, *Diane Arbus,* 144.

18. See note 19 of Chapter IV.

mance."[19] Part of the effect of the resulting portraits is the difference between what Brassaï's subjects are willing to have him see and what they unwittingly reveal about themselves. The complicated interplay between deliberate self-presentation and inadvertent self-disclosure is what defines them as subjects.

Brassaï's self-consciousness as an observer emerges as a theme as early as *Voluptés de Paris;* later, the 1949 *Camera in Paris* included a series of images entitled "Onlookers." The majority of these images show their subjects lost in contemplation, seemingly unaware that they are being observed or photographed. However, two figures in this collection turn to face the camera—a burly "market porter" standing with his arms crossed, his torso filling the whole frame, and a stocky prostitute standing hand on hip—seeming by their sheer physical bulk and defiant postures to confront the photographer, although they do not look directly at the camera. The reflexive action of "observing the observer" or "seeing oneself being seen" is also reflected formally in the mirrors that have an important place in the iconography of Brassaï's photographs.

The Play of Mirrors

The multiple levels on which the observer figures in such portraits are objectified in the complex relationships between the speaking subject and the narrator in *Histoire de Marie.* Brassaï attempts to make himself into a mirror that will reflect her image, yet he displaces her, substituting his text for her story. The content and style of *Histoire de Marie* are the product of this identification and displacement, a compromise, and in some sense compromised form results. Marie, who can barely sign her name and puzzle out the letters of the alphabet one by one, is "written up" for a literate public. Brassaï does not formally suggest her lack of education by giving idiosyncratic spellings or phonetic transcriptions. He merely suggests the qualities of her presence as a "voice" by using capital letters for emphasis, excusing himself in a note for "the somewhat surprising use of capital letters. But Marie frequently thinks in capital letters."[20] He retains Marie's errors where they are unconsciously humorous, witty, or have a certain poetic accuracy. As a result, Marie speaks eloquently, and in repeating the words of her lawyer she uses sophisticated language—not to mention some legal terminology—with considerable (even surprising) facility.

19. Westerbeck, "Night Light," 37.
20. Brassaï, "Histoire de Marie," *PA,* 37.

Jean Paulhan, editor of *La Nouvelle Revue française,* and Francis Ponge, the poet of *Le Parti pris des choses,* found *Histoire de Marie* admirable, although Paulhan wished for more authenticity: "What is perhaps missing a little bit is having it written by Marie (with her odd writing and spelling mistakes)," he wrote Brassaï.[21] Where Paulhan regretted Marie's displacement, Henry Miller might have argued that Marie's story was a perfect example of Brassaï's ability to submerge his personality in that of his subjects, "to penetrate instantly the multiple identities that ordinarily remain foreign and closed to us."[22]

Yet Brassaï's "submersion" in Marie's story does not prevent his surfacing in notes to the reader, or keep him from having the last word. In fact, he includes a curious appendix to her story, listing in alphabetical order all the words that appear in capital letters in the text—from "Agent cycliste" (Bicycle Policeman) to "Voisins" (Neighbors) and "Voleurs de vélos" (Bicycle Thieves)—as "the constellation of [Marie's] existence." This lexicon, although it contains no rare or unusual terms, suggests that Marie's language is somehow different in kind from that of the author and further distances her as a primitive or "ethnographic" subject.

Histoire de Marie translates the observer's identification with his subjects into problems of form and style. Such an identification frequently underlies Brassaï's choice of marginal subjects, although it is offset by the self-conscious detachment that characterizes his representation of them. These marginal figures—the primitive or childlike "genius," the bohemians and tramps, the actors and actresses, dancers and clowns, the transvestites, homosexuals, and lesbians, prostitutes, outlaws, and outcasts—that dominate the universe of *The Secret Paris of the 30's* can also be read as alter egos for the artist.

As Hal Foster points out, such marginal figures had an "ambivalent charge" in early modern art. He cites "Gericault's paintings of the insane or Manet's full-dress portraits of 'philosopher bums' " as images that " 'troubled' the propriety of the discursive circuits of art." Yet he argues that by the time of early Picasso "these figures no longer have this ambivalent charge: they are *coded* images for the artist of [his own] social marginality and historical alienation."[23] In this respect, however, Marie more closely resembles the figures in Manet's painting—an object of the artist's "ambivalent gaze." If he

21. "Jean Paulhan m'écrivait: 'Moi, je trouve Marie admirable. Aussi elle est exemplaire. . . . Ce qui lui manque peut-être c'est d'avoir été écrit par Marie (avec bizarreries d'écriture et fautes d'orthographe).' " Brassaï quotes from his letter and Ponge's in the notes to *Brassaï* (Paris: Editions Neuf, 1952), unpaginated.

22. Henry Miller, *The Eye of Paris,* reprinted as the introduction to *Brassaï,* unpaginated.

23. Hal Foster, *Recodings* (Port Townsend, Wa.: Bay Press, 1985), 37.

distances her as a specimen—an occasionally grotesque specimen—of the "primitive," making her the subject of a quasi-ethnographic study, he also elevates her to the status of heroine, dramatizing her (apparently certain) triumph over the rich and powerful *Société* that owns her apartment building. Marie's triumph obscures the persistent inequities of her position, but "her" narrative reconciles her, formally and legally, if not socially, with a *Société* that recognizes her right to "her own little place." Interestingly, if Marie's story were revised, substituting "writer" for "primitive," "literary" for "legal" success, this new version would bear a strong resemblance to Brassaï's two-volume biographical work on his friend Henry Miller because both narratives are success stories, accounts of the "recognition" and "legitimization" of their subjects.

This is particularly true of *Henry Miller, grandeur nature,* which is Brassaï's account of Miller's Paris years: the *sturm und drang* of Miller's efforts to find himself as a writer and to find a publisher for *Tropic of Cancer* and *Black Spring.* The first volume concludes as Miller flees Paris and the approaching war to join Lawrence Durrell in Greece. By then Miller was no longer the nobody who had arrived in Paris without "a cent, a reputation, or a fixed domicile." When Brassaï first met him at the Café du Dôme, Miller had nothing but "a toothbrush, a razor, a pen and notebook, a raincoat and a cane he had brought with him from Mexico"; the police could have picked him up for vagrancy at any time (*GN,* 10).

The second volume, *Henry Miller, rocher heureux,* chronicles the later years of Miller's notoriety. The continuity of the work is established through accounts of Miller's sporadic reunions with Brassaï, either in France or in the course of their travels. Full of details about lunches and dinners, reminiscences and gossip, this volume merely sustains the conversation between them. However, the two volumes on Miller fit together with the earlier *Conversations with Picasso,* so much so that versions of the same conversations figure in both books. The repetitions demonstrate the continuity of Brassaï's relationships during the most productive period of his own creative work, which is in some sense the underlying subject of both biographical efforts. Brassaï offers his accounts as partial and intimate glimpses of friends, close-ups of fellow artists; he makes no pretense of writing a full-blown biography or attempting to see his subjects *whole* in order to reveal some larger truth about them. In keeping with a documentary approach, he concentrates on those periods of the artist's life in which he was directly involved; each book begins where Brassaï himself comes in.

These biographical works convey more clearly than *Histoire de Marie* Brassaï's conception of literature as the extension of a speaking subject. This

conception brings Brassaï into conflict with Miller, because he tended to approach Miller's autobiographical fictions as the products of real experience and felt compelled to review Miller's portrayal of the photographer in *Tropic of Cancer* in order to dispel any notion that this character bore more than a superficial resemblance to him. He admitted that "the cavalier manner Miller took toward the facts initially profoundly troubled, even shocked" him. "Why," he wondered, "did Miller feel the need to distort the facts?" (*GN*, 163, 159) Brassaï's referential conception of language, perhaps reflecting the declarative character of Hungarian speech, plays a crucial role in defining his style. In the two volumes on Miller, he mixes letters, diary entries, reports of conversation, as well as quotations from literary and philosophical works, creating an effect that corresponds closely to his characterization of Miller's prose: "diffuse, . . . an astonishing mixture! Novel, essay, diary, poetry, reportage, philosophy, . . . esthetics, theology, pell mell in a disorganized order." [24] In this sense, his style mirrors his subject, recalling Francis Ponge's *Le Parti pris des choses,* where each of the "objects" represented by the poet dictated a particular stylistic approach.

If Brassaï's prose reconciles his differences with Miller to some degree, their different conceptions of literary art led to occasional "heated discussions" (*GN*, 41) in the thirties. However, this heat does not convey the sense of intense involvement in another artist's creative work that animates the *Conversations with Picasso.* One reason may be that this was a period of intense creative activity for Brassaï himself, and a crucial moment in his career as a photographer. He was at work on the photographs that would make up *Paris by Night* as well as the disavowed *Voluptés de Paris*—and, ultimately, *The Secret Paris of the 30's.* In one sense, it was not Brassaï's interest in Miller's work, but Miller's interest in Brassaï's photographs that drew the two men together. Measured against Brassaï's cautious and reserved response to Miller's work, Miller's admiration for Brassaï's photographs appears unbounded. He writes a photographer into *Tropic of Cancer,* reworking the text into *The Eye of Paris,* while in a more private vein, his letters to friends express astonishment at the extraordinary work Brassaï is doing. He wants to buy "perhaps two dozen" of Brassaï's photographs to illustrate his novel (*GN*, 40). Miller discovered in Brassaï "a man like myself who understood Paris without any effort of will. [A] man who worked like a slave, without my knowing it to illustrate my books" (*Brassaï,* unpaginated).

24. "Sa prose était diffuse, baroque, embrouillée comme le rêve. Et quel mélange insolite! Roman, essai, journal, poésie, reportage, philosophie, obscénité, esthétique, théologie, pêle-mêle, dans un désordre ordonné." *GN*, 43–44.

In a 1974 interview Brassaï was asked what he thought of being "described as the Henry Miller of photography." He replied, "Right, in as far as my photographs of the Paris underworld are concerned. . . . But my other interests can not be classified as such." [25] Despite his understandable reluctance to be considered another Henry Miller, he frequently lets Miller "speak for him" by quoting from *The Eye of Paris* when describing his own work or the nature of his creative sensibility. Yet he distances himself from Miller's portrait of him by shrewdly observing that it is informed by Miller's nostalgic longing for a creative sensibility that would be his own opposite: "Curious thing, in creating my portrait, feature by feature, he drew his own at the same time, but *en négatif*" (*GN,* 170).

Although Miller's "negative" self-portrait remains latent in his portrait of Brassaï (Miller's references to himself are by no means absent from it), Brassaï is an even more positive presence in his book on Miller. *Henry Miller, grandeur nature* provides Brassaï with a pretext for rediscovering his own work through the impact it had on another, very different, creative sensibility. "I see myself being reflected in an infinitely distant mirror," he admitted, commenting on Miller's descriptions of him in letters to other friends (*GN,* 39).

Such self-discovery generally flaws biographical writing, and the biographer must remain alert to the dangers of identification, compensating for the fact that "any biography uneasily shelters an autobiography within it." [26] Yet Brassaï constantly contrasts his own reactions and impressions with those of Miller, with the result that his book becomes something of a double portrait. The gallery of Brassaï's photographs that "prefaces" the text of the Gallimard edition confirms this, for the first image is Brassaï's portrait of Miller, followed by other portraits of the friends who played an important role in Miller's life, Lawrence Durrell, Anaïs Nin, and Henry's earliest muse, June; the last portrait is of Brassaï, formally paired with Miller. The first page of Brassaï's account confirms the author's partial displacement of his subject, as it begins, not with Brassaï's description of Miller's arrival in Paris, or even his first meeting with Miller, but with a passage quoted from a letter in which Miller recalls his first meeting with Brassaï. "Your eyes hypnotized me," Miller recalled in the letter, "like Picasso's" (*GN,* 9).

Brassaï creates a network of affinities that he shares with Miller and that Miller shares with Proust, Céline, l'Abbé Prévost, Goethe, Victor Hugo, Rabelais, Rimbaud, and the Surrealists. He reports that Miller judged the

25. Hill and Cooper, eds., *Dialogue with Photography,* 42.
26. Paul Murray Kendall, *The Art of Biography* (New York: Norton, 1965), x.

Surrealists "rather harshly" (*GN*, 179), but reveals the power they exercised over his own imagination when he portrays Miller as more Surrealist than the Surrealists themselves. He sees Miller's June as another Nadja, an inspired embodiment of the Surrealist "voice" and an inventive genius capable of troubling the course of everyday events. He pushes the parallel still further by insisting that Miller's prose, like the Surrealists' automatic texts, was dictated by an inner voice over which the author had only limited control. Miller merely took dictation, transcribing a stream of words that flowed onto the paper without a pause or a single correction, the transcription made possible by Miller's ferocious attachment to his all-important typewriter (*GN*, 174). "What would Henry's style have been like," Brassaï wondered, "had he written more calmly by hand" (*GN*, 143).

Behind this emphasis on the typewriter as an instantaneous recording machine lurks an unformulated parallel between Miller's use of the typewriter and the function of the camera in Brassaï's own work. Although the parallel is less elaborate than the one Brassaï established between drawing and photography in the preface to *Camera in Paris*, it is similar, equating writing (by hand) and drawing as primary expressive forms ("emanations" of the body), and suggesting that the use of a typewriter (camera) represents the same creative act at one remove. The persistence of such arguments, even in a latent form, suggests Brassaï's desire to "humanize" photographic technology and establish its validity as an expressive medium. In this sense, his effort to promote photography as the metaphorical model for a particular kind of artistic sensibility is crucial to his aesthetics. He refers to this model in order to define Miller's sensibility as an artist (and by implication, his own).

The issue emergès as he recounts Miller's fierce quarrel with Anaïs Nin over her insistence on the value of keeping a diary. Ultimately, his account of the argument becomes a pretext for asserting the value of photography practiced as an art, and art conceived in the spirit of photography:

Miller thinks, with Marcel Proust, that raw sensation, actual events experienced in their immediacy, immediate instantaneous perceptions, have little value. . . . She [Anaïs Nin] wants to remain on the level of the *non-transformed, non-transmuted, non-transposed*. She insists absolutely on the truth of the moment, the only authentic truth, according to her. . . . Transforming, creating, as Proust or Henry does, she thinks, is to warp, to falsify, to move away from the truth.[27]

27. "Elle veut rester sur le plan du *non-transformé*, du *non-transmué*, du *non-transposé*. Elle tient absolument à la vérité du moment, la seule authentique selon elle. . . . Transformer, créer, comme fait Proust ou Henry, pense-t-elle, c'est gauchir, fausser, s'éloigner de la vérité." *GN*, 66.

Brassaï saw Nin's defense of her journal as only one example of the contem-
porary "thirst for reality," the effort to capture the immediacy of events
directly, without the mediations of art: "Photography, film, radio, television,
weren't they invented for that?" While this new direction threatened tradi-
tional conceptions of art, he insisted that "the most mediocre photograph
contains some of the unique, irreplaceable substance of reality that neither
Rembrandt, Leonardo, nor Picasso, nor any work of art or artists, living or
dead, could attain, equal or replace." Consequently, when he quotes Nin's
defense of her journal: "I must prove the possibility of *instantaneous art,* im-
mediate, spontaneous, before it passes through the circuits of the brain and
lived events become abstractions, fiction, a lie" (*GN,* 66–67), he also makes
a case for photography.

Brassaï appears to make the case for photography over and against Miller,
who—as one of the transmogrifiers of reality—could only be an adversary
of art in the spirit of photography. Yet it is also true that a complicated
network of "elective affinities" linked Brassaï to Miller, Nin, Proust, Picasso,
and many other artists and writers in whose work he saw reflections of his
own. This complicated play of mirrors allows us to see Brassaï's image "en
négatif" in his portrait of Miller. And, by virtue of the identification, Miller's
portrait becomes Brassaï's own narrative of "recognition" and "legitimiza-
tion," compensation for the formal autobiography that he avoided writing
by displacing it onto his subjects.

The fundamental contradiction that defined Brassaï's career as an artist—
the desire to create an art form that would be the direct expression of reality
"*non-transformed, non-transmuted, non-transposed*" may have flawed his writing,
yet it contributes to the extraordinary resonance of his photography. As
Jeremy Wood wrote in 1980, "it is one of the ironies of Brassaï's career that
while working in one of the most popular and accessible mediums (one
which until recently has not had the mystique of 'art') he should seek to
inherit the traditional values of European painting, particularly when many
artists (who were his friends) chose to explore different directions." [28] Wood's
characterization of this contradiction as ironic suggests he considered Brassaï's
ambitions curiously retrograde. However, Brassaï's work—in its blurring of
the distinction between art and photography, conversation and fiction, oral
and literary traditions, popular and high culture—suggests the shift from
modernist to media culture. It is precisely Brassaï's importance as a transi-
tional figure that I would like to suggest in the conclusion.

28. Wood, "Brassaï: A Major Exhibition," 120.

Conclusion
From Modernist to Media Culture

Brassaï took up photography at a time when the illustrative, documentary image of photojournalism was largely responsible for shaping his contemporaries' conception of photography as a medium. This is not to say that viewers were insensitive to the aesthetic qualities of documentary photography—on the contrary—as Emile Henriot's review of *Paris by Night* for the January, 1933, *Le Temps* demonstrates. "While looking through this beautiful document, in which the friend of nocturnal Paris can take such keen pleasure," Henriot wrote, "we have tried to discern what it is that constitutes its particular attraction: its truth and poetry, its analysis and design, its rendering of atmosphere, its physical accuracy and its transforming fantasy."[1] The juxtaposition of truth and poetry, accuracy and fantasy, clearly demonstrates the tension between qualities associated with documentary representation as opposed to artistic invention, a tension that Henriot made no attempt to resolve precisely because there was no apparent need to resolve it. Resistance to the idea that a photograph could embody the unique vision of the creative artist—or the formal perfection traditionally associated with art—was based on the old 1850s prejudice against photography. Daumier had summed up the attitude in its most negative form when he scornfully dismissed photography as a medium that "imitates everything and expresses nothing."[2]

Seen in this context, Brassaï's effort to place photographic technology in the service of a traditional conception of art constitutes the fundamental contradiction of his position as an artist. It forces him into the paradoxical position of having to claim that he *invented nothing, but imagined everything.*

1. Emile Henriot, "Photos de Paris," *Le Temps,* January 30, 1933.
2. Georges Besson, *La Photographie française* (Paris: Arts et Métiers, 1936), unpaginated.

Yet the contradictions of his position are precisely what mark him as a transitional figure, an important link between modernist and media culture whose work reflects the gradual transformation of certain traditional ideas about art and culture. It might be objected that labeling Brassaï a transitional figure obscures his uniqueness as an artist and that the term could be used to refer to any of the major photographers who worked during the thirties, or in fact any number of artists whose work straddles different stylistic traditions or periods of cultural change. However, in Brassaï's case the label is particularly meaningful precisely because it reflects both Brassaï's situation with regard to the art of the thirties and the situation of photography with regard to the larger culture. More than any of the other photographers of the thirties—or in fact many artists in other media—Brassaï was preoccupied with the nature of creative activity and the evolution of artistic expression. Perhaps the fact that he deliberately chose photography over drawing and painting at a crucial moment in his development made him more aware of the issues at stake in the choice. Regardless, Brassaï is both a unique artist and a transitional figure whose work reconciles contradictory aesthetic impulses. In conclusion, then, I intend to sum up briefly the contradictions that characterized Brassaï's situation as an artist associated with Surrealism in order to suggest that his contradictions reflect those of a culture in transition.

We might say that Brassaï devised a variety of strategies for dealing with what Jean-Pierre Chamboredon referred to in the 1965 sociological study of photography *Un Art Moyen* as the "uneasiness" of virtuoso photographers—an uneasiness arising from the uncertainty of their position as artists.[3] Brassaï began by mastering a form of photography recognized for its technical difficulty, showing his creative abilities by developing particular techniques to overcome the limitations of the medium. He reconciled technology with art by making artistic virtues of these limitations; his compensations for them—photographing in rain and fog, using trees and buildings to deflect harsh night lighting, using water, fog, and mirrors to reflect and soften it, combining flash and normal exposures—became important elements in his style. As the technology improved, Brassaï remained faithful to his old equipment, relying on the technology in a deliberately limited way and making a certain poverty of means demonstrate his mastery of the medium.

Brassaï's preface to *Camera in Paris* represents a deliberate effort to find artistic antecedents for his work and to place it in a tradition of artist-reporters. However, he also appealed to artistic tradition by making frequent

3. Jean-Pierre Chamboredon, "Art mécanique, art sauvage" in *Un Art Moyen,* ed. Bourdieu, 220–21.

allusions to it in the content and formal structure of his images. Some of his compositions with mirrors have Baroque counterparts, certain of his café scenes recall Degas (notably the *Absinthe Drinkers*) and Manet (the *Bar aux Folies Bergères*), as do certain of his photographs of the opera and of ballet dancers. Jeremy Wood notes that "Brassaï's photographs taken in brothels such as 'Suzy's' are almost clinical, and share some of the detachment to be found in the Degas illustrations to *La Fille Elisa* by Edmond de Goncourt (which was itself derived from [Constantin] Guys's drawing of prostitutes)."[4] There are suggestions of Picasso's saltimbanques in the image of a pair of exhausted dancers resting between rehearsals that appeared in *Camera in Paris,* and Brassaï wittily recast Rembrandt's *Nightwatch* in a photograph that shows a museum guard in a darkened museum training a flashlight on a Rembrandt self-portrait. Brassaï's photographs of artists and studios adapt a variety of pictorial traditions to photographic effect and experiment with pictures within pictures. Brassaï uses mirror reflections, views from windows, actual paintings, and even advertisements to call the viewer's attention to the photographer's more inclusive compositions, which attempt to give fragments of reality the formal coherence of art.[5] Through such allusions to artistic tradition Brassaï asserts his artistic literacy, his ability to "quote" from the tradition and to "rephrase" it.

Brassaï's complex identification with Henry Miller, with Picasso, his qualified admiration for the Surrealists, his constant references to a literary and artistic tradition have their ideological function within the context of his work. They represent his continued efforts to associate himself with this tradition, to "write" his place within it and so assure the perception of his work as art. Significantly, it is precisely Brassaï's association with Surrealism that Chamboredon considered the crucial factor in his success. "The most famous aesthetic photographers," Chamboredon argued, "such as Man Ray, Brassaï, or Clergue are primarily distinguished by belonging to a group of artists and writers whose works constitute a commentary, direct or indirect, on their work."[6]

However, the Surrealists' embrace of photography in the twenties and thirties did not so much legitimize photography as art as it epitomized the

4. Wood, "Brassaï: A Major Exhibition," 119.

5. See Krauss, "Nightwalkers," 33–38. She notes that mirrors in Brassaï's work function "like reduced, miniature photographs contained within the space of the master photograph," and emphasizes the importance of such interior images as a structure "en abyme," a reflexive doubling that deliberately refers to the status of the photograph as a reflection of the real (36–37). While this is certainly one possible way of interpreting them, it should not be overemphasized.

6. Chamboredon, "Art mécanique," in *Un Art Moyen,* ed. Bourdieu, 240.

movement's ambivalent and contradictory attitude toward art in general. "We are *not* in literature and art," Breton had declared emphatically in his essay on Surrealism and painting. He categorically rejected any suggestion that Surrealism was primarily concerned either with artistic expression or formal experimentation, emphasizing instead the revolutionary nature of the Surrealist "intervention" in the arts in an effort to change modes of thought and perception.[7] Although over time this "intervention" has come to represent yet another form of cultural production, an aesthetics rather than a politics ("an aesthetics that yearned to be a politics," as Susan Sontag characterized the movement), nonetheless it was Surrealism's consistent preference for "the underdog, . . . the rights of a disestablished or unofficial reality" that explained photography's attraction.[8]

To some degree the Surrealists' use of photographic images as documents and illustrations merely reflected the proliferation of such images in print media and their corresponding importance in popular culture. However, the Surrealists also used such photographs to contest or subvert conventional perceptions of reality and, implicitly at least, as counterculture or "anti" art. Photography's not inconsiderable value to Surrealism resided in its uncertain status as a mode of representation. Viewed as a form of mechanical reproduction requiring no particular artistic skills and no long apprenticeship, photography appeared to offer an alternative to drawing and painting in the expression of Surrealist automatism. Yet photography also provided beautiful, provocative images that clearly rivaled other Surrealist plastic experiments, even though photography had no institutional recognition as an art form. Nonetheless, except in the case of Man Ray, whose expressive concerns Breton assimilated to those of Surrealist painting, photography remained on the margins of Surrealist activity as an *ad hoc* practice that was never examined critically to assess its potential or broader implications. Consequently, Brassaï's association with Surrealism was more an arrangement of convenience than an effort at legitimization. However, there is a correlation between the nature of Surrealist activity in the thirties and the increasing importance accorded photography in *Minotaure,* a correlation that favored Brassaï's artistic ambitions.

The internal rift between Surrealism's politics—its demand for revolution and social change—and its psychological and aesthetic preoccupations wid-

7. The quotation here refers to the French text: "Car *nous ne sommes pas* dans la littérature et dans l'art" (*SP,* 19) rather than Taylor's translation: "Because in terms of literature and art, *we do not yet exist,*" which puts a slightly different slant on the claim.

8. Sontag, *On Photography,* 54.

ened in the thirties despite Breton's masterful efforts to maintain the movement's integrity. Aragon's "defection" to the Communist party represented an important loss, as he was both one of the group's founding members and an important poet with a considerable reputation. Yet Breton continued to attract new talents to the movement, and the loss of Aragon was offset by the glow generated by Dali's rising star. Significantly, Breton viewed Dali's creation of symbolic objects and his method of paranoiac critical interpretation in the light of a more direct engagement with exterior reality that ultimately led Surrealism to declare "the crisis of the object" in the mid-thirties.[9] However, if this period of Surrealist activity was characterized by what Breton considered "an unprecedented desire to objectify" (SP, 277), the Surrealists' efforts to challenge conventional perceptions of exterior reality had an increasingly important aesthetic rather than political dimension. *Surrealism at the Service of the Revolution* gave way to *Minotaure* in 1933, and Brassaï began contributing photographs to an "art" magazine whose elegant presentation elevated his images to the status of art objects. *Minotaure* engaged Brassaï's work in an interrogation of culture that ultimately blurred the distinction between art and photography because it implicitly adopted a broader, more inclusive view of art. Nonetheless, when Breton championed the art of the real in an eloquent essay (illustrated by Brassaï's photographs) written for the first issue of the review, his subject was not photography, but Picasso's painting and sculpture. Ironically, perhaps, if Breton's essay explored some of the most important questions raised by considering photography as art, it did so "unconsciously."

In fact, Breton never even alluded to Brassaï's photographs in the essay "Picasso in His Element," focusing instead on Picasso's incorporation of a real object in a painted composition. "It is only in 1933 that a real butterfly has been able to enter the field of a painting . . . without its entire surroundings crumbling immediately into dust," he marveled. Breton considered Picasso's ability to contain the overwhelming impact of a real object within a network of formal or pictorial associations nothing short of revolutionary, and declared that, once again, Picasso had gone beyond "the limits set to artistic expression" (SP, 101–102). However, in celebrating the marriage of art and reality, Breton's essay undercut the necessity for the artist's mastery

9. Breton's essay "The Crisis of the Object" dates from 1936, as does the Surrealist exhibition of objects at the Galerie Pierre Colle, although as Breton himself points out, he had called for the creation of objects seen in dreams as early as 1924. Salvador Dali defined "objects with symbolic functions" in 1931, and of course ready-made objects had been a preoccupation of Marcel Duchamp much earlier.

of technique: the ability to translate vision into form in the elaboration and representation of a subject. He redefined "art" as a dialectical process in which the artist assimilates the real world, a process in which the works themselves merely constitute the by-products of "a series of *optimal moments*" (*SP,* 108).

Breton further denigrates art by comparing these by-products to excretions, although as representations that can capture and preserve optimal moments he might have more aptly compared them to photographs. In any case, "the artist's primary concern," Breton asserted, "should be to accomplish a body of living work." He considered the enduring beauty—or for that matter the beauty itself—of the resulting work to be of only minimal importance. He praised Picasso for seeking out "the perishable and the ephemeral for their own sake." If Picasso's early *papiers collés* had faded and discolored, their forms warped by humidity, Picasso's real aim, Breton maintained, was "to bring to terms in advance all that is precious, because ultrareal, in the process of their gradual dilapidation" (*SP,* 109). While this curiously melancholy reflection on the workings of time as a crucial element in the transformations of art suggests a modern variation on the romantic predilection for ruins, it also undermines "traditional" notions of art by devaluing the uniqueness and enduring beauty of the artwork.

In the first *Manifesto of Surrealism* (1924) Breton's emphasis on automatism and its various forms of expression had undermined the romantic conception of the artist as author/creator by instituting a form of artistic or literary activity in which the "artist" was no longer the "author" of the work. Breton continued to insist on this tenet of Surrealist faith long after automatic writing had failed to live up to its promise, reaffirming his position in the thirties in his defense of Aragon's poem "Le Front rouge." Aragon could not be held accountable for the ostensibly seditious nature of the poem, Breton argued, precisely because Surrealist artists and poets could not be held accountable for "their" works. His essay on Picasso further eroded traditional notions of art by subordinating artistic production to a psychology of creation and aesthetic response in which the emotional impact of the work as a form of reality testing took precedence over the formal perfections of the work as an art "object."

Such a conception of art might have led Breton to make a powerful case for photography as the only medium that could make it possible to produce a body of "living work" that captured and revealed the perishable or ephemeral nature of reality. However, the Surrealist case for photography continued to be argued most convincingly between the covers of *Minotaure,* where

photographic images mixed freely and on an equal basis with photographic representations of more traditional works of art. It may seem surprising that Brassaï never criticized the Surrealists' attitude toward photography, but instead took issue with their attitude toward painting, claiming they were not sufficiently interested in pictorial values.[10] His attitude becomes more understandable if we recognize that while *Minotaure* provided him with a valuable connection to important modern artists and an outlet for his work that emphasized its aesthetic qualities, Surrealism's efforts to subvert traditional conceptions of art represented more of a threat than a justification for his "art."

Brassaï suggested something of the difficulties of his position as a photographer and the perils of the photographer's double bind in an anecdote he recounted in *The Secret Paris*. Startled awake by a late visitor to his room, he sleepily opened his door only to be confronted "by a giant brandishing a crime magazine." Brassaï recognized the man as a "marvelous mobster" he had photographed one evening in a bar. However, his editors had published the photograph with a caption identifying the man as an assassin. "So I'm a murderer," his visitor raged, pushing back his cloth cap and brandishing a switchblade. "All right then, I'm going to kill you" (*SPT,* Introduction). Caught between the "real" subject and the editors who appropriated his images, reinterpreting and sensationalizing them for mass consumption, Brassaï risked both literal and professional extinction.

One way for him to break out of the role of intermediary and assert control over his production was to emphasize the uniqueness of his creative vision by exploring certain themes or images. He could then attempt to give his photographs the unmistakable imprint of a style that would ultimately allow him to claim them as his own work as he gradually made a name for himself. Consequently, Brassaï described his role rather accurately when he acknowledged simultaneously the all-importance of his subjects (the position of the documentary photographer: "I invent nothing") and of the creative sensibility that reinvented them as the subjects of his own work (the position of the artist-photographer: "I imagine everything").

Of course, in order to adopt this position Brassaï could not dismiss the importance of the artist as the creative author of his works or devalue the importance of the formal qualities of the works themselves. Consequently, instead of justifying his practice as a photographer by looking to Surrealism, he looked back toward the modernism defined by Baudelaire (despite Bau-

10. He complained that the Surrealists did not admit any serious consideration of pictorial qualities so that "even good painting would be admired for the wrong reasons." *Picasso,* 27.

delaire's rejection of photography) and claimed photography as a quintes-sentially modern medium. Jeremy Wood remarked on the contradiction, noting that when Brassaï called photography the " 'modern medium' which gives 'expression to the true twentieth-century style,' " he sounded "ambig-uously nineteenth-century in tone, recalling 'il faut être de son temps' and Baudelaire's conception of 'modernité.' " Although Wood concluded that "Brassaï's aesthetic corresponded "to the pictorial attitudes of Guys, Daumier and Degas," it is actually not quite so easy to classify if we look to *Graffiti*, which as Wood himself admits, reveals most clearly the "ambivalence be-tween tradition and modernism in Brassaï's work." [11]

Brassaï published his first photographs of graffiti in *Minotaure* during the thirties, prefacing the images with a short essay that emphasized their break with traditional aesthetics. Presenting graffiti as art—a "seedy art of the back streets"—harmonized perfectly with the Surrealist attack on established forms of art and their emphasis on anonymous collective works. As expres-sions of desire and symbols of the "vital need" (*G*, 10) for self-affirmation over and against the world, the graffiti derive their force and authenticity from the crude, primitive qualities of their realization. The fragility of their testimony to a desire for self-affirmation links Brassaï's graffiti to the "ultra-real" dilapidation of Picasso's *papiers collés*—and to photography as the me-dium best suited to preserve the art of the ephemeral. However, Brassaï's introduction to the collection of his images of graffiti published in 1961 placed them squarely in the "tradition" of modern art, which he traced back to Van Gogh's love for the *estampe japonaise* and Gauguin's fascination with Polynesian art.

" 'Barbarian' and 'childlike' arts, African and Polynesian totems, Aztec and pre-Columbian idols, Etruscan and Hittite gods, Indian, Eskimo, and Canack fetishes, Aurignacian goddesses have invaded the West," Brassaï as-serted. Whatever the reason for this "mutation" in the modern sensibility, whatever the reason for the ascendancy of primitive, non-Western, and naïve works over those of modern artists, the transformation of artistic values it effected was permanent, Brassaï maintained: "Everything that has been in-tegrated into art, or excluded from it, has changed the very notion of art" (*G*, 11). Brassaï's analysis implicitly links Baudelaire's defense of the expressive qualities of primitive or "barbarian" works to the Surrealist fascination with the art of primitive and non-Western cultures on the grounds that such works have a directness and expressive force superior to many more formally perfect

11. Wood, "Brassaï: A Major Exhibition," 120.

works. Once expressive value is divorced from technical mastery, "awkwardness can signify grandeur; clumsiness ingenuity," Brassaï affirmed; "they can be the marks of authentic creation." [12]

Brassaï barely hinted at the importance of photography in this cultural evolution, perhaps because photography has a contradictory role to play in the scheme he develops. On the one hand, "more than any other form of artistic expression, graffiti are required to pay tribute to photography," he asserted, "for unless the camera intervenes to capture them, or the incandescent lava of Vesuvius preserves them, they inevitably disappear." [13] By interposing the camera between graffiti and the perceiver, Brassaï implicitly establishes a parallel between the projective work of the photographer and that of the graffiti artist. Both perceive a certain expressive potential in the world around them, which they actualize by a gesture of appropriation that gives formal coherence and meaning to disparate or ephemeral elements of reality. [14] Paradoxically, however, although Brassaï asserts the importance of photographic technology in preserving graffiti, he explains the "mutation" of sensibility that led to an appreciation of the graffitists' art as a reaction against the evils of technology. "It is possible that modern art is the standard bearer of an underground revolt against the crimes of mechanized civilization," he suggests. "Isn't it strange that in a world whose idols are Science, Technology, Economics and Mathematics, art aims at the liberation of precisely those forces that deny them?" [15] Brassaï's use of photographic technology to preserve a form of expression that he viewed as a protest against

12. "Arts 'barbares' et 'enfantins,' totems nègres et polynésiens, idoles aztèques et hittites, fétiches indiens, esquimaux et canaques, déesses aurignaciennes ont envahi l'Occident. . . . Tout ce qui fut peu à peu intégré à l'art, ou exclu, a changé la notion même de l'art. . . . La valeur de l'expression n'a plus rien de commun avec la science, le savoir faire, l'habileté. Gaucherie peut signifier grandeur; maladresse, ingénuité; elles peuvent être la marque d'une authentique création." G, 11.

13. "Plus qu'aucune autre expression de l'art, les graffiti sont tributaires de la photographie. A moins que l'objectif n'intervienne pour les fixer, ou la gangue incandescente du Vésuve qui les a préservés, ils disparaissent fatalement." G, 10.

14. Clearly, however, the parallel best fits the kind of graffiti Brassaï photographed, where the artist dug into the surface of the wall using a sharp implement and gouged out cracks, or used preexisting depressions, surface irregularities, and even old posters or other printed matter adhering to the wall as part of the "design." Spray-paint graffiti artists who cover smooth (and preferably blank) surfaces with their own designs obey a somewhat different impulse.

15. "Il se peut que l'art moderne ne soit que le porte-drapeau d'une sourde insurrection contre les méfaits d'une civilisation mécanisée. N'est-il pas étrange que dans un monde qui a pour idoles 'Science,' 'Technologie,' 'Economie,' 'Calcul,' l'art vise précisément à libérer les forces qui les nient." G, 11.

technological civilization has its irony, as does the fact that by photographing graffiti and preserving them as art, his photographs mediate and dissipate their impact as intentionally disruptive signs of presence.

According to Walter Benjamin, the "loss" of reality this entails is symptomatic of changing conditions and modes of perception occasioned by the development of mechanical means of reproduction. In his 1936 essay "Art in the Age of Mechanical Reproduction," Benjamin argued that in the age of mechanical reproduction the work of art inevitably loses its "aura": its unique existence in time and space.[16] Photographic reproduction, while in no way attacking the object itself, depreciates its aura by detaching the work from its particular place in history and tradition and replacing its unique presence with multiple copies. These copies allow the work to be brought to the viewer, who then experiences it within the space of his or her own particular social and historical circumstances. Benjamin saw this "tremendous shattering of tradition" as a "process whose significance points beyond the realm of art" and ascribed "the decay" of the aura to two circumstances arising from "the increasing significance of the masses in contemporary life."[17] He considered the first of these circumstances to be the "desire to bring things 'closer' spatially and humanly," and the second "a sense of the universal equality of things" so powerful that it willingly sacrificed the uniqueness of reality to obtain this equality through its reproduction. "This adjustment of reality to the masses and of the masses to reality is a process of unlimited scope," Benjamin concluded, "as much for thinking as for perception."[18]

The rise of illustrated papers such as *Paris-Soir* and illustrated weeklies such as *Vu*, which sought to bring both everyday occurrences and events of national and international importance to the "eye-level" of their reading public, clearly represented a form of this adjustment. Surrealism, although it engaged a cultural elite rather than the masses, aimed at a similar shattering of tradition by blurring distinctions between life and art. Photography played a significant role—all the more subversive for being unarticulated—in this "leveling" by providing a model of convulsive beauty, an aesthetics based on "the experience of reality transformed into representation."[19] Ironically, it is precisely in its experience of reality as representation that the revolutionary

16. Walter Benjamin, "Art in the Age of Mechanical Reproduction," in *Illuminations*, trans. Harry Zohn (New York: Harcourt, Brace & World, 1968), 224–25.

17. *Ibid.*, 223, 225.

18. *Ibid.*, 225.

19. Krauss and Livingston, *L'Amour fou*, 35–36.

dimension of the Surrealist intervention in the arts has been appropriated by media culture, largely through advertising. "First and second degree permutations of Surrealism continue to exist in contemporary art photography and mass media vehicles of fashion and advertising photography," Nancy Hall-Duncan pointed out in the introduction to the 1979 exhibition *Photographic Surrealism*.[20] She included examples of such mass-media "commercial" Surrealism in the show in order to emphasize their social significance. "Because of its enormous distribution, mass-media photographic surrealism has affected our society's perceptions and values in a way that orthodox surrealism never could," she maintained. "That a photograph of the chalk-mark outline of an accident victim can sell shoes is telling both in terms of our society's values and the changes that have taken place in surrealist images since the 1930's."[21] Retrospectively, Surrealism can be seen to bridge—however uneasily and paradoxically—the modernist avant-garde and media culture. The Surrealists' embrace of photography is then an important indication of the imbrication of art and media culture and of a shift in attitude toward art and its role as cultural expression. This shift is implicit in *Minotaure*'s use of photography, and Brassaï's collaboration with the Surrealists is certainly one reflection of it.

However, according to Georges Besson's *La Photographie française,* the photographer of 1936 was already convinced that any distinction between photography and art was purely academic. "Some [photographers] imagine that it would be insulting to suspect them of not making works of art," Besson maintained, "and consider, given their own merits, the case closed. Others only think of being irreproachable technicians in order to be true, lively and even amusing, leaving it to the critics to classify them."[22] Further, as Christopher Phillips points out, it was "during the thirties that the task of ordering and valuing photographic artifacts began decisively to pass from the hands of technical historians—such as the German photochemist J. E. Elder—and antiquarians—like the indefatigable Gabriel Cromer—to those of university-trained art historians."[23]

Beaumont Newhall's famous 1937 exhibit at the Museum of Modern Art—*Photography 1839–1937*—also represented an important step in the rec-

20. Hall-Duncan, *Photographic Surrealism,* 5, 11.

21. *Ibid.,* 11–12.

22. "Les uns s'imaginent qu'il serait injurieux de les suspecter de ne pas faire oeuvre d'art et considèrent, vus leurs mérites, cette affaire comme étant réglée. Les autres ne pensent qu'à être des techniciens irréprochables pour faire vrai, vivant et même amusant, laissant aux littérateurs le soin de les classer." Besson, *La Photographie française,* unpaginated.

23. Phillips, "A Mnemonic Art?" 36.

ognition of photography as art. If in putting together the exhibition Newhall adopted an inclusive perspective on photography similar to that of the European avant-garde in the *Film und Foto* exhibition, he emphasized the importance of photographic "art" by publishing a history of photography in which he attempted "to construct a foundation by which the significance of photography as an esthetic medium [could] be more fully grasped."[24] By 1940 Newhall had been named the curator of photography at the Museum of Modern Art, the first such position in any museum. When Brassaï's first major exhibition in France took place at the Bibliothèque Nationale some twenty years later, the place of photography in the museum was justified by emphasizing the original vision and technical perfection of the work of the individual photographer—implicitly ascribing to photographic "art" precisely those qualities that photographic technology had originally been denied. Yet Brassaï's ambivalence about being assigned a place in the museum reminds us that in the introduction to *Camera in Paris* he claimed something more for photography than art. "Whether they like it or not, the painters of modern life are the photographers and cinematographers," he argued. "Since they possess the real power, it matters little whether they are considered to be 'artists' or as mere operators of picture machines" (*Camera,* 17).

For the Walter Benjamin of the 1936 "Art in the Age of Mechanical Reproduction," the debate about the status of photography as art merely prolonged a "devious and confused" nineteenth-century dispute that obscured the far more important question of "whether the very invention of photography had not transformed the entire nature of art." Originally, the artwork was the object of a cult and had symbolic or ritual functions, Benjamin maintained; consequently its value resided in its very existence, and it remained hidden from view or accessible to only a few people at a time. However, the possibility of mechanical reproduction conferred an entirely different status on the artwork by divorcing it from its importance in ritual and placing emphasis on the work's "fitness for exhibition." "By the absolute emphasis on its exhibition value the work of art becomes a creation with entirely new functions, among which the one we are conscious of, the artistic function, later may be recognized as incidental."[25]

Viewed in the context of Benjamin's analysis, the cultural appropriation of photography as art begun during the thirties can only be a form of regression, an effort to deny the changing nature of art and to preserve old

24. Beaumont Newhall, *Photography: A Short Critical History* (New York: Museum of Modern Art, 1938), 9.

25. Benjamin, "Art in the Age of Mechanical Reproduction," in *Illuminations*, 226–227, 229.

cultural categories even though they were no longer meaningful. However, the reclassification of photography as art might also be said to point to a crisis in photography that has larger cultural significance. In this sense, and despite its profound difference as a cultural phenomenon, the acceptance of photography as art parallels the crisis in painting described by Benjamin, which was the result of the transition from ritual to exhibition values. "The simultaneous contemplation of paintings by a large public, such as developed in the nineteenth century, is an early symptom of the crisis of painting," Benjamin wrote, "a crisis which was by no means occasioned exclusively by photography but rather in a relatively independent manner by the appeal of art works to the masses." Although Benjamin deliberately avoids drawing the conclusion that this crisis is an early indication of the inevitable decline of painting, he does intimate that it constitutes a serious threat "as soon as painting, under special conditions, and as it were, against its nature, is confronted directly by the masses."[26] Brassaï's rather more polemical introduction to *Camera in Paris* in the late forties presents this decline or marginalization of painting as a fact, claiming that "the great respect in which oil-painting is held . . . is due to its former glory and not to the part it plays in modern life" (*Camera*, 16).

Whereas the crisis in painting Benjamin described arose because the medium "[could] not present an object for simultaneous collective experience," the crisis in photography results from the medium's role as an intermediary or illustrative form.[27] Associated with print media as illustration or captioned image, photography has been eclipsed by film and television (and ultimately video) as a means of bringing people and events to eye-level. As photography has a more limited ability to provide a focus for collective experience than film, television, or video, it has come to serve as a modern equivalent for painting and has taken its place beside painting in the museum. Equally significant is that through its illustrative function photography remains associated with written communication. While the photograph can escape being subordinated to the written word, it usually serves to draw a reader into a text or provides an immediate visual confirmation of a text. Film, television, and video, on the other hand, move closer to the spontaneity of conversation, bringing the world to the masses with greater immediacy and directness. Photography falls between the two extremes: associated with written communication, it compensates for the immediacy the written word lacks, yet only rarely escapes its hegemony. Brassaï's contradictions as an artist

26. *Ibid.*, 236–37.
27. *Ibid.*, 227.

reflect the transitional nature of his medium and its role in a culture in
transition. He is pulled in different directions by two opposing conceptions
of art: one embodies the cultural values associated with written communi-
cation; the other, evolving from the practice of photography, asserts the
importance of immediacy and spontaneity, qualities associated with oral
communication.

Written communication, as Robin Tolmach Lakoff indicates, has a certain
permanence and respectability; it is "the stuff of history." [28] A skill deliberately
acquired, written communication is practiced deliberately and so is generally
taken to be the result of the writer's considered decision as to what he or
she intends to convey. As the product of a carefully planned presentation, a
written communication can create a more lasting impression "and allows a
reader as well as a writer to rethink, re-experience, and revise impressions
which, in traditional forms of oral discourse, are lost forever once uttered."
Oral communication, on the other hand, is more spontaneous and conveys
the warmth, liveliness, and emotional power of a real human presence. While
Lakoff admits that it is sometimes possible to avoid choosing between the
values implied in these two modes of communication, she contends that by
and large "a society must decide whether the ideal is that of writing or that
of talking." She argues that for the past several hundred years Western culture
has preferred the written to the oral ideal, but that it is now in a period of
transition, finding evidence for this shift in the work of innovative writers
where "the introduction of oral devices into written communication suggests
the merging of oral and literate traditions." [29] Susan Sontag had asserted
something similar not quite a decade earlier in *On Photography* (unknowingly
supporting Brassaï's earlier contention that art had begun to reflect the con-
temporary "thirst for reality") when she noted that "the only prose that
seems credible to more and more readers is not the fine writing of someone
like Agee, but the raw record—edited or unedited talk into tape recorders;
fragments or integral texts of sub-literary documents (court records, letters,
diaries, psychiatric case histories, etc.); self-deprecatingly sloppy, often par-
anoid first-person reportage." [30]

We might then see Brassaï's career in the light of his effort to reconcile
both the tension between artistic and documentary photography, and the

28. Robin Tolmach Lakoff, "Some of My Favorite Writers Are Literate: The Mingling of Oral
and Literate Strategies in Written Communication," in *Spoken and Written Language, Volume IX:
Advances in Discourse Processes,* ed. Deborah Tannen (Norwood, N.J.: Ablex Publishing, 1982), 242.

29. *Ibid.,* 242, 260.

30. Sontag, *On Photography,* 74.

two entirely different conceptions of art at war in his work. The cultural tradition that shaped Brassaï's view of art was a product of the literate ideal that placed value on the beauty and formal clarity of carefully elaborated, finished, timeless works of art. Nonetheless, Brassaï would have found the second and competing model of art equally compelling as it evolved out of his own experience and practice of photography. This second model is rooted in technological progress, social and cultural fragmentation, and what Benjamin called the adjustment of the masses to reality, reality to the masses. Influenced by Surrealism, it most closely resembles the oral ideal of "an instantaneous art" that can express "the truth of the moment" and retain something of the "irreplaceable substance of reality" (GN, 66–67).

Significantly, while Brassaï's photographic practice and his approach to style embody the contradictions of photography's position in the transition from modernism to mass-media culture, his writings repeat these same contradictions. He attempts to resolve them by elaborating a form of literary art "in the spirit of photography," which takes conversation as its model. However, his attachment to literate cultural values prevents him from merely transcribing conversations and abandoning any effort to shape his material. Unlike the writers Sontag mentions, Brassaï was adamantly opposed to tape recorders and literal transcriptions, insisting on the important role of memory as a critical filter that allows the writer to concentrate and distill the significance of spoken words.

Brassaï's writings bring his role as a transitional figure into clearer focus and suggest his anticipation of the cultural shift which Lakoff describes. Even though Brassaï's conception of his art is anchored in traditional, literate, high-cultural values, he insists on the cultural significance of photographic technology (despite the fact that it weakens his claims to creative authorship), and he instinctively adopts forms of expression that place a higher value on spontaneity and immediacy than the mediations of form. We find evidence of this not only in Brassaï's insistence that drawing is superior to painting, but in his efforts to capture popular speech, his appreciation for conversation as an art, and his preference for forms such as diaries, journals, and letters that shape experience only minimally. His career exemplifies the difficulty in reconciling the values implicit in new and emerging forms of expression (the more immediate, visual modes of the media; a conception of cultural literacy based on oral forms of expression) with older, high-cultural norms.

On the face of it, Brassaï's reissuing of his photographs in the sixties and seventies is a triumph of older cultural norms. It represents an attempt to consolidate the work of a lifetime and present it to history as his legacy. By

organizing his work into several thematic series, he demonstrates the un-
derlying unity of his aesthetic concerns and articulates them in a coherent
oeuvre. For although Brassaï had already published *Camera in Paris* (a selec-
tion of his photographs from the thirties and forties grouped by theme that
came out in 1949) and what amounted to a portfolio of his work in a variety
of media in the 1952 album entitled *Brassaï,* many of his photographs from
the thirties and forties remained unpublished or were known mainly through
exhibitions. If much of his later work was dispersed in various periodicals—
Life, Verve, Labyrinthe, and most importantly *Harper's Bazaar,* to which he
contributed regularly in the forties and fifties—his later publications appear
intended to confirm the judgment of Jean Galliani in a 1953 article for *Photo-
Monde:*

> Brassaï is one of those rare photographers the expression of whose thought has
> crystallized into an integrated *oeuvre,* and whose work is now becoming known to
> the public on the same plane and by the same means as some writers are known.
> Indeed Brassaï's prints engrave themselves on the memory with an emotional impact
> similar to that experienced during the reading of a literary work, and the emotions
> themselves are comparable. In other words these emotions have a source, a devel-
> opment and a conclusion, following a certain necessary progression. From the be-
> ginning Brassaï has conceived his creations as works belonging to a greater whole.[31]

Nonetheless, this thematic and aesthetic unity should not obscure the
conditions under which Brassaï's oeuvre was realized. The dispersion of
Brassaï's images under a by-line in mass-circulation magazines provides an
important perspective on his art. He occupies a privileged position in the
history of photography in that he was able to protect his position as an
independent artist and to accommodate his interests to the economic exi-
gencies of practicing photography during the forties and fifties. It was during
this period that the role of photographer increasingly became that of illus-
trator, and as Christopher Phillips notes, "the young photographers . . . who
came of age just after World War II and looked to the mass circulation
magazines for their livelihood, generally understood illustration as the con-
dition of photography. The most renowned artist-photographers at this time
could expect to sell their work for no more than fifteen to twenty-five dollars
a print." Phillips finds "institutional" corroboration for the "slippage of the
photographer from the status of autonomous artist to that of illustrator of
(another's) ideas" in the choice of Edward Steichen to succeed Beaumont
Newhall as curator of MoMA's department of photography.[32]

31. Quoted in Bryn Campbell, *World Photography* (New York: Ziff Davis Books, 1981), 205.
32. Christopher Phillips, "The Judgment Seat of Photography," *October,* XXVI (Fall, 1983), 48.

Certainly Brassaï had come of age earlier, during the interwar period, and by the forties he had worked his way out of more crassly commercial assignments ("I too have worked for a hairdressing magazine," he lamented). He insisted that he accepted such assignments only out of necessity, and that when he joined *Harper's Bazaar* he was able to photograph only what he wanted for the magazine.[33] However, the photographer for a mass-circulation magazine can only have relative autonomy; he inevitably works on assignment—however loosely defined—taking photographs to complement a text that is usually not his own. His photographs will be mediated by this text and a page layout that must ultimately reflect the overall style of the publication. Consequently, Brassaï's effort to publish collections of this work represents his reassertion of authorial control: he determines the discourse that surrounds and conditions the reader's view of his photographs.[34]

In the case of *The Secret Paris of the 30's* (1976) he "reauthors" his photographs from an earlier period. This new, more inclusive version of *Paris de nuit* also allows him to reclaim earlier work that had been "misrepresented": the photographs published in the 1935 *Voluptés de Paris*. In reauthoring his photographs, Brassaï was not only able to "revise" his earlier work in the light of changing mores but to reach a wider public, to create a larger audience for his work. While he appears to have understood intuitively the importance of reaching a mass audience in order to establish his career, he credits Henry Miller with articulating a basic truth about the arts in a media age, quoting him as saying: "Today it is not enough to have talent, originality, to write a good or a beautiful book. . . . [You have to] not only *touch* the public, but create your public. Otherwise you run the risk of suicide" (*RH*, 214).

Brassaï's writing in the sixties and seventies is not only a retrospective rearticulation of his work as an oeuvre but also a form of self-assertion in a media culture in which recognition takes the form of a television special: "Brassaï ou Les Yeux d'un Homme" ("Brassaï or A Man's Eyes") aired on French television in 1960. However, there is perhaps no greater indication of the enduring cultural significance of Brassaï's work than that we have come to see it as both history and art. Philip Kaufman's film *Henry and June* (1990) draws on Brassaï's images in order to re-create Paris in the thirties. Unlike Marcel Carné, whose film *Les Portes de la nuit* was inspired by the

33. Hill and Cooper, eds., *Dialogue with Photography*, 39.

34. See Allan Sekula, "On the Invention of Photographic Meaning," *Artforum*, XIII (January, 1975), 36–45, for a discussion of the importance of context in determining the meanings of a photograph.

atmosphere and style of Brassaï's photographs, Kaufman has Brassaï figure as a character in the film, and he uses individual photographs from *The Secret Paris* as freeze frames intended to capture a moment in time. The film communicates something of its own movement and life to the still images, translating them into the age of film and video.

Bibliography

WORKS BY BRASSAÏ

Brassaï. *Les Artistes de ma vie*. Paris: Denoël, 1982. Translated as *The Artists of My Life* by Richard Miller. London: Thames and Hudson, 1982.

———. *Brassaï*. Includes "Souvenirs de mon enfance." Paris: Editions Neuf, 1952.

———. *Camera in Paris*. London: The Focal Press, 1949.

———. *Conversations avec Picasso*. Paris: Gallimard, 1964. Translated as *Picasso and Company* by Francis Price. Garden City, NY: Doubleday and Company, 1966.

———. "Du mur des cavernes au mur des usines." *Minotaure*, nos. 3–4 (1933), 6–7.

———. *Elôhivas Levelek, 1920–1940*. Bukarest: Kriterion Könyvikadó, 1980.

———. *Graffiti*. Paris: Les Editions du Temps, 1961; rpr. Paris: Flammarion, 1993.

———. *Henry Miller, grandeur nature*. Paris: Gallimard, 1975.

———. *Henry Miller, rocher heureux*. Paris: Gallimard, 1978.

———. *Histoire de Marie,* with an introduction by Henry Miller. Paris: Editions du Point du jour, 1949.

———. "My Friend André Kertész." *Camera* (Lucerne, April, 1963), 7–32.

———. "My Memories of E. Atget, P. H. Emerson and Alfred Steiglitz." *Camera*, XLVIII (January, 1969), 4–37.

———. *Paris de nuit,* with an introduction by Paul Morand. Sixty-four photographs by Brassaï. Paris: Arts et Métiers Graphiques, 1933; rpr. Paris: Flammarion, 1987. English edition *Paris by Night* translated by Gilbert Stuart. New York: Pantheon Books, 1987.

———. *Le Paris secret des années 30*. Paris: Gallimard, 1976. English edition *The Secret Paris of the 30's* translated by Richard Miller. New York: Random House/Pantheon, 1976.

———. *Paroles en l'air*. Paris: Firmin-Didot, Editions Jean-Claude Simoën, 1977.

———. "Le Procès de Marie." *Labyrinthe* (Geneva, December, 1946), 8–9.

———. "Reverdy dans son labyrinthe." *Mercure de France*, CCCXLIV (January–April, 1962), 159–68.

————. "Le Sommeil." *Labyrinthe* (Geneva, November, 1945), 11.

————. "Techniques de la photographie de nuit." *Arts et Métiers Graphiques,* XXXIII (January 15, 1933), 24–27.

————. *Ten Photographs by Louis Stettner.* Paris, New York: Two Cities Publications, 1949.

————. "The Three Faces of Paris." *Architectural Digest,* XLI (July, 1984), 26–33.

————. "La Tourterelle et la poupée." *Labyrinthe* (Geneva, May, 1945), 9.

————. *Transmutations.* Portfolio of 12 *cliché-verres.* Lacoste, France: Gallerie des Contards, 1967.

————. "La Villa Palagonia, une curiosité du baroque sicilien." *Gazette des Beaux-Arts* (September, 1962), 351–64.

————. *Voluptés de Paris.* Paris: Paris Publications, n.d.

————. "Walls of Paris." *Harper's Bazaar* (July, 1953), 42–45.

Brassaï, and Andre Bréton. "La Sculpture de Picasso." *Minotaure,* no. 1 (1933), 3–29. Text by Bréton; photographs by Brassaï.

Brassaï, and Dominique Aubier. *Séville en fête.* Text by Aubier; 140 illustrations by Brassaï. Paris: Robert Delpire, 1954.

Brassaï, and Salvador Dali. "Sculptures involontaires." *Minotaure,* nos. 3–4 (1933), 68.

Brassaï, Henry Miller, and Lawrence Durrell. *Hans Reichel, 1892–1958.* Paris: Editions Jeanne Bucher, 1962.

OTHER REFERENCES

Abbott, Berenice. *The World of Atget.* New York: Berkeley Windhover Books, 1977.

Ades, Dawn. "*Minotaure.*" In *Dada and Surrealism Reviewed,* with an introduction by David Sylvester and a supplementary essay by Elizabeth Cowling. London: Arts Council of Great Britain, 1978.

————. *Photomontage.* London: Thames and Hudson, 1986.

Adhémar, Jean. *Les Lithographies de paysage en France à l'époque romantique.* Paris: Archives de l'art français, Librairie Armand Colin, 1937.

Adhémar, Jean, *et al. Brassaï.* Paris: Bibliothèque Nationale, 1963.

Aragon, Louis. *Le Paysan de Paris.* Paris: Gallimard, 1926.

Assouline, Pierre. *Gaston Gallimard.* Paris: Editions Balland/Points, 1984.

Balzac, Honoré de. *Père Goriot.* In *Oeuvres complètes II: Etudes de moeurs, scènes de la vie privée.* Paris: Gallimard, 1963.

Barthes, Roland. *L'Aventure sémiotique.* Paris: Editions du Seuil, 1985.

————. *La Chambre claire.* Paris: Cahiers du cinéma/Gallimard, 1980.

Bataille, Georges. "Lascaux ou la naissance de l'art." In *Oeuvres complètes IX.* Paris: Gallimard, 1979.

————. "L'Esprit moderne et le jeu des transpositions." *Documents* (1930); rpr. (without ill.) in *Oeuvres complètes I.* Paris: Gallimard, 1970.

Baudelaire, Charles. *Oeuvres complètes.* Paris: Gallimard, 1966.

———. *Selected Writings on Art and Artists.* Translated by P. E. Charvet. Cambridge: Cambridge University Press, 1972.

Bazin, André. "Le Style et l'univers de Marcel Carné." In *Marcel Carné,* by Robert Chazal. Paris: Editions Seghers, 1965.

Beaujour, Michel. "Qu'est-ce que *Nadja?*" *La Nouvelle Revue française,* CLXXII (1967), 780–99.

Becker, Howard S. *Exploring Society Photographically.* Catalog to accompany the exhibition at the Mary Leigh Block Gallery, October 16–November 29, 1981, Northwestern University, Evanston, Il.

Bellanger, Claude, ed. *Histoire Générale de la Presse française.* 3 vols. Paris: Presses Universitaires de France, 1972.

Bender, Donald Ray. *Early French Ethnography in Africa and the Development of Ethnology in France.* Minneapolis: University of Minnesota Dept. of Anthropology, 1964.

Benjamin, Walter. "Art in the Age of Mechanical Reproduction." In *Illuminations,* translated by Harry Zohn. New York: Harcourt, Brace & World, 1968.

———. "A Short History of Photography." In *Classic Essays on Photography,* edited by Alan Trachtenberg. New Haven: Leete's Island Books, 1980.

Besson, Georges. *La Photographie française.* Paris: Arts et Métiers, 1936.

Boase, T. S. R. *Georgio Vasari: The Man and the Book.* Princeton: Princeton University Press, 1979.

Bosworth, Patricia. *Diane Arbus: A Biography.* New York: Avon Books, 1984.

Bourdieu, Pierre, *et al. Un Art Moyen: Essai sur les usages sociaux de la photographie.* Paris: Editions de Minuit, 1965.

Bowness, Alan. "Two Books on Picasso." *Studio,* CLXXIV (July, 1967), 71.

Breton, André. *Les Manifestes du Surréalisme.* Paris: Gallimard, 1969.

———. *Nadja.* 1928; rev. ed. Paris: Gallimard, 1964. English edition (corresponds to 1928 French edition) translated by Richard Howard. New York: Grove Press, 1960.

———. *Les Pas perdus.* Paris: Gallimard, 1969.

———. *Le Surrealisme et la peinture.* Paris: Gallimard, 1965. English edition *Surrealism and Painting* translated by Simon Watson Taylor. London: Macdonald and Co., 1965.

Bull, George, trans. Introduction to *The Lives of the Artists,* by Giorgio Vasari. New York: Viking Penguin, 1965.

Bulletin de la Société Française de photographie, 1920–37.

Burgin, Victor, ed. *Thinking Photography.* London: Macmillan Press, 1982.

Burke, James D. *Charles Meryon: Prints and Drawings (Catalogue raisonné).* New Haven: Yale University Art Gallery, 1974.

Campbell, Bryn. *World Photography.* New York: Ziff Davis Books, 1981.

Carrouges, Michel. *André Breton et les données fondamentales du Surréalisme.* Paris: Gallimard, 1950.

Chafe, Wallace, and Deborah Tannen. "The Relation Between Written and Spoken Language." *Annual Reviews of Anthropology,* XVI (1987), 383–407.

Chevrier, Jean-François. "La Bibiothèque Nationale: Collections du XXe Siècle, entrées octobre–décembre 1983." *Photographies,* IV (April, 1984), 84.

————. "Editorial." Translated by C. L. Clark. *Photographies,* VI (December, 1984), 9.

Clark, T. J. *Image of the People: Gustave Courbet and the Second French Republic.* Greenwich, Ct.: New York Graphic Society, 1973.

Clifford, James. *The Predicament of Culture.* Cambridge: Harvard University Press, 1988.

Collier, John. "Photography and Visual Anthropology." In *Principles of Visual Anthropology,* edited by Paul Hocking. The Hague: Mouton Publishers, 1975.

————. *Visual Anthropology: Photography as a Research Method.* New York: Holt, Rinehart and Winston, 1967.

Colloque Atget: Actes du Colloque au Collège de France 14–15 juin 1985. Numéro hors série of *Photographies.* Paris: Fernand Hazan, 1986.

Cowling, Elizabeth. "The Eskimos, the American Indians and the Surrealists." *Art History,* I (December, 1978), 484–99.

Crevel, René. "Le Miroir aux objets." *L'Art vivant,* XIV (July 15, 1925), 23–25.

Décaudin, Michel. "Collage et montage dans l'oeuvre d'Apollinaire." In *Apollinaire, Eine Vortragsreihe aus der Universität Bonn,* edited by Eberhard Leube and Alfred Noyer-Weidner. Wiesbaden: Franz Steiner Verlag, 1980.

Delorme-Louise, M. N. "La Ville Bauhaus." In *La Ville n'est pas un lieu: Revue d'esthétique, 1977, nos. 3–4.* Paris: Union Générale des éditions, 1977.

du Pont, Diana. *Florence Henri: Artist-Photographer of the Avant-Garde.* San Francisco: San Francisco Museum of Modern Art, 1990.

Evenson, Norma. *Paris: A Century of Change, 1878–1978.* New Haven: Yale University Press, 1979.

Fargue, Léon-Paul. *Le Piéton de Paris.* 1932; rpr. Paris: Gallimard, 1939.

Fels, Florent. *Voilà.* Paris: Libraire Arthème Fayard, 1957.

Foster, Hal. "L'Amour faux." *Art in America,* LXXIV (January, 1986), 117–28.

————. *Recodings.* Port Townsend, Wa.: Bay Press, 1985.

Fraser, John. "Atget and the City." *Cambridge Quarterly* (Summer, 1968), 199–233.

Freund, Gisèle. *Photographie et Société.* Paris: Editions du Seuil, 1974.

Fricke, Roswitha, ed. *Bauhaus Photography.* Translated by Harvey L. Mendelsohn. Cambridge, Mass.: MIT Press, 1985.

Galassi, Peter. *Henri Cartier-Bresson: The Early Work.* New York: Museum of Modern Art, 1987.

Gidal, Tim N. *Modern Photojournalism: Origin and Evolution, 1910–33.* New York: Macmillan, 1973.

Gilot, Françoise. *Ma Vie avec Picasso.* Paris: Calmann-Lévy, 1965. English edition with Carleton Lake, *Life with Picasso.* New York: McGraw-Hill, 1964.

Grad, Bonnie L., and Timothy A. Riggs. *Visions of City and Country: Prints and Photographs of Nineteenth-Century France.* Worcester, Mass.: Worcester Art Museum, 1982.

Grenier, Roger. *Brassaï.* New York: Random House/Pantheon, 1988.

Hall-Duncan, Nancy. *Photographic Surrealism.* Akron, Oh.: Akron Arts Institute, 1979.

Hambourg, Maria Morris, and Christopher Phillips. *The New Vision: Photography Between the World Wars.* New York: Museum of Modern Art/Harry N. Abrams, 1989.

Harper's Bazaar, 1930–50.

Haus, Andreas. *Moholy-Nagy: Photographs and Photograms.* New York: Thames and Hudson, 1980.

Henriot, Emile. "Photos de Paris." *Le Temps,* January 30, 1933, p. 1.

Hill, Paul, and Thomas Cooper, eds. *Dialogue with Photography.* New York: Farrar, Straus & Giroux, 1979.

Holcomb, Adèle M. "Some Aspects of Meryon's Symbolism." *Art Journal,* XXXI (Winter, 1971–72), 151–57

Hubert, Renée Riese. *Surrealism and the Book.* Berkeley: University of California Press, 1988.

Jaguer, Edouard. *Les Mystères de la chambre noire.* Paris: Flammarion, 1982.

Jamin, Jean. "Une Initiation au réel: A propos de Segalen." *Cahiers internationaux de Sociologie,* LXVI (1979), 125–39.

Jammes, André, and Eugenia Parry Janis. *The Art of French Calotype.* Princeton: Princeton University Press, 1983.

Janis, Eugenia Parry. "The Man on the Tower of Notre-Dame: New Light on Henri Le Secq." *Image,* XIX, no. 4, pp. 13–25.

Kendall, Paul Murray. *The Art of Biography.* New York: Norton, 1965.

Kertész, André. "Brassaï: Portfolio and an Appreciation." *Infinity* (July, 1966), 3–13.

————. *Paris vu par André Kertész.* Text by Pierre Mac Orlan. Paris: Editions d'Histoire et d'Art, Librairie Plon, 1934.

Krauss, Rosalind. "Nightwalkers." *Art Journal,* XLI (Spring, 1981), 33–38.

————. "The Photographic Conditions of Surrealism," *October,* XIX (Fall, 1981), 3–34.

Krauss, Rosalind, and Jane Livingston. *L'Amour fou: Photography and Surrealism,* with an essay by Dawn Ades. New York: Abbeville Press, 1985.

Lakoff, Robin Tolmach. "Some of My Favorite Writers Are Literate: The Mingling of Oral and Literate Strategies in Written Communication." In *Spoken and Written Language, Volume IX: Advances in Discourse Processes,* edited by Deborah Tannen. Norwood, N.J.: Ablex Publishing, 1982.

L'Art vivant, 1925–39.

Lubin, David. *Act of Portrayal: Eakins, Sargent, James.* New Haven: Yale University Press, 1985.

Luke, David, and Robert Pick, eds. and trans. *Goethe: Conversations and Encounters.* Chicago: Henry Regnery Co., 1966.

Lukacs, John. *Budapest 1900: A Historical Portrait of the City and Its Culture.* New York: Weidenfeld & Nicholson, 1988.

Mac Orlan, Pierre. *Atget, photographe de Paris.* Paris: Henri Jonquières éditeur, 1930.

————. "Les Compagnons de l'Aventure." In *Le Mystère de la malle numéro un.* Paris: Union Générale des éditions, 1984.

————. *Masques sur mesure.* 1937; rpr. Paris: Gallimard, 1965.

Martin, John Rupert. *Baroque.* New York: Harper & Row, 1977.

Martino, Pierre. *Le Naturalisme français (1870–1895).* Paris: Armand Colin, 1923.

Mathews, Timothy. *Reading Apollinaire: Theories of Poetic Language*. Manchester: Manchester University Press, 1987.

Mead, Margaret, and Rhoda Métraux. *The Study of Culture at a Distance*. Chicago: University of Chicago Press, 1953.

Mellor, David, ed. *Germany: The New Photography, 1922–33*. London: Arts Council of Great Britain, 1978.

Miller, Henry. *Max and the White Phagocytes*. Paris: Obelisk Press, 1938.

———. *Tropic of Cancer*. New York: Grove Press, 1961.

Morizet, André. *Du Vieux Paris au Paris Moderne, Haussmann et ses prédécesseurs*. Paris: Librairie Hachette, 1932.

Natkin, Marcel. *L'Art de voir en photographie*. 1935; rpr. Paris: Editions Tiranty, 1948.

Newhall, Beaumont. *The History of Photography*. New York: Museum of Modern Art, 1978.

———. *Photography: A Short Critical History*. New York: Museum of Modern Art, 1938.

Newhall, Beaumont, ed. *Photography: Essays and Images*. New York: Museum of Modern Art/New York Graphic Society, 1980.

Nin, Anaïs. *The Diary of Anaïs Nin, 1934–39*. Edited by Gunther Stuhlmann. New York: Harcourt, Brace & World, 1967.

Owens, Craig. "Photography *en abyme*." *October*, V (Summer, 1978), 73–88.

Pagé, Suzanne, and Catherine Thieck. *Florence Henri: Photographies, 1927–1938*. Paris: ARC, Musée d'Art Moderne de la Ville de Paris, 1978.

Peyre, Henri. *The French Literary Imagination and Dostoevsky*. Tuscaloosa: University of Alabama Press, 1975.

Phillips, Christopher. "The Judgment Seat of Photography." *October*, XXII (Fall, 1982), 27–63.

———. "A Mnemonic Art?: Calotype Aesthetics at Princeton." *October*, XXVI (Fall, 1983), 35–62.

Phillips, Christopher, ed. *Photography in the Modern Era: European Documents and Critical Writings, 1913–1940*. New York: Museum of Modern Art/Aperture, 1991.

Phillips, Sandra S. "The French Picture Magazine *VU*." In *Picture Magazines Before Life*. Woodstock, NY: Catskill Center for Photography (Exhibition Catalog), 1982.

Phillips, Sandra S., David Travis, and Weston J. Naef. *André Kertész: Of Paris and New York*. Chicago: Art Institute of Chicago, 1985.

Pollack, Peter. *The Picture History of Photography*. New York: Harry N. Abrams, 1958.

Proust, Marcel. *A la recherche du temps perdu*. Vols. I and III of 3 vols. Paris: Gallimard, 1966.

Rubin, William, ed. *"Primitivism" in Twentieth-Century Art: The Affinity of the Tribal and the Modern*. 2 vols. New York: Museum of Modern Art, 1984.

1er Salon Indépendent de la Photographie du 24 mai au 7 juin inclus. Catalog of the exhibition. 1929.

Schapiro, Meyer. "Courbet and Popular Imagery." In *Modern Art, 19th and 20th Centuries: Selected Papers*. New York: George Braziller, 1978.

Sekula, Allan. "On the Invention of Photographic Meaning." *Artforum*, XIII (January, 1975), 36–45.

Sharpe, William, and Leonard Wallock, eds. *Visions of the Modern City: Essays in History, Art and Literature*. Baltimore: Johns Hopkins University Press, 1987.

Sheon, Aaron. "The Discovery of Graffiti." *Art Journal*, XXXVI (Fall, 1976), 16–22.

Sichel, Kim Deborah. "Photographs of Paris, 1928–34: Brassaï, André Kertész, Germaine Krull and Man Ray." Ph.D. dissertation, Yale University, 1986.

Snyder, Joel. "Picturing Vision." *Critical Inquiry*, VI (Spring, 1980) 499–526.

Sontag, Susan. *On Photography*. New York: Delta Books, 1977.

Soupault, Philippe. "Etat de la Photographie." In *Photographie*. Paris: Arts et Métiers Graphiques, 1931.

Steichen, Edward. "Four French Photographers." In *U.S. Camera, 1953*, edited by Jonathan Tichenor and Jack Terracciano. New York: U.S. Camera Publishing, 1953.

Stettner, Louis. "A Visit to Brassaï." *Photo Notes* (Fall, 1948); rpr. Rochester, NY: Visual Studies Workshop, 1977.

Stewart, Susan. *On Longing: Narratives of the Miniature, the Gigantic, the Souvenir, the Collection*. Baltimore: Johns Hopkins University Press, 1984.

Szarkowski, John. *Brassaï*, with an introduction by Lawrence Durrell. New York: Museum of Modern Art, 1968.

Szarkowski, John, and Maria Morris Hambourg. *The Work of Atget*. 4 vols. New York: Museum of Modern Art, 1985.

Thomas, Ann. *Lisette Model*. Ottawa: National Gallery of Canada, 1990.

Tiryakian, E. A. "La Sociologie naissante et son milieu culturel." *Cahiers Internationaux de Sociologie*, LXVI (1979), 97–114.

Twyman, Michael. *Lithography, 1800–1850*. London: Oxford University Press, 1970.

Valéry, Paul. "La Crise de l'Esprit." In *Oeuvres complètes I*. Paris: Gallimard, 1957.

Van Tieghem, Philippe. *Les Grandes Doctrines Littéraires en France*. Paris: Presses Universitaires de France, 1968.

Verhaeren, Emile. "La Ville." In *Les Villes tentaculaires, précédées des Campagnes hallucinées*. Paris: Mercure de France, 1931.

Vu: Journal de la semaine, 1928–30.

Warehime, Marja. "On Longing: Narratives of the Miniature, the Gigantic, the Souvenir, the Collection." *SubStance 49*, XV (1986), 97–99.

———. " 'Vision Sauvage' and Images of Culture: Georges Bataille, Editor of *Documents*." *French Review* (October, 1986), 39–45.

Warnaud, André. *Visages de Paris*. Paris: Firmin-Didot, 1930.

Westerbeck, Colin J., Jr. "Night Light: Brassaï and Weegee." *Artforum*, XVI (December, 1976), 34–45.

Williams, Raymond. *The Country and the City*. London: Chatto and Windus, 1973.

Wood, Jeremy. "Brassaï: A Major Exhibition." *Pantheon: Internationale Zeitschrift fur Kunst*, XXXVIII, no. 2 (1980), 119–20.

Zola, Emile. "L'Inondation." In *A Survey of French Literature: Volume II,* edited by Morris
 Bishop. New York: Harcourt, Brace & World, 1965.
————. "Le Roman expérimental." In *An Anthology of Critical Prefaces to the Nineteenth-
 Century French Novel,* edited by Herbert S. Gershman and Kernan B. Whitworth, Jr.
 Columbia, Mo.: University of Missouri Press, 1962.
Zola, François-Emile, and Massin. *Zola photographe, 480 documents.* Paris: Denoël, 1979.

Index

Abbott, Berenice, 9, 58*n,* 84

Académie Moderne, 14

Adam, 7

Ades, Dawn, 4, 39, 40–41, 94, 95

Agee, James, 172

Albers, Josef, 14

Apollinaire, Guillaume, 93, 95, 147–49, 149*n*

Aragon, Louis, 15–16, 84, 90, 163, 164

Arbus, Diane, 1, 134, 151

Art vivant, L', 60, 60*n,* 70

Arts et Métiers Graphiques, 13, 15, 33, 85, 98

Arts et Métiers Graphiques (publisher), 16, 31, 49, 61, 83

Atget, Eugène, 5, 10, 53–60, 63, 69, 83, 102*n,* 110

Automatic writing and automatism, 68, 78, 146–47, 164

Bal des Quatre Saisons, 114*n*

Bal des Quat'z Arts, 138

Bal Nègre, 110–11

Bals-Musette, 35–36, 151

Balzac, Honoré de, 73, 81, 100, 116, 130, 144

Barbusse, Henri, 28

Baron, Jacques, 94

Baroque, 96–97, 102, 104, 108, 110–11, 124, 124*n,* 128–29, 129*n,* 132–34, 138, 140, 161

Barthes, Roland, 102–103

Bataille, Georges, 12*n,* 93, 94, 97, 99

Baudelaire, Charles: *The Painter of Modern Life* by, 4, 81, 82, 84, 98, 100; and Meryon, 50; and tour Saint-Jacques, 52; on photography, 71–72, 77; treatment of lesbianism and homosexuality by, 116; on the artist, 123; modernism of, 165–66; and primitive works, 166

Bauhaus, 8, 10, 12, 14, 62, 65, 122

Bayer, Herbert, 8, 56

Bazin, André, 107–108

Beauvoir, Simone de, 107*n*

Becker, Howard, 90, 117

Bender, Donald Ray, 91*n*

Benjamin, Walter, 6, 20, 59, 168, 170, 171, 173

Berliner Illustrirte Zeitung, 7, 29

Bernard, Claude, 72–73

Besson, Georges, 169

Bibliothèque Nationale, 2, 170

Bijou (Miss Diamonds), 66, 66*n,* 86, 107, 115, 151

Blossfeldt, Karl, 11, 12*n,* 16

Boiffard, Jacques-André, 38, 79

Bonnard, Pierre, 126, 127, 130, 131, 134

Bowness, Alan, 120

Brancusi, Constantin, 95

Brandt, Bill, 61

Braque, Georges, 91, 130, 137, 141, 148

Brassaï: death date of, 1; exhibitions of, 1–2, 170; and introductions to his books, 1–2,

18, 120, 122–23, 143, 160–61, 170; publication of photographs by, 1, 16–17, 88, 173–74, 175; as writer, 1–2, 17–18, 114–15, 120, 142–58, 173–75; and contacts with writers and artists, 2–3, 37–38, 119–21, 126, 158, 161; as contributor to Surrealist publications, 2, 4, 7, 11, 12n, 30, 34, 85, 95–97, 122, 126, 132, 163; and Surrealism, 4–5, 37, 38, 68–69, 80, 84, 95–97, 131–32, 134, 139n, 145, 160–62, 165, 165n; and graffiti, 5, 67, 89, 90, 96–101, 114, 145, 166–68; as photojournalist, 5–6, 14, 32–33, 174–75; arrival of, in Paris, 22–23, 25; as painter, 22, 28, 56, 142, 160; birth date of, 23, 81, 140; early life and family of, 23–24, 45, 140; as journalist, 23, 25–31, 56–57, 142, 144–45; eyes of, 24, 137, 156; Miller on, 24–25; naturalization of, as French citizen, 24; use of name Brassaï, 27; beginnings of photographic work, 27–31; cameras used by, 29–30, 31, 32n; *modus operandi* as photographer, 31–38, 160; photographs of artists by, 32, 32n, 125, 126–41; and film, 34–35, 175–76; and Atget, 56, 57, 60, 60n, 110; compared with Kertész, 62–67, 114, 130; and Realism and Naturalism, 69, 81–83, 144, 150; and concept of photograph, 81–82; Guys as model of, 81, 82, 84, 123; and "otherness," 84, 103, 110–11; photographic style of, 85–88, 101–18, 128–41; and the Baroque, 96–97, 102, 104, 108, 110–11, 124, 128–29, 129n, 132, 133, 138, 140, 161; and cultural tourism, 104–106; spectacle in photographs of, 104–13; compared with Man Ray, 110–11; mannequin in work of, 110; observer in photographs by, 110–12, 152; nudes in photographs by, 111, 111n; cropping of photographs by, 113–14n; narratives accompanying photographs by, 114–15; and ethnographic surrealism, 116–18; compared with Vasari, 119–20; justification of interest in photography, 121–22; rejection of special effects in photography, 122–23; preferences for sketches and drawings, 123–24, 173; myth of, on origin of his photography, 124; on form versus content, 125–26; as collector, 131; light and shadow in photographs by, 132–33; humor of, 134; frame within the frame in photographs by, 135–36; mirror compositions by, 136, 138–40, 152–58, 160, 161; and fascination with artist's gaze, 137–38; indirect presence of, in photographs, 137; and German occupation of Paris, 142; aesthetic philosophy of photography, 143–44, 159–60, 165–66; techniques used by, 143; fascination with conversation, 145–47, 173; compared with Apollinaire, 147–49; on writing compared with photography, 147–49; as transitional figure, 159–76; as contributor to mass-circulation magazines, 174–75; television special on, 175. *See also* Picasso, Pablo

—works: *Les Artistes de ma vie/The Artists of My Life*, 17, 119–21, 126–41, 143; "Bistrot Tabac," 143, 145–47, 149; *Brassaï*, 17, 174; *Camera in Paris*, 1–2, 16, 18, 29, 31, 35, 81, 85, 102, 120–23, 126, 127, 138, 151, 152, 157, 160–61, 170, 174; *Ciel postiche*, 4, 122; *Conversations avec Picasso/Picasso and Company*, 17, 98, 99, 118, 120, 121, 124–25, 127, 129, 143, 145, 146, 154, 155; *Fiesta in Seville*, 3n, 17; *Graffiti*, 1, 17, 85, 96–102, 143, 166; Henry Miller biography, 17, 30, 132, 143, 154–58; *Histoire de Marie*, 17, 143, 145, 147, 149–54; "A Man Dies in the Street," 34; *Paris de nuit/Paris by Night*, 1, 3, 16, 18–19, 22, 31, 33–35, 37n, 49, 61–66, 85–86, 97, 101, 103, 115, 132, 155, 159, 175; "Paris intime," 67, 85; *Le Paris secret des années 30/The Secret Paris of the 30's*, 1, 2, 17, 18, 35–37, 44, 46, 65, 66, 82, 85–88, 98, 102–104, 108–18, 138, 143, 150, 151, 153, 155, 165, 175, 176; *Paroles en l'air/Words in the Air* or *Idle Talk*, 17, 143, 146, 151; *Sculptures involontaires*, 4; "Souvenirs de mon enfance"/"Memories of my Childhood," 140; *Tant qu'il y aura des bêtes*, 34; "Techniques of Night Photography," 33–34; *Transmutations*, 17, 68–69, 122; "La Villa Palagonia," 96; *Voluptés de Paris*, 3, 18, 85–86, 98, 101–104, 108–13, 152, 155, 175

"Brassaï ou Les Yeux d'un homme," 175
Brassoi Lapok, 23, 26

Brauner, Victor, 114*n*

Breton, André: on the newspaper, 6; on painting, 12, 38, 78; on "convulsive beauty," 41; on the "marvelous," 76–77; on automatic writing and automatism, 78, 147, 164; and photography, 78–81; on *hasard objectif*, 87–88; and Aragon, 90; on relationship between science and art, 90–91; on writing, 146; and Surrealist movement, 162–64

—works: *L'Amour fou*, 4, 40, 52, 80; "The Crisis of the Object," 89–91, 163*n*; first *Manifesto of Surrealism*, 43, 76–78, 164; *Nadja*, 6, 38, 40, 41, 43, 78–81, 84, 125; "Picasso in His Element," 163–64; second *Manifesto of Surrealism*, 39; *Surrealism and Painting*, 12, 38, 78–79, 92, 95, 111*n*, 132, 162; *Les Vases communicants*, 40

Bretonne, Restif de la, 99

Burke, James, 48–49, 52

Calotype, 51, 53

Cameras, 29–30, 29*n*, 31

Canal Saint-Denis, 55–56

Canal Saint-Martin, 55–56

Carco, Francis, 61, 105

Carné, Marcel, 69, 107–108, 107–108*n*, 175–76

Cartier-Bresson, Henri, 14, 31, 31–32*n*

Céline, Louis-Ferdinand, 145, 156

Cendrars, Blaise, 8

Chamboredon, Jean-Pierre, 160, 161

Champfleury, Jules, 71, 72, 100

Charensol, Georges, 9

Chevrier, Jean-François, 88

Children's art, 99, 100

Clair, René, 9, 103, 115

Claudel, Paul, 82

Clemenceau, Georges, 30

Clergue, Lucien, 161

Clifford, James, 44, 44*n*, 89, 93

Cocteau, Jean, 61

Coiffure, 7

Colette, 8, 102*n*, 104, 107*n*

Collège de Sociologie, 93

Collier, John, 117

Coronet, 126

Courbet, Gustave, 63, 71, 72, 81

Crapouillot, Le, 60

Crevel, René, 70–71

Cromer, Gabriel, 169

Cubism, 91–92, 135, 141, 148

Cultural tourism, 104–107

Dabit, Eugène, 108*n*

Dada, 6, 10, 37, 40, 56, 92

Dali, Salvador: 99, 130, 130*n*, 135–37, 163, 163*n*; and Gala, 130, 130*n*, 135, 136

Dame de chez Maxims, La, 34–35

Danjou, Henri, 14, 105

Dans la Salle de Culture Physique, 7

Daumier, Honoré, 123, 159, 166

De Chirico, Giorgio, 12, 14, 59, 59*n*

Décaudin, Michel, 148, 149*n*

Degas, Edgar, 123, 161, 166

Delaunay, Robert, 9

Desnos, Robert, 37, 79, 98

Despiau, Charles, 134–35

Détective, 7, 16

Deutscher Werkbund, 10

Diderot, Denis, 145

Dignimont, 102

Documents, 13, 40, 93, 94, 95, 97

Doisneau, Robert, 1

Dostoevsky, Fyodor, 82, 116

Du Cinéma, 16

Duchamp, Marcel, 56, 163*n*

Dufy, Raoul, 26, 129, 135

Duhamel, Georges, 8

Durkheim, Émile, 91, 92

Durkheim School, 91–92, 91*n*

Durrell, Lawrence, 1, 32–33, 35, 154, 156

Eckermann, Johann Peter, 146

Eiffel Tower, 56, 61

Eisenstaedt, Alfred, 8

Elder, J. E., 169

Éluard, Paul, 79

Ernst, Max, 10, 12, 38, 99

Etchings, of Meryon, 49–53

Ethnographic surrealism: origin of term, 5*n*, 89; definition of, 89–90; relationship be-

tween science and avant-garde art, 90–94; of Brassaï, 116–18

Ethnography, 89–94

Exhibitions. *See* specific exhibitions and museums

Exposition des Arts Décoratifs, 26

Exposition Internationale de la photographie contemporaine, 13–14

Fargue, Léon-Paul, 105–107

Fauves, 91

Feininger, Andreas, 10

Fels, Florent, 9, 26, 60*n*, 101

Film und Foto exhibition, 9–14, 29, 38, 58, 59, 170

Films, 34–35, 103, 107–108, 115, 175–76

First Independent Salon of Photography. *See* Salon de l'Escalier

Flaubert, Gustave, 73, 150

Foire du Trône, 108–109

Folies-Bergère, 110, 123, 132

Foster, Hal, 39*n*, 153

Foto-auge, 10, 58

Fraser, John, 54

Freud, Sigmund, 98, 102*n*, 134

Freund, Gisèle, 7–8, 14

Galassi, Peter, 31–32*n*

Galerie d'Art Contemporain, 13

Galerie de la Pléaide, 13

Galerie Pierre Colle, 163*n*

Galerie Surréaliste, 92

Galliani, Jean, 174

Gallimard, Gaston, 16

Gauguin, Paul, 166

Gazette des Beaux-Arts, La, 96

Gazette du bon ton, La, 8

Géricault, Théodore, 153

Giacometti, Alberto, 135, 136

Gidal brothers, 8

Gide, André, 82

Gilot, Françoise, 32*n*

Giono, Jean, 107*n*

Giraudoux, Jean, 66, 107

Goethe, 17, 99, 145, 146, 156

Goncourt, Edmond de, 72, 161

Goncourt brothers, 72

Goya y Lucientes, Francisco José de, 123

Grad, Bonnie, 46, 52

Gräff, Werner, 16

Graffiti, 5, 67, 89, 90, 96–101, 114, 145, 166–68, 167*n*

Grenier, Roger, 32*n*, 147

Grosz, George, 10

Guillot, Laure-Albin, 9, 9*n*

Guizot, François, 47

Gunther, Thomas Michael, 55*n*

Guys, Constantin, 81, 82, 84, 123, 161, 166

Halász, Gyula. *See* Brassaï

Hall-Duncan, Nancy, 38, 39–40, 41, 169

Hambourg, Maria Morris, 7*n*, 55

Harper's Bazaar, 3*n*, 33, 66*n*, 107, 107*n*, 126, 174, 175

Haussmann, Baron Georges Eugène, 48, 49, 53, 53*n*, 56

Heartfield, John, 10

Henri, Florence, 10, 13, 14–15, 16, 139

Henriot, Emile, 159

Henry and June, 175–76

Historic Monuments Commission, 49, 51

Höch, Hannah, 10

Hokusai, 123

Hoyningen-Huene, Georges, 9

Hugo, Victor, 47, 48–49, 50, 51, 52, 100, 103, 115, 156

Hungary, 23–25, 144–45

Illustration, L', 7, 7*n*, 29–30

Impressionism, 91

Institut d'Ethnologie, 91, 91*n*

International Exhibition of Film and Photography. See *Film und Foto* exhibition

Intransigeant, L', 95

Jaguer, Edouard, 38–39

Jamin, Jean, 106*n*, 117–18

Janis, Eugenia Parry, 52*n*, 53

Jardin des Modes, Le, 7, 8

Jensen, Wilhelm, 98

Jour se lève, Le, 108, 108*n*

Journalism: Brassaï as photojournalist, 5–6; during interwar years, 6–9; photo-essays in late 1920s, 7–8; Brassaï's early journalistic career in Paris, 23, 25–31, 142, 144–45; emergence of photojournalism, 70–71
Jouvet, Louis, 9
Joyce, James, 145

Kahnweiler, D.-H., 127, 128–29, 134
Kaufman, Philip, 175–76
Kertész, André: friendship with Brassaï, 2; as contributor to German weeklies, 8; as contributor to *Vu*, 8, 29, 30, 63, 114; on organizing committee of Salon de l'Escalier, 9; in exhibit at Musée des Arts Décoratifs, 13; in 1920s, 14, 83; photograph of Chartier restaurant, 26; and Brassaï's early interest in photography, 28–29; as model of professional photographer, 28–29; in *Film und Foto* exhibition, 29; camera used by, 31; compared with Atget, 59; compared with Brassaï, 62–67, 114, 130
Klee, Paul, 97
Kokoschka, Oskar, 135, 137
Korda, Alexander, 34–35, 37
Kostrowitsky, Wilhelm. *See* Apollinaire, Guillaume
Krauss, Rosalind, 4, 39, 41–42, 78, 136, 139, 139n, 161n
Krull, Germaine: as contributor to German weeklies, 8; industrial forms in photographs of, 8, 9, 56, 61, 62; in Salon d'Automne exhibition, 9, 16; in 1920s, 14, 83; *Métal* by, 16; compared with other photographers, 59, 61–62, 114; as contributor to *Vu*, 105, 114

Labyrinthe, 34, 174
Lakoff, Robin Tolmach, 172, 173
Laurens, Henri, 135, 136
Le Corbusier, 131, 136
Le Secq, Henri, 51–53, 52n
Léger, Fernand, 14, 58–59
Leica, 29–30, 29n, 31
Leiris, Michel, 93, 116–17, 118
Leonardo da Vinci, 17, 98
Lévi-Strauss, Claude, 94

Lévy-Bruhl, Lucien, 91n
Lhote, André, 14
Life, 126, 174
Liliput, 126
Lipchitz, Jacques, 127
Lissitzky, El, 10, 11, 12
Lorant, Stefan, 7
Lubin, David, 128
Lukacs, John, 23

Maar, Dora, 38, 136
Mac Orlan, Pierre: as contributor to *Vu*, 8; writings of, 8, 60, 61, 69; on photography, 69–70, 78; on the social fantastic, 75–77; and *Voluptés*, 101; urban themes of, 105, 108, 108n
Madwoman of Chaillot, The, 66, 107
Maillol, Aristide, 95, 126, 129n, 130–35, 130n
Malraux, André, 8
Manet, Édouard, 153, 161
Mann, Thomas, 27, 33
Mannequin, 12, 59, 110, 151
Manuel, Henri, 79
Marianne, 16, 97
Marius, 35
Martin, John Rupert, 124, 124n
Martino, Pierre, 72
Marville, Charles, 53n
Masson, André, 94
Matisse, Henri, 120, 126, 127, 129, 133–36
Maupassant, Guy de, 73
Mauriac, François, 37
Mauritius Verlag, 30
Maurois, André, 37
Mauss, Marcel, 91, 91n, 93
Mead, Margaret, 106n
Mérimée, Prosper, 82
Meryon, Charles, 49–53, 52n, 93, 115, 116
Michaux, Henri, 37
Michelangelo, 98, 120
Miller, Henry: Brassaï's friendship with, 2, 136, 161; Brassaï's biography of, 17, 30, 126, 132, 143, 154–58; and *Histoire de Marie*, 17, 143, 145, 149–51, 153; on Brassaï's eyes, 24, 137, 156; and *Hôtel des Terrasses*, 37; novels of, 102n, 154, 155; and cultural tourism, 105;

Brassaï's interest in details of life of, 125;
Brassaï's conversations with, 140, 145–46;
arrival of, in Paris, 154; Brassaï's photo-
graphs of, 156; on Surrealism, 156–57; and
Anaïs Nin, 157–58; writing style and tech-
niques of, 157; on photography, 158; on
creation of public, 175

Miller, Lee, 38, 40

Minotaure: Brassaï as contributor to, 2, 4, 7, 11,
12n, 85, 95–97, 122, 126, 132, 163; Surreal-
ist photographs published in, 13, 40, 162,
164–65; Breton's essay on Picasso in, 78,
163–64; Breton's "La Nuit du tournesol" in,
80–81; special issue of, on Mission Dakar-
Djibouti, 93–94, 95; focus of, 94–97;
founding of, 94–95

Miró, Joan, 97, 130, 135, 136

Mirror compositions, 136, 138–40, 152–58,
160, 161, 161n

Mission Dakar-Djibouti, 93–94, 95, 118

Missions Héliographiques, 53, 54

Model, Lisette, 151

Modernist syncretism, 133

Moholy-Nagy, László: as contributor to Ger-
man weeklies, 8; in *Film und Foto* exhibi-
tion, 10, 11; and the Bauhaus, 14, 62, 122;
on photography, 15; compared with Brassaï,
65; portrait of Schlemmer, 65; special effects
in photography of, 122

Molderings, Herbert, 11

MoMA. *See* Museum of Modern Art

Montesquieu, Charles Louis de Secondat, 83

Montmartre, 105, 133

Montparnasse, 105

Morand, Paul, 8, 37, 37n, 62, 63, 85, 115

Moreno, Marguerite, 66n, 107

Morizet, André, 47

Münchner Illustrierte Presse, 7–8

Munkacsi, Martin, 8

Musée des Arts Décoratifs, 13

Museum of Modern Art, 1–2, 169–70, 174

Napoleon III, 48

Natkin, Marcel, 84, 84n

Naturalism, 72–75, 81, 144, 150

Nègre, Charles, 51–52

Newhall, Beaumont, 169–70, 174

Newspapers, 6–7. *See also* Journalism; and spe-
cific newspapers

Nin, Anaïs, 24, 156, 157–58

Nodier, Charles, 46

Noll, Marcel, 90

Notre-Dame, 48–49, 51–52, 115–16, 123

Nudes, 111, 111n

Oeil, L', 126, 138

Outerbridge, Paul, 9

Owens, Craig, 139

Ozenfant, Amédée, 14

Pagé, Suzanne, 139

Pagnol, Marcel, 35

Painting: Breton on, 12, 38, 78; and Surreal-
ism, 12, 78–79; Brassaï as painter, 22, 28, 56,
142, 160; Brassaï on preference for sketches
and drawings over, 123–24, 173; Picasso's
use of real object in, 163–64; Benjamin on,
171. *See also* specific painters

Paris: graffiti of, 5, 67, 89, 90, 96–101, 114,
145, 166–68; Brassaï's arrival in, 22–23, 25;
cafés in, 25, 38, 105, 115, 154; night pho-
tography of, 29; changes in, during last years
of 1920s, 30; bistros and Bals-Musette in,
35–36, 105, 151; Hôtel des Terrasses in, 37;
of Brassaï's childhood, 45; metaphor of Ro-
manesque church for, 45–46, 114; nine-
teenth-century preservation of, 46–49;
Notre-Dame in, 48–49, 51–52, 115–16,
123; Meryon's etchings of, 49–53, 115, 116;
tour Saint-Jacques in, 51–52, 80–81, 116;
Atget's photography of, 53–60; industrial
section of, 55–56; Eiffel Tower in, 56, 61;
L'Art vivant articles on, 60; Kertész's photo-
graphs of, compared with Brassaï's, 61–67;
photographic books on, in 1930s, 61; in
Paris by Night, 85–88, 97; in *The Secret Paris
of the 30's,* 85–88, 98, 102–104, 108–18; in
Voluptés de Paris, 101–104, 108–13; erotic di-
mension of, 102–104, 102n; Montmartre in,
105, 133; Montparnasse in, 105; rue de
Lappe in, 105–106, 114n; Foire du Trône in,
108–109; Folies-Bergère in, 110, 123, 132;

Miller's arrival in, 154. *See also* Brassaï: works

Paris Magazine, 7

Paris-Soir, 6–7, 7, 8, 168

Parry, Roger, 38

Paulhan, Jean, 153

Péret, Benjamin, 79

Periodical press, 7–9, 16, 40, 168. *See also* Journalism; and specific magazines

Peterhans, Walter, 10, 11

Peyre, Henri, 82

Phillips, Christopher, 7*n,* 169, 174

Phillips, Sandra, 8–9, 8*n,* 145*n*

Photographic exhibitions. *See* specific exhibitions and museums

Photographic Surrealism exhibition, 169

Photography 1839–1937, 169–70

Photography: in newspapers and periodicals in interwar years, 5–9, 13; Bauhaus, 8, 10, 12, 14, 62, 65, 122; Surrealist, 12–13, 38–44, 136, 161–65, 168–69; role of photographer and control of work in 1930s, 14–15; new realism in, 15–16; Brassaï's initial lack of interest in, 27; Brassaï's early interest in, 27–31; night, 29, 33–34; Brassaï's approach to, 31–38; Cartier-Bresson's "decisive moment," 31; Man Ray's techniques, 40, 58*n;* of Atget, 53–60; literariness of photographic image from Realism to Surrealism, 69–81; Crevel on, 70–71; emergence of photojournalism, 70–71; Mac Orlan on, 70, 75, 77–78; Baudelaire on, 71–72, 77; and Zola, 74–75, 83; and Breton, 78–81; Brassaï's conception of the photograph, 81–82; Vétheuil on, 83; and visual anthropology, 117; Brassaï's justification for interest in, 121–22; Brassaï's rejection of special effects in, 122–23; Moholy-Nagy's special effects in, 122; Brassaï's myth of origin of, 124; Picasso on, 124–25; Brassaï on form versus content in, 125–26; Brassaï's aesthetic philosophy of, 143–44, 159–60, 165–66; Brassaï's comparison of writing with, 147–49; Miller on, 158; Daumier on, 159; Benjamin on, 168, 170, 171; status of, as art, 168–71. *See also* Portraiture; and specific photographers

Picasso, Pablo: Brassaï's photographs of, 1, 127, 129, 130, 131, 135; Brassaï's friendship with, 2, 120, 161; as Surrealist painter, 12; Brassaï's book on, 17, 98, 99, 118, 120, 121, 124–26, 129, 143, 146, 154, 155; Miller on, 24; Brassaï's photographic sessions with, 32, 32*n,* 125; Breton's essay on, 78, 163–64; Cubism of, 91; graffiti by, 97; and children's art, 99; on creativity, 99; nudes painted by, 111*n;* on objective reality, 118; reaction to Brassaï, 121; Brassaï's preference for drawings of, 124; on photography, 124–25; Brassaï's interest in life of, 125; Brassaï's photographs of sculpture of, 126, 132–33; angel sculpture by, 128–29, 134; *Demoiselles d'Avignon* by, 128; as collector, 131; eyes of, 137, 156; premonitory works of, 140; concentration of, 142; as conversationalist, 146; and Apollinaire, 148; collages of, 148, 164, 166; early works of, 153; influence of, on Brassaï's photographs, 161

Plume d'or, 13

Poiret, Paul, 26

Pollack, Peter, 101

Ponge, Francis, 153, 155

Portes de la nuit, Les, 107–108, 108*n,* 175–76

Portraiture: observer in, 111–12, 152; in *The Artists of My Life,* 126–41; as exploitation, 128; double portrait of Dali and Gala, 130, 130*n,* 136; light and shadow in, 132–33; humor in, 134; frame within the frame of, 135–36; mirror compositions in, 136, 138–40; Brassaï's fascination with artist's gaze, 137–38; Brassaï on, 151–52

Prévert, Jacques, 82, 107, 107–108*n*

Prévost, Jean, 9

Prévost, l'Abbé, 156

Primitive art, 92–94, 96–99, 100, 166

Prostitutes, 112–13, 152, 153, 161

Proust, Marcel, 45–46, 82, 116, 137–38, 145–47, 150, 151, 156–58

Queneau, Raymond, 37

Rabelais, 156

Rákosi, Jenó, 25

Ray, Man: in Salon de l'Escalier, 9; in *Film und Foto* exhibition, 10, 11, 12; in exhibit at Musée des Arts Décoratifs, 13; in 1920s, 14, 83; defense of work by, 15; as Surrealist photographer, 37, 38, 40, 58*n*, 79, 122, 161, 162; and Atget, 56, 57*n*, 58; move to Paris, 56; connections with writers, 70; Crevel on, 70–71; Breton on, 79; and photographs for *Nadja*, 79; in inaugural show at Galerie Surréaliste, 92; compared with Brassaï, 110–11
Raynal, Maurice, 95
Realism: in photograph, 69, 71–73, 81–83, 144; literary, 72–73, 81–83
Reichel, Hans, 136, 140
Rembrandt, 17, 123, 124, 124*n*, 161
Rendez-vous, Le, 107
Renger-Patzsch, Albert, 10, 11, 16
Révolution Surréaliste, La, 13, 40, 58, 59, 102*n*
Ribemont-Dessaignes, Georges, 37
Richier, Germaine, 130, 135, 136, 138–41
Riggs, Timothy, 46, 52
Rimbaud, Arthur, 92, 156
Rivière, Jacques, 82
Rodchenko, Aleksandr, 11
Roh, Franz, 10
Rolleiflex, 31, 32*n*
Romantic movement, 100
Ronis, Willy, 1
Rubin, William, 133
Rue de Lappe, 105–106, 114*n*

Saint-Exupéry, Antoine de, 107*n*
Salon d'Automne, 9, 16
Salon de l'Escalier, 9, 13–14, 29
Salon of 1859, p. 71
Sander, August, 150–51
Sartre, Jean-Paul, 107*n*
Scandale, 102, 108
Schall, Roger, 61
Schlemmer, Oskar, 65
Science and avant-garde art, 90–94
Secrets de Paris, 7
Segalen, Victor, 117–18
Service des travaux historiques, Le, 53*n*, 54
Seuphor, Marcel, 61
Sexuality, 102–104, 102*n*, 108–13, 116

Sichel, Kim, 61, 63–64*n*
Simenon, Georges, 8
Skira, Albert, 95
Snyder, Joel, 129
Social fantastic (*Le fantastique social*), 75–77
Société Française de Photographie, 9, 14
Sontag, Susan, 39, 39*n*, 41, 42–43, 44, 79, 88, 89, 150, 162, 172, 173
Soupault, Philippe, 8, 15
Sous les toits de Paris, 103, 115
Stalin, Joseph, 11
Steichen, Edward, 174
Stendhal, 82
Surrealism: and Brassaï, 4–5, 37, 38, 68–69, 80, 84, 95–97, 131–32, 134, 139*n*, 145, 160–62, 165, 165*n*; ethnographic surrealism, 5*n*; and principle of defamiliarization (*dépaysement*), 5, 41, 43, 89–90; and breakdown of culture in interwar years, 6; Surrealist publications, 7, 8–9, 40, 94–97; use of images in, 11–12; city of, 12; compared with the Bauhaus, 12; and painting, 12, 78–79; and photography, 12–13, 38–44, 136, 161–65, 168–69; and Man Ray, 37, 58, 58*n*, 79; Breton's second *Manifesto of Surrealism*, 39; goal of, 39; Breton's first *Manifesto of Surrealism*, 43, 76–78, 164; and collecting, 43–44, 131; and Atget, 57–60; and automatic writing, 68, 78, 146–47, 164; and the "marvelous," 76–77; and ethnography, 89–94; and primitive art, 92–93, 98–99, 166; and Freud's works, 98; Miller on, 156–57; appropriation of, by advertising, 169. *See also* specific Surrealists
Surréalisme au Service de la Révolution, Le, 40
Surrealist Baroque, 96–97, 102, 104, 108, 110–11, 132, 134
Surrealist photography, 12–13, 38–44, 136, 161–65, 168–69
Szarkowski, John, 55, 102, 107

Tabard, Maurice, 12, 38
Tanguy, Yves, 92
Taylor, Baron Isidore, 46, 49, 51
Television special on Brassaï, 175
Tériade, 37*n*, 38, 94–95
Theater. *See* specific plays

Thomas Aquinas, 145
Tihanyi, Lajos, 22–23, 26, 27, 37, 145
Tiryakian, E. A., 91–92
Toulouse-Lautrec, Henri de, 123
Tour Saint-Jacques, 51–52, 80–81, 116
Tourism, cultural, 104–106
Travis, David, 9, 14, 61, 70
Tzara, Tristan, 37

Ubac, Raoul, 38
Uccello, Paolo, 119
Umbo, 8

Valéry, Paul, 92
Van Gogh, Vincent, 166
Vasari, Giorgio, 119–20
Velasquez, Diego Rodríguez de Silva, 138
Vénus, 7
Ver, Moï, 61
Verhaeren, Emile, 47–48
Versailles, 57
Verve, 126, 174
Vétheuil, Jean, 83

Villon, François, 150
Viollet-le-Duc, Eugène, 51, 115
Vitrac, Roger, 94
Vogel, Lucien, 8, 9
Vogue, 9
Voigtlander Bergheil, 31
Voilà, 7, 16, 101
Vollard, Ambroise, 128, 130, 140
Votre Beauté, 7
Vu, 7, 8–9, 29, 30, 34, 63, 105, 114, 168

Warnaud, André, 16, 61
Watney, Simon, 11, 59
Watteau, Antoine, 129n
Weimar Republic weeklies, 7–8
Westerbeck, Colin, 65, 86, 102, 113–14, 113–14n, 116, 151–52
Weston, Edward, 10
Williams, Raymond, 48
Wood, Jeremy, 123, 158, 161, 166

Zeitgeist, 75
Zola, Emile, 72–75, 81, 83, 144, 149, 150